FEELING LIKE A NUMBER ONE

The unofficial 1980 Top Of The Pops *guidebook*

Steve Binnie

Copyright © 2016 Steve Binnie.

All rights reserved. This book or any portion thereof may not be reproduced or used in any manner whatsoever without the express written permission of the publisher except for the use of brief quotations in a book review or scholarly journal.

First Printing: 2016

ISBN 978-1-326-52514-9

http://www.soundofthecrowd.org.uk

In memory of those we lost in 2015 during the BBC Four repeat run, including Errol Brown, Louis Johnson, Keith Michell, Rico Rodriguez, John Bradbury, Phil Taylor and Lemmy.

Contents

Acknowledgements.....................7
Introduction..............................9
January 3................................11
January 10..............................16
January 17..............................20
January 24..............................26
January 31..............................31
February 7..............................36
February 15............................41
February 22............................46
February 28............................50
March 6..................................55
March 13................................59
March 20................................64
March 27................................69
April 3....................................74
April 10..................................79
April 17..................................84
April 24..................................89
May 1....................................94
May 8....................................99
May 15................................105
May 22................................110
May 29................................116

July 9..................................122
August 7..............................127
August 14............................133
August 21............................137
August 28............................142
September 4........................148
September 11......................153
September 18......................158
September 25......................162
October 2............................166
October 9............................170
October 16..........................175
October 23..........................180
October 30..........................184
November 6........................188
November 13......................193
November 20......................197
November 27......................201
December 4........................205
December 11......................209
December 18......................214
December 25......................219
January 1 1981....................227
Index..................................233

Acknowledgements

Grateful thanks to Neil Barker and all at *Popscene* for their seemingly boundless knowledge of all things TOTP related, and to those who must remain nameless for supplying the forbidden episodes that BBC Four dared not show, especially the unbroadcast pilot edition which is worth its weight in videotape.

Introduction

I was born in 1972. For the rest of the century, pop music was my life. The radio was on all day (playing Radio 1, more often than not), family members bought me records as soon as I was old enough to identify the songs I liked, and the week revolved around *Top of the Pops* on a Thursday evening.

The tipping point in my early existence was the autumn of 1979, when I bought a record with my own pocket money, rather than using a combination of hints and pleading to persuade a grown-up to buy it for me (in all fairness, it didn't usually take much persuasion). Having shelled out for the Buggles' *Video Killed the Radio Star*, I began to take an interest in the mechanics of the singles chart. Here was a measure of public opinion in which I, a mere seven year old, could participate. The grown-ups could vote for boring things like who got to be Prime Minister, but when the Buggles made it to number 1 it was partly thanks to me. I was part of the democratic process. I helped their follow-up single *The Plastic Age* into the chart, I was part of the *Captain Beaky* revolution and the excitement of helping *The Bucket of Water Song* into the top forty has never left me.

Of course, after a while this feeling of power began to wear off as I realised that my patronage of a particular act wasn't enough to propel them up the chart on its own (sorry about that, Frazier Chorus, I did try), and by the mid-1990s when the chart became a desperate race to get a single as high up the listings as possible in its first week, the magic was gone. In the '80s, however, the charts were still a living, breathing, ever-changing opinion poll of the best records around that week and *Top of the Pops* was the weekly outlet for our opinions. If you made it onto TOTP people liked your record, people were buying your music, you were *famous*.

When BBC Four started repeating old episodes of *Top of the Pops* in 2011, the magic was rekindled in me. Once again I started to arrange my life around Thursday evening television. The decision to start the reruns in 1976, when pop music was very much in the doldrums, was a bit odd and it's fair to say that some of those early repeats - featuring the likes of Twiggy, Demis Roussos and seemingly endless hits for Liverpool Express - were hard going. Still, we persevered in the hope that repeats would continue into the 1980s and incredibly - despite the best efforts of the Daily Mail - BBC Four stuck with it. In 2015 they showed all the 1980 editions that were fit to broadcast, i.e. the ones not hosted by Jimmy Savile or Dave Lee Travis. By this time I had started my own '80s music website *The Sound of the Crowd* and it seemed logical that I should document these shows for the site. These week-by-week reviews are collected in this book for posterity so that the internet doesn't eat them.

1980 was an important year for *Top of the Pops*: it was the year it began to

transform from a light entertainment show into essential viewing for pop music aficionados. The appointment of Michael Hurll as producer was pivotal in this process; the transition didn't happen overnight, but when a Musicians' Union strike forced the show off air for the whole of June and July, Hurll took the opportunity to restructure the show. As a result the latter half of 1980 was often bizarre, occasionally quite grim, but always fascinating as Hurll threw all sorts of new formats at the screen to see what would stick. Moving the top thirty countdown from the start of the show to various segments throughout the proceedings was a change that became a permanent fixture; others, such as the use of celebrity guest hosts with little presentation talent, were less successful.

This transitional year is documented here. Hopefully you will find it a breathtaking rollercoaster of good and bad decisions made in the pursuit of television excellence. Or maybe it will just inspire you to dig out some old records you'd forgotten. Either's good.

Introduction

I was born in 1972. For the rest of the century, pop music was my life. The radio was on all day (playing Radio 1, more often than not), family members bought me records as soon as I was old enough to identify the songs I liked, and the week revolved around *Top of the Pops* on a Thursday evening.

The tipping point in my early existence was the autumn of 1979, when I bought a record with my own pocket money, rather than using a combination of hints and pleading to persuade a grown-up to buy it for me (in all fairness, it didn't usually take much persuasion). Having shelled out for the Buggles' *Video Killed the Radio Star*, I began to take an interest in the mechanics of the singles chart. Here was a measure of public opinion in which I, a mere seven year old, could participate. The grown-ups could vote for boring things like who got to be Prime Minister, but when the Buggles made it to number 1 it was partly thanks to me. I was part of the democratic process. I helped their follow-up single *The Plastic Age* into the chart, I was part of the *Captain Beaky* revolution and the excitement of helping *The Bucket of Water Song* into the top forty has never left me.

Of course, after a while this feeling of power began to wear off as I realised that my patronage of a particular act wasn't enough to propel them up the chart on its own (sorry about that, Frazier Chorus, I did try), and by the mid-1990s when the chart became a desperate race to get a single as high up the listings as possible in its first week, the magic was gone. In the '80s, however, the charts were still a living, breathing, ever-changing opinion poll of the best records around that week and *Top of the Pops* was the weekly outlet for our opinions. If you made it onto TOTP people liked your record, people were buying your music, you were *famous*.

When BBC Four started repeating old episodes of *Top of the Pops* in 2011, the magic was rekindled in me. Once again I started to arrange my life around Thursday evening television. The decision to start the reruns in 1976, when pop music was very much in the doldrums, was a bit odd and it's fair to say that some of those early repeats – featuring the likes of Twiggy, Demis Roussos and seemingly endless hits for Liverpool Express – were hard going. Still, we persevered in the hope that repeats would continue into the 1980s and incredibly – despite the best efforts of the Daily Mail – BBC Four stuck with it. In 2015 they showed all the 1980 editions that were fit to broadcast, i.e. the ones not hosted by Jimmy Savile or Dave Lee Travis. By this time I had started my own '80s music website *The Sound of the Crowd* and it seemed logical that I should document these shows for the site. These week-by-week reviews are collected in this book for posterity so that the internet doesn't eat them.

1980 was an important year for *Top of the Pops*: it was the year it began to

transform from a light entertainment show into essential viewing for pop music aficionados. The appointment of Michael Hurll as producer was pivotal in this process; the transition didn't happen overnight, but when a Musicians' Union strike forced the show off air for the whole of June and July, Hurll took the opportunity to restructure the show. As a result the latter half of 1980 was often bizarre, occasionally quite grim, but always fascinating as Hurll threw all sorts of new formats at the screen to see what would stick. Moving the top thirty countdown from the start of the show to various segments throughout the proceedings was a change that became a permanent fixture; others, such as the use of celebrity guest hosts with little presentation talent, were less successful.

This transitional year is documented here. Hopefully you will find it a breathtaking rollercoaster of good and bad decisions made in the pursuit of television excellence. Or maybe it will just inspire you to dig out some old records you'd forgotten. Either's good.

January 3

"This ain't 1823, ain't even 1970"

"Welcome to the sound of the '80s!" enthuses Peter Powell, resplendent in a very '70s canary yellow v-neck sweater. Of course very little has changed; despite the ten foot tall "1980" at the back of the stage where Madness are waiting to get on with it, we're still dealing with records that were released in 1979 – or earlier, in some cases. "It's a new year and a new chart and, as young as ever, it's *Top of the Pops*!" Powell makes a fair claim for musical integrity but then ruins it with a "Woo-hoo!" and fist pump. The top 30 countdown (or countup, really) is soundtracked by The Clash, a band who refused to appear on TOTP as it was too commercial for their punk sensibilities (although allowing their music to be used on a jeans commercial ten years later would be a perfectly acceptable career move). *London Calling*, at number 29 this week, plays behind pictures of such '80s giants as The Moody Blues, The Three Degrees and Fiddler's Dram.

MADNESS - My Girl (#54)

Fittingly, the first act to appear on the first TOTP of 1980 is the still fledgling Madness, showcasing their just released third single. Looking impossibly young (except Suggs, who still only looks about ten years older now than he did then) the Nutty Boys appear suitably sombre for this tale of a failing relationship, the band unusually dressed identically in white jackets and bow ties. Much wailing and gnashing of teeth follows, especially from saxophonist Lee Thompson who is so upset he contrives to fall off the stage at the end of the introduction. Thompson also got the band into hot water for using a toy saxophone in his performance while Chas Smash, having no shouting or nutty dancing to do, doubles up with Mike Barson, both of them playing the same keyboard. It's almost as if they weren't taking it seriously. Peter Powell enjoyed it though: "If that doesn't go top ten in the first month of this year, nothing will." Stay tuned to see if *My Girl* does make the top ten, or if everything above number 11 is cancelled.

PAUL McCARTNEY - Wonderful Christmastime (#6)

Although various members of Wings ("The band the Beatles could have been," as Alan Partridge once observed) appear in the video, this was actually McCartney's first solo single in eight years and curiously found itself one place higher in the chart at the start of January than it had been during Christmas week. This is the video which you'll have seen countless times if you've ever watched any music TV channels between the start of November and New Year's Day, but it's interesting to see it here in pristine condition rather than the

wobbly third-generation Betamax version that gets shown nowadays. If you're sick of hearing the song, take solace in the fact that two weeks after this episode was first shown, McCartney was in a Japanese prison cell after casually trying to bring half a pound of marijuana into the country. The drugs, he claimed, were strictly for his own personal use, suggesting a hefty pot habit which possibly explains why this song seemed such a good idea at the time.

PRETENDERS - Brass in Pocket (#5)

Although they had scored a couple of top forty hits in 1979 (and appeared on TOTP to promote both of them), *Brass in Pocket* was the Pretenders' first major success, climbing to number 3 this week and on its way to becoming the first new number 1 of the decade. Originally from Ohio, Chrissie Hynde had lived in the UK for several years by this point, having worked for the NME and also for Malcolm McLaren in his London shop. The title of the song was inspired by a dressing room encounter with Yorkshire band Strangeways; when Hynde enquired as the owner of a pair of trousers in the dressing room, Strangeways' singer claimed they were his "if there's brass in't' pocket." Good job he wasn't looking for his condoms. Powell seems suitably impressed by the song and claims "If that's just a taste of what's to come on their first album, looking forward to 1980."

DAVID BOWIE - John I'm Only Dancing (#12)

"The music business wouldn't be business without Bowie," claims Powell, which is seemingly intended as a compliment. *John I'm Only Dancing* had originally reached number 12 back in 1972; coincidentally it peaked at the same position this time around. This 1979 release was a double A-side with *John I'm Only Dancing (Again)* - a slower, funkier 1974 recording of the song bearing little resemblance to the original apart from the chorus - on one side and a remix of the 1972 original on the other. On tonight's TOTP we get neither of these, but the original 1972 video for the song which had apparently been banned from the show on its first chart run for being too risqué. The Lindsay Kemp dance routine was certainly unusual, but now it was the '80s and we'd been brought up on Legs & Co, we could take it.

BONEY M - I'm Born Again (#36)

"They've come to *Top of the Pops!*" remarks Powell, as if this was an unusual occurrence. Of course Boney M had been frequent visitors to the show over the last three years, with a run of nine consecutive top ten hits including the massive sellers *Rivers Of Babylon / Brown Girl In The Ring* and *Mary's Boy Child*, still two of the ten best selling singles in UK history having sold almost

four million copies between them. Nothing lasts forever of course; this lame attempt at another Christmas hit limped to number 35, its overtly religious lyrics striking a chord with only a fraction of the audience who bought Lena Martell's *One Day At A Time* just a few weeks earlier. Even Bobby Farrell, despite having given his James Brown afro a trim and bought a nice suit instead of a lycra bodystocking, fails to enliven proceedings, doing little other than sway from side to side. Boney M would only achieve one more (very minor) top 40 hit after this, a damp squib of an ending to a once brilliant career. Still, only eight years until Milli Vanilli come along.

THE BEAT - Tears of a Clown (#17)

Just like Madness, The Beat released their first single on The Specials' 2 Tone label before being seduced by another. Like The Specials, Madness and most other 2 Tone acts they seem somewhat overstaffed, especially with Ranking Roger doing little other than holding a tambourine and offering a cod-Jamaican accented *"Tears of a clown"* just as the song fades. Also, like Madness, they've been plonked in front of the massive 1980 so that we don't forget what year it is. This skanking version of Smokey Robinson & The Miracles' 1970 number 1 was the first of five top ten hits for The (English) Beat, all but one of them released within this twelve month period.

FIDDLER'S DRAM - Day Trip to Bangor (Didn't We Have a Lovely Time) (#3)

And this is why the UK chart is so important: there's room for everybody, no matter how awful. Fiddler's Dram were a motley collection of folkies from Kent including a guitarist with the biggest afro ever seen on a white man and a singer whose Received Pronunciation accent suggested she didn't even know where Bangor was. It's on the north coast of Wales of course, although there was some controversy and angry noises from the local council when it was alleged that they had actually gone to nearby Rhyl which didn't scan so well. 35 years on it's hard to imagine how they could all have had lunch for under a pound, unless they just shared an Asda own-brand Pot Noodle. Unsurprisingly this was the only hit Fiddler's Dram ever managed, although various members are still performing as part of The Oysterband and the song was appropriated in 2014 by Vic Reeves and Bob Mortimer for their BBC Two sitcom *House of Fools*.

KURTIS BLOW - Christmas Rappin' (#30)

Another Christmas song? Really? It's neither the biggest Christmas hit nor the biggest rap hit in the chart this week, nor is it the best single called *Christmas (W)Rapping* (we have to wait another 35 months for The Waitresses to make the

chart and even then they only reached number 45), nor indeed is it Kurtis's biggest hit (that would be *If I Ruled The World* in 1986). As with much early rap it bares a disturbing resemblance to Anthony Carmichael's *The Rapping Song* from the BBC comedy *Look Around You* (made in 2005 but set circa 1980). Still, *Christmas Rappin'* was the first rap single to be released on a major label and Kurtis has dressed up for the occasion in a natty three piece suit, so it's only fair to give him a chance.

BILLY PRESTON & SYREETA - With You I'm Born Again (#24)

"Now, who better for Billy Preston to sing with than Syreeta?" asks Powell, presumably rhetorically. Of all the people who have laid claim to the title of "the fifth Beatle" over the decades, Preston has a better claim than most; he's the only person to have had a co-credit on a Fabs single, having played keyboards on *Get Back* in 1969. Just over a decade later he would return to the top ten with this duet with Syreeta Wright, ex-wife of Stevie Wonder and a Motown recording artiste in her own right. For all their musical pedigree, the song is an interminable dirge with a tempo of about 3 bpm which kills the show's momentum stone dead; no amount of virtuoso piano flourishes (and there are plenty) from Preston can revive it. Boney M didn't move about much either when they were born again but at least they seemed reasonably happy about it.

CHIC - My Feet Keep Dancing (#21)

As if to prove that nothing has changed with the dawn of the new decade, here come Legs & Co with their usual brand of literal choreography. The song's called *My Feet Keep Dancing* so naturally we open with a shot of the girls' feet, but unfortunately their appendages can't dance on their own and even Flick Colby wasn't literal enough to amputate them. The camera pulls out to reveal that the feet are indeed still attached to their respective legs, although the dancers' impossibly tight costumes mean that their feet, encased inside impractical looking fur-lined boots, are the only parts of their bodies not on display in alarmingly graphic detail. The song itself isn't even one of Chic's best; it seems that by writing and producing hits for everyone from Sister Sledge to Diana Ross to Johnny Mathis, they had forgotten to keep anything in reserve for themselves. *My Feet Keep Dancing* would peak at number 21 and bring Chic's run of hits to an end.

DR HOOK - Better Love Next Time (#58)

To be fair to Fiddler's Dram for a moment, here comes an equally motley crew from the other side of the Atlantic. Fresh from an unexpected number 1 hit with *When You're In Love With A Beautiful Woman*, the eponymous Dr Hook arms

himself with an ambitious four maracas which he shakes with unnecessary gusto while exchanging "how the hell did we get here" glances with singer Dennis Locorriere. At no point is it explained what Hook actually doctored in, or at what point during his doctorate he came to lose an eye. Of course we're perpetuating a popular myth here: "Dr Hook" is the name of the band, not the eyepatch wearing proto-Bez figure Ray Sawyer. Despite sticking to the same easy-listening-disco-lite template as its predecessor, *Better Love Next Time* couldn't repeat the chart topping success although it did climb to number 8.

PINK FLOYD - Another Brick in the Wall (Part 2) (#1)

"We don't need no education!" "Yes you do, you've just used a double negative." Yes, a mere twelve years after their last hit single, the Floyd are still clinging on to the top spot with their recent Christmas number 1. No surprises here, as everyone in the entire world is familiar with the video: a long panning shot of London, some children, a teacher, some more children being fed through a mincing machine, hammers, walls and the Bash Street Kids choir who ain't needing no edyookayshun or nuffink. By the end Peter Powell has managed to lose his canary yellow jumper somewhere, almost looking like he might be "down with the kids" as he wishes us a good week. We play out with Rose Royce's *Is It Love You're After*, over which you are now legally obliged to quote lines from *Theme from S-Express*.

January 10

"Who said anything about love?"

"Good evening and good welcome to a host of hits on tonight's *Top of the Pops*." Disappointingly, Kid Jensen's attempt to introduce the phrase "Good welcome" to the language was as doomed as his parting "Goodbye and good love" a few years earlier. Nevertheless the likeable Canadian (© John Peel) is in good spirits as he introduces the top 30 countup, soundtracked by Madness's *My Girl* as performed on the show last week and next week. In fact the Nutty Boys feature twice in the top 30, crashing in at number 14 with their new release while *One Step Beyond* is still hanging around at 27. Elsewhere, someone is still buying Christmas records by Elvis Presley and Paul McCartney, a sign of how much more sedate the charts were in those far off days - nowadays the downloads of festive tunes usually peak a week or so before the day itself. Maybe there were just a lot of Orthodox Christians buying records this year.

UFO - Young Blood (#63)

Not to be confused with Urge for Offal, a fictional band whose career was chronicled by indie veterans Half Man Half Biscuit on the title track of their 2014 album, this UFO had been peddling their brand of guitar-based rock for a decade by this stage of their career, achieving little in the way of singles success although they had a top ten album *Strangers in the Night* in 1979. Since then, though, they had lost guitarist Michael Schenker, who went on to form his own successful but unromantically named Michael Schenker Group. UFO carried on without him, but tonight they've blundered into the obvious trap of setting themselves up backwards on stage, with drummer Andy Parker stage front and singer ~~Mick Exclusion Zone~~ Phil Mogg giving his all at the back where nobody can see him. Despite having the celebrated George Martin on production duties, the song is desperately unmemorable and could be said to mark the beginning of NWOBHM - the New Wave of British Halfarsed Metal.

ABBA - I Have a Dream (#2)

Despite an amazing run of success - this was the thirteenth of fifteen consecutive top five hits - it was almost two years since ABBA had scored a number 1 single. Even after six high profile sold-out concerts at Wembley Arena, commemorated on this souvenir gatefold sleeve single release, *I Have a Dream* still couldn't quite reach the top, peaking at number 2. The video depicts the group during one of those live performances, although with everyone sitting together, facing forwards, it's hard to read the body language and establish

which members of the band are still talking to each other. Then the bloody children's choir comes in, and if you think it's bad having a children's choir on the number 1 and 2 singles this week, just wait until next Christmas. *I Have a Dream* eventually topped the charts at Christmas 1999 when covered by Westlife as a double A-side with *Seasons in the Sun*. Saints preserve us.

ROSE ROYCE – Is It Love You're After (#13)

Admit it, you can't listen to this without subconsciously singing bits of *Theme From S-Express* over it, can you? The seventh top forty hit for Rose Royce (although Kid Jensen counts eight) was also their last, at least until it was comprehensively sampled by Mark Moore for his 1988 enormo-hit. In the wake of S-Express's success, *Is It Love You're After* returned to the chart as a double A-side with a re-issue of the group's début hit *Car Wash*. Here we have the song on its original chart run at its peak position of number 13, illustrated by lots of afros, brightly coloured suits, a synthesizer the size of a small family car, somebody miming the distinctive electronic drum sound on a set of distinctly analogue tom toms, and a guitar and bass duo apparently having to play their instruments while running on a treadmill.

JOE JACKSON – It's Different for Girls (#50)

"It's different for girls... let's find out how." Unfortunately for the Kid, this isn't a sex education lesson but a classic tune from that all-too-brief period when Joe Jackson used to have hit singles. Following up his top twenty hit *Is She Really Going Out With Him?* from last year, *It's Different for Girls* explores the difficult gender reversal concept of a man rebuffing a woman's demands for uncomplicated sex with no romantic involvement. This motif was, of course, lost on the general public who just liked the song and sent it all the way to number 5, giving the man with the highest forehead in pop (with the possible exception of Art Garfunkel) his biggest hit single. Incidentally Joe's website is just a delight, featuring a whole page of his rants against the anti-smoking lobby over a period of seven years. Do pay it a visit next time you're tired of reasoned argument.

SHEILA & B. DEVOTION – Spacer (#28)

So what exactly is the name of this act? Having reached number 11 almost two years ago with a disco version of *Singin' in the Rain* under the name Sheila B. Devotion, here they are teaming up with Nile Rodgers and Bernard Edwards (finally getting the chance to work with an actual French act after several years in Chic pretending to be French), only now they're called Sheila *and* B. Devotion. To confuse things even further, Sheila was actually called Annie and the "B" stands for "black", but Annie & Black Devotion clearly wasn't acceptable

nomenclature. Anyway, despite attracting many favourable comments on Twitter, *Spacer* is clearly nothing more than a pale imitation of Hot Gossip's *I Lost My Heart To A Starship Trooper* and the band's name confusion is a smokescreen for their obvious sponsorship deal with Bacofoil.

THE SKIDS - Working for the Yankee Dollar (#21)

Sing along now! Yes, TV's Richard Jobson is back with his unorthodox approach to singing. While perhaps not as famously obscure as last year's *Into The Valley*, the lyrics to the band's latest hit are still pretty indecipherable (*"Yankey, 2-1"* - clearly a reference to the English women's football team's victory over the USA in 2011) and Jobson, this week pitching his look somewhere between Steve Strange and Derek Smalls, is still bouncing around playing The Floor Is Made Of Lava. Legend has it that, on meeting the Nolan Sisters backstage, Jobson spat on the floor on disgust; more likely he was just trying to put the fire out. This was The Skids' last top twenty hit and if you look closely you can see guitarist Stuart Adamson wondering how this would sound if the guitars were made to sound like bagpipes, prior to forming Big Country in a couple of years' time.

KC & THE SUNSHINE BAND - Please Don't Go (#7)

"In a few moments we have a special guest star popping in to say hello," promises Kid, before ushering us towards our weekly appointment with Legs & Co. Surprisingly they're all fairly modestly dressed and there's very little in the way of literal choreography, no Emergency Exit doors or giant Monopoly boards with somebody wagging their finger reproachfully as the girls try to pass Go. *Please Don't Go* would be KC & The Sunshine Band's last hit except for the completely out of the blue one-off number 1 *Give It Up* in 1983, and what better way to mark the occasion than by introducing the promised special guest... KC? Yes, he's in Blighty to promote the single, but this promotion doesn't extend to miming to his own record. Lightweight. Still, this is no easy job for him as he has to introduce the next act.

DOLLAR - I Wanna Hold Your Hand (#30)

Well now. It's said that if you're going to do a cover version of a famous song, you have to make it substantially different to the original. Fair play to Dollar, they've certainly done that. In fact they've managed to make a song that's already 17 years old sound more contemporary than any of their previous hits, not just by changing the terribly old fashioned "Want To" into the cutting edge '80s "Wanna", but by employing a minimalist backing consisting mainly of heavily processed drums and a sprinkling of new wave synths, pre-empting their more revered work with Trevor Horn by a good eighteen months. The single had

struggled into the lower reaches of the top 40 over Christmas and then fallen out, but now it was back in and climbing into the top ten. Just don't hold your breath for their cover of *Revolution 9*.

THE NOLANS - I'm in the Mood for Dancing (#20)

The Nolans started out in showbiz as part of the family group The Singing Nolans back in 1963, spinning off as The Nolan Sisters in the mid-1970s. They achieved some light entertainment success, even supporting Frank Sinatra on a European tour, but by the end of the '70s they had rebranded again as simply The Nolans and branched out into pop music. *I'm in the Mood for Dancing* was the group's first big pop hit and is oddly performed in two places, repeatedly cutting between the sisters boogieing on the dancefloor and swaying awkwardly on some kind of gantry while half a dozen audience members do the dancing. This would go on to be the Nolans' biggest hit, both in the UK and Japan where it reached number 1. You may also remember it from the episode of Ben Elton's 1987 comedy *Filthy, Rich & Catflap* in which the sweet, innocent Nolans blackmail the hapless Richie Rich with a number of incriminating photos. Richard Jobson would have thought twice about spitting at them had he known about that.

PINK FLOYD - Another Brick in the Wall (Part 2) (#1)

Yes, it's still there. Pink Floyd's biggest hit single by some considerable distance is enjoying its final week at number 1, but we still haven't seen anything of the band other than an indistinct photo in the chart countup which looks like it may well be at least a decade old. The Floyd have only troubled the top 40 on four occasions since this hit, most successfully in 1994 when *Take it Back* reached number 23, but have scored four number 1 albums in that time, including 2014's swansong *The Endless River* which was little more than offcuts from the sessions for their previous album twenty years earlier. Jensen winds up the show by wishing us a good week and a good night (but not good love) as we play out with the oldest record in the chart, *Green Onions* by Booker T & the MGs from 1962. What's that doing there? Find out next week...

January 17

"Such a digital lifetime"

"Hello and welcome to *Top of the Pops*." Phew, rock 'n' roll, right kids? This week we're in the large, manly hands of housewives' favourite Simon Bates, author of *Fifty Shades of Beige* and director of the award-losing independent film *Three Colours: Brown*. This is his second attempt at hosting TOTP, having roundly ballsed up his first attempt by announcing Sugarhill Gang's *Rapper's Delight* as "The Rapper" amongst other things, but he's back for another go at the helm of this epic 45-minute show and fires us up with the appropriately insipid *Spirits Having Flown*, the Bee Gees' final hit from the dregs of their disco era. In the top 30 countup department, someone has either read the manual or pressed a wrong button as the chart this week is startlingly garish, with dark text on a bright yellow background instead of the other way around as usual. This plays all sorts of havoc with the recording and causes a wobbling effect on the boxes around the acts' photos which would have taken weeks to create deliberately. They're still using *that* photo of Pink Floyd though.

NEW MUSIK - Living by Numbers (#52)

Out of the top thirty countdown into a song called *Living by Numbers*, this show isn't just thrown together you know. But hang on, we can't start yet, Keith Harris and Bob Carolgees have turned up to paint the studio! Oh, wait... Nope, it's actually New Musik in some kind of futuristic all-white clobber. This wasn't their first appearance on the show – they were on last October with their début *Straight Lines* – but the band's new (vaguely) futuristic look, their sound and the song's subject matter make it the perfect song for the first month of the new decade and it would soon become their biggest hit. If only there was some way of finding out whether or not they wanted your name. Not sure what the bassist is doing with his hand in his pocket (probably best not to ask) but singer ~~Keith Harris~~ Tony Mansfield would go on to produce some of the decade's biggest hits including a-ha's *Take On Me*... but not the version you remember. His 1984 version failed to chart and the song was subsequently re-recorded with Alan Tarney at the helm, after which it became a massive worldwide hit. Oh well.

BILLY PRESTON & SYREETA - With You I'm Born Again (#2)

Actually, having just had a go at them, it occurs that Bob Carolgees does appear on the show later this year, albeit on a DLT-fronted episode which BBC Four skipped over, and in 1982 Keith Harris & Orville scored a bigger hit single than New Musik ever would, so I suppose that's me told. Anyway, the Beatles' former

keyboard player and Stevie Wonder's ex-wife are up to number 2 this week with a repeat showing of what Simes thinks is "a beautiful song", which is as damning a critique as anything I could come up with. This was their last appearance on the show although they did release a follow-up single *It Will Come In Time* in March; despite giving them as much time as we could, it only made number 47. Let's be charitable to Bates and assume that his comment "Billy Preston and Syreeta, and that's the way God planned it" is a clever reference to Preston's biggest solo hit and not just Simes messing up his song titles again.

SAD CAFÉ - Strange Little Girl (#53)

Strange Little Girl (no, not that one) was Sad Café's second hit after the mighty *Every Day Hurts* reached number 3 last year, but this is an entirely different kettle of jelly babies. Singer Paul Young (no, not that one) has had a haircut, making him look very new wave and a lot less like Chris Morris, which can't be bad, although the guitarist still has a slightly unhinged Brian May look about him. The track is altogether meatier than their first hit but the unsettling ice cream van intro and *"Little girl who lives down the lane"* refrain makes the whole thing sound a bit like a Scarfolk nursery rhyme. Being just a bit too weird for those who had discovered the band through *Every Day Hurts*, *Strange Little Girl* only reached number 32, but the band still had another top twenty hit in them and will be back on TOTP in a couple of months' time. Thoughtfully, Bates pre-empts the confusion with The Stranglers' *Strange Little Girl* from two and a half years in the future and announces the song simply as *"Strange Girl"*. Well played, Simes, well played.

SISTER SLEDGE - Got to Love Somebody (#47)

What's often forgotten about TV schedules before about the mid-1990s is that not everything ran in multiples of 30 minutes as it does these days. For example, when this edition was first broadcast there was an unusually large gap to fill between a 25-minute edition of *Tomorrow's World* and a 25-minute edition of *Wildlife on One*, so TOTP was simply extended from its usual 35-ish minute slot to an eye-watering 45 minutes. In order to fill this unexpected ten minutes all sorts of filler had to be parachuted in, including this, apparently filmed some months earlier on the show's much brighter and less futuristic 1979 set. Despite the continued input of Nile Rodgers and Bernard Edwards, *Got to Love Somebody* has none of the flair or, indeed, chic of *We Are Family* or *Lost in Music* and struggled to number 34; the sisters wouldn't return to the top forty until 1984 when the record label gave in and released *Thinking of You* as a belated fourth single from 1979's *We Are Family* album. Oh, and one of the sisters is missing, but presumably we're not supposed to notice that.

MADNESS – My Girl (#4)

"The new records are really starting to make it," observes Simes without a hint of pleasure. "At number 4, here's Madness, one step further, and it's their new one which is gonna be enormous." Well, it got as high as number 3, if you consider that enormous; certainly it was the Nutty Boys' biggest hit to date and a peak they wouldn't better (only *Baggy Trousers* would match it) until *House of Fun* reached number 1 in 1982. Presumably the "one step further" comment is another arch reference to a previous hit, well done Simes, etc. This is a repeat of the show's first performance of the year, enormous pink "1980" sign and all, so Suggs still tries and fails to look sincere, Lee still contrives to fall off the stage with emotion and Chas still cheekily shares a keyboard with Mike. It's also the third week in a row the song has graced TOTP, having been played behind the top thirty last week.

POSITIVE FORCE – We Got the Funk (#32)

"Now, hidden behind me are two young ladies..." Let me stop you there, Simes, lest Operation Yewtree should jump to conclusions. In fact Positive Force consisted of six male musicians as well as singers Brenda Reynolds and Vickie Drayton, but for reasons unknown the two ladies are the only ones who have turned up. Pitching themselves somewhere between Althea & Donna and Mel & Kim's aunties, the girls whoop, flail and improvise their way through a distinctly limp disco track consisting mainly of the phrase *"We got the funk"* repeated ad nauseum and a (seemingly exhaustive) list of people who, it seems, *"got the funk"*. These lucky funk possessors are identified only by Christian name, meaning that their identity remains hidden from the general public, lest we become jealous and try to appropriate the funk for ourselves. It's all astonishingly grim, but don't worry, they won't be on again.

DEXYS MIDNIGHT RUNNERS – Dance Stance (#60)

"Come with me just a bit and I will introduce you to some people from Birmingham." Well, there's an offer you can't refuse. But hang on, because for once Bates has stumbled across something important: the debut appearance of Mark I Dexys Midnight Runners, in all their donkey jacketed and woolly hatted docker chic finery. Three months before *Geno* topped the chart – and a full two and a half years before a different line-up of the band scored a worldwide raggle-taggle hit while looking like they'd slept in a hedge – here they are performing their first single. Despite their introduction as "some people from Birmingham", *Dance Stance* is about Kevin Rowland's Irish heritage and namechecks writers such as Brendan Behan and Oscar Wilde. There's a definite overstaffing problem – two saxophonists, really? – and at one point Rowland is

DR HOOK - Better Love Next Time (#14)

There's also a top comedy moment at the end of Dexys' performance as the camera pans across to Bates for the next link, only to find him lounging against the gantry railings, script in hand, delivering a link which quite obviously should have been done out of vision. Somebody press the button! One quick electronic wipe later and we're back with Dr Hook. It's the same performance as two weeks ago, with the optically challenged Ray Sawyer shaking two sets of maracas like some kind of over-achieving Bez, while the backing band looks like a collection of Radio 1 DJ impersonators – that's definitely Noel Edmonds on bass and over to his left I'm sure it must be Steve Wright on guitar. This is on its way up to number 8 to give the good doctor his second of three consecutive top ten hits, after which he never again ventured past number forty.

AMII STEWART - Paradise Bird (#58)

Back in the studio, Simon's enormous comedy glasses have steamed up. "Now, there is a lady who lives just around the corner from me," he announces to no relevance, "and when she goes to the supermarket she doesn't look like this!" Well, you wouldn't in this country, not in January anyway. Getting Simes all hot under the tweed collar is Amii Stewart in a state of undress that must have had Limbs & Co spitting feathers. Amii had scored top ten hits in 1979 with disco versions of *Knock on Wood* and *Light my Fire* and indeed this single was a double A-side with a disco-ish cover of The Box Tops' 1967 hit *The Letter*. Sadly we don't get the intriguing *Amii Stewart Sings Alex Chilton* moment as for some reason the downbeat *Paradise Bird* has been deemed more suitable. It's pleasant enough, with hints of Rose Royce e-drums and Minnie Ripperton bird noises, but it stalled at number 39 and Amii wouldn't be back on TOTP for another five years.

STYX - Babe (#17)

After half a decade of success in the US peddling the kind of soft rock to which the UK is normally quite resistant – including *Come Sail Away*, best known over here in its cover version by *South Park*'s Eric Cartman – Styx finally broke through in Britain with this overwrought ballad. Lead vocalist Dennis DeYoung wrote the song for his wife, whose name appears to have slipped his mind as she is referred to only as "babe" for the full four minutes. The song would climb to number 6 over here but this white-trouser-electric-piano-and-luxuriant-moustache-heavy video would be their only appearance on TOTP. The band's US success continued into the mid '80s with hits like *Mr Roboto* from their sci-fi

rock opera *Kilroy Was Here* while in the UK their name is kept alive in Half Man Half Biscuit's epic tale of unimaginable embarrassment *Styx Gig (Seen By My Mates Coming Out Of A)*.

BOOKER T. & THE M.G.s - Green Onions (#12)

Oh dear, Bates is having one of his hot flushes again as he thinks about Legs & Company and their very short '60s-style dresses. As if by magic, Simes is whisked backstage by a young lady in exactly that style of dress (this may be a dream sequence on Bates's part, it's not clear) and out come the girls to dance to a track older than TOTP itself. Originally dismissed as a throwaway B-side by Booker T. Jones when it was recorded back in 1962, the track gained new life through its use in the 1979 film version of The Who's *Quadrophenia*, hence its sudden appearance in the chart. The performance is a curious mix of old and new as Limbs & Co, in short, black and white dresses, thrash around in front of futuristic rotating grids of some kind. Perhaps they're supposed to be food processors, although Flick Colby has reined herself in and there are no vegetables of any kind involved in the performance – not once Simes has been led off-stage, anyway.

RUPERT HOLMES - Escape (The Pina Colada Song) (#38)

Much proper BBC behaviour still in evidence in the pre-Michael Hurll era as Bates, dressed like a geography teacher, hands over to Rupert Holmes who has come as a slightly more hip music teacher – he's even loosened his tie! At least, we're told it's Rupert Holmes, although he has the air of a BBC technician or aspiring local radio DJ who's been asked to stand in at the last moment. Who would know? The song itself is an appalling tale of deception as Holmes gets the hump with his missus and takes out a personal ad for a replacement, only for the ad to be answered by the trouble and strife herself – a situation which resolves itself not with screaming and blood, but a resigned *"Oh, it's you."* Having said that, it's quite possible she murdered him quietly once they'd gone home, which would explain why his part has been taken by Steve Wright's brother.

PRETENDERS - Brass in Pocket (#1)

And so it came to pass that the first single to reach number 1 in the 1980s came from an ex-member of punk band Masters Of The Backside, the rest of whom went on to form The Damned. Looking the coolest she ever did, Chrissie Hynde is strangely positioned so far in front of the rest of the band that it's not clear whether the unimpressed looking bloke in waistcoat and black tie behind her is actually in the audience or has just fallen off the stage. Finally Bates ponders whether the record will still be number 1 next week and closes his marathon

shift by introducing Jon & Vangelis's *I Hear You Now*, so exhausted by his 45 minutes' work that he can't even remember to say goodnight. It's Mike Read on hosting duties next week, so mind your language.

January 24

"Boys love future girls"

"Thirty seconds earlier and I could have been on *Tomorrow's World*," laments Mike "Hello chums" Read, dressed somewhat nattier than Simon Bates was last week in what appears to be some kind of 2 Tone shirt. Ironic really, given that around the time of the BBC Four rerun Read had aligned himself with UKIP, a political party whose main policy seems to be "send all the immigrants back where they came from". You may remember that in 2014 he even released a single to that effect, which seemed to draw very little influence from The Specials and more from Lance Percival. Still, let's get on with the top thirty, accompanied by a bit of jazz-funk - or is it funk-jazz? - from Brazilian combo Azymuth, whose *Jazz Carnival* should not be confused with Spinal Tap's *Jazz Odyssey*. The person who jammed a screwdriver into the Top 30 machine last week has been fired and the colour scheme has reverted to the usual yellow on black, although in a pleasingly ramshackle way the caption for Billy Preston & Syreeta has been remade using completely the wrong font.

BUGGLES - The Plastic Age (#54)

As with last week we kick off with a singer who would go on to much greater success as a producer. We didn't get to revel in Trevor Horn's only week at number 1 as a vocalist, as *Video Killed the Radio Star* topped the charts last October in a DLT-fronted episode meaning that BBC Four chose not to repeat it. To be fair we didn't really miss much as they only showed the video; this is the band's first studio appearance on a regular episode and despite the title there's very little plastic on show (Trevor's remarkable specs notwithstanding). Indeed Horn's getup is decidedly 20th century, as if he's just come from a wedding, although the rest of the band have donned shiny metallic jackets because *they're from the future.* Although only a select band of hardened Buggles devotees seem to remember it, or any Buggles songs apart from the obvious one, *The Plastic Age* would go on to reach the top twenty and provided an almost title track for the band's debut album *The Age of Plastic*.

THE NOLANS - I'm in the Mood for Dancing (#4)

It seems that having been stuck up on a tiny gantry two weeks ago hasn't diminished the Nolans' mood for dancing; if anything their inclination to cut a rug has increased. Now they've been given some proper space to do so and even the TOTP Orchestra can't talk them out of it. In all fairness Johnny Pearson leads his musicians through a spirited rendition of the track - we even get to see him

conducting for once – and the entirely live performance shows just what a class act the Nolans were when they didn't have random audience members in grey jumpers getting in the way or self-important singers of post-punk bands expectorating at them. Still can't see past their *Filthy, Rich & Catflap* performance though.

BOOMTOWN RATS - Someone's Looking At You (#45)

Oops, look out, Geldof's gone all conceptual on us. Not content with just performing the song on the TOTP stage, the band all dressed in camouflage gear for some reason (except keyboardist Johnnie Fingers who has seemingly just broken out of prison), the scene intercuts rapidly with Sir Bob sitting in a chair apparently watching himself and the band performing on stage (He's in two places at once! He *is* a saint, he can perform miracles!), dressed in some kind of plastic overcoat which he proceeds to cut and tear to shreds. This spectacle is also mixed with shots of some kind of electronic noughts and crosses motif like the most nightmarish episode of *Celebrity Squares* imaginable. Quite what it's all supposed to mean is anyone's guess, but at least he's not demanding money from anyone.

BEE GEES - Spirits Having Flown (#16)

"Now, here's a fellow attempting to ride a bicycle. But he's having some trouble, isn't he? Because he's a Scot! Hneunh hnuh hnuh hnuh." Yes, just as the show is getting into fourth gear, here comes Buzz Killington in the shape of Legs & Co to illustrate one of the weakest Bee Gees singles in living memory. *Spirits Having Flown* would be the brothers' last top forty hit as a group until the pounding *You Win Again* kick-started the third phase of their career seven and a half years later. This evening the girls are dressed as tarts. Lattice tarts, to be exact, with some kind of skirt affair made out of feathers to indicate flight, as in the song. Presumably Flick Colby's initial idea for the ladies to be dressed as huge bottles of vodka, gin and whisky fell through due to advertising issues.

JOE JACKSON - It's Different for Girls (#12)

Read beckons us closer in a conspiratorial manner as Limbs & Co fade out – "You should see that without the feathers – it's different for girls," he whispers, restraining himself from adding "know what I mean, nudge nudge, say no more." But wait, because what he's actually done is link us into Joe Jackson! Read, you sly old fox. It may well be different for girls but this is the same clip as two weeks ago, with Jackson apparently issuing whispered instructions to his guitarist during the intro. This was on its way up to number 5 and on the back of his previous hit *Is She Really Going Out With Him?* seemed to signal the start of

a hugely successful career for Jackson, although for some reason it never materialised and we won't see him again on the show until *Steppin' Out* takes him back into the chart in three years' time.

SUZI QUATRO - Mama's Boy (#50)

Fire up the Quatro! Introduced by Read in an American accent so poor even he looks embarrassed, this is the last of Suzi's twenty-five performances on the show in a run stretching back to 1973. Although most of her big hits came in the first two years of her chart career, you may remember her doing *If You Can't Give Me Love* on the 1978 repeats or *She's In Love With You* at the tail end of last year. *Mama's Boy* follows the usual template of Suzi, dwarfed by her massive bass guitar, rocking out in front of her band, although the leather jacket of the mid-70s has been replaced by a more conventionally tailored affair. The song itself is a pretty shoddy character assassination on a lover who "throws a light dart" and apparently isn't manly enough for her, the insinuation being that he might be one of those new-fangled homosexuals - *"Don't know why he gets involved with women / He's a closet case with all the trimmings"* - but probably no-one was listening to the lyrics anyway.

DOLLAR - I Wanna Hold Your Hand (#9)

Time for a history lesson with Professor Read. "Sixteen years ago this month was the first *Top of the Pops* with Jimmy Savile, number 1 was *I Wanna Hold Your Hand*, it's back there in the charts today courtesy of Dollar." A nation splutters tea across the room and takes to social media to register its disgust - "Get this filth off my television! I don't pay my licence fee to see that great nancy boy David Van Day murdering a Beatles classic!" Yes, J*mmy S*v*le was mentioned on TOTP and civilisation failed to come to a halt, although coming directly after a song about a closet gay and with songs about teenage sex and birth control still to come, it was hardly the most controversial thing on the show this week. The Dollar track remains a self-consciously modern remake of a pop standard, but luckily they bumped into Trevor Horn backstage.

THE SPECIALS - Too Much Too Young (#15)

While their erstwhile 2-Tone labelmates Madness seemed to have overtaken them in bringing ska-pop to the masses, The Specials were about to up the ante with their EP *The Special AKA Live!* Lead track *Too Much Too Young* is the one that got all the airplay, despite Terry Hall's assertion on the *Old Grey Whistle Test* that "This should have been our next single but they wouldn't play it on the radio." Sadly the band aren't in the studio to play the song live but are represented by a video of themselves playing the song live, although despite

being the shortest song in the chart at the time the track is mysteriously cut off before the final verse can bring the concepts of contraception and sterilisation and the advice *"Keep a generation gap, try wearing a cap"* to a nation already traumatised by the mention of Sir Jimmy. At least the ad-libbed, almost off-mike cry of *"You silly moo!"* before the instrumental break remains intact.

BARBARA DICKSON – Caravan Song (#53)

It's a strange career progression for Mike Batt, from The Wombles to this in four years. Fife's foremost former folkie Barbara Dickson takes this Batt composition and fills it with all the excitement of a wet weekend in a static caravan in Bognor, not even having the common decency to change out of her pyjamas and dressing gown for her TOTP appearance. Despite only reaching number 41 this remains one of Dickson's most famous songs, although she was best known at this point for her 1976 hit *Answer Me*, the following year's *Another Suitcase in Another Hall* from *Evita* and her frequent guest slots on *The Two Ronnies*. It would be another five years before she scored her biggest hit, the Elaine Paige duet *I Know Him So Well*, but before that we'll see her again performing *January February* in, er, March.

MATCHBOX – Buzz Buzz A Diddle It (#30)

As well as the ska revival and the mod revival, there was also something of a rockabilly revival going on at the start of the 1980s. Amongst those blazing a trail for rock 'n' roll in the confused post-punk era was Matchbox, who had actually formed back in 1971 but first charted in 1979 with the top twenty hit *Rockabilly Rebel*. Their TOTP début having been stricken from the record due to the extreme misfortune of appearing only on shows hosted by Savile or Travis, this is the first time BBC Four has been graced with their presence; Confederate flags and Stetsons are very much in evidence, which is a bit odd for a group from Feltham in Middlesex. They have a few more hits to come throughout the year, but if you can't wait to see them again the full 1980 line-up is back together and touring the UK and Europe at the time of writing. Form an orderly queue.

SHEILA & B. DEVOTION – Spacer (#20)

Well, Mike Read certainly enjoyed Matchbox, to the extent that he is moved to honk a bicycle horn in appreciation. From this unbridled show of emotion we move on to another outing for this slab of futuristic French disco, or "Gabby Logan: The Disco Years" as several viewers observed on Twitter. Strange how shiny metallic clothing was always used to signify "the future" and yet we're still waiting for it to take off. We're still no closer to finding out what a spacer

actually is, other than "a star chaser" which doesn't really clarify matters, and I'm sure you couldn't hold a real light sabre like that without losing several fingers, but never mind. This is Sheila's - and, indeed, B. Devotion's - last appearance on the show, although the track returned to the chart in 2001 when it was sampled on Alcazar's *Crying at the Discoteque*.

THE REGENTS - 7 Teen (#22)

"Right chums, it's time for the Regents with *7 Teen* and you'll notice the lead singer's wearing a seatbelt in case the girls try and pull him off into the audience." Sorry, Michael? Stop sniggering at the back, because Read's unintentional innuendo is the least of the moral majority's worries here. This song about teenage shenanigans has been around for a few months and was on a Savile-fronted show before Christmas, but it's only just made it into the top forty. Lead singer Martin Sheller is indeed wearing a seatbelt and has the unfortunate air of Robert Smith without make-up, but *7 Teen* is a forgotten new wave classic. They might not have been able to get the phrase *"permanent erection"* past the censors (although the uncut version was given a limited release) but they managed to get the line *"So clean, thought that you were never coming"* onto prime time television right under the nose of Mike "this record is obscene" Read, so fair play to them.

PRETENDERS - Brass in Pocket (#1)

Mike hasn't noticed the lyrical filth in *7 Teen* because he's too busy working on a joke - apparently the Regents "took their name from a well known London park... Hyde Park." Once the tumbleweed has gone past and the sound of a distant church bell has died away, it's a second week at number one for Chrissie Hynde and band, a position they have yet to equal although Hynde did top the chart again in 1985 as guest vocalist on UB40's remake of *I Got You Babe*. In fact Chrissie is credited with discovering UB40, having seen them play in a pub and given them a support slot with the Pretenders, but we're getting ahead of ourselves. We play out with *Too Hot* by Kool & the Gang, a band formed back in 1964 but enjoying only their second hit single, having reached the top ten with *Ladies Night* a few months earlier, and Mike's got to run because he's on the radio in a minute.

January 31

"Take control of the population boom!"

"Well hi there!" Yes, hi Kid. The artist still known as "Kid" Jensen is back again, looking more serious than last time in a jacket he might have borrowed from Simon Bates. This week Jensen fails to wish us "Good welcome", "good love" or good anything really, maybe he's in a strop because he's been called in to do the show for the second time in four weeks. The top thirty machine has gone funny again, with black text on that yellow background which must have sent many a DER colour set into meltdown at the time, but try and shield your eyes from the radiation and listen to a minute of *Three Minute Hero*, The Selecter's second hit and yet another hit for the 2 Tone label, which has three acts in the top thirty and was responsible for launching the career of a fourth, impressive stuff for a label that's only been running for six months.

THE REVILLOS - *Motorbike Beat* (#56)

How did that motorbike get in here? The first act on the show this week is absolutely *not* the Rezillos, famous for their 1978 hit *Top of the Pops*; they split up in 1979 and singers Fay Fife and Eugene Reynolds formed an entirely different band, promising their former record label that they wouldn't use the name Rezillos. Enter the Revillos, a completely different band with the same singers playing exactly the same type of music. Despite having recruited a Vivian Stanshall lookalike on guitar, *Motorbike Beat* stalled outside the top forty and was the last hit for Edinburgh's answer to the B-52's, although the Rezillos reformed in 2001 and continue to record and perform, albeit without most successful member Jo Callis who spent much of the early '80s in the Human League.

KENNY ROGERS - *Coward of the County* (#10)

The suspicious amount of screaming and applause at the start of this clip isn't from the studio audience but the crowd at one of Kenny's concerts, presumably not one in the UK where he hadn't troubled the top thirty since his 1977 chart topper *Lucille*. Now, completely out of the blue, he's back in the top ten with an appalling tale of small town prejudice, gang rape and a mild-mannered gent being driven to the point where he beats three people to a pulp. Amazingly none of this seemed inappropriate for daytime radio or prime time television in 1980. All of this is delivered by Kenny, looking like Noel Edmonds' dad in an unflattering grey suit - or perhaps it's meant to be silver, like his beard.

AZYMUTH - Jazz Carnival (#19)

Also seemingly perfectly acceptable on TV in 1980: grown women in cages pretending to be animals. Kid Jensen even gets one of them to eat his carrot (stop sniggering at the back). Yes, it's Legs & Co, and with no obvious literal choreography translation of the lengthy and uninspiring instrumental *Jazz Carnival* coming to mind, the girls have resorted to a back-up plan and dressed up as animals, although the costumes are so vague that Kid has to introduce each one in turn explaining what they're meant to be. Apparently realising that nobody's listening, Jensen gives up midway through his final sentence and the ladies are released from their cages to parade around for a bit, although at one point the wolf seems to be attempting to murder the rabbit by strangulation, which seems a tad harsh. *Jazz ~~Odyssey~~ Carnival* was the only UK hit for Brazilian trio Azymuth, which will come as no great surprise.

JOHN FOXX - Underpass (#47)

Former lead singer of Ultravox! in the days when they had an exclamation mark on the end of their name, John Foxx is the first artist on the show tonight who actually sounds like he's from the 1980s. Over a backing of synths on the non-specific-stringed-instrument setting and drum machine that sounds like someone hitting a cake tin with a dessert spoon, the track gives off the atmosphere of a British inner city version of Kraftwerk's *Autobahn*, Foxx repeatedly bellowing "Underpants!"... sorry, "Underpass!" like a human version of Gary Numan. The rest of Ultravox, sitting at home without their exclamation mark, must have been furious, although by this time next year they had recruited Midge Ure and become more successful than Foxx ever would.

MADNESS - My Girl (#3)

The giant "1980" sign, the comedy falling off stage, the twin pianists... yes, it's that performance receiving a third airing on the show, after the Nutty Boys were apparently not invited back following Lee Thompson's refusal to take his miming seriously and use a real saxophone. As well as the BBC Four reruns, this performance also features on the 35th anniversary deluxe edition of their *One Step Beyond...* album in November 2014, meaning it's been aired more often in those three months than the whole of the previous thirty years. Plenty more Madness performances to come throughout the year though, and of course the band is still together (after a brief hiatus in the late '80s and early '90s), although sadly TOTP was cancelled before they got a chance to appear on the show to perform their 2012 single *My Girl 2*.

THE SHADOWS - Riders in the Sky (#52)

"If you were watching the telly on Sunday you may have seen a fantastic programme, a twentieth anniversary celebration reunion with the Shadows and Cliff Richard." Sorry, Kid, I was out. Never mind though, because here are the Shads with the second instrumental on the show tonight, a thoroughly inappropriate disco-ish version of *Riders in the Sky*. First a hit in the UK for the Ramrods in 1961, the song was written as far back as 1948 and has been recorded dozens of times by artists such as Bing Crosby, Elvis Presley, Johnny Cash and even, bizarrely, Deborah Harry. The Shadows' performance is typically awkward, Hank Marvin in particular grinning like a loon as if wondering how the hell he got here again; even the Wilf Lunn figure on bass in the background can't detract from the fact that nothing at all is going to happen and we're just watching some blokes pretend to play the guitar.

RUPERT HOLMES - Escape (The Pina Colada Song) (#27)

Another repeat performance from "one of the cleverest songwriters around today" according to Kid. It's very easy to mock this tale of attempted newspaper-ad-based infidelity, and to judge Rupert for being so eager to cheat on his "lady", but in the interests of fairness I feel the need to point out that it was his missus who put the advert in the paper in the first place, so really its the female protagonist who wants someone who has half a brain and likes shagging on the beach, so when the beardy twonk turns up to meet her it's really no more than either of them deserve. Serves her right for marrying a Steve Wright lookalike in the first place. This is Rupert's last appearance on the show as, sadly, we don't get to see his second and superior hit *Him* later in the year.

THE RAMONES - Baby I Love You (#36)

1-2-3-4! Oh... right. By far the New York punk legends' biggest hit in the UK, despite - or perhaps due to - sounding nothing like any of their other releases, this cover of the Ronettes' 1964 hit was produced by Phil Spector, who also co-wrote the song and produced the original hit version. Due to Spector's... let's say "idiosyncratic" production methods, none of the band appear on this track (or much of its parent album *End of the Century*) other than singer Joey Ramone; Spector - a convicted murderer, let's not forget - was apparently prone to waving a pistol around in the control room while producing the album and made guitarist Johnny Ramone repeat his guitar parts hundreds of times at gunpoint. Still, the end result was a commercial success and probably 90% of the people you see wearing Ramones T-shirts these days think all their songs sound like this. The band's next and final appearance on TOTP was in 1995 performing two tracks from their farewell album *Adios Amigos*.

JON & VANGELIS - I Hear You Now (#15)

From the album *Short Stories*, half of whose tracks clock in at over five minutes long, this was the first hit for the ongoing collaboration between Yes vocalist Jon Anderson (soon to be replaced in Yes by Trevor Horn of all people) and Greek synth wizard Vangelis of *Chariots of Fire* fame. Sadly the video has dated very badly, seemingly featuring Rowan Atkinson's mime Alternative Car Park from *Not the Nine O'Clock News* prancing around in a bodysuit made of the sky and frolicking on a now very valuable analogue synthesizer, not to mention three Harlequins playing non-existent violins. *I Hear You Now* and 1981's *I'll Find My Way Home* were both top ten hits, but perhaps Jon & Vangelis's best known song is *State of Independence* which became a hit for Donna Summer in 1982.

BILLY OCEAN - Are You Ready (#46)

"Well, one thing we have on this programme tonight is plenty of variety," offers Kid by way of apology, "and I reckon it's time to get things moving again!" This, apparently, requires the introduction of Billy Ocean, who had reached number 2 twice in 1976 and '77 with *Love Really Hurts Without You* and *Red Light Spells Danger* but hadn't been in the top forty since then. He wouldn't make it with this one either, the second song on tonight's show which fell short of the number 40 spot; the combined might of the TOTP Orchestra and the Maggie Stredder Singers would see to that. Consisting of little more than the words *"Are you ready? Are you ready to go?"*, Billy turns in an amiable performance on his small podium surrounded by disinterested audience members, but the song is of little consequence and it would be another four and a bit years before he returned to the top forty with 1984's *Caribbean Queen*.

NEW MUSIK - Living by Numbers (#20)

Despite Jensen's opinion that the next act "have a really bright future ahead of them", this would be the biggest hit for New Musik; follow-up singles *This World of Water* and *Sanctuary* both peaked at number 31 and singer Tony Mansfield would soon be spending more time producing other acts than concentrating on his own band. Having said that, *Living by Numbers* and indeed the whole *From A to B* album from whence it comes are great records. This is the same performance from two weeks ago, the studio still isn't painted and they still don't want your name. New Musik released three albums in total; the last, 1982's *Warp* includes a song called *All You Need Is Love* and another song called *All You Need Is Love*; the latter, it pains me to say, being one of the weakest Beatles cover versions ever recorded.

KEITH MICHELL - Captain Beaky (#40)

Well now, how to explain this to a 21st century audience? The brainchild of writer Jeremy Lloyd, best known for TV sitcoms such as *Are You Being Served?* and *Allo! Allo!*, Captain Beaky was one of a number of poems about anthropomorphic animals, set to music and narrated by celebrities such as Harry Secombe, Peter Sellers and Twiggy for a 1977 album. Two years later Noel Edmonds caught Tony Blackburn playing the title track on Radio 1's *Junior Choice* and snatched the record off him to play on his own show, sparking a craze which would involve books, TV shows and even a West End musical. Esteemed Shakespearean actor Keith Michell was chosen to tell the tale of Captain Beaky and his band, the single eventually eclipsing his own musical career which consisted of one number 30 hit in 1971.

THE SPECIALS - Too Much Too Young (#1)

Bringing a particularly diverse edition of TOTP to a close, Kid Jensen brings on Radio 1's newest recruit ~~Rupert Holmes~~ Steve Wright to introduce the number 1; with his "fashionable" chinstrap beard Wright looks more like a lightweight Kenny Everett than the Weird Al Yankovic lookalike we're used to these days. The Specials have rocketed from number 15 to the top of the chart with their *Special AKA Live!* EP; it's only the second EP and only the second live recording ever to reach number 1 but strangely there still isn't enough time to play the last verse with all its birth control references in it because Kid has to close the show and play out with Queen's *Save Me*, the band's last release before Freddie Mercury grew his infamous moustache. We'll see the video for this next week with Wrighty at the helm, but for now it's good night and good love.

February 7

"Just another message on a payphone wall"

Well now, who's this handsome young fella rocking the Captain Kremmen beard and massive, slightly tinted glasses look? It's only Steve Wright on his first TOTP hosting gig, a position he would cling onto for the whole decade before becoming the voice of TOTP2 for many a long year, and if you think he looks ridiculous here you should Google him and see what he looks like now. Wrighty even had his own top forty hit *I'm Alright* in 1982, which makes absolutely no sense now if you don't remember listening to Radio 1's *Steve Wright in the Afternoon* around that time. The top thirty machine is still stuck on INK 0; PAPER 6 accompanied by *Jane*, an unexpected UK hit for Jefferson Starship, the missing link between '60s stoners Jefferson Airplane and '80s FM rockers Starship, a link that perhaps should have remained missing.

THE TOURISTS - So Good To Be Back Home Again (#46)

Almost as if they knew this would be their last major hit, the Tourists have decided to do the show in fancy dress. Dave Stewart has come as Ziggy Stardust, while bassist Eddie Chin has come as Dave Stewart ten years in the future. Guitarist Peet Coombes does a more than passable impression of Elliott Smith, Annie Lennox has come as some kind of combination of Lady Gaga and Petr Cech and drummer Jim "Do It" Toomey hasn't bothered because nobody can see him and he has the best nickname anyway. Coming on the back of their successful remake of *I Only Want To Be With You* late last year, *So Good To Be Back Home Again* was the band's only original composition to reach the top thirty; within a year Dave and Annie had jumped ship to become Eurythmics, who we may yet see on the show if the reruns carry on into 2018.

CLIFF RICHARD - Carrie (#27)

Along with *Devil Woman* and *We Don't Talk Anymore*, this is one of the few post-60s Cliff singles where he seemed like he was trying to do something relevant and interesting rather than just coasting along being Cliff Richard. This is due in part to the writing talents of a certain B.A. Robertson, who generated more polarised opinions on social media with his hits *Bang Bang* and *Knocked It Off* than anyone else in 1979 and will do so again later this year. Meanwhile Cliff is in search of a young lady friend who used to live round these parts; they've lost touch in recent years, seeing as how they don't talk anymore - the kind of conceptual continuity Frank Zappa would be proud of. Nowadays you would just tweet a photo of her and wait for it to go viral, but in the dark days of 1980 Cliff

had to traipse around town with her picture, showing it to random people. Did he ever find her? We just don't know.

THE WHISPERS - And The Beat Goes On (#18)

As Kenny Everett had Hot Gossip, so Wrighty has a Kenny Everett beard and Legs & Co. Having rejected the literal choreography options of dressing the girls up as metronomes or members of The Beat, there's nothing else for it but to dress them up in normal (if unfeasibly short) dresses of varying colours. But how can we keep the viewers' attention if they're dressed like normal people? Don't worry. Noticing that bands' logos have started showing up on the circular portions of the set in the past few weeks, someone has designed a logo for Limbs & Co which can be used in a similar way. I say "designed", it actually looks like it's written in Elvish and the director has seen fit to superimpose the barely legible word "Legs" over most of the dancing, so as usual it's memorable but not in a good way. This would go on to be the Whispers' biggest hit by some considerable margin, reaching number 2 in a couple of weeks' time.

BOOMTOWN RATS - Someone's Looking At You (#8)

Another outing for the performance from two weeks ago, which is really two performances in one so it seems only fair. Geldof is still flitting between being some kind of leather jacketed Rambo figure and a freaky cataract-suffering game show contestant who's found himself on *Mastermind* when he thought he was going on *Celebrity Squares*. As a conceptual art piece it must make sense to someone, if only Geldof himself. Reaching a peak of number 4 next week, this was the Rats' penultimate top ten hit although they struggled on for another five years after this, even managing to wangle a slot at Live Aid, by which time Geldof was busily shooting his mouth off about rather more pressing matters than saving some fish.

THE NOLANS - I'm in the Mood for Dancing (#3)

While Geldof relaxes after putting in a double shift during the same performance, here come the Nolans with another great example of the Irish work ethic; this is now their fourth different TOTP performance of the same song (although we didn't see the first one for jangly reasons). This time there's no sign of Johnny Pearson and his orchestra in the background and no precarious looking podium for the girls to shuffle awkwardly on, but we do still get some unnecessary clips of audience members who clearly aren't in the mood for dancing but have been coerced into doing so anyway. This concerted effort in returning to the studio time after time still couldn't push them past number 3, the same position Madness got to with their one performance shown three

times; this was, of course, the Nolans' most successful single although they managed another six top twenty hits after this one.

THE CHORDS - Maybe Tomorrow (#44)

Ah yes, the Mod revival, remember that? This was the first of two appearances for the Chords, who had been signed up by TOTP's semi-regular gobshite Jimmy Pursey of Sham 69 before falling out with him and signing to Polydor, making them labelmates with The Jam. It's fair to say that a record label is not all they shared with Weller & Co; this, their only top forty hit, sounds for all the world like a Jam demo. All the required chord sequences and drum fills are in place, singer and guitarist Billy Hassett has acquired the obligatory Rickenbacker, all that remains is for Paul to write a melody and sing it over the top. Sadly this never happens and we're left with a template for a Jam record which is pleasant enough but lacking an indefinable something to make it memorable. Still, their performance was enough to push the single to number 40 the following week.

REGENTS - 7 Teen (#11)

"I have a feeling we might be seeing a lot more of the Chords," predicts Wrighty, unwisely, as he links into another bunch of one hit wonders. Yes, the Regents are back and still looking like Robert Smith fronting a homemade Human League, although at this point the League was still four blokes dicking around with analogue synths and slide projectors, so maybe it's more accurate to say that the *Dare*-era Human League looked like a smartened up Regents. Either way, it's the ramshackle nature of the track that gives it its charm – a re-recorded, slightly more polished version was ditched for the single release in favour of this demo recording – and got the band as high as number 11, although surprisingly it couldn't push through into the top ten. The Regents went on to sign with a major label and were never seen on TOTP again, while the Human League were barely off the show in the second half of 1981. The music industry, there.

QUEEN - Save Me (#20)

"I understand Freddie Mercury and his band Queen have been getting into ballet recently," observes Wrighty, seemingly not as a dig at Fred's famous encounter with Sex Pistols bassist Simon Ferocious[1] but a reference to Mercury's performance with the Royal Ballet the previous October. Very little in

1 Legend has it that when Queen and the Sex Pistols were recording at the same studio complex in 1977, Sid Vicious stuck his head into Queen's studio and enquired of Freddie Mercury, "Have you managed to bring ballet to the masses yet?" Addressing him as "Simon Ferocious", Mercury apparently forcibly removed the hapless bassist from the studio.

the way of ballet to be seen in the video for Brian May's ballad *Save Me*, although there's plenty of rocking out in front of a massive drum kit as you might expect. Freddie has gone for a formal look this evening, in red leather trousers and matching tie, but the effect is somewhat marred by the fact that he's forgotten to put his shirt on. The video is unusual in that it mixes live action with animation, half a decade before a-ha's *Take On Me* did; including a scene where the animated female character morphs into a dove which Freddie fails to catch. Luckily it flies away before dropping a load on Roger's drums.

THE SELECTER - Three Minute Hero (#21)

Another hugely overstaffed 2 Tone act following The Specials and Madness into the chart, The Selecter were notable for their appalling spelling and the fact that, uniquely among the 2 Tone acts of the time, they had a female lead singer in Pauline Black. The band's performance is generic 2 Tone - if there can be such a thing for a movement that was barely six months old at the time - with each member chiefly required to jump around until exhausted, regardless of how difficult it becomes to play his instrument while so doing. Despite Wrighty's expectation that this would soon join the Specials at the top of the chart, it seemed the band's popularity was already on the wane; *Three Minute Hero* only climbed as far as number 16 and was their last top twenty hit.

AC/DC - Touch Too Much (#47)

And now a bit of genuine rock history: AC/DC's last UK television appearance with Bon Scott on vocals. It seems surprising now that they were even invited on the show to promote this single, entire chunks of which have had to be edited out; typical AC/DC single entendres such as *"She liked it done medium rare"* were apparently not suitable for TOTP, which is a family show and will not tolerate such filth. Twelve days after this show was first broadcast the legendarily hard living Scott was no more; having passed out after a night of heavy drinking in London, he was found dead the following morning, acute alcohol poisoning being given as the cause of his demise. As a fitting (and probably accidental) tribute, this episode was shown as part of the BBC Four reruns 35 years to the day after Scott's passing.

BUGGLES - The Plastic Age (#28)

AC/DC, of course, carried on with Brian Johnson taking Bon Scott's place and are still going, having released their latest album *Rock or Bust* in 2014. Not still going, on the other hand, are the Buggles, who were already struggling to live up to the success of their début hit. Once again Trevor Horn didn't get the memo about dressing up in shiny futuristic gear, although he still doesn't look as odd as

keyboardist Geoff Downes who, for reasons known only to himself, appears to be wearing a pair of rubber washing-up gloves. Maybe one of his keyboards wasn't earthed properly. As if to make up for the fact that they weren't on the show with *Video Killed the Radio Star* (except for the Christmas special), *The Plastic Age* will be on again in a couple of weeks and even their difficult third single gets a slot in a month or two.

THE SPECIALS - Too Much Too Young (#1)

Well, surely we'll have enough time to show the whole 2'05" of the song this week, won't we? Ah, no, out of time again, deary me, they've had to cut the verse about contraception again. It's almost as if they didn't want you to hear it. Anyway, Wrighty has made it through his first of countless TOTPs and we play out with Joe Jackson's *It's Different for Girls* again, after Steve teases us with an intriguing teaser for next week's show, apparently on Friday instead of the regular Thursday. Don't tune in next Friday though, because (a) it's not 1980; (b) *The Sky at Night* is on BBC Four next week in place of the regular TOTP repeat, pushing the next edition back a week as it has done since 2011 although it still seems to confuse people on Twitter who will postulate that they've dropped the show because of the number of editions they can't broadcast any more; and (c) Simon Bates is hosting.

February 15

"We can ride the boogie"

"Thank you, Mr Voice, and welcome to Friday night, it's *Top of the Pops*!" Ah, the sweet essence of BBC Four trolling Simon Bates because (a) the pre-show announcer was quite obviously female and (b) depending on which showing you're watching it's either Thursday evening, very early Friday morning or Saturday night / Sunday morning. To be fair (do we have to be fair to Simon Bates?) this edition was originally broadcast on a Friday due to coverage of the Winter Olympics on the Thursday, as was next week's edition, which raises all sorts of questions about why there wasn't Winter Olympics on the Friday evening as well. Be that as it may, someone has been fiddling with the top thirty machine again – we're back to yellow titles on a black background but now each picture has an entirely pointless identical but smaller picture placed just to its left like a bad echo. In another bit of expert trolling the countup music is Kool & the Gang's completely unsuitable for the Winter Olympics period *Too Hot*.

MATCHBOX - Buzz Buzz A Diddle It (#22)

In a small corner of Television Centre, a tiny band of misfits are still fighting the American Civil War. Quite why Matchbox were so fond of the Confederate flag is not entirely clear 35 years on, and wasn't particularly eloquently explained even then, but despite its connotations of slavery and segregation, Matchbox continue to display it as a symbol of watered down rockabilly. They're from Middlesex, lest we forget. In the background someone has attempted to make some kind of vaguely abstract "TOTP" sign as part of their A-level metalwork course; unfortunately it appears to say "TOTO" who won't be on the show until 1983 and even then only on video. Some work still required there, obviously.

KEITH MICHELL - Captain Beaky (#5)

Since his first appearance on the show two weeks ago, Captain Beaky mania has broken out, hence the appearance of various Tiswas-style placards proclaiming "Hissing Sid Is Innocent", "Timid Toad Lives", "Hissing Sid Hasn't Got a Leg to Stand On" and so on. Unfortunately tonight it seems Keith Michell can't quite hear the TOTP Orchestra careering through the musical backing with little aplomb, a state of affairs which would normally be considered a blessing except that he's expected to recite a poem over the top of it. The resulting twenty minute free-form beatnik jazz-poetry recital is all very well but it's not really selling the record to its target audience, which might explain why the single didn't get any higher than this number 5 position. Hastily conceived follow-up *The Trial of Hissing Sid* stumbled to number 53 and Michell went back to being

a proper actor, pretending none of this ever happened.

THE FLYING LIZARDS - TV (#55)

From Captain Beaky to Captain Beefheart, or at least some vague attempt at surrealism from the group best known for their minimalist spoken word version of *Money* which had been a top five hit the previous summer. Desperate not to be labelled a novelty act, the Lizards are trying ever so hard to be avant garde, but everything about this performance is just annoying. While Deborah Evans-Stickland fails to lip-synch to her stilted spoken words with any great accuracy, the other band members talk amongst themselves as Chicory Tip's *Son of my Father* plays backwards on a distant radiogram. The drummer's even holding his sticks the wrong way round! Anarchy. Worst of all, they've employed a children's TV presenter in yellow dungarees to fart around on a variety of improbable instruments while simultaneously looking smug and bored. Due to some clerical error the whole tedious mess was Simes's record of the week but failed to reach the top forty and the Lizards went back to doing novelty cover versions.

ELVIS COSTELLO & THE ATTRACTIONS - I Can't Stand Up For Falling Down (#17)

"There's one for anyone who thought the Flying Lizards were a one hit wonder band!" trumpets Simes triumphantly, as the single goes on to stall at number 43. Meanwhile on video here's Elvis Costello, fresh from his success as producer of The Specials' début album, and in fact this single almost came out on their 2 Tone label until record company politics put paid to that idea. The song had originally been recorded by soul duo Sam & Dave back in 1967 although Costello's version puts a whole new uptempo spin on the track, leading to a video full of quite unnecessarily energetic dad-dancing in a variety of exotic locations. While the A-side was a cover, the B-side of the single was the Costello composition *Girls Talk* which had been a hit for Dave Edmunds the previous year. More of him in a tick.

MICHAEL JACKSON - Rock With You (#12)

"And now here's Michael Jackson and *Rock With Me*." Oh Simes, it's good but it's not right. Naturally Jacko isn't in the studio because he's already too important for that kind of nonsense, so instead Limbs & Co are wheeled out "as you may never have seen them before," according to Bates, by which he apparently means "fully clothed". Once again Flick Colby's literal choreography idea has been vetoed so we don't see the girls dancing around a huge boulder or a long, thin, vaguely phallic stick of candy sold at seaside resorts. No, this classic track from Jackson's quintessential disco album quite clearly screams

"ballroom dancing". Luckily Craig Revel Horwood isn't around to judge them or they'd all be going home.

DAVE EDMUNDS - Singing the Blues (#39)

Although he'd scored a number 1 hit with *I Hear You Knocking* way back in 1970, Dave Edmunds was now apparently locked into an almost incestuous relationship with Nick Lowe and their joint band Rockpile, regularly appearing on TOTP as a unit whenever either of them had an allegedly "solo" hit. Tonight Lowe - complete with fashionable 2 Tone guitar strap - is backing Edmunds on a cover of the "rock classic" which had been a number 1 hit in 1957 for both Guy Mitchell and Tommy Steele - Steele's version knocked Mitchell off the top spot, only for Mitchell to reclaim the place a week later, and for a couple of weeks their respective versions held the number 1 and 2 positions simultaneously. There would be none of that shenanigans with Edmunds' version though, as it's a depressingly workmanlike run through of the song which sounds like Status Quo performing at gunpoint.

JON & VANGELIS - I Hear You Now (#8)

"Alright, who threw that? Mr Car Park has been kind enough to come here this afternoon all the way from Nottingham!" Yes, it's another (mercifully brief) outing for this mime-filled interpretive dance influenced video which must have looked incredibly naff and dated even then. In fact, despite punk having long since fizzled out, there's a remarkable amount of the kind of thing it was meant to have replaced on tonight's edition - disco, novelty records, avant garde smugness, pub rock and now the last remnants of prog; Jon Anderson's role as frontman of Yes is well documented, but Vangelis had also been in the Greek prog band Aphrodite's Child in the late '60s, alongside the man mountain (and recently deceased at the time of the BBC Four repeat) Demis Roussos. This was the peak position for *I Hear You Now* but their other hit *I'll Find My Way Home* would go even higher in a couple of years' time.

THE SHADOWS - Riders in the Sky (#21)

As if to demonstrate just how little effect punk had on the wider record-buying public, Simes is proudly cradling a platinum disc for The Shadows who have somehow managed to shift 300,000 copies of their *String of Hits* album. While Cliff was enjoying a new lease of life with the help of hip young songwriters such as Alan Tarney and B.A. Robertson, his former backing band were content to record guitar-led instrumental covers of hits such as *Heart of Glass*, *Bright Eyes* and this cowboy standard from the late 1940s. As usual, with nothing else to do but stand there and pretend to play the guitar, Hank Marvin takes embarrassed

gurning to a new level while Brian Bennett, confused and frightened by the sudden appearance of a set of electronic drums in his kit, just hits them all and hopes for the best.

MARTI WEBB – Take That Look Off Your Face (#49)

It really is like punk never happened in here tonight, isn't it? *Take That Look Off Your Face* is a song from the one-act Andrew Lloyd Webber musical *Tell Me on a Sunday* which, being too short to do anything with in the theatre, had been converted into a TV special aired a few days before this edition of TOTP. Thanks to that and the song's cross promotion here – and despite the jarring Americanisms in the lyrics – the record rocketed into next week's top twenty and would go on to reach number 3. Yes, Marti, lots of young guys wear corduroy pants. Despite Lloyd Webber apparently not really knowing what to do with it, *Tell Me on a Sunday* has been performed in various permutations over the past 35 years with singers including Lulu, Sarah Brightman and, er, Denise Van Outen.

STIFF LITTLE FINGERS – At the Edge (#45)

Ah, well, maybe punk did happen after all. Chances are you remember Stiff Little Fingers for their incendiary early singles *Suspect Device* and *Alternative Ulster*, so you'll be as surprised as me to discover that neither of those singles charted and this was their biggest hit by quite some distance. Despite opting for the perennially controversial drummer-at-the-front stage configuration, *At the Edge* seems rather tame and unfocussed compared to their ultra-specific first two singles; Jake Burns is clearly still very angry about something, but it's hard to tell what. At times it seems even Burns himself isn't sure, as he struggles to keep a straight face throughout the performance. Even Bates seems amused by the band's antics, allowing himself a grin in their direction before composing himself to introduce the number 1.

KENNY ROGERS – Coward of the County (#1)

And what a number 1 it is, surely the only time in the entire history of the charts that a song about contraception has been deposed from the top of the charts by a song about multiple sexual assault. As if to prove that nobody actually listens to the lyrics of songs, Kenny Rogers follows up his 1977 chart topper about adultery with a number 1 about a pacifist driven to extreme violence. What Tommy actually does to those awful Gatlin boys is never really explained, but he "let them have it all" so you can draw your own perverted conclusions from that. Simes bids us goodnight as we play out with *Baby I Love You*, "a rising climber from The Ramones"; Peter Powell is back next week with the début of one of the

show's most regular guests.

February 22

"Your hair is beautiful"

Oh for heaven's sake. "Direct from Lake Placid, you're very welcome to the *Top of the Pops* studio and another great show!" That's right, the Winter Olympics are still in full swing and consequently the BBC's entire output has been relocated to a small village in New York State. No, of course it hasn't, it's just an excuse for Peter Powell to dress like a ~~tit~~ world champion skier. Very convincing, Pete. The top thirty machine has been reset to clear the weird echoey pictures from last week, removing the hazy coloured border around the photos in the process, but it's also gone back to the bright yellow background which might explain why Powell is wearing those enormous dark glasses. Countup music this week comes from Rainbow; that's Richie Blackmore and Graham Bonnet, not George and Zippy.

SHAKIN' STEVENS - Hot Dog (#40)

This week's show actually turns out to have been pretty important, featuring as it does the début appearances of two hugely successful and prolific acts. This fact seems to have been lost on whoever chops the episodes down to half an hour for the 7.30 BBC Four showing though, as both débuts were lost for that edit. Here's the first of them, the esteemed Michael Barratt of Cardiff who had already been gigging as Shakin' Stevens for over a decade, although appearances in the stage musical *Elvis!* and the '70s revival of '50s TV show *Oh Boy!* increased his profile significantly and helped him to finally score a hit single. In all fairness it's not Shaky's best work - a love song about a girl who works on a hot dog stand, really? - but it was a foot in the door and Stevens would go on to make more than forty appearances on the show.

BLONDIE - Atomic (#3)

Storming into the chart at number 3 comes the third and ultimately most successful single from Blondie's *Eat to the Beat* album, accompanied by some kind of terrifying post-apocalyptic video in which the band are reduced to performing in whatever clothes they could scavenge from the local dump, including PVC bin bags, an old Who T-shirt and what seems to be some kind of awful clown outfit complete with bow tie and curly wig. Things are so bad that they're also forced to play the emergency version of the song, in which vocals are rationed to a single verse and a tedious bass solo is inserted to fill time; in World War II we had powdered egg, but that was nothing to the horror of the World War III bass solo. Still, we have to make the best of the situation, so get

down, get funky, and remain indoors.

THE BEAT – Hands Off... She's Mine (#48)

Like Madness, The Beat departed the 2 Tone label after one single in search of broader horizons. While the nutty boys had the time of their lives at Dave Robinson's Stiff label, Dave Wakeling and co rolled up at major label Arista, who gave them their own vanity label Go Feet. With *Tears of a Clown* barely out of the chart, *Hands Off... She's Mine* was the first release on their new label and was very much more of the same. They would never emulate the success of Madness but this would see them back into the top ten, with all the required running on the spot from Ranking Roger and flailing around from rubber guitar and bass combo Andy Cox and David Steele, still half a decade away from becoming two thirds of Fine Young Cannibals.

BUGGLES – The Plastic Age (#18)

You may well feel like you've heard this more times this year than in the rest of your life, but amazingly it's still only just creeping into the top twenty. It's a second outing for the second performance of the song, with keyboardist Geoff Downes still wearing washing up gloves as if trying to protect himself from an improperly-earthed Moog. Sadly the Buggles' time was already almost up and they only have one further appearance on the show to look forward to, although Trevor Horn would, of course, go on to produce some of the biggest hits of the decade for acts such as ABC, Dollar and Frankie Goes To Hollywood. Before that, though, Horn and Downes would somehow find themselves assimilated into a rather unorthodox line-up of prog rock behemoths Yes. Still not quite sure how that happened.

THE TOURISTS – So Good To Be Back Home Again (#10)

Also on their last legs are the Tourists, making their last appearance on the show here with another repeat of an earlier performance. They would go on to score one further minor hit later in the year with *Don't Say I Told You So* before disintegrating, never to be seen again until 1983 when Annie "Petr Cech" Lennox and Dave "Ziggy Stardust" Stewart achieved their first success as Eurythmics. Sadly Tourists guitarist and songwriter Peet Coombes died in 1997, which led to Lennox and Stewart – who had been estranged for most of the nineties – putting aside their differences and recording Eurythmics' 1999 reunion album *Peace*. The Tourists' other top ten hit *I Only Want To Be With You* was appropriated by Thames Television in 1992 and used in an evocative montage as the station closed down for the final time after losing its ITV franchise.

FERN KINNEY - Together We Are Beautiful (#23)

Funny how things work out, isn't it? If you have a good memory for tedious no-hit wonders you might remember Steve Allan who was on the show just over a year ago doing an even slower, less interesting version of this song. Now former session vocalist Fern Kinney has done a version and it's inexplicably about to become a massive hit, prompting Allan to put his foot through the television set and send the BBC the bill. Fern's performance is lacklustre, not helped by the combined might of the TOTP orchestra and the Maggie Stredder Bellowers feeding the song through a mincer, but something must have clicked with the public because - spoiler alert - it's on its way to number 1 in a couple of weeks.

RAMONES - Baby I Love You (#8)

"From the west coast of the States, produced by Phil Spector, a sound that's so big it's gonna go massive!" Yes Pete, maybe you should have rehearsed this link beforehand, hmmm? Despite sounding nothing like anything else the Ramones ever recorded, *Baby I Love You* has already gone as massive as it ever would, peaking at number 8 this week, a chart position the Ramones would never even come close to again. For all their street cred over the intervening 35 years, the band never had another top fifty hit in the UK - selling more T-shirts than records in the past decades - and all the band's original members have now died, the only surviving member from this line-up being drummer Marky Ramone who, thanks to Spector's bizarre production techniques, doesn't actually play on the song.

THE WHISPERS - And The Beat Goes On (#2)

Did The Whispers ever actually exist? If so, someone at their record company needs to get them to make a video or get a on a plane because this is the second time in three weeks Limbs & Co have been drafted in to dance to their hit. Even with The Beat in the studio this week, Flick Colby has resisted the temptation to make the girls dance around them, instead going for a fairly aimless routine with the girls in big jackets and sparkly trousers dancing atop huge sticks of rock. No, Flick, *Rock With You* was last week! *And The Beat Goes On* couldn't quite make the final leap to number 1 but the Whispers had a few more hits including another top ten smash *It's a Love Thing* in about a year's time.

CLIFF RICHARD - Carrie (#6)

"We don't talk anymore about Cliff not having a hit," observes Powell, and indeed Cliff was going through a surprisingly successful period in which he released some truly great pop records. This is one of them, although the video

doesn't do him any favours – he's asking random strangers "about a friend, I've her picture, could you take a look?" He holds up his hand – there's no picture. Oh Cliff, she never really existed, did she? Never mind, come and have a seat here, just slip your arm through here, the nice men in the white van will be here in a minute. *Carrie* climbed to number 4 and remains one of Cliff's finest moments, before he sank back into the easy listening mire later in the decade.

IRON MAIDEN - Running Free (#46)

"Who said heavy metal music was dead?" No-one, Pete, in fact 1980 was perhaps heavy metal's most successful year chartwise, with the New Wave of British Heavy Metal (NWOBHM) movement gaining a foothold and the likes of Saxon, Judas Priest and Motörhead all scoring regular top twenty hits. Leading the NWOBHM charge, here's the TOTP début of Iron Maiden, although they don't look exactly as you might imagine. For one thing, who the hell's that singing? Still eighteen months away from recruiting Bruce Dickinson, *Running Free* features the little remembered Paul Di'Anno on vocals, who performed on the band's first two albums before being dismissed when his drug use became a liability. Naturally, as a fascinating and historically vital performance, it was cut from the 7.30 edit, proving that whoever edits these down to 30 minutes knows nothing about music history.

KENNY ROGERS - Coward of the County (#1)

A second and final week at the top for Kenny with a song that, although almost forgotten now, embedded itself into the public's consciousness at the time to such an extent that "comedy" duo Little & Large used it in a trailer for their new series broadcast immediately following this show's original broadcast; the horror of Eddie Large crooning *"Everyone considered him the coward of the County Council"* is something that has never left me. Anyway, now Tommy has paid the Gatlin boys back for what they did to his Becky (whether it be by shooting them, punching them repeatedly in the head or sodomising them, the lyrics don't specify which) we can all move on and forget this ever happened. We play out with ~~Brian Pern~~ Peter Gabriel's *Games Without Frontiers* and look forward to some sensible hosting from Kid Jensen next time on the proper day of the week.

February 28

"Everyone avoids me like a cyclone ranger"

"Hi there! You've joined us just in time as we punch out more pop on this week's edition of Top of the Pops!" Well, that was lucky. Imagine if we'd turned up late for a 35-year-old TV show. After the Winter Olympic related shenanigans of the past two weeks we're back to normal tonight with Kid Jensen, returning to the regular Thursday night slot and the good old-fashioned yellow-on-black top thirty countup. The accompanying music is Jefferson Starship's Jane, backing the countup for the second time in a month without ever appearing on the main show itself; we won't see anything of them until late 1985 when they dropped the Jefferson bit and hit the top twenty with We Built This City, although there was a strange period in 1987 when their number 1 hit Nothing's Gonna Stop Us Now shared space in the top 100 with White Rabbit by their predecessors Jefferson Airplane. This is all completely irrelevant to tonight's show, of course.

ELVIS COSTELLO & THE ATTRACTIONS – I Can't Stand Up For Falling Down (#5)

So let's get going with two of the silliest minutes of television you'll ever see associated with Elvis Costello. Even the boy McManus can't keep a straight face as a once sombre Sam & Dave number turns more Chas & Dave. Clearly someone has consulted Flick Colby's Big Book of Literal Interpretation as the TV picture totters from side to side and even slides right off the screen in case you weren't sure what "falling down" meant. As if that wasn't enough there's a brilliantly ludicrous insert for the last chorus where Elvis is hooked up to some bungee ropes and dropped to the floor, before being hoisted up again and dropped again. Costello can come over as being somewhat austere – it's not that long since he was sneering at "silly little man" Tony Blackburn – so it's nice to see him behaving like a tit for once.

MARTI WEBB – Take That Look Off Your Face (#6)

With Elvis still vibrating in the background after all his falling down, The Kid slows proceedings back down to a crawl, introducing Marti Webb's inexplicably huge hit with a gesture that invokes images of Billy Connolly's famous "I'll take my hand off your face!" routine. This song from Andrew Lloyd Webber's Tell Me On A Sunday is on its way to spending three straight weeks at number 3, while grammar pedants across the country hiss "didn't sleep well last night!" at their televisions. It's the same performance as two weeks ago so much of it is still done in unnecessarily extreme close-up and the combined might of Pearson and

Stredder are still tearing it to shreds, and it's still not as good as French & Saunders' version but as that doesn't seem to be on YouTube you'll just have to take my word for it.

THE VAPORS - *Turning Japanese (#34)*

What is it with everything tonight referencing a yet-to-be-made comedy sketch? Flick's book is out again as the graphics department illustrate *Turning Japanese* with pictures of every Japanese person they can find, in the style of Father Ted's hastily prepared slideshow about how much he loves the Chinese. All it needs is to end with repeating slides of Vapors singer Dave Fenton and the phrase "Not a racist." In fact you could be forgiven for being surprised to see this shown at all, given that a Barron Knights performance from the tail end of last year was excised from the repeat run for a dubious joke about the Chinese. Never mind, if nothing else the Japanese slideshow has enabled us to get through the song without once suggesting that the lyrics are about self abuse. Oops.

MICHAEL JACKSON - *Rock With You (#7)*

A nice bit of misdirection from The Kid here who introduces Michael Jackson, the camera panning to the right as if to swing round to catch the man himself on stage in the studio... but no, of course not, we end up just fading into the video instead. The video itself is no *Thriller*, but it's also no *Earth Song* so we can be grateful for that. What it lacks in zombies or Christ-like self-mythology it makes up for in lasers. There are lasers. Lots of them. So many that the lasers probably accounted for 90% of the total budget, especially in those far-off days when lasers were still viewed with the same scepticism as witchcraft and computers. In fact there are so many lasers that Michael's spangly, sparkly outfit seems superfluous, not to mention dangerous as it threatens to redirect one of the laser beams directly into your retina. It's a Health & Safety nightmare, etc.

LIQUID GOLD - *Dance Yourself Dizzy (#47)*

It's fair to say that this lot are not taking it seriously. The guitarist and bassist are playing their instruments with violin bows, the guitarist has a heart-shaped guitar and has come as a prototype Adam Ant, the singer's forgotten to put her skirt on and the drummer... well, he's forgotten to put anything on except a tie and an indecently snug pair of nylon shorts. What he has remembered to do is paint a piano keyboard on his torso, which singer Ellie Hope "plays" during the xylophone solo in the instrumental break, to little acclaim from the audience. Still, it's going all the way to number 2 and rather spoiling the idea that disco was dead and buried by the end of the 1970s.

GIBSON BROTHERS – Cuba (#40)

In fact it's disco frenzy this week – "It's just like New Year's Eve up here tonight," observes The Kid – with three floorfillers in succession. Here are the Gibson Brothers – Mel, Henry and Debbie – salsaing their way through a song which had reached number 41 a year ago and had now made it one place higher on the back of their two top ten hits *Ooh! What a Life* and *Que Sera Mi Vida*. "My only desire is making you mine," croons Mel, and indeed someone with a Davy lamp would be very useful on this strangely dimly lit set, decorated only by half a dozen balloons tied together – it doesn't exactly scream "Fiesta" until twenty seconds before the end when the dancing girls arrive in huge feathered headdresses and not much else. Clearly the whole thing is a US-instigated plot to bring about the fall of Communism.

PETER GABRIEL – Games Without Frontiers (#17)

Five years after his departure from Genesis, Gabriel had yet to set the singles chart alight apart from his very first solo single *Solsbury Hill* in 1977. To be fair, Genesis were not exactly a bankable singles act at the time either, and Gabriel had reached the top ten with his albums *Peter Gabriel* and *Peter Gabriel*. This single helped his third solo album *Peter Gabriel* (titles were never his strong point) to number 1 and eventually reached number 4 in the singles chart – his joint biggest hit, matched only by 1986's *Sledgehammer*. Despite the reference to '70s game show *It's a Knockout* and its pan-European equivalent *Jeux Sans Frontiers*, the video does not include anyone in a ten foot tall rubber costume attempting to carry a bucket of water over a bouncy castle, but there are also no references to Stuart Hall, so we got off lightly there.

STIFF LITTLE FINGERS – At the Edge (#25)

Time for "a bit of that kind of rock," as silly little man Tony Blackburn would have called it. It still seems odd that this was such a huge hit compared to some of the band's more inflammatory material which failed to register on the chart; maybe the inclusion of a live version of *White Christmas* on the B-side helped propel it into the top twenty in March. Jake Burns and his cohorts give a suitably impassioned performance although again the studio is so dimly lit that Flick Colby could have smuggled U2's guitarist in to the line-up and nobody would have noticed, not that anyone would have known who he was at the time anyway, so really it would have been a very obscure joke that only a tiny number of viewers would have appreciated at the time but utterly fantastic 35 years later.

DAVE EDMUNDS - Singing the Blues (#28)

Back again, it's Dave Edmunds on vocals, Nick Lowe on bass and ~~Keith Chegwin~~ Billy Bremner on guitar, who would go on to have a bit of a solo career including almost hit single *Loud Music in Cars*. This sub-Status Quo version of a song that was already 24 years old sounds totally out of place in the post-punk era, a bit like Mumford & Sons covering *Everything I Do (I Do It For You)* nowadays, which is something I'm sure you don't even want to contemplate. Sorry for bringing it up. This turned out to be Edmunds' last appearance on TOTP although he managed one further top forty hit, a version of *The Race Is On* with the Stray Cats which limped to number 34 in 1981.

THE POLICE - So Lonely (#19)

Filling an awkward nine-month gap between singles, we call upon The Police's third single *So Lonely* to make a belated appearance in the chart, in much the same way that both *Roxanne* and *Can't Stand Losing You* had to be coaxed into the top forty many moons after their original release. Naturally the band had moved on by this point and weren't particularly interested in appearing on TOTP to promote a single that was over a year old, so enter Legs & Co. Clearly there's been enough literal interpretation for one night so rather than dance around a giant effigy of Sue Lawley, the girls just do their own thing, which involves a lot of pointing for some reason, as well as whipping off their jackets and dancing in double time for the chorus as Sting emotes the full depth of his loneliness. How insensitive.

RAINBOW - All Night Long (#22)

Last week Peter Powell asked "Who said heavy metal was dead?" Quite clearly no-one did, because this is Rainbow's second of three top ten hits between 1979 and 1981, and singer Graham Bonnet also scored a solo top ten hit just after the last of those. That said, Bonnet looks somewhat out of place here, with his look positioned somewhere between M's Robin Scott and *Let's Dance*-era Bowie. Mind you, with Deep Purplist Roger Glover taking on bass duties in full beard and fedora, not to mention keyboardist Don Airey in a fetching sky blue sweatshirt, it's a toss-up as to who looks least rock 'n' roll. Luckily the song itself is an unimpeachable metal classic which is climbing all the way to number 5 and should not be confused with the classic kids' TV show *Rainbow* in the same way the Official Charts website does.

THE SHADOWS - Riders in the Sky (#12)

Yes, this lot again, but in fact this is an historic occasion because this would be

the Shads' last ever performance on TOTP. Following the success of this single they left EMI, where they had been since the late '50s when they were still Cliff Richard's backing group The Drifters, and signed to Polydor where they released numerous albums of tepid cover versions such as *Moonlight Shadows, Simply Shadows* and *Steppin' to the Shadows*. If they suspected this might be their last appearance it certainly didn't show, with Hank still grinning like a loon and Brian Bennett provocatively moved to the front of the stage to battle with those electronic drums again. The Shadows' only top forty single after this one came in 2009 when they reunited with Cliff for a cover of - guess what? - *Singing the Blues*.

BLONDIE - Atomic (#1)

The Shadows, of course, "have inspired countless musicians over the years, maybe even Blondie." Yeah, not entirely sure about that, Kid, unless you're basing it on the fact that they both have guitarists. Anyway, despite being one of their weaker singles, *Atomic* has deposed Kenny Rogers from number one so we get to see the apocalyptic nightmare scenario video and listen to the interminable bass solo again. Far more interesting, if that's the right word, is the playout track which is David Bowie's take on Brecht and Weill's *Alabama Song*, a jarring listen which sounds like seven entirely different records being played at once but somehow made it to number 23 by virtue of being a David Bowie record. That's all for this week, Dave Lee Travis is at the helm next week, or is he?

March 6

"Far away in time"

We've been on a roll for the first two months of 1980 with no interruptions to the repeat run on BBC Four, but the long dark shadow of Operation Yewtree had to cast its gloom over the run sooner or later. Yes, despite having never been found guilty of any kind of impropriety at any point during his tenure as a TOTP presenter, Dave Lee Travis is still persona non grata as far as BBC Four is concerned. Luckily, thanks to some new fangled invention called The Internet, lots of things that you would never have hoped to see again are widely available if you know where to look, so let me talk you through what you missed, including a hairy man in an unattractive jerkin and the top thirty countup to the strains of *Cuba* by the Gibson Brothers. You may remember they were on last week's show and they'll turn up on next week's show too, so at least they're doing well.

THE LAMBRETTAS - *Poison Ivy (#44)*

Come to think of it, you could say it was DLT's unattractive jerkin' that got him into trouble in the first place, ha ha. Anyway, with the mod revival if not in full swing, at least still in three-quarters swing, here are the Lambrettas reviving Leiber and Stoller's *Poison Ivy*, a song which compares a lover to a poisonous plant which causes an itchy rash. Yes folks, it's a metaphor for the clap, although I probably shouldn't mention that as the band perform the song another twice on episodes yet to be shown and I don't want to alert the BBC censors to this appalling fact. Vocalist Jez Bird's appalling red suit is bad enough, not to mention the horn section who are all wearing massive 1970s headphones for no obvious reason. Signed to Elton John's Rocket label, the Lambrettas could have been huge if their third single hadn't been torpedoed by The Sun. More about that later.

THE CAPTAIN & TENNILLE - *Do That To Me One More Time (#25)*

You probably won't be surprised to learn that DLT loves this one, because it's a generic love ballad with no redeeming features whatsoever. Although huge in the States where they had their own TV show in the mid '70s, husband and wife duo The Captain (not a real captain) and Toni Tennille (not a real Toni, unless you consider that an acceptable abbreviation for Antoinette) had only scored a couple of minor hits over here with *Love Will Keep Us Together* and, er, *The Way I Want to Touch You* (silence the Yewtree klaxon!) before this became their biggest UK hit by a significant margin. The video is mainly soft focus shots of Tennille walking on a beach in a floaty dress while The Captain watches her

through a window and writes a song about her, which is just moderately creepy until the instrumental break when he gets his recorder out and pops it in his mouth – I said silence the Yewtree klaxon!

UK SUBS - Warhead (#42)

We've established over the past couple of weeks that heavy metal isn't dead, but you could argue a strong case that punk is, so here to blur the lines between the two are the UK Subs. Last seen just before Christmas 1979 with a dodgy version of the Zombies' *She's Not There*, *Warhead* was about to become their fourth top forty hit in nine months, although they had formed way back in 1976 at the dawn of the punk era. With singer Charlie Harper sporting a haircut closer to Leo Sayer (or, dare I suggest, DLT) than Johnny Rotten, *Warhead* was the beginning of the band's shift from punk towards a more generic rock approach. The change in direction clearly worked as the band is still a going concern, releasing a 25th album in 2015; in a distinctly artistic and non-punk move, each of their album titles starts with a successive letter of the alphabet, from 1979's *Another Kind of Blues* to 2015's *Yellow Leader*. Presumably after their next album they'll have to use numbers or something.

THE BEAT - Hands Off... She's Mine (#16)

Well, it might be The Beat, but there's so much smoke / dry ice / steam from DLT's underwear that it's hard to tell exactly who's on stage. Seemingly unconcerned that the studio might actually be on fire, The Beat skank their way through another run-through of their first self-penned hit, complete with xylophone solo, an instrument rarely used in ska. *Hands Off... She's Mine* would go on to give the band their second top ten hit from two attempts and is one of the few hit singles to use an ellipsis in its title, the only obvious others being Britney Spears' *...Baby One More Time* and *Oops!... I Did It Again* and Heaven 17's minor 1985 hit *...(And That's No Lie)* which nobody but me remembers.

MARTHA & THE MUFFINS - Echo Beach (#39)

Annoyingly this is the only time Martha & The Muffins ever performed on TOTP – although we do get to see the video in a couple of weeks' time – and what a peculiar looking lot they are, Two-Tone Martha seemingly leading a bunch of offcuts from the Attractions, Swing Out Sister, They Might Be Giants and the manager of the local branch of Barclays Bank on bass. Confusingly the band had two keyboardist / vocalists, both called Martha; Martha Johnson handles lead vocals on the band's only UK hit *Echo Beach* and so is the only one anyone remembers, but Martha Ladley went on to work with the Associates in a couple of years' time. *Echo Beach* is on its way into the top ten and was later covered

by Toyah, but we don't really talk about that.

SHAKIN' STEVENS - Hot Dog (#30)

Perhaps feeling that Shaky's début performance a fortnight ago was a tad lacklustre, the *Flick Colby Big Book of Literal Interpretation* comes out again and Stevens is joined on stage by the object of his affections, a young lady perched atop a mobile hot dog stand with the unpleasant sounding phrase "THE BIG BEEFY SNACK" painted on it. Oops, there goes the Yewtree klaxon again. Does she really work on a hot dog stand, or is the whole thing just an appalling sexual metaphor? I'm not sure I want to know. It seems to work for Shaky though, inspiring him to leap up and perform some of his signature leg shaking moves on top of his keyboard player's large organ (oh, please). A lengthy career as the most successful singles act of the eighties does not appear imminent.

SQUEEZE - Another Nail in my Heart (#40)

Showing the same respect for TV hosts as he would later show Richard Madeley, Shaky ends his performance by clambering up the scaffolding forming part of the set just as Travis emerges beside him. DLT jokily rebukes him for climbing on the set, to which Shaky responds by wrapping his leg around Travis's neck and attempting to throttle him. All this, of course, is a Colby-esque literal introduction to Squeeze, still in their imperial phase after back-to-back no.2 hits with *Cool for Cats* and *Up the Junction* last year, even though a clerical error seems to have resulted in Glenn Tilbrook being partnered by Chris de Burgh rather than Chris Difford. Curiously keyboardist Jools Holland is stuck over on the side of the stage, largely out of shot, to the extent that it's not entirely clear if he's actually there or if this is a stand-in and he's off playing boogie-woogie with someone else.

FERN KINNEY - Together We Are Beautiful (#2)

Cor blimey. Remember Fern's tepid performance of this song two weeks ago? To counteract that, here are Legs & Co with perhaps their most baffling performance of the year. They're all dressed as fairies, but fairies with massive Janet Street Porter glasses, wearing the standard fairy outfit of wings, magic wands, unfeasibly short dresses, stockings and suspenders. Er... what? To add to the confusion, their performance is interspersed with still photographs of celebrity couples such as Margaret and Denis Thatcher, Prince Charles and a mystery woman seen only from behind with a question mark drawn on the back of her head, and Tom & Jerry. The whole thing collapses into insanity as the fairies start moving cardboard cutout people around on a board in the manner of generals moving model soldiers on a map of a battlefield. Completely baffling,

but at least we don't have to deal with the TOTP Orchestra so, y'know, every cloud.

TONY RALLO & THE MIDNITE BAND - Holdin' On (#41)

Here's the hairy one again. "Watch out for some great rhythms on this next piece of music, it's gonna be a chart success." Instant kiss of death there for Tony Rallo, whose previous claim to fame was conducting France's entry in the 1976 Eurovision Song Contest. Like the Muffins earlier, the Midnite Band appear to be made up of various misfits from dodgy tribute bands; there's a rubbish Elton John, a rubbish Ben Elton, a rubbish Weird Al Yankovic and a passable Mark Steel on the end pretending to play saxophone. After last week's spirited attempt to prove that disco was still alive and kicking, this mid '70s cabaret piece kills it stone dead, although thanks to DLT's patronage the single got as high as number 34 the following week before disappearing into oblivion.

BLONDIE - Atomic (#1)

Third week in a row for this video, which still feels like it should have "REMAIN INDOORS" superimposed over it at regular intervals. This is *Atomic*'s last week at number 1 but Blondie have two more chart toppers to come this year, neither of which come with unnecessary bass solos. We play out with Liquid Gold's *Dance Yourself Dizzy* which, like the intro track *Cuba,* was on last week and will be on again next week, as if to try and revive disco from its unfortunate but timely demise at the blood-stained hands of Tony Rallo. Steve Wright is next week's host, so if you find him less objectionable than Dave Lee Travis, read on.

March 13

"Just take a seat, they're always free"

So it's one of those weeks on BBC Four where, without warning or explanation, we've skipped an episode due to its host, ruining the famous rule that nothing gets on the show two weeks in a row unless it's number 1 and leaving less enlightened viewers scratching their heads and muttering "Wasn't this rubbish on last week?" To add insult to injury this week's host is Steve Wright, still persisting with the "poor man's Kenny Everett" beard, and as we'll see later on there's not really much about his presentation style to give him an air of respectability greater than that of DLT. You'll also notice that the rubbish "TOTO" sign from a few weeks back has been melted down and refashioned into a new one that quite definitely reads "T.O.T.P." complete with superfluous full stops. Anyway, the top 30 countup music comes from Canadian rock gods Rush, enjoying their biggest ever UK hit with *Spirit of Radio*.

THE DOOLEYS - Love Patrol (#39)

Sadly there's no record of the Dooleys ever having released a song called *You've Got Me*, so the story about someone phoning up a radio show to request "*You've Got Me* by the Dooleys" must be apocryphal, or at least wildly inaccurate. Anyway, this is all very strange as the Dooleys used to be a pretty straight laced, establishment-friendly bunch - they had a hit album in the USSR in 1976 and performed the theme tune to legendary adult literacy show *On the Move* which made a star out of Bob Hoskins - but appear to have reinvented themselves for the new decade, squeezing themselves into multi coloured lycra and glittery boob tubes - and that's just the guys, ha ha. Ha. It doesn't seem to have done them much good as, after two consecutive top ten hits, *Love Patrol* only just scraped into the top thirty.

THE POLICE - So Lonely (#6)

So it seems the Police were in Japan when *So Lonely* finally charted and were required to spend an hour or so fannying about in Tokyo making a video. Hence we get the band members on a subway train singing the song into walkie-talkies - because that's what the real police do, of course - while being completely ignored by the Japanese public. This is intercut with shots of drummer Stewart Copeland wandering around the streets drumming on anything he can find; street signs, fences and trams are all fair game for Copeland's sticks, but not the food jars of an unimpressed street vendor who shoos him away. Hard times for the man who was allowed to drum on a Saturn V moon rocket a few months earlier. *So Lonely* would end up in the top twenty again a few months later as

part of a *Six Pack* along with the band's previous four singles and one new one.

DETROIT SPINNERS - Working My Way Back To You / Forgive Me Girl (#20)

Just as The Beat were known as The English Beat and Squeeze rebranded as UK Squeeze in certain other countries to avoid confusion with other groups, so the US soul group The Spinners had to be renamed in the UK to differentiate them from the Liverpool folk group of the same name. This medley was on its way to becoming their biggest UK hit, but they weren't around for TOTP, so... enter Legs & Co, with the *Flick Colby Big Book of Literal Interpretation* falling open at W for "Working". Of course "Working" translates only as "digging bloody great holes in the road", so the girls are dressed as... well, I don't know what they're dressed as, but the set is covered in scaffolding, traffic cones and signs reading "DANGER - LADIES AT WORK". Not sure any of those outfits would pass a risk assessment though, and there really doesn't seem to be any work going on, just a lot of dancing. Thatcher's Britain, ladies and gentlemen.

BROTHERS JOHNSON - Stomp (#25)

The other Spinners, incidentally, never had a hit single but were regulars on undemanding light entertaining television and are probably best remembered for a public information film encouraging you to give blood. Anyway, more American soul now, from another band enjoying its biggest UK hit - the Brothers Johnson (Lyndon B., Linton Kwesi, Holly and Marblehead) who scored a top forty hit in 1977 with the bafflingly titled *Strawberry Letter 23*. The Johnsons aren't in the studio either, but they have supplied a video which is a fairly nondescript affair, consisting mainly of the band performing the song in another studio, but interspersed with shots of George and Louis Johnson (they're brothers, y'know) driving around in a car and some people dancing at a party. There are varying degrees of fancy footwork on display but at no point does anyone actually stomp.

SECRET AFFAIR - My World (#40)

Glossing over the image of Steve Wright with his arms around two of the five young ladies forming a line around him for no obvious reason, we'd better get on with pretending that the mod revival is still a "thing". Secret Affair had reached no.13 last Autumn with *Time for Action* and after an underwhelming follow-up *Let Your Heart Dance* they were about to score their second and final top twenty hit with this single. Fortunately Limbs & Co have finished whatever work they were doing, but nobody has taken the scaffolding down or put the lights back on, so the band has to perform gamely behind a mass of metal poles in almost total darkness. Although this would be their last top forty hit, Secret Affair is still

going and undertook a tour celebrating the 35th anniversary of their début album *Glory Boys* in 2014.

LIQUID GOLD - Dance Yourself Dizzy (#14)

Having struggled to win over the crowd with their "xylophone on my chest" routine two weeks ago, Liquid Gold are back and trying even harder, irritating Wrighty in the process - "this lot were so much trouble in rehearsals" - which really isn't surprising when you discover that this week drummer Wally Rothe has come as Tarzan. Thirty seconds in, before we're even out of the introduction, and he's already covered in silly string and struggling to breathe, never mind drum. Meanwhile Syd Twynham with the heart-shaped guitar and bassist Ray Knott who looks suspiciously like Mud's non-gender-specific guitarist Rob Davis are having a great time with singer Ellie Hope in an even more revealing dress than last time. Time for Wally's xylophone solo though, and you'll be delighted to know that this week the keyboard isn't painted on his chest, but strapped to his arse. What fun.

RAINBOW - All Night Long (#5)

Another video? Limbs & Co must be looking nervously over their shoulders, while wagging their fingers reproachfully and, I don't know, putting their feet through television sets or something. Rainbow was the only real rock band on the show this week, although Def Leppard had been in the studio to record a performance of their not-quite-in-the-top-forty hit *Hello America* last week in the hope that it could be shown this week; awkwardly it went down instead of up so they didn't get on the show and it would be another seven years before they did. Still, Richie Blackmore and Cozy Powell are keeping the heavy metal flag flying, while Roger Glover and Graham Bonnet are flying the flags for Jethro Tull and M respectively. This was as high as *All Night Long* got but Rainbow had another, even bigger hit up its collective sleeve next year.

THE VAPORS - Turning Japanese (#8)

Towards the end of the 1979 run there was mild outrage on Twitter when the Barron Knights' *Food for Thought* was cut out of the show because of this dubious Chinese takeaway routine to the tune of M's *Pop Muzik*. Three months later and here's Steve Wright introducing *Turning Japanese* in exactly the same voice. He even does a little bow after it, as if he's just done something very polite instead of incredibly racist. At least there are no gratuitous insets of sumo wrestlers / Yoko Ono / Ming The Merciless this week, but this is the performance where drummer Howard Smith loses a drumstick, stands up to retrieve it and returns to his kit without missing a beat, only to be upstaged by a massive,

clunking edit in the track a few seconds later. There, that's twice the song's been on and we still haven't mentioned self-abuse. Oh.

SIOUXSIE & THE BANSHEES – Happy House (#36)

Probably best for Wrighty to say as little as possible and just move straight on with the next song. The Banshees had been going since the early days of punk – Siouxsie was the young lady Bill Grundy suggested he could "meet afterwards", sparking howls of sweary protest from the Sex Pistols on live television – but somehow this was only their second appearance on TOTP. *Happy House* catches the band in a kind of limbo between punk and goth, with Siouxsie looking as effortlessly cool as she ever would simply by not trying too hard to be one thing or the other. She does keep pulling handfuls of glitter out of her pocket and throwing them in the air for no clear reason though. This would become the band's second top twenty hit and later inspired Cappella's 1993 dance hit *U Got 2 Know*.

GIBSON BROTHERS – Cuba (#16)

Ooh, Steve, "a re-release from the Gibson Brothers"? You're spoiling us! But yes, it's true, *Cuba* had stalled at number 41 a year earlier but was now well inside the top twenty, ostensibly as a double A-side with *Better Do It Salsa* which, it's fair to say, contributed little to the overall sales of the single. It was *Cuba* that got all the airplay and the TOTP appearances, the Brothers doing their thing here in front of the new T.O.T.P. sign for the first time, without any dancing girls this week but with singer Chris Gibson sporting a fetching Mickey Mouse T-shirt. Both sides of this single, like many of their other songs, were produced and co-written by one Daniel Vangarde, father of Daft Punk's Thomas Bangalter. Could Daft Punk actually be two of the Gibson Brothers underneath those helmets? Er, no.

PETER GABRIEL – Games Without Frontiers (#4)

It's such a packed show tonight that there is only time for a minute and fifteen seconds of the video for *Games Without Frontiers*, a fact that provoked more mildly annoyed tweets after the edited 7:30 showing on BBC Four, although for once it wasn't the fault of Edward Scissorhands in the BBC Four editing suite, it was the original showing that was mercilessly hacked down to 75 seconds. Still, you get the general idea: pan-European game show used as metaphor for war or racism or some such. The incredibly short running time means we're spared any of the potentially upsetting clips from the US *Duck and Cover* films advising what to do in case of a nuclear attack, but we do get lots of scenes of Peter Gabriel pretending to whistle, which is just as unsettling.

MARTI WEBB - Take That Look Off Your Face (#3)

Oh no, not again. Third time around for the sole TOTP performance of this song, still with unnecessarily extreme close-ups and awful Americanised grammar. (Excuse me a moment, sorry, these corduroy pants are really chaffing.) The two follow-up singles from *Tell Me on a Sunday* flopped and it was five years before Marti had another hit; she reached number 5 with a cover of Michael Jackson's *Ben*, released at the behest of Esther Rantzen in memory of the UK's youngest liver transplant patient Ben Hardwick, a fact which becomes harder to swallow when you remember that the song *Ben* is actually about a boy and his pet rat. Webb also reached the top twenty the following year with *Always There*, a vocal version of the theme from the BBC's yuppie yacht-based soap *Howards' Way*. We'll deal with those in a few years if needs be.

GENESIS - Turn It On Again (#35)

Humorously the removal of Marti Webb from the 7.30 edit made it look like Peter Gabriel and his erstwhile colleagues were right next to each other. Wrighty makes a big deal out of the fact that this is Genesis's very first appearance on TOTP; this was the start of their transition from being an "albums band" to a more commercial act with one eye constantly on the singles chart, although they had their first hit single as far back as 1974 when *I Know What I Like (In Your Wardrobe)* had the honour of being danced to by Pan's People. Despite being in some completely unfathomable time signature *Turn It On Again* was poppy enough to reach the top ten and gave us our first sighting of a not-yet-totally-bald Phil Collins who would become ubiquitous over the course of the decade. And with Mike Rutherford, B.A. Robertson and Sad Café's Paul Young all on the show over the course of this month, it's like watching Mike & The Mechanics in instalments.

FERN KINNEY - Together We Are Beautiful (#1)

Top of the charts for one solitary week, Fern Kinney would become the decade's first genuine One Hit Wonder, using the *British Hit Singles* definition of the phrase which means she reached number 1 with her first hit and then had no more hits of any kind at all, ever. For her special week we've gone back to the tedious studio performance from three weeks ago in preference to last week's baffling Legs & Co interpretation. Once again the TOTP Orchestra have pushed in all the stops for a performance that sucks all the life out of what was a pretty dull song to start with. Never mind, this is the last time the song appears on TOTP until the Christmas Day edition and thanks to a certain tracksuit-clad cigar smoker we won't be seeing that on BBC Four. As if to make the number 1 sound more interesting, we play out with *Do That To Me One More Time* by the Captain & Tennille, although we don't see the Captain get his recorder out this week.

March 20

"The public gets what the public wants"

"Welcome, ye of good music taste, to another *Top of the Pops*." It's very easy to take the mickey out of Mike Read, so here's a space to write in your own comments: _____

_____ (You may wish to focus on his UKIP membership and accompanying calypso, his seemingly unquenchable desire to get his guitar out and give us a song at the slightest provocation, his attitude to Frankie Goes To Hollywood's *Relax* or his Cliff Richard impression.) Now that's out of the way, we can concentrate on a detailed critique of his TOTP presentation skills. The countup is to the sound of the Detroit Spinners' *Working My Way Back To You* and it seems like someone's been sticking a screwdriver into the Top Thirty Machine and wiggling it around again, because the captions this week are in blue on an appalling turquoise background. Still better than Legs & Co's routine to this song last week, mind.

THE BODYSNATCHERS - Let's Do Rock Steady (#31)

Another week, another massively overstaffed 2 Tone act, this time the all-female septet The Bodysnatchers who had only played their first gig some four months earlier. Like the Specials' *A Message To You Rudy* which had been a hit at the end of 1979, *Let's Do Rock Steady* was written and originally recorded by Dandy Livingstone, best known in the UK for his 1972 hit *Suzanne, Beware of the Devil*. Technically the Bodysnatchers' version is too fast to be rocksteady, but let's not split hairs; more important is that there is so little lyrical content to the song, singer Rhoda Dakar has time to introduce most of the band during it. The band's controversial approach to 2 Tone involves some of them wearing red as well as black and white, which is probably why they failed to reach the heights that the Specials and Madness did. That and the fact that they split up after two singles.

SQUEEZE - Another Nail in my Heart (#26)

"They can snatch my body any time," remarks Read, cryptically, raising the question of whether or not he has to be dead before they do so. Anyway, another outing for this performance from two weeks ago which we didn't see on BBC Four because of the show's host; Squeeze will only appear on the show once more this year, and it's on another DLT show so we won't see that either. For shame. This would climb as high as number 17, still not as high as it deserved on the back of two number 2 hits the previous year, but somehow the band seemed

unable to maintain even this level of success, making this their last top twenty single until the countrified *Labelled With Love* at the end of 1981. "They can squeeze me any time," Read fails to remark afterwards.

RUSH – Spirit of Radio (#16)

This was by far the biggest UK hit for Canadian rock legends Rush, eclipsing their only previous hit *Closer to the Heart* which reached number 36 two years earlier. But, hey, guess what, they're not here, so… enter Legs & Co! Their literal interpretation doesn't involve a massive radio, ghosts or enormous bottle of vodka, but a few vignettes – involving the girls waking up in bed to represent the phrase *"Begin the day"*, driving in a car to represent *"the open road"* and so on – are inset over footage of the troupe dancing aimlessly in one-armed, one-legged leotards, itself overlaid with terrifying flash close-ups of faces pulling various alarming expressions. This is then treated to a psychedelic fit-inducing blue and red treatment which plays merry hell with the digital encoding and makes the whole thing look like your aerial has fallen off the roof. Exactly what Rush had in mind when they wrote the song, I'm sure.

SAD CAFE – My Oh My (#43)

Having been forcibly restrained from saying "They can rush my legs any time," Read introduces Sad Café, last seen on here two months ago with their not-really-much-of-a-hit *Strange Little Girl*. This time around they have a severe case of loud-quiet-loud syndrome, *My Oh My* beginning in a restrained fashion which recalls their biggest hit *Every Day Hurts* from last year, before bursting into all-out rock for the chorus, although the mix seems very heavy on drums and light on everything else. Lead singer Paul "not that one" Young still has the look of Chris Morris about him, and by the second verse his voice is descending into some kind of half-arsed Mick Jagger impression; at one point Young even holds his guitar over his head, but fails to smash it on the ground in an act of rock 'n' roll rebellion. Still, Mike Read seems impressed – "They can sadden my café any…" Nah, that one doesn't work.

THE LAMBRETTAS – Poison Ivy (#27)

"Back in the 1950s the Coasters first did *Poison Ivy,* since then a lot of people have had a go at it," reckons *British Hit Singles* co-author Read, and he should know. Indeed, the Coasters took it to number 15 in 1959, the Paramounts reached number 35 with it in 1964, but the Lambrettas' version was the most successful in the UK, going on to reach number 7. Singer Jez Bird is still wearing that awful red suit from two weeks ago and looking somewhat uncomfortable with his new-found "pop star" status as a couple of lads at the front of the crowd

look on, arms folded and eyebrows furrowed, as if waiting to beat them up after the show. Such is the lonely life of a mod revivalist. "They can poison my ivy any time," Read doesn't say, because that would be a reference to a sexually transmitted disease and therefore unacceptable for a family show such as this.

BARBARA DICKSON - January February (#29)

Dunfermline! Unlikely rock capital of Scotland, at least at this point in time. Home to the Skids, Nazareth, the Rezillos / Revillos' Fay Fife (so named because she came "fae Fife") and Barbara Dickson. Still half a decade away from topping the charts in league with Elaine Paige on a song written by ABBA's Björn and Benny, here she enlists the writing and production help of the mighty Alan Tarney for what would become her biggest hit for four years, the fact that it's a song called *January February* in the charts in March on a show repeated in April notwithstanding. None of this explains why Read introduces her by climbing the spiral staircase which has suddenly been added to the set and sticking his microphone into the beak of a toy owl at the top. "She can Barbara my di..." No, that's just wrong.

SHAKIN' STEVENS - Hot Dog (#24)

Another repeat of an earlier performance, sadly it's Shaky's first appearance on the show from a month ago rather than his more interesting and innuendo-laden second. What's more alarming is that four weeks after his first appearance on the show - and despite his spirited attempt to strangle Dave Lee Travis last time he was on - the single has still only climbed as high as number 24. Shaky would release three more singles in 1980, only one of them reaching the top forty, before 1981's *This Ole House* rocketed to number 1 and kicked off a run of twenty-one consecutive top twenty hits. Must have been his adoption of the double denim look, because here he still looks like a '50s throwback. Following the clip Read unconvincingly describes Shaky as the "Eddie Cochran of the '80s," although as we all know he didn't die in a car crash two years later. "He can shake my..." No, no, no.

UB40 - Food for Thought (#40)

Before the next song, Mike Read inexplicably - and very briefly - interviews David Soul, who had his last hit single two years ago and, despite his best efforts, would never have another. As if to sweep away this mid '70s relic, David is brushed aside to make way for the very first appearance of UB40 who, along with Shaky and Madness, would dominate the charts and the show for the next decade or so. It's easy to forget just how vital and relevant UB40 were in these early days when many of their songs were overtly political; *Food for Thought*

was about African famine and was released as a double A-side with *King* which discussed the fate of Martin Luther King's followers after his death. A few years later they started having number 1 hits with novelty covers and that was the end of that. "They can..." No, there's nothing I can do with this one.

MARTHA & THE MUFFINS - Echo Beach (#15)

Not a new studio performance, not even a repeat of the performance from two weeks ago, but the video for *Echo Beach* for some reason. Not that there's much difference between the two: they're still miming to the song in a dimly lit studio, just with a larger stage and no disinterested audience. Martha (Johnson) is even wearing the same two tone jumpsuit she wore on the show. This is the last we'll see of the band on TOTP as *Echo Beach* remains their only top forty hit, although they scraped the top fifty in 1984 with *Black Stations, White Stations* by which time they had lost several members and shortened their name to M + M. "She can Martha my muffins any time." "Which one?" "Don't really mind."

B.A. ROBERTSON - Kool in the Kaftan (#45)

Rarely has an artist provoked such divided opinion on Twitter after appearing on the Pops as B.A. Robertson. The general rule of thumb seems to be that if you liked his records at the time, you still do; if you're just discovering him you probably think he's an utter arse. After two top ten hits with *Bang Bang* and *Knocked It Off* B.A. was discovering the law of diminishing returns, only reaching number 17 with this song about jacking it all in to become a hippy only thirteen years after the summer of love, but he still gives it his all and the mix of sitar and weird angular keyboards could almost be Blancmange if you're not listening very hard. Robertson still had another top ten hit in him later in the year, but after a few flops and a brief period with Mike & The Mechanics, he went on to become Rob Brydon in the late 1990s. (Note: check this before publishing.) "He can kool my kaftan any time, I expect."

THE JAM - Going Underground (#1)

"Straight in at number 1 it's The Jam and *Going Underground*." Let's just let that sink in for a minute. From the mid '90s onwards, as record labels concentrated on getting as many people as possible to buy a record in its week of release, it became unusual for anything to climb to number 1 instead of débuting at the top, but in 1980 *Going Underground* was only the ninth single ever to enter the chart at the highest position. It had happened only three times in the 1960s and four in the 1970s; the last record to achieve this feat was Slade's *Merry Xmas Everybody* back in 1973. The Jam would go on to repeat the trick another twice before their demise at the end of 1982. Strangely Mike Read

seems to be of the opinion that Lonnie Donegan also achieved this feat; he had three chart toppers but never entered the chart at number 1. Anyway, after all that, The Jam aren't even here so we just get the video and Read doesn't get to say "They can jam my underground any time," which is for the best. We play out with The Vapors' *Turning Japanese* and it's a good job Read didn't listen to closely to the lyrics of that.

March 27

"No more lonely nights for me"

"Hi everybody, you're listening to the Vapors and you're going to see the chart." Think of the TOTP presentation style of John Peel and then think of the exact opposite. That's Peter Powell, your host this week, a man whose enthusiasm for the music on the show is so great it makes him look like some kind of religious zealot. Hopefully the repeat runs on BBC Four will continue for at least another couple of years so we can witness Peel's laconic introductions to the likes of Dollar and Wham! first hand. In the meantime here's the top thirty countup, to the strains of *Turning Japanese* again, the song we played out with last week which suggests that it's been playing on constant repeat in the empty TOTP studio for the past week. This makes it the song's fourth time on the show although we've only seen the band twice and we won't see them again this year, as their excellent follow-up single *News at Ten* came out when the show was mysteriously off air in the summer.

LIQUID GOLD - Dance Yourself Dizzy (#4)

This is also the last time we'll see this bunch doing their biggest hit – unless BBC Four sneak out the Savile-hosted Christmas Day edition at 3am on Boxing Day when everyone's too drunk to complain – although be warned they will return with future singles *Substitute* and *The Night, the Wine and the Roses*. This performance is notable for perhaps the last ever in-vision appearance of the TOTP Orchestra, gamely miming to a track they don't appear on, and the full-on fancy dress of the guitarist. Has he come as (a) Charlie Chaplin, (b) Ron Mael or (c) Mickey Pearce from *Only Fools and Horses*? Send your answer to us at the usual address, not forgetting to include your £50 entry fee. The drummer appears to be doing the show while running the London Marathon and so hasn't had time to paint a keyboard on any part of his anatomy, so they have to be content with hitting the bassist on the head instead. Comedy gold, I'm sure.

GENESIS - Turn It On Again (#23)

"Hey, Beefheart? It's Zappa here. Can you work out what time signature *Turn It On Again* is in? No, me neither." A repeat of the band's début TOTP performance from two weeks ago, Phil Collins still in his hideous Hawaiian shirt which presumably sat in his wardrobe for the next eight years until he needed it for filming *Buster*. After a couple of weeks in the lower reaches of the chart this rocketed up to number 8 next week, fuelled by thousands of baffled music students buying the record in order to try and count the number of beats per bar. The song's parent LP *Duke* was also about to give Genesis their first number

one on the album chart, but it would be well over a year until the band's next top forty hit, the title track from their 1981 album *Abacab*. Still, doesn't Phil have lovely hair? For the time being, anyway.

BROTHERS JOHNSON - Stomp (#11)

Second time on the show for this track too, but again the camera-shy Johnson siblings haven't turned up, so... enter Legs & Co! Luckily we're too early for the literal choreography to involve lots of people hitting metal bins with sticks and pretending it's some kind of street theatre, so stomping is renounced in favour of the usual aimless hoofing. The ladies are decked out in black dresses, shoes and hats but white ankle socks, the cut of the dresses giving the routine the air of some kind of flamenco funeral, which of course is what *Stomp* is really about. This was enough to push the record to number 6 next week, but that was its peak position so it won't be on again and the Johnsons have missed their chance to appear on the show. Look upon the Gibson Brothers, ye Johnsons, and despair.

DR HOOK - Sexy Eyes (#38)

There's a clunking great freeze frame at the end of the Legs & Co performance where presumably it's meant to dissolve into the next act via some clever special effect that never comes. Instead we're thrown straight in to Dr Hook's new one and, in all fairness, this performance is no different from their last, or the one before that. Ray Sawyer - the one with the eyepatch - flaps idly at some tom toms while Dennis Locorriere - the one who's actually the singer - simpers through a tepid ditty about being all lonely in a club until he spots a girl with sexy eyes which is enough to form the basis of a meaningful relationship. Presumably in Sawyer's case one sexy eye would have been sufficient. This would be Dr Hook's last major hit in the UK and it's the last time we'll see them perform on the show, although there's a Limbs & Co interpretation of this to come in a couple of weeks.

JUDAS PRIEST - Living After Midnight (#25)

"A much played track," comments an uncomfortable looking Powell sitting cross-legged on the floor, although he quickly gets to his feet for the next act, revealing that he's broken the unwritten dress code that has existed since 1964 by wearing leather trousers! I say leather, in fact they have the look of cheap plastic about them compared to Judas Priest who look like they've cleared out all the leatherwear shops in the area for this performance. Lead singer Rob Halford cuts a faintly ludicrous figure in tight black vest top and trousers with a blond pudding bowl haircut that brings to mind the image of Graham Chapman wrestling himself in a Monty Python sketch. Still, this would become the first of

two consecutive number 12 hits for the band this year (although *Breaking the Law* is clearly better) and whether Halford looks more ridiculous then or now is a moot point.

SIOUXSIE & THE BANSHEES - Happy House (#21)

Another repeat performance with the erstwhile Susan Ballion in a not-quite-punk, not-quite-goth quandary which she attempts to resolve by randomly throwing handfuls of confetti into the air to see where they land. *Happy House* was on the verge of giving the Banshees their second top twenty hit and was the opening track on their third LP *Kaleidoscope* which reached number 5 and remains their most successful album. Not bad for a band whose first gig consisted entirely of a twenty minute version of *The Lord's Prayer*. This was the band's first single with long-term drummer Peter "Budgie" Clarke (a nickname bestowed upon him by no less a personage than Holly Johnson) who went on to join Siouxsie in side project The Creatures and eventually married her. This performance gets yet another outing in a couple of weeks' time, because they were clearly still punk enough not to be arsed coming back to perform the song again.

SECRET AFFAIR - My World (#27)

Peter Powell seems inordinately pleased to introduce Secret Affair again, urging us to go and see them on their "mini tour" next week and even breaking into spontaneous shadow boxing as the camera pans off him and over to the stage. After performing in almost total darkness last time, the scaffolding has been removed and the band emerge blinking into the daylight for their second run-through of *My World*. This may not actually have been a good move, as despite the Fred Perry shirts and and suedehead haircuts of the band in the background, singer Ian Page (born Ian Page, as his Wikipedia entry helpfully points out) oozes what can only be described as bank manager chic in his sensible suit and daring-but-not-actually-dangerous red tie. Meanwhile their record label Arista was changing hands and the single, great though it was, got rather lost in the transition process, only reaching number 16 despite having the potential to go much higher. The band appeared only once more on TOTP and that was on a Dave Lee Travis edition so it's goodbye BBC Four from them.

THE DOOLEYS - Love Patrol (#29)

Another outing for this performance from the new Lycra-clad, sexed-up Dooleys, which must have been as shocking at the time as when wholesome girl-next-door Kylie Minogue morphed into SexKylie in the '90s. Er, or not. Anyway, after our previous musings on whether there really was a song called "*You've Got Me* by

The Dooleys", it has been noted that they released a 1977 B-side *Only You Can Get Me By* which credits the whole band as writers, giving rise to the label credit "Only You Can Get Me By (The Dooleys)". Despite their proactive approach to the new decade, *Love Patrol* was the group's last top forty hit and this was their last appearance on TOTP. A spirited attempt to relaunch the band five years later with a song called *New Beginning* ended in failure, but the song which was later used to relaunch Bucks Fizz's career instead so it wasn't a complete disaster.

JOHN FOXX - No One Driving (#32)

Kudos to everyone who simultaneously tweeted "Underpants!" as this started. Despite lacking the immediate hook of *Underpass*, *No One Driving* became Foxx's second top forty hit, somewhat justifying his decision to leave Ultravox! the previous year, although the perfect cheekbones revealed in his many close-up shots suggest that his real reason for leaving was to form a supergroup with David Sylvian from Japan. Handsome Squidward is a good name for a band if you ever get that going, guys. Over the next few months Foxx and his former bandmates, who had dropped the exclamation mark but recruited Midge Ure, would trade minor hits before the enormous success of Ultravox's *Vienna* blew Foxx out of the water. Foxx scored his biggest hit in 2010 as part of Cage Against the Machine, a protest group who attempted to scupper the X Factor winner's inevitable Christmas number 1 hit by releasing a version of John Cage's *4'33"*.

DETROIT SPINNERS - Working My Way Back To You / Forgive Me Girl (#5)

The Spinners still aren't in the studio, this is a clip taken from the US TV show *Don Kirshner's Rock Concert* - a fact which would have been less obvious if they had started the clip five seconds later when the "Don Kirshner's Rock Concert" sign was out of shot - but at least we don't have to put up with Limbs & Co doing their "Ladies At Work" routine again. There's no room for complacency though, as the *Flick Colby Big Book of Literal Interpretation* is largely vindicated by the Spinners' dance routine which, incredibly, also involves the group miming digging up a road to signify "working", as if any of them has ever done an honest day's work in his life. *Working My Way Back To You* was first recorded by the Four Seasons whose version holds the (presumably unique) distinction of having spent three consecutive weeks at number 50 (the bottom rung of the UK chart at the time) without ever getting any higher.

THE JAM - Going Underground (#1)

Having been unprepared for a TOTP appearance last week when the single

unexpectedly barged its way into the chart at number 1, The Jam have finally made it to the studio. Famously Paul Weller, fearing that the band had sold out by releasing such a popular single, appeared on the show wearing a Heinz Tomato Soup apron in reference to The Who's 1967 album *The Who Sell Out*. Civilisation was saved, however, as Weller was persuaded to wear the apron backwards by BBC bosses who feared censure for allowing such flagrant product placement, because nobody could work out what Znieh Otamot Puos could possibly mean. Still, despite the number of repeats tonight Powell seems to have genuinely enjoyed himself and we play out with *Don't Push It, Don't Force It* by Leon Haywood, another future top twenty inconvenience for those posturing that disco is dead.

April 3

"My bombers, my Dexys, my high"

Amazing, isn't it? We're well into 1980 and Radio 1's coolest daytime presenter Kid Jensen is still using phrases like "This week's hit sound countdown" while Judas Priest's *Living After Midnight* blares out behind him. We're in a bit of an odd phase of TOTP actually, as we've clearly outgrown the light entertainment hell witnessed in the 1976 episodes from the early BBC Four reruns, but the balloons-and-streamers party vibe of the Michael Hurll era is still some time away. Still, the show's current dimly-lit, grim industrial feel only lasts another couple of months before it's replaced with something even weirder, so let's get cracking. This episode had been sitting quietly on A Well Known Video Streaming Website for some time now without the copyright police noticing, but it's nice to see it in context as part of the BBC Four run. It's also nice to see a proper broadcast quality version where the top 30 machine is set to a fairly soothing yellow on mid-blue rather than the blinding cyan rendered up from the original off-air recording. Was everyone colour blind in those days?

MADNESS - Night Boat to Cairo (#14)

Can it really be three months since we saw Madness opening the first show of 1980 with *My Girl*? Well, yes and no, because (a) the repeats are somehow now almost a month behind and (b) that performance was shown three times, the Nutty Boys not having been asked back because saxophonist Lee Thompson wasn't taking it seriously. However, thanks to the band's burgeoning success TOTP had no option but to get them back to perform their next single. This time Suggs & Co have decided to play it safe and ensure that *nobody* in the band is taking it seriously, having apparently raided a fancy dress shop on the way to the studio. Various Arabian headdresses and fezes are in evidence, while Suggs himself opts for an oversized pith helmet which combines with the poor lighting to ensure that we don't see his face at any point during the song. *Night Boat to Cairo* was the fourth single release from the *One Step Beyond* album, a shameful state of affairs at the time, so for added value it was packaged with three new songs as the *Work, Rest & Play* EP to become the band's third top ten hit.

BARBARA DICKSON - January February (#12)

"There's plenty of variety in the chart and we're about to reflect all of that on this week's show," smirks the Kid. Despite being cursed with the impossibly curly hair so prevalent in Scotland in the late '70s and early '80s (see also Alan Brazil, Dan McCafferty, Ian Krankie), Barbara overcame her misfortune to

become a respected musician, although she was more often seen on *The Two Ronnies* than TOTP, making it odd to hear her introduced by the Likeable Canadian rather than Ronnie Corbett. This was Dickson's third and final solo top forty hit although she would return to the chart in no uncertain terms in 1985 when her duet with Elaine Paige *I Know Him So Well* reached number 1. We'll have to hang around a long time and cross our fingers really hard if we're to see those editions of TOTP on BBC Four though.

DEXYS MIDNIGHT RUNNERS - Geno (#37)

Dexys certainly benefited from the patronage of TOTP; here they are back for a second performance despite still not having cracked the top 36. A fresh-faced Kevin Rowland, increasingly confident in his docker chic despite being just about the only member of the collective not wearing a wooly hat, earnestly mimes his way through the song giving no indication that he would completely ditch this musical direction within two years, far less appear in a "man's dress" on the sleeve of an album of easy listening covers within two decades. Of course the band would experience huge success in the next few years and this Geno Washington eulogy was soon to eclipse their first single *Dance Stance*, despite its catchy horn riff owing more to Zoot Money's Big Roll Band than Geno himself, but due to one thing and another we won't see this again on BBC Four for about a month until – spoiler alert – it's at number 1.

PRETENDERS - Talk of the Town (#26)

"The latest and arguably the best from the Pretenders," Kid reckons, and given that it's not much different from their three previous singles you probably wouldn't bother arguing with him. This is one of those strange promo videos that have been set up to look like the artist is actually performing on a TV show, not in an ironic way like The Strokes' *Last Nite* but more like the video for Elton John's *Part Time Love* which recently fooled a dim researcher for ITV's *Pop Gold* into believing it was a clip from *Get It Together* despite the exact same clip having been shown on TOTP about eighteen months earlier. Anyway, this video is pretty unremarkable with lots of strip lighting and shots of the band looking moody, enlivened only by some shots of Chrissie Hynde from a bizarrely low angle which make it look like the cameraman has fallen over and is trying to pretend he meant it. And isn't she wearing a lot of leather for someone who once suggested firebombing McDonalds?

LEON HAYWOOD - Don't Push It, Don't Force It (#19)

A one hit wonder in the UK, Leon Haywood had several hits in the US, making him the exact opposite of Dexys Midnight Runners. In the States Haywood is

best known for his 1975 hit *I Want'a Do Something Freaky To You*, which presumably means something sexually explicit rather than just something weird and unsettling like dressing up in a Spiderman costume and repeatedly rubbing a rasher of bacon on a sponge. Not having expected in a million years that he would ever score a UK hit, naturally Leon can't be here tonight, so... enter Legs & Co! It seems the *Flick Colby Big Book of Literal Choreography* has drawn a blank this week, so the girls have just been shoved into indecently short micro-dresses and told to get on with it. Forced to rely on their natural instincts, they resort to their default squats, high kicks and pelvic gyrations in order to show off their Bill Grundies in as many different ways as possible. Something for the dads, there.

UB40 - Food for Thought (#10)

One very notable aspect of pop music in 1980 is the way that, despite the fears of the Musicians' Union, computers and synthesizers have yet to replace musicians in any significant way. Already tonight we've had Madness (seven members), Dexys (eight members) and now UB40 (another eight members) cancelling out the theory that less is more. Of course, once it became apparent that splitting royalties between anywhere up to a dozen band members was less lucrative than splitting them between two people and a Fairlight, this would change. For now though, the idea of the band as a gang rather than one singer and one person in charge of all the instruments through a keyboard was very much in vogue. This was the first of seventeen top ten hits for UB40, a band discovered by the aforementioned Chrissie Hynde who would go on to sing on two of those hits.

THE SELECTER - Missing Words (#34)

As if to prove my previous point, here's another band with six... seven... nine... hang on... damn it, they won't stop jumping up and down long enough for me to count them. Anyway, once Madness and The Beat had jumped ship for slightly bigger labels, The Selecter became 2 Tone's second biggest act (after The Specials, obviously). Strangely though, despite the obvious quality of their material, they were suffering from the law of diminishing returns. Their first release, the eponymous *The Selecter* had reached number 6 as the B-side of 2 Tone's first release *Gangsters* by The Special AKA. Since then they had scored one top ten hit (*On My Radio*) and one top twenty hit (*Three Minute Hero*); *Missing Words* would peak at number 23 and next single *The Whisper* reached number 36, and then they were gone. The band split in 1982 but Pauline Black now leads a reformed version of The Selecter, while Neol Davies who wrote the original track *The Selecter* heads up a completely different version of the band. This is probably why vocal and synth duos became so popular.

B.A. ROBERTSON - Kool in the Kaftan (#25)

I have to admit I'm still struggling to comprehend just why B.A. Robertson provokes so much hatred on Twitter every time he's on the show. It can't all be because he wrote Mike & The Mechanics' ghastly *The Living Years*, although that's a pretty good reason. Is it his slightly pretentious use of initials rather than a first name (it's Brian, incidentally; the initials are to avoid confusion with Brian Robertson of Thin Lizzy), or is it because his face looks like a foot? Or do we just expect him to be more like B.A. Baracus? Anyway, this is a repeat of his performance from two weeks back and if you hated this you'll be glad to know that its only other airing is on an edition hosted by J*mmy S*vile, which has naturally been locked in a vault three miles below the surface of the Earth for all eternity. Not only that, but Robertson's next single and third top ten hit *To Be Or Not To Be* fell victim to The Event which blacked out TOTP for two months in the early part of the summer. Not that this means you're spared any exposure to Robertson during July, oh no, far from it.

THE LAMBRETTAS - Poison Ivy (#7)

You could be forgiven for thinking this was a repeat, with Jez Bird still resplendent in his bright red suit, but in fact it's a third different performance for this song. The giveaway is the fact that the drummer and guitarist have taken pity on Jez and turned up wearing green and blue suits respectively, making the band look like some kind of mod Showaddywaddy. Shomoddymoddy. Number 7 was peak position for *Poison Ivy* (still nobody has cottoned on that it's about a sexually transmitted disease, so thanks for keeping the secret everyone) but the band did manage one more appearance on the show, sneaking on with their next single *Da-a-a-ance* in late May just before The Event.

PRIMA DONNA - Love Enough for Two

Oh blimey, is it that time of year again? Yes, this was the UK's entry in the 1980 Eurovision Song Contest, written by Stephanie de Sykes and Stuart Slater who had also written our amazing 1978 entry *Bad Old Days* by Co-Co. Sadly, unlike that wild card with its unexpected minor key chorus, this was a predictable mid-'70s middle of the road singalong with a distinct nod towards the theme from TV's *On The Move*. Annoyingly it did much better in the contest than Co-Co, finishing third behind the almighty Johnny Logan's *What's Another Year*. We'll see more of J-Lo next month of course, but despite the combined might of Slater and de Sykes plus Kate Robbins, Sally Ann Triplett (later one half of Bardo) and Jay Aston from Bucks Fizz's brother Lance, chartwise *Love Enough for Two* became the UK's least successful Eurovision entry to date, stalling at number 48. Clearly some kind of detachable skirt arrangement is required for next year.

THE JAM – Going Underground (#1)

Still wearing his apron backwards for legal reasons (other brands of tomato soup are available), this is the third and final week at number 1 for *Going Underground* and still no recognition for its alleged double A-side *The Dreams of Children*. Of course The Jam made lots more appearances on the show before splitting at the end of 1982, at which point all of their singles were reissued and most of them charted again, *Going Underground* becoming the most successful by reaching number 21 second time around. Saying goodnight (but not good love), Kid Jensen is kind enough to alert us to a Dr Hook special on BBC 2 next Monday as the good Doctor (he's not really a doctor, you know) plays us out with *Sexy Eyes*. What the Kid fails to mention is that the special guest on that show was Kate Bush, an unlikely bedfellow for the maraca-shaking cyclops and his beardy mate, but there you go. Simon Bates is here next week, so look out.

April 10

"Not to lose now, but to win"

"Thank you sir, and welcome to *Top of the Pops!*" Yep, less than a second into this week's episode and Bates has done it again, thanking the continuity announcer which would have worked very well if the BBC Four announcer wasn't so blatantly female. Maybe there were no female continuity announcers in 1980. Simes, a man who has always looked and sounded middle-aged even though he was only 33 here, introduces the top thirty countup to the strains of Liquid Gold's *Dance Yourself Dizzy* – yes, again. After eighteen years in the chart the song has now climbed as high as number 2, but at least we're spared the sight of the exhibitionist drummer in just his pants. The top 30 machine has been reset to yellow on black, which Bates has approved as being sufficiently sensible. Please be warned, however, than Simes is sticking two fingers up to the establishment by not wearing a tie. Restrain yourselves, ladies.

THE UNDERTONES - My Perfect Cousin (#43)

All the way from Norn Iron, the Undertones had first appeared on TOTP back in 1978 with *Teenage Kicks*, a song which apparently moved John Peel to tears when he first heard it and became his all-time favourite record, the opening line even being engraved on his gravestone following his death in 2004. This, on the other hand, is a rather tedious bit of nerd-bashing, like *Teenage Kicks* with all the life-affirming joy sucked out of it. Feargal Sharkey vents his frustrations about his cousin Kevin who, it seems, is much, much cleverer than Feargal, has four degrees (unusual at such a young age) and has even learned to play music, anathema to Feargal and his mates. Quite how Sharkey can stand there and pretend to be punk while wearing that awful jumper is an issue which the song does not address. Still, the Human League, eh? Bunch of charlatans, that's not proper music, they'll never be as big as the Undertones, etc.

DAVID ESSEX - Silver Dream Machine (#19)

From the soundtrack of *Silver Dream Racer*, a film starring Essex as a motorbike racer, comes this song and a video starring Essex as a disembodied head which floats gormlessly into shot superimposed over footage of bikes racing around Silverstone. The footage, of course, comes from the film which also stars the unlikely combination of Beau Bridges and Harry H. Corbett. Essex's chart success had been patchy in the previous few years with only one top ten hit to his name since his last no.1 *Hold Me Close* in 1975, but he could still knock out the occasional hit to remind everyone he was still around; in fact Simes reckons the single is going to be number one. He is wrong. *Silver Dream Machine* did

make it into the top ten though, whereas *Silver Dream Racer* was a commercial and critical disaster and convinced the Rank Organisation, once the biggest film company in the UK, to stop making films for good.

DR HOOK - Sexy Eyes (#4)

Simes seems unprepared for the next link; we find him sitting cross-legged in a plastic chair, script visibly resting on his lap, unable to comprehend that *Silver Dream Racer* is the name of the film, not the song. Moving on, you'll be distraught / delighted / massively unmoved (delete as appropriate) to learn that this is the last airing for a Dr Hook song on TOTP and would you believe it, they're not even there! What to do? Never mind, because we've got "*Sexy Eyes* and a few sexy legs... and Co!" Careful now, Bates. Yes, enter Limbs & Co to illustrate the song in no particular way. It seems incredible that Flick didn't seize her chance to dress the girls up as giant eyeballs on legs, or even as letter "I"s in a kind of nightmarish *Sesame Street* scenario. Instead, the ladies gyrate aimlessly in dresses even shorter than the ones they wore last week, and that's eye-wateringly short. Farewell, Doctor, we hardly knew ye.

SAXON - Wheels of Steel (#37)

"The first of two heavy metal bands on *Top of the Pops*," announces Simes with little enthusiasm. Yes, the New Wave Of British Heavy Metal (or "NWOBHM" - I'm not making this up, you know) was approaching its peak and this was the first TOTP appearance for one of the movement's leading acts. Saxon had formed back in 1976 under the splendidly radio-unfriendly name "Son of a Bitch", unexpectedly signed to the mainly disco label Carerre (also home to Dollar and Sheila & B. Devotion) and went on to score eighteen hit singles, although only five of those made the top 40. Here the band has adopted the time-honoured "drummer at the front" formation, with vocalist "Biff" Byford obscured from view in a cloud of smoke and bad lighting. As a unit they look like the archetypal heavy metal band, an image cemented by the fact that Harry Shearer joined the band on tour in 1983 while researching *This is Spinal Tap* - Tap's bassist Derek Smalls is, to all intents and purposes, Saxon bass player Steve Dawson.

SKY - Toccata (#46)

"This is what you get when five top musicians take hold of Johann Sebastian Bach, call themselves Sky and rock it!" Oh, wait, did he mean "rock it" or "rocket"? Simes, you slippery eel. While the Undertones were busy having a sly dig at the Human League, the exact thing punk was supposed to have swept away has snuck in the back door. Yes, ladies and gentlemen, it's the prog rock

revival. Featuring famed classical guitarist John Williams, bassist Herbie *"Walk on the Wild Side"* Flowers and drummer Bubbles from *Trailer Park Boys* among their number, Sky took Bach's *Toccata and Fugue in D minor, BWV 565* and rocked it up very slightly for this unlikely hit. Like the Shadows before them, the guitarists seem unable to contain their "How the hell did this happen?" grins as they pretend to play the piece sitting on what appear to be dining room chairs. This eventually went as high as number 5, while virtuosa violinist and failed skier Vanessa-Mae took her version into the top twenty fifteen years later.

JUDAS PRIEST - Living After Midnight (#12)

"That piece of music is 300 years old, the band is younger." Not much, Simes. Time for the déja vu section now with the first of three repeat performances in a row, and while Spinal Tap's Derek Smalls was factually based on Saxon's bassist, it's clear that his look owes a lot more to this lot. While the leather and studs approach became the defining image of NWOBHM, Rob Halford's pudding bowl haircut left Twitter debating whether he looked more like Graham Chapman or Tim Brooke-Taylor. Oddly there are also two people at the front of the crowd in flat caps, as if celebrating the appointment of Brian Johnson as AC/DC's new singer, which would be very impressive as it hadn't happened yet. Anyway, such was the Priest's accuracy this was the first of two consecutive number 12 hits for the band, and if we move on now we'll have managed not to mention the court case.

SIOUXSIE & THE BANSHEES - Happy House (#17)

Introduced by Simes surrounded by five young ladies, with whom he attempts and fails to have a pre-arranged spontaneous joke - he even tells one of them "Give us a smile" and sticks the microphone up to her face so we can hear it - it's a third outing for this sole performance of *Happy House*. The Banshees appeared on the show eleven times in total, from their early punk days through their '80s goth period right up to their early '90s indie-dance years, *Kiss Them For Me* being their last appearance in 1991. Siouxsie split the band in 1996, partly in protest at the Sex Pistols' reunion the same year. But we're getting ahead of ourselves! This was the band's only performance on the show this year, their next single *Christine* reached number 22 in the summer but fell victim to The Event.

SAD CAFE - My Oh My (#24)

At first glance this looks like a repeat of Sad Café's performance from a couple of weeks back, but on closer inspection it turns out Paul Young had a selection of horrid magenta jackets and black shirts from which to choose for his many TOTP

appearances. Still, it provides us with this week's Half Man Half Biscuit reference, the band having been namechecked in the Biscuits' paean to Radio 2's Charles Nove, *Nove on the Sly*. Bates thinks *My Oh My* is "beautiful", which it clearly isn't if you listen beyond the first minute when it erupts into a bluesy Rolling Stones "tribute", the likes of which Primal Scream have been trading on for the last twenty-odd years. It's still on its way up the chart though, which means in two weeks time we'll have to fill this entry with lots of amusing observations about Paul Young looking like Chris Morris. Again.

BODYSNATCHERS - Let's Do Rock Steady (#22)

"Here's a bunch of ladies I've been playing on the wireless a lot!" Not through your own choice though, Simes. Anyway, this is the Bodysnatchers' second and final performance on the show, another run through of their deceptively slight 2 Tone anthem. The writing was already on the wall for the band called "the female Madness" by absolutely no-one; they've stuck their drummer at the front but she's already lacking the ability or inclination to carry on miming to the song, giving up halfway through with her head in her hands and deciding that conducting the rest of the band with her drumstick is a better option. After one further single the Bodysnatchers split, singer Rhoda Dakar going on to join The Special AKA while most of the others formed the Belle Stars, ditching the ska stylings and following Madness to Stiff Records for a more successful pop career. Coincidentally the Belle Stars' first TOTP appearance in July 1982 was on an edition hosted by the one and only... Simon Bates!

BUGGLES - Clean, Clean (#45)

Surprisingly the next link wasn't edited out of the 7.30 showing, despite clearly being unsuitable for a pre-watershed slot. Not in the way you're thinking, madam, but because it shows Simes "auditioning for a late night horror movie on BBC2" as he has it. This involves him being lit from below, making him look even more terrifying than he usually does, for no obvious reason. He's linking us into the third hit for the Buggles, a source of total amazement for those who weren't even aware that they'd had a second hit. Like *Video Killed the Radio Star*, *Clean, Clean* had previously been released by Bruce Woolley, a former member of the Buggles who co-wrote the songs but left the band before they secured a recording contract. This version was the Buggles' final top forty hit and it's situation normal for their performance: Trevor Horn still looks like he's just come from a wedding and Geoff Downes is still wearing washing-up gloves. After *Clean, Clean* snuck into the top forty and next single *Elstree* topped out at number 55, Horn and Downes were assimilated into prog rock behemoths Yes, before Horn escaped to become a production god and form ZTT Records.

DETROIT SPINNERS - Working My Way Back To You / Forgive Me Girl (#1)

Introduced by Simes being wrong again, with some spiel about remembering "the first time that this song came out, by the Four Tops." Oh dear, Simes, it's good but it's not right. Of course it was the Four Seasons who originally recorded *Working My Way Back To You*, but hey, the Four Seasons, the Four Tops, the Four Bucketeers, they're all the same, aren't they? This is the same clip from *Don Kirshner's Rock Concert* as shown two weeks ago, except they've taken my advice and cut out the sign with the show's name on it at the start of the clip. Simes reckons next week there'll be a new number one, "tune in and see!" Alas, it's not that simple, as you'll find out. We play out with *My World* by Secret Affair, who it turns out are still together and still touring. Jimmy Savile or Steve Wright presenting next week, depending on who you find less offensive.

April 17

"The rude boys are dancing to some heavy heavy ska"

Well, now then. We've been doing pretty well so far this year with only a DLT episode omitted from the BBC Four run, but now here comes Jimmy Savile to ruin everything, so if you don't want to read about this episode, look away now. Regardless of whatever unspeakable crimes he may or may not have committed, you have to wonder just what Savile was still doing hosting TOTP at this stage of his career; he only had one Radio 1 show a week and that was exclusively for old records. His opening cry of "Hello ladies and gentlemen, welcome to *Top of the Pops* and here we go with the charts and the music of Leon Haywood, yes sirree!" is typical of his insincere light entertainment approach, but anyway, let's see what the Liberace of TOTP has in store for us tonight.

PHILIP LYNOTT - Dear Miss Lonely Hearts (#37)

After a decade as lead singer of Thin Lizzy, Phil Lynott struck out on his own with this first single from his début solo album *Solo in Soho*. For once the unnecessarily formal expansion of Lynott's first name is not a Savile affectation but the actual credit on the record, Phil obviously experiencing some kind of Deborah Harry-esque need to be taken seriously all of a sudden. There's not much about it that marks it out as being different to a Thin Lizzy record, especially on the back of their last hit *Sarah*, but *Solo in Soho* is hugely important in the timeline of TOTP for its inclusion of a little thing known as *Yellow Pearl*. Meanwhile record company politics dictate that Thin Lizzy will be back in the charts with new material in little over a month's time, before Phil has even had a chance to issue a second single from his solo set.

BARBARA DICKSON - January February (#11)

"Yes indeed, right, now then, how about, number 11 in the charts, *January, February*, Miss Barbara Dickson, and how are all you ladies and gentlemen at home, very well we hope, thank you." Dear God, it really is a baffling stream of consciousness that comes out of Savile's mouth, isn't it? That startlingly random collection of short phrases introduces a third showing of this Barbara Dickson performance, and with her impeccable Saturday night light entertainment credentials as musical turn on numerous episodes of *The Two Ronnies* you get the impression that Savile has at least heard of her, which is more than you can say for some of the acts on tonight's show. Written and produced by the great Alan Tarney, this track provides us with a link back to the very first episode in this repeat run back in 2011 when he appeared as one half of Tarney & Spencer

performing the clumsily titled *I'm Your Man Rock 'n' Roll*. Tarney went on to produce loads of pop classics including the famous version of a-ha's *Take On Me* (not the original version produced by New Musik's Tony Mansfield) and Saint Etienne's *You're In A Bad Way*.

GIRL - Hollywood Tease (#50)

...and there's a bin just over there where you can deposit all your snide comments about Savile introducing a band called "Girl", right next to the one that's still full of all your snide comments about the band called "Child" a couple of years back. Really, your efforts are unnecessary because Girl are perfectly capable of generating their own snide comments. Counting future Def Leppard guitarist Phil Collen amongst their number, Girl are often described as "glam metal" but in truth there's very little glam about them, except that they discovered hair styling products ahead of most of the NWOBHM bands. With toe-curling lyrics like *"Hey I'm sarcastic, I'll treat you like a spastic,"* Hollywood *Tease* is a graceless precursor of Spinal Tap's *Tonight I'm Gonna Rock You Tonight* which plummeted down the chart after this TOTP appearance. Singer Phil Lewis later joined L.A. Guns who also recorded a version of *Hollywood Tease* with even lesser success.

BLONDIE - Call Me (#2)

As Savile forces his way in between two young ladies, who look suitably unimpressed, we come to the mighty Blondie who have already scored a number 1 hit this year and are within touching distance of a second. Not wanting to come within touching distance of Jimmy Savile, however, Blondie are not available tonight and nobody at the record company has thought it necessary to put together a video - the one you may be vaguely familiar with was created much later to pad out a VHS compilation. Never mind... enter Legs & Co! On a set seemingly inspired by Norman Wilkinson's dazzle camouflage of ships in World War I, or perhaps someone just thought it looked a bit like the cover of *Parallel Lines*, the girls skip, bounce and perform some kind of prototype nutty dance in gangster suits and hats. *Call Me* comes from the soundtrack of *American Gigolo* which, to Flick Colby's disappointment, turns out not to be a gangster movie. Oh well.

B.A. ROBERTSON - Kool in the Kaftan (#19)

If tonight's episode had been shown on BBC Four, the Twitter feed would still have singled out B.A. Robertson as the most objectionable person on the show, now then now then, goodness gracious, how's about that then. This is the third showing of Robertson's performance and it's not getting any better, his sarcastic

attack on hippies and flower power about as relevant in 1980 as a song making fun of Blazin' Squad would be in 2015. Mention should be made of Robertson's backing band though, who are so heavily reliant on facial hair and wackily playing keyboards with stiff arms like a robot, they've been stuck in a far corner of the studio while B.A. does his thing on a podium twenty feet away. It's possible the guitarist is under some kind of restraining order. We will see Robertson again soon but not as a performer for a year or so, shortly after which somebody gave him his own TV show and got him to interview Annabella Lwin from Bow Wow Wow. That went well.

THE SELECTER - Missing Words (#26)

Back to Sir Jim'll, his cream suit, black tie and white hair causing him to almost (but, sadly, not quite) disappear on the Limbs & Co dazzle stage. It's another repeat for the only 2 Tone act on the show tonight; Pauline Black and the band try and put a brave face on things but it's always hard to appear dignified when your stage has been replaced by a trampoline. This was the band's last top thirty hit unless you count the appearance of *On My Radio* on 1993's *2 Tone EP* which also collected tracks by the Specials, Madness and The Beat. The Selecter have one more TOTP appearance to come, turning up in August on a show co-hosted by the one and only Mr B.A. Robertson. But I'm telling you the plot! Better get Jimmy back on, his calm, measured demeanour always brings an air of sensibility to the proceedings.

THE RUTS - Staring at the Rude Boys (#51)

Oh dear, Savile's lost it. Having no understanding of the song or its title, he pulls the most alarming face to illustrate "staring". In fact the song is not about a headmaster glowering at some unruly pupils but describes a group of right wing skinheads attending a 2 Tone gig in order to pick a fight with the ska fans (or "rude boys" in Jamaican street slang). Although singer Malcolm Owen cuts a rather menacing figure with his suedehead haircut, polo shirt and Dr Martens boots, the Ruts were vociferously anti-racism; their biggest hit, 1979's *Babylon's Burning* dealt with the riots in Owen's home town of Southall following the death of a protester during an Anti-Nazi League demonstration. Sadly, although it gets another showing in a couple of weeks' time, *Staring at the Rude Boys* was the band's last TOTP appearance; Owen died of a heroin overdose in the summer of 1980.

PRETENDERS - Talk of the Town (#8)

More jagged black and white lines, it's as if this episode was set up as a test of MPEG encoding. It's another showing for the video, Chrissie Hynde and band

presenting a vision of the future by strumming moodily on a set that looks like the result of a damaged LCD monitor. After the number 1 success of *Brass in Pocket* it quickly became apparent that the Pretenders were not going to be regular visitors to the top of the chart; *Talk of the Town* peaked here at number 8 and the band only managed another four top ten hits in their twenty-four year chart career, although Hynde would return to number 1 in 1985 helping out another band on this week's show whom she had discovered and helped to secure a record deal. Clue: it's not the Nolans.

DEXYS MIDNIGHT RUNNERS - Geno (#12)

As previously noted, the Pretenders clip features some very odd low angle shots which are all very well in the context of the video but should not under any circumstances be recreated with Jimmy Savile. Focus instead on Dexys Midnight Runners, already on their third TOTP appearance, all twenty-seven of them crammed onto a tiny podium so that when Big Jim Paterson's trombone is at full stretch it's in danger of taking Al Archer's eye out. In the two weeks since their last appearance Kevin Rowland has grown a bum-fluff moustache, pre-empting the upper lip caterpillar Freddie Mercury is about to unleash onto an unsuspecting public in a few weeks' time. *Geno* is, of course, on its way to becoming one of the biggest hits of the year although Rowland's idiosyncratic delivery means that many of the lyrics are still indecipherable 35 years on.

THE NOLANS - Don't Make Waves (#34)

"She's not old enough to join in but the rest of them are, down there, my goodness yes." Yup, it's the infamous link where Savile has his arm around the 15-year-old Coleen Nolan, later cited as evidence of his heinous sexual predatory nature, although watching the clip without prejudice it has to be said that his gesture looks more protective than pervy. Anyway, the elder Nolans are back with the follow-up to their megahit *I'm in the Mood for Dancing,* which means the TOTP Orchestra gets pressed into service again. Despite its appropriate similarity to the Hues Corporation's *Rock the Boat, Don't Make Waves* isn't a patch on their previous hit, but it does provide the special effects person with an unmissable opportunity to fiddle with the picture settings in order to produce a wave effect at the bottom of the screen. Didn't they tell you not to do that?

UB40 - Food for Thought (#4)

Along with heavy metal, reggae was also undergoing something of a revival in 1980, spurred on by the obvious reggae influences of bands like The Clash as well as the hugely successful 2 Tone movement. Although it seems a bit early for Jimmy Savile to be referring to them as "the great UB40," the Brummie

collective went on to become one of the decade's most successful acts. Their success was so great that there are now two rival factions of the band: while a depleted version of the band continues to trade as UB40, while their original lead singer released a 2014 album *Silhouette* ponderously credited to "Ali Campbell, the legendary voice of UB40, reunited with Astro and Mickey". Ironically both acts now rely heavily on cover versions, so here's the band when they were young, fresh and important before they discovered karaoke.

SHAM 69 - Tell the Children (#47)

"If the kids are united they will never be divided!" Unfortunately by 1980 most of "the kids" were united in the belief that Jimmy Pursey was an irritating gobshite. *Tell the Children* was at least an attempt to move on from their dated, shouty punk style; a slice of dated, shouty rock with a wheezy saxophone section. Pursey is clearly still very, very angry about something although as usual it's not clear what. *"We gotta tell the children! We gotta let 'em know!"* he bellows earnestly, without actually mentioning what it is we've got to tell them. Perhaps it was that they should buy more Sham 69 records as this number 45 smash was their last hit, a shameless 2006 World Cup cash-in re-recording of *Hurry Up Harry* as *Hurry Up England* notwithstanding.

DETROIT SPINNERS - Working My Way Back To You / Forgive Me Girl (#1)

It's a second and final week at number one for the Spinners with their alleged "medley" of *Working My Way Back To You* and *Forgive Me Girl*, the latter a song written by Michael Zager which appears to be exclusive to this track, making it not so much a medley as "I've written a new middle eight for an old song and I want 50% of the writing credit." Zager is best known for the Michael Zager Band's *Let's All Chant* and for discovering Whitney Houston when she was 14, but not in the way Jimmy Savile discovered Coleen Nolan when she was 14. We play out with Bobby Thurston's *Check Out the Groove*, a song destined to cause confusion in the charts for the next few weeks, but we'll come to that on next week's Steve Wright fronted show.

April 24

"I've been waiting such a long time"

Having been spared the horror of a Jimmy Savile episode on BBC Four (not because of his alleged position as Britain's most prolific sex criminal, but rather for his heinous crimes against television presentation), it's wacky zany Steve Wright's turn to host this week. Still persevering with the Kenny Everett beard, Wrighty is resplendent in an horrific stripy blazer which looks like it inspired both the ZX Spectrum loading pattern and Ford Prefect's attempts to blend in with the people of Earth. Thankfully Wrighty stopped trying to blend in with the people of Earth a long time ago. The top thirty countup is accompanied by *The Groove* by Rodney Franklin, causing all sorts of confusion as it's in the chart at the same time as another song with "the groove" in the title which we'll come to later. Meanwhile someone has dropped the chart machine down a flight of stairs, causing a very distracting video feedback effect on the artist names making them almost impossible to read. That's progress.

SMOKIE - Take Good Care of My Baby (#50)

You thought you'd seen the last of this lot, didn't you? Smokie had a run of 11 hits in the mid-70s including *If You Think You Know How To Love Me*, *Living Next Door to Alice* and *Oh Carol*. They had also been responsible for Kevin Keegan's brief pop career, but they were very much a '70s act and this TOTP appearance, their first in eighteen months, seems quite out of step with the changing times; singer Chris Norman struggles to contain the Hank Marvin "How did we get here again?" grin as the band runs through a barely-updated version of a 1961 Bobby Vee hit. This would be Smokie's last appearance on TOTP until they unexpectedly found themselves back on the show fifteen years later in even more unlikely circumstances, teaming up with Roy "Chubby" Brown for a foul-mouthed reworking of *Living Next Door to Alice*.

PAUL McCARTNEY - Coming Up (#7)

It's been a busy year already for fab wacky thumbs-aloft Macca; back in January he spent nine days in jail in Japan, having somehow failed to realise that he wasn't allowed to bring marijuana into the country. Now he was about to issue his first solo album in a decade, *McCartney II*, which he had recorded at home the previous summer. Like the rest of the album, first single *Coming Up* was written, performed and produced exclusively by McCartney, a fact reflected in the video which stretches 1980's technology to its very limits to create an entire band of Paul McCartneys, including a Hank Marvin McCartney on guitar, a very convincing Ron Mael McCartney on keyboards and loveable '60s moptop

McCartney on bass. Oh, and Linda. Macca's new solo success meant Wings was effectively over, the band officially splitting a year later, although the B-side of *Coming Up* included a live Wings version of the song which became a hit in the US in preference to the solo version.

THE CURE - A Forest (#41)

"Right, here comes a good band called The Cure," announces Wrighty as if he's ever heard of them. Having failed to dent the chart with early gloomfests *Killing an Arab* and *Boys Don't Cry*, *A Forest* saw Robert Smith and cohorts in the chart - and, consequently, on TOTP - for the very first time. The spirit of goth has yet to consume them, Smith looking almost unrecognisable with no make-up and a smart, sensible haircut. Sadly he hasn't yet found any stage presence either; apart from the movement of his hands on his guitar, Smith turns in an extraordinary display of inertia, performing as if at gunpoint. His only concession to the *Flick Colby Big Book of Literal Choreography* is to abruptly stop miming the guitar at the line *"Suddenly I stop,"* but by then the producer has had enough and Wrighty is hanging around waiting to take over again, leaving Smith to traipse off to the make-up counter at Boots.

ELVIS COSTELLO & THE ATTRACTIONS - High Fidelity (#30)

By contrast the normally austere Declan MacManus is in unusually upbeat mood. This is the video for his latest release *High Fidelity* in which we find Costello cavorting on a spiral staircase, writhing around in the least seductive bed scene imaginable, pointing rhythmically in an appalling purple and black striped pullover, looking a bit like Bono in a pair of dark glasses and generally displaying the kind of awful dad dancing not seen since... well, since the video for *I Can't Stand Up For Falling Down* a couple of months back. Surprisingly *High Fidelity* didn't climb any higher than this number 30 position and Elvis wouldn't be back in the top ten for another eighteen months, by which time normal gloomy service had been resumed.

SKY - Toccata (#11)

"Now, here's an unusual record that I think could well make the top ten next week." Not exactly sticking your neck out there, Wrighty, considering it's already at number 11. Despite having been afforded a slightly bigger stage this time, the band still looks completely out of place, drummer Roland out of Grange Hill Tristan Fry even committing the ultimate rock star faux pas of wearing a T-shirt with the name of his own band written on it. Despite a run of top twenty albums with such extravagant titles as *Sky, Sky 2, Sky 3, Sky 4 - Forthcoming, Sky News, Sky Sports* and *Sky Five Live*, the band never managed another hit single

and as *Toccata* peaked at number 5 the following week (well done Wrighty) and then dropped, this is the last time they ever had to be embarrassed at being on TOTP.

SAD CAFE - My Oh My (#14)

It's hard to tell the difference between the various performances of this song, but this is definitely (as far as I can tell) a repeat of the second performance from two weeks ago, with the hastily reassembled scaffolding all over the stage and not a protective hard hat or hi-vis jacket in sight – apart from Young's magenta number, obviously. *My Oh My* was Sad Café's last top twenty hit although they did creep into the top forty again at the start of 1981, which we may yet see again if BBC Four lasts that long.

COCKNEY REJECTS - The Greatest Cockney Rip-Off (#47)

"Nah then," announces Wrighty, "'ere come the Cockney Rejects and *Cockney Rip-Orf!*" Bless him, he's got half the title right and he made a stab at a Cockney accent, although if the Rejects heard his attempt they'd probably make a stab at him. That would be after they'd finished laying into Jimmy Pursey though, as *The Greatest Cockney Rip Off* is essentially a Sham 69 parody in which they mock Pursey's lack of punk integrity, his relatively privileged upbringing in well-to-do Surrey rather than rough-and-ready East London, and of course his accent. The Rejects, on the other hand, had plenty of Cockney clout; singer Jeff Geggus and his guitarist brother Micky were both boxers in their younger days, while bassist Vince Riordan was the nephew of Jack "The Hat" McVitie. Unlike McVitie, who was violently murdered by Reggie Kray, on this occasion Pursey escaped with only a bruised ego and lived to carry on his career as a freelance gobshite.

BOBBY THURSTON - Check Out the Groove (#26)

There's been a terrible clerical error down at the British Market Research Bureau. Somehow two different records with similar titles have been given consecutive chart positions: Rodney Franklin's *The Groove*, which we heard earlier, is at number 27 while *Check Out the Groove* by Bobby Thurston is one place higher. Or is it the other way around? Anyway, Thurston was enjoying huge success in the clubs with this disco smash, especially in its 7½ minute 12" version, but he can't be here tonight so... enter Legs & Co! Being a dance hit, there's not much for the girls to do other than strut their own peculiar brand of stuff. Awkwardly though, they've all forgotten to bring trousers with them so Flick, in the manner of a sadistic PE teacher, has made them do it in their pants. This leads to some inadvertently literal choreography as the tightness of said

undergarments means we can "check out" each dancer's "groove" in rather too much detail. Mary Whitehouse must have been watching BBC 2 instead.

BAD MANNERS - Ne-Ne Na-Na Na-Na Nu-Nu (#36)

Consternation at the end of Limbs' routine as the girls cavort down to the end of the catwalk in single file, only for Wrighty to pop up from the back of the set and shimmer his own way down there, inexplicably sporting a false cardboard moustache on top of his regular facial fuzz. No explanation for this behaviour is forthcoming as we are introduced for the very first time to a band who would become regular visitors to the show over the next couple of years. Led by Doug "Buster Bloodvessel" Trendle, a man whose corpulence belies the incredible amount of effort he puts into his performance, Bad Manners were like watching Madness at double speed, or The Specials on acid, cocaine, speed and ecstasy all at once. *Ne-Ne Na-Na Na-Na Nu-Nu* is *One Step Beyond* fed through Google Translate and back again, with Buster running on the spot, gurning, sweating and spouting utter gibberish. Imagine how good they'll be later in the year when they have an actual song.

DAVID ESSEX - Silver Dream Machine (#6)

Another outing for this video which is really just a three minute advert for the movie *Silver Dream Racer*, although it's still better than what's been cobbled together to illustrate Blondie's new single later in the show. Like Bates before him, Wrighty confuses the title of the song with the title of the film - really, it's not hard, the word "racer" doesn't even appear in the song. Put some effort into it, gents. This climbed as high as number 4 next week but is rarely heard now, although it was covered in 1993 by Carter The Unstoppable Sex Machine. Mind you, what wasn't? *Silver Dream Racer* is available on DVD if you're really interested, but be careful which version you pick up because the nasty original ending of the UK version was sanitised for release in the US where a happy ending is a legal requirement.

THE UNDERTONES - My Perfect Cousin (#21)

We're really packing them in tonight, aren't we? Here's frustrated, fault-finding Feargal again, still banging on about his cousin's fur-lined sheepskin jacket, although Feargal's mum made him wear this nice warm jumper for going on the telly so I suppose he does have a point. Annoyingly this is on its way to giving the Undertones their only top ten hit, when they released numerous better singles both before and after this one. Still, while we're making fun of Sharkey and his questionable toggery, let's remember Christmas Day 1985 when, at the height of his sophisticated solo pop career, his earphones failed on the Noel

Edmonds show and he became the first pop star to appear live on TV from an airborne commercial aircraft while standing around shrugging hopelessly like a man who doesn't know how to play Subbuteo. Maybe Kevin was in charge of the sound that day.

JOHNNY LOGAN - What's Another Year?

Well, would you believe it? We sent our best Guys & Dolls tribute act Prima Donna out to The Hague to sing the theme from *On the Move* and we still didn't win Eurovision. Looking back it seems like a remarkable achievement to have finished as high as third, but there was never any doubt who was going to win. *What's Another Year* romped home for Australian-born Irish legend Johnny Logan, now known as "Mr Eurovision" after winning the thing twice and composing a further winner. Back in 1980 though, his unfortunate haircut, hapless expression and precarious position atop a stool give him the air of Rodney Trotter auditioning for Westlife, while the jacket hanging limply across his shoulders suggests a secret hankering to play Batman once the song is over. There's more to come from J-Lo over the next month though, as this is going all the way to number 1.

BLONDIE - Call Me (#1)

After Wrighty bounds on stage for an in-depth interview with the future Mr Eurovision ("What did it feel like the moment you knew you'd won?" "Fabulous." "Great. Well, he looks pleased for himself.") we come to the second of Blondie's three number 1 hits in 1980. Only problem is there isn't a video for it and the band apparently don't do TOTP any more - they haven't been in the studio since Christmas 1979 and won't be back until their comeback single *Maria* almost twenty years later. So... enter Limbs & Co, right? Ah, well, no, because they did this last week and they've already done a routine tonight, so... enter a hasty cut and paste job consisting of clips from *American Gigolo* (the movie to which *Call Me* was the theme) and some random still pictures of La Harry and her chums; zooming, rotating, magically flipping over to reveal a different still picture. Oh, and a couple of very brief Legs & Co clips to remind you that you're watching TOTP and not *Film '80*. Not to worry, it only spent this week at number 1 before being deposed by... well, I won't give away the plot, but we play out with Dexys Midnight Runners. Another new host makes his début next week, so look out for lots of CAPITAL LETTERS and a large amount of GUITAR BASED ROCK.

May 1

"Cures you whisper make no sense"

"Well hello there, good evening and welcome to *Top of the Pops*!" Wait a minute, who's this authoritatively-voiced vision in a satin blouson? Why, it's the one and only Richard Anthony Crispian Francis Prew Hope-Weston, better known to a generation of headbangers as Tommy Vance. Vance had been one of the original Radio 1 DJs (which nobody remembers because he wasn't in that famous photo) before decamping to Capital Radio for a bit, returning in 1978 to host the legendary *Friday Rock Show* which ran until 1993. This doesn't make Tommy obvious TOTP material, although something about him must have clicked because he also had an incongruous stint on the Radio 1 Top 40 show in 1982 and '83. Tonight his booming tones introduce the top 30 countup to the sound of Leon Haywood's *Don't Push It, Don't Force It* for the second time in three weeks and a still echoey caption machine. Luckily The Event will be taking the show off the air at the end of the month so they'll have plenty of time to get it fixed.

NEW MUSIK - This World of Water (#38)

One pleasing thing that's come out of the 1980 repeats on BBC Four is an outpouring of love on Twitter for New Musik, who until the start of this year were either forgotten, remembered as one hit wonders for *Living by Numbers*, or just completely unknown. I'm going to stick my neck out here and proclaim them one of the great synthpop bands and certainly the only one to score two consecutive number 31 hits. With its strange squeaky vocal treatment which once in your brain is impossible to remove, *This World of Water* is a terrific record that even the cheap watery dribbles from the visual effects department and an attention seeking keyboard player can't spoil. Sadly this is the last time we'll see them on TOTP as The Event prevented us from seeing their next single and final hit, the even better *Sanctuary*, but singer and Keith Harris lookalike Tony Mansfield went on to produce loads of hits later in the decade.

NARADA MICHAEL WALDEN - I Shoulda Loved Ya (#19)

That's not your real name, is it, Michael? The name "Narada" is important in many religions, especially Hinduism and Buddhism, and was given to Michael Walden by Indian spiritual master Sri Chinmoy in the '70s, as it literally translates as "singing drummer". Sorry, that last bit's not true. Walden is a singing drummer though, with all the stigma that goes along with that concept, and you've been pronouncing it wrong all these years - it's "NArada" as in "narrative", not "NaRAda" as in "Granada". Walden had managed a minor hit

earlier in the year with *Tonight I'm Alright* but this was his only major hit at the time, branding him a one hit wonder for some eight years until he returned to the top ten with *Divine Emotions* in 1988, by which time he'd dropped his original name and was now known simply as Narada, which you were still pronouncing wrong.

THE CHORDS - Something's Missing (#57)

Hey ho, another week, another chance to associate Jimmy Pursey's name with the word "gobshite" in an attempt to influence his Google search results. Introduced by Vance on an unexpected sofa amongst a gaggle of young ladies, a situation which has caused Tommy to forget the song's title ("Here's The Chords and something called, well, you've got it, here it is,"), you may vaguely remember these former protegés of Pursey's stumbled into the top forty earlier in the year with *Maybe Tomorrow*. Now they're back, singer and guitarist ~~Jay from The Inbetweeners~~ Billy Hassett leading his band through another Jam cast-off which may only have been at number 57 this week but eventually reached the dizzy heights of number 55. Something is indeed missing; I'm sure you can work out what it is.

RODNEY FRANKLIN - The Groove (#13)

And now a public information message. What's the best way to distinguish Rodney Franklin's *The Groove* from Bobby Thurston's *Check Out the Groove*? Well, until tonight it was that Limbs & Co had danced to Thurston's track while Franklin's had been restricted to the top thirty countup. With the two of them still hurtling up the charts, however, it was inevitable that both would need to be featured on the show and so, with Rodney "you plonker" Franklin unavailable... enter Legs & Co! To add to the confusion, we find them dancing to *The Groove* just a week after they danced to *Check Out the Groove*. Nevertheless, in a commendable display of fairness they've forgotten their trousers this week too, so we can continue to "check out" their "grooves" in a similar way to last week as they crawl all over the unexpected sofa in a way that cries out for Tommy to intone "Interest free credit on everything at the DFS sale."

WHITESNAKE - Fool For Your Loving (#30)

Of course DFS hadn't been invented yet so all Vance could come up with was "I wish that was my living room." On to Tommy's specialist subject now: GUITAR BASED ROCK spoken about in a COMMANDING TONE as if in CAPITAL LETTERS. This was the first top forty hit for former Deep Purple singer David Coverdale's new band and the video shows them in typical workmanlike early '80s mode before their glamorous Americanised reinvention a few years later.

Thus there are no ravishing blondes spreadeagled over car bonnets but plenty of unflattering hats, unpleasant facial hair and bad T-shirts. The only focal point linking this incarnation of Whitesnake to the late '80s version is Coverdale's ubiquitous shaggy perm, as usual making him look like the "before" section of a shampoo commercial. "Nice to see some heavy music back in the charts," observes Vance with a knowing glint in his eye.

JIMMY RUFFIN - Hold On To My Love (#36)

Also on the comeback trail is Jimmy Ruffin, a former Motown star who had hits in the '60s and '70s such as *What Becomes of the Broken Hearted?* and *Farewell is a Lonely Sound*. A reissue of the former had sparked a brief career revival in 1974 but this was Ruffin's first hit since then, his appearance suggesting that he hadn't been able to buy any new shirts since the hits dried up. Rather harshly the director has stuck Jimmy on top of the podium and then set his shoes on fire, requiring him to perform his disco number with smoke billowing around him as he desperately tries to stamp out the flames. *Hold On To My Love* would go on to give Ruffin a sixth top ten hit in the UK some fourteen years after his first, but it would also be his last major hit.

SAXON - Wheels of Steel (#20)

Look out, Tommy's back in his element. "We played you some David Coverdale, let's play you some heavy music by a newish band." It's another outing for some proper NWOBHM from two weeks back, although it does look like the smoke from Jimmy Ruffin's burning shoes has drifted across the studio to obscure Biff Byford and the lads. This was the first of eighteen hit singles for Saxon over the next eight years and as well as inspiring Spinal Tap's Derek Smalls, the song bears an uncanny resemblance to *Meals on Wheels*, a track from Vic Reeves' 1991 album *I Will Cure You*. Delighted with a chance to show off his knowledge of GUITAR BASED ROCK, Vance observes that Saxon's album, also called *Wheels of Steel*, is "doing very well." He's not wrong; the album made number 5 and would hang around the chart until October, by which time they had a second album ready to go.

HOT CHOCOLATE - No Doubt About It (#31)

Mercilessly cut from the 7:30 edit despite Errol Brown's passing just a few days earlier, *No Doubt About It* was a departure from Hot Chocolate's usual subject matter (cute girls, sexy girls, dancing): an apparently true story of a UFO sighting. No such departure in the wardrobe department though, as Errol delivers his tale of an extra-terrestrial encounter in characteristically tight trousers, the kind which would almost certainly scare off visitors from another

planet. Much is made of Hot Chocolate having a hit every year between 1970 and 1984, but 1979 had been a lean year for the band; their only top 40 hit of last year was *I'll Put You Together Again* which was released at the end of 1978. Jaded song titles like *Mindless Boogie* and *Going Through the Motions* suggested the end was nigh, so it was heartening to see them back in the top 40 - even with a song about little green men.

MOTÖRHEAD - Leaving Here (#23)

Seems a bit of a coincidence that Tommy Vance should be presiding over so much metal on his first TOTP - which came first, the decision to employ him as host or the inclusion of LOTS OF GUITAR BASED ROCK on the running order? We may never know. Anyway, after the poodle-haired preening of Coverdale and the shiny leather-clad posturing of Saxon, here comes some no-nonsense dirty rock from probably the least photogenic band ever to appear on the show. An unrecognisable version of a Holland / Dozier / Holland composition, Motörhead originally recorded the song in 1977 as their first single. This version was taken from the *Golden Years* live EP which was already the band's biggest hit and would go on to reach number 8, a higher position than even the iconic *Ace of Spades* later in the year. Somehow drummer Phil "Philthy Animal" Taylor's "Whale oil beef hooked" T-shirt managed to slip through the censorship net, presumably because nobody bothered to read it out loud.

THE NOLANS - Don't Make Waves (#25)

Is this the hardest working group in showbiz? This is already the Nolans' fifth appearance on the show this year and it's only the 1st of May. The transition from balls-out metal to shiny disco pop may seem discordant but it does allow us to debunk a popular urban myth that Motörhead and the Nolans once made a record together. In fact that's almost, but not quite, true - the Young & Moody Band's 1981 single *Don't Do That* featured guest appearances from Lemmy on bass, Cozy Powell on drums and - yes! - Coleen and Linda Nolan on backing vocals. In fact all four Nolans feature in the video, trying to look like rock chicks with varying levels of success. Back in the real world, *Don't Make Waves* wouldn't match the success of *I'm in the Mood for Dancing* but it did give them the second of seven consecutive top twenty hits.

THE BEAT - Mirror in the Bathroom (#58)

Mind you, you think the Nolans are working hard? The Beat are already on their third hit single of the year. Lots of mirror imagery in this performance, unsurprisingly, from Ranking Roger performing into a hand-held mirror to the state-of-the-art-video effect that mirrors the top half of the screen in the bottom

May 1 97

half, or even vice versa. Presumably the effects people were too busy programming the reflection to apply the "waves" effect to the Nolans' performance like they did last time. Star of the performance is venerable Jamaican saxophonist Saxa whose career stretches back to the birth of ska in the '60s, when he played with the likes of Prince Buster and Laurel Aitken. These days there are two rival versions of The Beat - one fronted by Dave Wakeling, the other by Ranking Roger - but at the grand old age of 85, Saxa is now enjoying his retirement.

KATE BUSH - Breathing (#29)

Two years after hitting number 1 at her first attempt with *Wuthering Heights*, Kate Bush launched her third album with this defiantly uncommercial single about an unborn child dealing with the aftermath of a nuclear attack. The song is written from the foetus's point of view and the promo clip appropriately features Kate in the role of the baby. Naturally this requires Kate to be in her birthday suit, but calm yourselves, she's discreetly wrapped in several layers of cling film and cocooned in a huge plastic bubble. She's being the baby, you see, it's performance art or something. Either that or she's off to an Extreme Zorbing event. Unsurprisingly, *Breathing* wasn't a top ten hit; her next single *Babooshka* was, but we won't see that thanks to TOTP's own apocalyptic event over the summer.

DEXYS MIDNIGHT RUNNERS - Geno (#1)

"What's number 1? I'll tell ya: this is, and it deserves to be!" Fine words from Tommy who doesn't actually tell us what's number 1, ironically presaging Dexys' 1985 twelve-minute epic *This is What She's Like* in which Kevin Rowland completely fails to tell us what she's like despite repeatedly promising to do so. Oh yeah, Dexys Midnight Runners are at number 1, apparently arriving late for the show and running on stage as the track starts, carelessly tossing towels and bags into the crowd and almost taking out a couple of audience members in the process. A chart-topping single at only the second attempt is a vindication for Rowland, one of pop's true mavericks whose belief in doing things his way has seen him through many successes and numerous notorious failures over the years. We play out with Johnny "Mr Eurovision" Logan's *What's Another Year?* after Tommy Vance bids us good evening; a creditable debut - better than those of Andy Peebles or Steve Wright, anyway - but we're back in the enthusiastic pop-friendly hands of Peter Powell next week.

May 8

"Times are changing fast but we won't forget"

Oops, Peter Powell has misread the invitation and turned up in... well, I'm not sure what, but it's an odd interpretation of "smart casual". Some kind of turquoise jumpsuit with an unnecessary zip right across the chest and a very obvious Radio 1 patch sewn onto the breast; a timeless look that will never go out of fashion because it was never in fashion in the first place. It's a bit of an odd show all round, really: not counting the number 1, half the songs chosen for tonight's show are outside the top 40, which accidentally introduces us to two of the decade's biggest bands and a much missed singer-songwriter miming to a record she didn't even appear on. The top 30 countup is accompanied by Mystic Merlin's *Just Can't Give You Up*, a song about someone who just can't give someone up and is at great pains to say so, to the exclusion of any other lyrics. In an amusing touch, the caption person has listed the act as "Mistik Merlin" - perhaps inspired by New Musik last week and M's *Pop Muzik* last year, or perhaps they just couldn't spell.

THE HUMAN LEAGUE - Rock 'n' Roll (#72)

Look out, here comes the future! Ironic really that this original incarnation of the Human League, a band diametrically opposed to any form of conventional non-synthetic musical instrument, made their only TOTP appearance with a cover version of a song about a genre of guitar-based music that was already quarter of a century old; the song itself had been the début hit for public enemy no.2 Gary Glitter back in 1972. The League's version was originally part of a medley with a cover of Iggy Pop's *Nightclubbing*, although I hesitate to call it a medley; it was more a decision to stop playing one song and immediately start playing another at a completely different tempo. By the end of 1980 the League mark 1 had split, Ian Craig Marsh and Martyn Ware naffing off to form the British Electric Foundation (and later Heaven 17) leaving Phil Oakey with custody of the haircut and very little else. Eighteen months from now the League mark 2 would be the biggest band in the country. That's showbiz.

JOHNNY LOGAN - What's Another Year? (#2)

Hopefully there's a parallel universe in whch the League's TOTP début sent the *Holiday '80* double single to number 1 for four weeks, during which time they performed a different track from the EP each week. The week they closed the show with *Dancevision* is still spoken about in hushed tones. No such frippery here though as Eurovision winner J-Lo's unstoppable march to number 1 continues. He's wisely ditched the stool and elected to remain standing

throughout, although the blue shirt, blue slacks, white jacket combination is slightly marred by his choice of footwear; perhaps he should have listened to Frank Zappa's advice that *Brown Shoes Don't Make It*. Also, since *Father Ted* deconstructed Eurovision so comprehensively in 1996, it's almost impossible to watch this clip without suddenly sitting bolt upright shouting "We have to lose that sax solo."

PRELUDE - Platinum Blonde (#51)

All the way from sunny Gateshead, folkies Prelude had almost reached the top twenty back in 1974 with an a capella version of Neil Young's *After the Gold Rush*. Six years on they were tickling the underbelly of the top forty again with this cautionary tale of a girl who defies her parents and runs away to the big city (Newcastle) to become an "actress". Her dad goes to see the show, only to discover his daughter is part of some kind of display of loose morals in a red light district - *"It might not be Shakespeare,"* she admits. Scandalised, her dad does what any self respecting father would do in this situation and shoots her. But there's another twist! This was her last night in the naughty play, she was on her way home to her ma and pa that night. But now she isn't, because he's shot her. With a gun. As Oz from *Auf Wiedersehen Pet* once remarked, "Sex is in its infancy in Gateshead." *Platinum Blonde* didn't reach the top forty but Prelude did manage another hit in 1982... with a new recording of *After the Gold Rush*. Oh well.

MICHAEL JACKSON - She's Out Of My Life (#25)

It's a remarkably colour co-ordinated night tonight; Prelude's Irene Hume turned up in a purple fake leather jumpsuit to complement Powell's turquoise number, and now here's Jacko in a purple shirt and turquoise jumper. Hang on, what's that, Michael Jackson is in the studio? Yes! Well... he's in *a* studio. Not the TOTP one, obviously, unless you can convince yourself that he did agree to do the show as long as there was no audience present. *She's Out Of My Life* was the big emotional ballad from *Off the Wall* and became the joint biggest hit from the album, thanks to a devastatingly passionate vocal from Jackson; he recorded almost a dozen takes of the song but broke down in tears at the end of each one, convincing producer Quincy Jones - who had wanted to record the song with Frank Sinatra instead - to leave in the quavering vocal on the final few words. A powerful, heartfelt performance that even Jarvis Cocker wouldn't waft his arse towards.

MATCHBOX - Midnite Dynamos (#67)

And then you go and spoil it all by saying something stupid like "Here's

Matchbox!" A studio performance intercut with brief scenes from the video in a desperate attempt to make them look more interesting, in fact Matchbox look and sound like an Asda SmartPrice Showaddywaddy. In fairness *Midnite Dynamos* is probably their best single, certainly it became their biggest hit to date, but the staging is so light entertainment it feels as old as the musical genre they're attempting to resuscitate. Starting out in various primary coloured jackets, the magic of television allows them to suddenly change into matching white suits during the instrumental break - *"Baby get a load of our fancy clothes!"* How did they do that? Shh, it's a secret. Matchbox scored five top 40 hits between November 1979 and December 1980, but their recording career carried on into 1983 when they released a single featuring someone we're about to see backing Jona Lewie. But I'm telling you the plot!

AVERAGE WHITE BAND - Let's Go Round Again (#28)

"I've never seen Legs & Co quite so scantily dressed," reckons Pete, which is alarming as they've completely forgotten their trousers for four of the last five weeks. Anyway, the Average White Band had scored their first and biggest hit back in 1975 with *Pick Up The Pieces*, a few months after the death of original drummer Robbie McIntosh whose father, actor Bonar Colleano, was mentioned in Ian Dury's *Reasons To Be Cheerful, Pt 3* - another element of the theory that everything about '80s pop is inextricably interlinked. *Let's Go Round Again* was on its way into the top twenty, making it the AWB's biggest hit since their first, but they weren't available tonight, so... enter Limbs & Co! And, sadly, Peter Powell is not wrong, the girls have given up on any pretence of wearing anything that might be considered clothes and are just wandering around in bra and pants. At least they're all spotlessly white, to the extent that you might consider Limbs & Co to be an Extremely Average White Band. Hopefully none of the girls' fathers is waiting backstage with a shotgun.

JONA LEWIE - You'll Always Find Me in the Kitchen at Parties (#73)

"Who said you'll always find me in the kitchen at midnight, hmmm? Who said that?" Er, no-one actually, Pete. Although this is Jona Lewie's first solo hit, it's not his TOTP début; that came eight years earlier when his band Terry Dactyl & The Dinosaurs reached no.2 with *Seaside Shuffle*. Now the artist formerly known as John Lewis has retired from running his chain of department stores and signed with Stiff Records, resulting in this new wave classic. If you look closely behind John/Jona you may notice that one of the backing singers is the late, great Kirsty MacColl who didn't actually sing on the record but, as a Stiff employee, stood in for one of the actual backing singers who were the wives of producer Bob Andrews and Stiff boss Dave Robinson. Presumably the real

singers were in Ikea while the show was being recorded.

COCKNEY REJECTS - The Greatest Cockney Rip-Off (#23)

"The best parties go all the way through to midnight," offers Pete, back-pedalling furiously as he realises he messed up the title of the previous song. This was the second and final showing for this prototype Spitting Image parody of Sham 69 and, therefore, probably our last chance for a while to call Jimmy Pursey a gobshite. Rich pickings for Cockney Rejects fans this month though as, due to an unusual sequence of events including the FA Cup Final and a series of allegations regarding the behaviour of a well known TOTP host, they'll be back on next week's BBC Four repeat performing a completely different song. A suitably chastened Sham 69 never appeared on TOTP again, but the sarcastic inclusion of a couple of lines from *Maybe It's Because I'm A Londoner* in this one won't seem so clever when you find out what the Rejects' next single is.

BONEY M - My Friend Jack (#63)

Boney M's fall from grace was alarmingly precipitous. In 1978 they released two of the UK's ten biggest selling singles of all time, but at the end of the '70s it appeared someone had flicked the off switch; previous single *I'm Born Again* struggled to number 35 and this one wouldn't even break the top fifty. *My Friend Jack* was originally recorded by The Smoke, possibly the finest psych-pop band ever to come out of York, and concerns a man called Jack who, it transpires, "eats sugarlumps". The reason for his unusual habit is never made clear, but it can be surmised that he is addicted to either (a) LSD, or (b) the polio vaccine. Quite how the previously clean cut Boney M, with their predilection for pseudo-religious songs such as *Rivers of Babylon*, came to be singing such appalling filth is unclear, although presumably it was an attempt to recreate the success of last year's *Painter Man*, originally recorded by another English power-pop group The Creation. Despite the M's natty turnout in three-piece suits and Bobby Farrell's recently discovered ability to levitate, we won't be seeing this again any time soon.

THE RUTS - Staring at the Rude Boys (#27)

Although Powell introduces this clip by embarrassing a couple of audience members who have turned up wearing identical shirts (funny nobody else turned up in a turquoise flying suit, eh Pete?), thankfully he doesn't pull an alarming face like Savile did a couple of weeks ago in an attempt to illustrate the concept of "staring" to those who don't understand it. It's heartening to see this finally getting a BBC Four airing because it turned out to be Ruts singer Malcolm Owen's last appearance on TOTP; two months later he died of a heroin overdose

aged just 25. The others carried on for a couple of years as Ruts DC (from the musical term da capo meaning "return to the beginning") with guitarist Paul Fox taking over vocal duties. In 2007 the Ruts reformed – with Henry Rollins filling Owen's shoes – to play a benefit gig for Fox, who died of lung cancer later that year. That's not the end of the story though, as remaining original members Segs Jennings and Dave Ruffy reformed Ruts DC in 2012 and are still touring. Where's your stupid staring face now, Savile?

ORCHESTRAL MANOEUVRES IN THE DARK – Messages (#53)

Like the Human League, Orchestral Manoeuvres In The Dark weren't really interested in being a pop group, it just sort of happened to them. These arty hipsters who hadn't yet started abbreviating themselves to "OMD" had been signed to über hip Factory Records and had their first minor hit earlier this year with *Red Frame / White Light*, a song about a telephone box with a title so painfully influenced by the Velvet Underground's *White Light / White Heat* it's a wonder they didn't sue. With *Messages* though, it transpired that OMD had an irrepressible knack for writing great pop songs. This would go on to give them their first of eleven top 20 hits and although they would carry on creating awkward artistic gems like *Souvenir* and two different songs both called *Joan of Arc*, the enduring image of OMD remains Andy McCluskey's awful dad-dancing. Significantly, the band's tape machine has Musicians Union-baiting "Keep Music Live" stickers on its reels, a provocation which may have played an important part in precipitating The Event in a few weeks' time.

THE UNDERTONES – My Perfect Cousin (#10)

Well, this is awkward. Having spent the last month goading the Human League by sneeringly suggesting that Kevin's mum asked them to help her choose a synthesizer for her pampered little cherub, Feargal Sharkey now finds himself in the same studio as the League and in serious peril of having his head stamped on by a six-foot Sheffielder in stiletto heels. To combat this threat Sharkey has defied his mother and taken his jumper off, performing the song in his shirt sleeves with arms flailing everywhere, which has the effect of making him look like Scrappy Doo squaring up to Phil Oakey snarling "Lemme at him, lemme at him!" Annoyingly this and next week were the Undertones' only two weeks ever in the top ten and we lose their next and possibly greatest single *Wednesday Week* to The Event. Where's the justice?

DEXYS MIDNIGHT RUNNERS – Geno (#1)

Late for the show two weeks running, they'll be getting sanctioned if they're not careful. Actually it's a repeat of last week's performance but they've already

done the song three times so we can't really begrudge them a week off. *Geno* of course comes from Dexys' legendary début album *Searching for the Young Soul Rebels*, which was eventually released in July after the band had stolen the tapes from the recording studio and held them to ransom, demanding more money from EMI. You won't be surprised to learn that they parted company with the label shortly afterwards. We play out with Hot Chocolate's *No Doubt About It*, Errol Brown's recent passing still not having been properly commemorated with a full showing on BBC Four; we'll have to wait until the very last show before The Event to see it because next week's show is hosted by a man with lots of hair.

May 15

"I don't know how to stop"

Another episode quietly dropped from the run of BBC Four repeats, but like many it was repeated on UK Gold back in the 1990s so it's not exactly "lost" if you know where to look. Although you can argue the rights or wrongs of omitting large chunks of history in this manner, Dave Lee Travis isn't doing anything to help his cause this week. Apparently the sun's been out for a day or two, so DLT has dressed appropriately in a gaudy Hawaiian shirt (unbuttoned down to mid-chest, obviously) and unpleasantly short shorts, with a cardboard sun strapped to his big hairy head. And why not? If you can't dress like a tit on a prime time music television show, reducing it to some kind of light entertainment farce, when can you? The top thirty count-up is accompanied by *You Gave Me Love* by the Crown Heights Affair, which was sampled by Utah Saints for their 1993 hit *Believe In Me*, as was *Love Action* by last week's opening act the Human League. Small world, innit?

SQUEEZE - *Pulling Mussels (From the Shell)* (#47)

Unlike Travis, Squeeze have captured the early summer vibe perfectly. Well, at least Glenn Tilbrook has, in his linen jacket, respectably buttoned up shirt and sensible hat. This is a great summer song, describing a day at the beach from the viewpoints of various surfers, topless ladies and holidaymakers. Perhaps released a month or so too early to soundtrack your 1980 summer holiday and capture sales from tourists needing some kind of tangible souvenir of their vacation, *Pulling Mussels* bafflingly and criminally peaked at number 44, although it's as familiar today as many of their more successful songs. It would be a full year before the band returned to the top forty with *Is That Love?* as the realisation that they were actually too good for the charts began to sink in.

ROXY MUSIC - *Over You* (#18)

"Squeeze and *Pulling Mussels* – I shall probably pull a few of them meself before the end of the show." Without wishing to sound like DLT's defence lawyer, one gets the impression that he often did and said things just because he thought they would get a laugh, without really thinking them through in any great detail. That would certainly explain the outfit and that sentence, which conjures up various images, none of them pleasant. Anyway, onwards, with the return of former glam gods Roxy Music who by now have ditched everything that made them such a fascinating proposition the first half of the '70s, including unconventional song structures, outrageous costumes and Brian Eno. They were, however, in the middle of their most commercially successful period; *Over You*,

which would become their third top five in succession, was the first single from the album *Flesh + Blood* which would spend over a year on the album chart but forever condemn them to leather-trousered bland-pop hell.

JIMMY RUFFIN - Hold On To My Love (#7)

"It's getting very warm in here, I might have to take something else off before the end of the night." Please don't, Dave, for the love of God. Now, flown in specially from two weeks ago, here's Jimmy Ruffin with his last top forty hit, *Hold On To My Love* peaking at number 7 this week. His shoes are still on fire, but we all have our problems. Although this was Ruffin's last hit in his own right, he did crop up again on TOTP in late 1984 when Paul Weller persuaded him to join the Council Collective, Weller's Band Aid-style charity assemblage whose *Soul Deep* raised money for striking miners. Ruffin also collaborated with Heaven 17 on their 1986 single *The Foolish Thing To Do*, and a less Heaven 17 sounding single you won't hear all day. He scored a couple of other minor hits including a reworking of *What Becomes of the Broken Hearted* with Ruby Turner before his death in 2014.

MYSTIC MERLIN - Just Can't Give You Up (#24)

Despite persistent reports of its demise, small pockets of disco continued to break out throughout the early '80s. Here's one of them, with an unusual arrangement and harmonies that make it sound like a 1960s advertising jingle sung over Spiller's *Groovejet*. Mystic Merlin started out as a novelty act with a live show which mixed music and magic tricks, but in the late '70s they dropped the tricks to concentrate on the music. Sadly they're all too busy sawing women in half to be here tonight, so... enter Legs & Co! After last week's debacle when they all forgot their costumes and had to do the show in their unmentionables, this week they've overcompensated and brought two outfits: a black one, which might be a cat but is probably a devil, what with the unconvincing cardboard flames around the stage, and a white one which presumably represents angels. Flick Colby there, tackling the perpetual struggle of good against evil through the medium of interpretive dance over a song whose lyrics are largely *"Just can't give you up."*

HOT CHOCOLATE - No Doubt About It (#6)

Talking of magic tricks, the director has really pulled out two or three of the stops tonight with Hot Chocolate's appearance - indeed, we literally see them appear as a shot of the empty stage is mixed through to a shot of the same stage with band and audience in place. As if they've beamed down from a spaceship, y'see. Clearly the *Flick Colby Big Book of Literal Choreography* was out on loan

when Limbs & Co were rehearsing their number. Errol Brown has outdone the girls in the costume department as well, turning up in some kind of futuristic getup with a big shiny-trimmed collar and, inevitably, really really really tight trousers as he describes his encounter with beings from another planet. "Was I frightened? Was I scared? Yes, of course, I crapped myself, and then wished I wasn't wearing such tight trousers."

THE FOUR BUCKETEERS - The Bucket of Water Song (#26)

Expertly introduced by DLT with no reference to who these people are or how they got here, the Four Bucketeers were the hosts of fondly-remembered anarchic kids' TV show *Tiswas*, whose modus operandi was to present celebrity interviews, comedy sketches and pseudo-educational features, all of which were thinly-disguised excuses to cover all participants in custard pies and buckets of water. Chartwise only John Gorman had any previous form, having been a member of the Scaffold - along with poet Roger McGough and Paul McCartney's brother Mike - who scored the 1968 Christmas number 1 with *Lily the Pink*. The other Bucketeers are Bob Carolgees (with his fantastically grotesque puppet Spit The Dog), Sally "The Fabulous Miss" James and, of course, Chris *"Who Wants To Be A Millionaire"* Tarrant, the voice of reason in "Compost Corner" T-shirt, sensible jacket and rubber waders. Oh, and thanks to tedious BBC health & safety rules it's not real water in those buckets.

WHITESNAKE - Fool For Your Loving (#20)

In all fairness it must be said that the TOTP Orchestra made a surprisingly decent stab at *The Bucket of Water Song*, although it's easy to imagine them watching the performance in complete disgust and re-evaluating their career choices. A group of vulgar performers from an ITV programme sullying the good name of TOTP? Shocking. Anyway, Travis manages to lower the tone even further by chatting to some American audience members - "D'you fancy a bit of Whitesnake? Yeah? I'll take you to the canteen after the show." That's the kind of joke Chris Tarrant used to try and sneak into *Tiswas* without anyone noticing, and the reason why the "adult *Tiswas*" *OTT* was such a disaster. Anyway, yes, here's that Whitesnake video again. "I was born under a bad sign," bemoans David Coverdale. Presumably it read "MATRENITY WARRED". That could be another *Tiswas* joke. Let's move on.

THE NOLANS - Don't Make Waves (#13)

Is this growing on anyone yet? Much like *I'm in the Mood for Dancing*, this seems to be taking an awfully long time to get anywhere despite being relentlessly plugged on the show every other week. Still, fair play to the Nolans,

not for them the easy route of taping one performance and having it endlessly repeated for as long as it takes to climb the chart; the girls are back once a fortnight, keeping the TOTP Orchestra busy and making sure nobody decides to give their song to Limbs & Co. This week they're in co-ordinated black and white outfits, no doubt sparking letters of unmitigated fury from Daily Mail readers who had shelled out the extra for a colour TV licence. The Nolans didn't release another single until September, after TOTP was restored following The Event, as it would have meant setting up a stage in their front room to perform it every other Thursday night.

THE BEAT - Mirror in the Bathroom (#4)

This is the second time in succession this line-up of Nolans, Beat and Bush has been flung out in the same order and still nobody has made a "Beat-ing around the Bush" joke. Probably just as well. This is The Beat's third top ten hit in five months and also their biggest to date; their only bigger hit would come three years later and if we see that on BBC Four I'll be very surprised, especially as one of the two performances of the song was on the 1000th edition in May 1983, which inevitably features Sir Jim'll and is therefore ineligible for broadcast at any point in the next hundred years. Meanwhile this performance of *Mirror in the Bathroom* is the same as two weeks ago so for once you're not missing anything.

KATE BUSH - Breathing (#19)

Unlike the Nolans, Kate did release a single over the summer, and it was her biggest hit since *Wuthering Heights*. Unfortunately The Event deprived us of seeing *Babooshka* on TOTP, unless you count the unbroadcast pilot episode for the new look TOTP which was made in July in preparation for the show's post-Event relaunch and included a clip from that Dr Hook special Kid Jensen warned us about a few weeks back. For now you'll have to make do with a naked Kate Bush wrapped in plastic. It's a hard life, but we persevere.

PETER GABRIEL - No Self Control (#44)

Of course Kate Bush had provided backing vocals for Peter Gabriel's previous hit *Games Without Frontiers* and they would go on to have a top ten hit together with *Don't Give Up* in 1986, so maybe they don't just throw this thing together after all. Remarkably this is the only time that Gabriel was ever tempted into the TOTP studio, unless you count his 2002 performance for TOTP2, by which time his top 40 career was well and truly over. It's a typically uncompromising performance, all dramatic lighting, extreme close-ups and Gabriel contorting into various unlikely positions. Despite his efforts, and even the patronage of

DLT who apparently made it his Record of the Week, *No Self Control* failed to emulate the success of *Games Without Frontiers* and struggled to number 33.

NARADA MICHAEL WALDEN - *I Shoulda Loved Ya (#8)*

"*No Self Control*, which sometimes is what they have not got in the studio, but never mind!" Ha, you're one to talk, Travis. Anyway, that was Peter Gabriel's only TOTP performance but we'd have to wait another eight years for Narada Michael Walden's only trip to the studio, by which time he'd dropped all pretence to having a real name and was known simply as "Narada". In the meantime though, he produced loads of hit singles, from Stacy Lattisaw's *Jump to the Beat* (another great single that fell victim to The Event) to massive mid-80s hits for Whitney Houston, Jermaine Stewart's *We Don't Have To Take Our Clothes Off* and even Starship's *Nothing's Gonna Stop Us Now*. Not a bad career for a singing drummer. *I Shoulda Loved Ya* peaked here at number 8, as did Narada's other hit *Divine Emotions* eight years later.

JOHNNY LOGAN - *What's Another Year? (#1)*

"WE HAVE TO LOSE THAT SAX SOLO!" Yes, J-Lo has finally made it to number one, but by now he's run out of suits so is forced to perform in purple trousers and a cyan shirt with white, yellow and pink stripes; something to placate the Daily Mail readers after the Nolans turned up in monochrome. Still, we can allow Johnny a bit of leeway in his attire this once, because it's his birthday! They've made him a cake and everything, which he receives from a member of the audience. As he bends over to give the lucky audience member a kiss there's a terrible moment where it looks like he might overbalance and land face first in the cake, but he doesn't and all is well until he gets it back to the dressing room and discovers there's a jumper baked into it. So, a happy ending to the show, and what better way to keep the jubilation going than to play out with the theme from *M*A*S*H*? Well, I'm sure there are lots, but that's what we're doing. Mike Read is your genial host next week, so no dirty language please.

May 15 109

May 22

"The sword of time will pierce our skins"

"Welcome to *Top of the Pops*! You've probably got a very good close-up of my nose where I've been lying in the sun." Er... no, not really. Mike Read is our host this week, and like Steve Wright a few weeks back he's wearing a blazer which reminds me quite vividly of my youth. Wrighty's looked like a ZX Spectrum loading screen, whereas Read's white-with-black-and-red-stripes effort looks like the curtains I had in my bedroom around 1987. On with the show then, and because BBC Four "overlooked" last week's DLT-fronted episode, there's a fair amount of repetition but it's also the last time we'll see most of these songs on the show, what with The Event looming on the horizon like a... big, looming thing. Of course, at the time everyone was blissfully unaware of what was about to happen to TOTP, so we carry on as normal with the top thirty countup soundtracked by Lipps Inc's *Funkytown*, a massive hit over the summer but restricted to a countup track this week, a playout track next week, a brief snippet on the pilot episode for the rebooted TOTP and only one full performance, soundtracking a Limbs & Co routine on the Christmas Day show.

THE LAMBRETTAS – D-a-a-ance (#48)

One of very few acts to have chart success on Elton John's Rocket label apart from Sir Reg himself, this turned out to be The Lambrettas' final appearance on TOTP although the single climbed as high as number 12. Over the summer the band's début album *Beat Boys in the Jet Age* reached the top thirty and they seemed set for a third hit with next single *Page Three* gaining lots of airplay on Radio 1, only to be shot down when The Sun "newspaper" claimed that they owned the rights to the phrase "page three" and the Lambrettas could just about blooming well go off and find their own phrase. The single was eventually released as *Another Day Another Girl* but by then the momentum was lost and the single failed to reach the top forty. Although original singer Jez Bird died in 2008, the Lambrettas are still going, with original guitarist Doug Sanders on vocals and Paul Wincer (seen here auditioning for *Stars In Their Eyes* as The Jam's Rick Buckler) back behind the drum kit.

MICHAEL JACKSON – She's Out Of My Life (#3)

Another outing for the fourth and joint-biggest hit from *Off the Wall*, but number 3 was the highest position for this tearjerker. Over the summer an unthinkable fifth single from the album, the Paul McCartney-penned *Girlfriend*, got stuck at the world's worst chart position, number 41. Of course Michael's not in the

TOTP studio; he only ever performed two of his solo hits on the show, once with his brothers doing that performance of *Rockin' Robin* that's on TOTP2 every three weeks and once on his own doing *Ben* which is never shown despite being one of the few performances from that era to still exist in some form. Anyway, the next time Jacko would reach the top forty would be in a year's time when Motown dug up an old blub-fest *One Day In Your Life* and confounded everyone by scoring a bigger hit with it than any of the singles from *Off the Wall*.

UK SUBS - Teenage (#32)

You thought punk was dead? No way! It just smells a bit. "Hang on a minute," you say, *"Teenage*? Charlie Harper's 35 if he's a day!" Yes, the song is a kind of reverse *Teenage Kicks* in which vocalist Harper, indeed just a few days short of his 36th birthday at the time, reminisces about being a teenager in 1962 rather than 1980. Given Harper's unfortunate resemblance to a fuzzy-permed Ben Elton, the whole thing has an air of *Nozin' Aroun'* about it, while his Sid Vicious t-shirt, guitarist Nicky Garratt's regulation loose-knit jumper and Billy Idol sneer and drummer Pete Davies' bright red hair tick off just about every punk cliché available. Nonetheless, the Subs refused to give in to fashion and continue to this day, releasing their 25th album *Yellow Leader* in 2015 and still led by Charlie Harper, now a sprightly 71.

JONA LEWIE - You'll Always Find Me in the Kitchen at Parties (#27)

In the interests of accuracy, we asked Twitter if Jona's opening statement was true. Is he really no good at chatting up? Does he always get rebuffed? Apparently so, according to one correspondent: "He was chatting me up in a small canteen at a Blues Festival, but some mad old bag kept talking to me and he got bored and walked off. So annoying. :(I was being polite as thought she was a friend of his, but next time I'll tell 'friends' to fuck off so I can shag a pop star." So it seems it's true. Maybe it's because people keep mistaking him for Fred Harris off of *Chockablock / Micro Live / End of Part One*. No Kirsty MacColl this week but at least ~~Fred~~ Jona does get off with one of the backing singers, presumably not one who was married to Stiff Records boss Dave Robinson because he didn't get dropped from the label and he'll be back with an even bigger hit at Christmas.

KAREL FIALKA - The Eyes Have It (#52)

So while Jona and his new lady friend dance out of the kitchen, Mike Read is left to do the washing up. Seems fair. Next up tonight is the Scrabble-tastic Karel Fialka, looking and sounding like something Czechoslovakia might have

speculatively entered into the Eurovision Song Contest in an attempt to emulate Kraftwerk, or at least Belgium's Kraftwerk-alikes Telex. Like Telex, the Indian-born, half Scottish, half Czech Fialka scored exactly one top forty hit in the UK, but this wasn't it. In fact he would have to wait another seven years for his hit, the supremely irritating *Hey Matthew*. *The Eyes Have It* is much better, all biscuit tin electronic drums and squelchy synths, and if you listen hard enough it sounds like it might have subconsciously influenced Camper Van Beethoven's subsequent indie classic *Take the Skinheads Bowling*. Despite this *The Eyes Have It* became one of those "special" records that actually went down the chart the week after it was on TOTP. See you in 1987 then, Karel.

THE SPECIALS - Rat Race (#18)

Having solved the problem of unwanted pregnancy with *Too Much Too Young* a few months back, laughing Terry Hall and his chums are back to tackle the problem of... students. Hang on, is this right? Yes, apparently so. Bloody students, eh? Going to university, studying hard, getting really good, well paid jobs. *"I got one Art O-Level, it did nothing for me,"* complains Hall, which suggests that he should have stuck in and worked harder at school, then he might have got a few more. A double A-side with *Rude Buoys Outa Jail*, *Rat Race* went on to reach number 5, becoming the fourth of seven consecutive top ten hits before the original line-up's split in the summer of 1981. We won't see their next single *Stereotype* on TOTP though, not because of The Event but because it's terribly rude.

COCKNEY REJECTS - I'm Forever Blowing Bubbles (#45)

Hang on, this lot were on two weeks ago with a completely different song and now they're back! Is this the hardest working band in punk? No, it's just unfortunate scheduling really. With *The Greatest Cockney Rip-Off* still at number 30, we switch our attention to the Rejects' cover of a music hall number from 1919, but don't panic, they haven't gone all Toy Dolls on us. *I'm Forever Blowing Bubbles* is, of course, the anthem of West Ham United, having been adopted as such in the late 1920s in reference to a player who bore a resemblance to the subject of a painting used in a famous soap advertisement. With West Ham reaching the 1980 FA Cup Final, the Rejects decided to support their team by releasing their own version of the song. The Rejects' version reached number 35, became their last top forty hit and effectively finished off their career, not because it was a novelty cover version but because it marked them out as West Ham supporters, which led to most of their subsequent gigs descending into violence orchestrated by supporters of other teams. As if that wasn't bad enough, it didn't even do as well as the West Ham team who took their own recording of the song to number 31 five years earlier.

GARY NUMAN - We Are Glass (#10)

Although his commercial success had already peaked, Gary Numan remained a surprisingly regular presence on TOTP, appearing at least once every year between 1979 and 1987. He's only on video tonight though, and the easily shocked among you may wish to sit down because despite clearly being some kind of alien from the future (about 1982, by my reckoning), Numan is seen playing a guitar. You remember those, right? Apart from that there's lots of smashing of glass and messing about with laser beams, but no synthesisers in evidence anywhere in the video. So much for the future, it might as well be a 1970s Queen album. *We Are Glass* smashed (ha!) into the chart at number 10 this week and climbed as high as number 5, making it Numan's biggest solo hit single after *Cars*.

JUNIOR MURVIN - Police and Thieves (#35)

If The Clash will not come to *Top of the Pops*, then *Top of the Pops* must come to The Clash! Er, or something. Originally released in 1976, Junior Murvin's *Police and Thieves* quickly gained reggae classic status, especially as it summed up the mood of black Britain after a perceived heavy-handed police presence at that year's Notting Hill Carnival led to the festivities turning into a riot. The following year it also became a punk classic when The Clash recorded it for their début album. Quite why Murvin's version took so long to enter the chart isn't clear, but now here he is on TOTP, looking frankly startled at suddenly having to mime to a four year old song and having to improvise a "trying to stay upright on a moving bus" dance routine which doesn't really befit such a significant record. Playing bass on *Police and Thieves* is one Boris Gardiner, who in 1986 would score a much bigger hit than either Junior Murvin or The Clash (jeans ad-related reissues aside) when *I Want To Wake Up With You* went to number 1.

AVERAGE WHITE BAND - Let's Go Round Again (#17)

"*This is number 17... what are you doing?*" Ah, if only all the TOTP presenters had been so admonishing when a female audience member attempted to put an arm around them, we wouldn't be in this mess. This was the Average White Band's second and final top twenty hit, the only other being their début chart entry *Pick Up The Pieces* which reached number 6 five years earlier, and although the AWB version of *Let's Go Round Again* peaked at number 12, leather-clad mid-90s pop goddess Louise took the song into the top ten in 1997. Unlike this song's first appearance on TOTP two weeks ago, the band has been persuaded to come to the studio this week so Limbs & Co are not required to spin around in circles or push clock hands in an anti-clockwise direction. Talking of Limbs & Co, where have they got to this week?

THE MASH - Theme from M*A*S*H (Suicide is Painless) (#6)

What's going on here then? As you've probably worked out, this is the theme from the 1970 film *M*A*S*H*, which begat the enormously popular US TV series which in 1980 had recently finished its eighth season. Originally released in 1970 as *The Song from M*A*S*H* when it made no impact on the chart whatsoever, the popularity of the TV series, plus repeated plays on Noel Edmonds' Sunday morning Radio 1 show, propelled it into the chart a full decade later. Of course The Mash can't be on TOTP because they never really existed, so... enter Legs & Co! Legend has it that the movie's director Robert Altman wanted the song's lyrics to be mind-numbingly stupid, so he got his teenage son to write them. No such excuses here for Flick Colby who, faced with all sorts of reasons why Limbs & Co can't interpret the song literally on early evening television, grabs hold of the opening line *"Through early morning fog I see..."* and sticks the girls out in a foggy yet still unrealistic grassy knoll. Note that, because nobody can see them, L&C have chosen not to go out in the usual skimpy outfits and instead are wearing all the clothes they own, all at once.

MATCHBOX - Midnite Dynamos (#26)

Suicide is Painless was, of course, later covered by the Manic Street Preachers for a charity album organised by the NME. What's not so well remembered is that, in the UK at least, the single was a double A-side with another track from the album, The Fatima Mansions' unprovoked assault on Bryan Adams' *(Everything I Do) I Do It For You*, and if you thought the Manics' cover was disrespectful you've clearly never heard the other side. Moving on, it's another showing of the Lidl Showaddywaddy's performance from a couple of weeks back, amazing costume change and all. Last time I hinted that they had made a record with someone else who appeared on the show, so now it can be revealed: Matchbox's final single release, 1983's *I Want Out*, was a duet with Kirsty MacColl. Of course we'll see more of Kirsty on TOTP over the years, but be warned, Matchbox have a massive top five hit to come in the autumn.

JOHNNY LOGAN - What's Another Year? (#1)

One final week at the top for ~~Rodney Trotter~~ Johnny Logan and he's back in his white jacket and blue slacks from a couple of weeks ago. Of course J-Lo will be on TOTP again with his next hit and second Eurovision winner, but we won't be seeing that until 2022. At least that one doesn't have a sax solo. We play out with Jermaine Jackson, the errant Jackson brother who absconded from the Jackson Five and stayed with Motown when the others moved record labels, forcing them to change their name to The Jacksons. He's enjoying his first solo hit with *Let's Get Serious*, while Mike Read is off to get his blazer made into a deckchair.

Kid Jensen is your host next week, with a show which turned out to be the end of an era for more reasons than the one that was intended.

May 29

"Memories are uncertain friends"
"Hello there and welcome to *Top of the Pops*!" Hello there to you too, Kid. This edition was always going to be the end of an era, as it was the likeable Canadian's last show before leaving the BBC and moving to Atlanta to join CNN, which might explain why he's dressed as a newsreader tonight in sensible suit and tie. That's the least of our worries at the moment though, as this is the last TOTP as we know it before The Event (a Musicians' Union strike over the BBC's plans to save money by disbanding five of its orchestras – yes, the BBC had so many orchestras that it could ditch five of them and still get by) took the show off air for two months. When it returned in August the show had been totally revamped, with Michael Hurll taking over as producer and the TOTP Orchestra and the Maggie Stredder Singers being given their marching orders. The top thirty countup at the start of the show was also jettisoned, meaning that this week's countup, soundtracked by Roberta Flack & Donny Hathaway's *Back Together Again*, was the last gasp of a tradition stretching right back to the 1960s.

LIQUID GOLD - Substitute (#52)
Oh, look out, they're back again. Despite their previous hit *Dance Yourself Dizzy* having "one hit wonder" written all the way through it like a stick of rock, it was actually the second of six top sixty hits for Liquid Gold between 1978 and 1982. This was the third, not a cover of The Who's *Substitute* or even Clout's *Substitute* but, ironically, a pale imitation of *Dance Yourself Dizzy* with all the catchy hooks carefully removed. The drummer is still a shameless attention seeker though, coming out from behind the kit in his white one-piece jumpsuit (tastefully open to the navel) to join the rest of the band up front, drumsticks flailing aimlessly in the breeze. But if you're up here, who's playing drums? Liquid Gold still have a few TOTP appearances up their collective sleeve after this one, including one which could have been the UK's 1981 Eurovision entry had not common sense – and Bucks Fizz – prevailed.

HOT CHOCOLATE - No Doubt About It (#2)
Although it's been in the charts for a month already, this is the first time *No Doubt About It* has graced the 7.30 BBC Four showing, thanks to a combination of aggressive editing and attempts to placate the Daily Mail. It's a repeat of the performance from two weeks back, with the band spookily appearing on stage out of nowhere. An impressive effect for the time, one supposes, although it

might have been better without the obvious appearance of someone behind the empty stage operating the smoke machine. Altogether Hot Chocolate scored 14 top ten hits in their career (although, to be fair, three of those were *You Sexy Thing* in 1975, 1987 and 1997); *No Doubt About It* was their biggest hit of the '80s but couldn't quite make that final push to the summit, spending three weeks at number 2. Would another TOTP showing in two weeks time – denied to us by The Event – have spurred it on to number 1? Probably not, but we'll never know for sure.

ELTON JOHN - Little Jeannie (#44)

No amount of plugging on TOTP would have helped this to number 1 though. Dame Elton was going through a bit of a rough patch; it was a full year since his last visit to the singles chart, the number 42 hit *Are You Ready for Love?* which remained almost completely forgotten until it unexpectedly shot to number 1 in 2003. Things were even worse in the album chart where Elton's 1979 album *Victim of Love*, a rum affair including an eight-minute disco version of *Johnny B. Goode*, had completely missed the top forty, ending a run of eleven consecutive top ten LPs. Back to the drawing board then for this ballad which harked back to classics like *Daniel* and *Song for Guy* without ever coming close to either. The only real winner here is the person in charge of the smoke machine who must be on double time – either that or Elton had some of his exotic smoking equipment stashed under his Bontempi. *Little Jeannie* wandered briefly into the top forty but it would still be another two years before Reg returned to the top ten.

CROWN HEIGHTS AFFAIR - You Gave Me Love (#17)

"Right, it's party time on *Top of the Pops*..." Well, thank flip for that... oh, hang on... "...as Legs & Co move to the music of Crown Heights Affair!" Oh. It may be the Kid's last show but he's not taking any chances, referring to Limbs & Co's actions as "moving to the music" rather than "dancing" for fear of becoming embroiled in a dispute involving the Trade Descriptions Act. *You Gave Me Love* was on a particularly casual stroll up the chart, having already taken five weeks to get this far, but would eventually climb to number 10 while TOTP was off air. There is a theory which states that The Event actually helped disco hits like this and Lipps Inc's *Funkytown* achieve higher chart placings over the summer, as they were still gaining sales through exposure in the clubs while less dance-friendly records were denied publicity on prime time BBC1. It also removed the necessity for potential buyers to sit through Limbs & Co jumping around in unnecessarily short nighties when the band in question couldn't make the studio or – in the case of Lipps Inc – didn't actually exist.

DON McLEAN - Crying (#13)

Safe to say it's no longer party time on TOTP. Don McLean (not to be confused with 1970s *Crackerjack* host Don Maclean, not that you ever would) had reached number 2 in 1972 with the deathless *American Pie* and followed it up with the number 1 hit *Vincent* but hadn't scored any significant hits since then. This version of the Roy Orbison classic was first released on McLean's 1978 album *Chain Lightning* but it wasn't until 1980 that the single took off. The simple video of McLean sitting by the fire singing the song and playing acoustic guitar is all very well until the face of his former love appears in the fire, all *Tales of the Unexpected*-like, when everything becomes a bit sinister. Although it's hard to argue that McLean's version is in the same league as Orbison's, the fact remains that the Big O only ever got as high as number 25 with the song in his own right, while McLean's recording was on its way to number 1. Even a posthumously released duet between Orbison and k.d. lang only reached number 13. Where's the justice?

THIN LIZZY - Chinatown (#37)

We didn't get to see Phil Lynott's first solo hit on BBC Four because of a certain Mr Fix-It and we won't get to see his second because of The Event, so you could be forgiven for thinking that Lynott had no intention of going solo and Thin Lizzy was just carrying on as normal. *Chinatown* is typical vaguely threatening Lizzy material; *"You don't stand a chance if you go down in Chinatown,"* apparently, although it's never made clear why, evoking memories of the oft-repeated and similarly imprecise line from *Jailbreak*, *"Tonight there's gonna be a jailbreak somewhere in this town"* - I'm no crime expert, but may I humbly suggest you start at the jail and work your way out from there? The *Chinatown* album saw the introduction of guitarist Snowy White to Lizzy's ever-changing line-up; White was previously a session musician best known for adding a guitar solo to Pink Floyd's *Pigs on the Wing* in order to join parts 1 and 2 of the song to make it fit nicely on the 8-track version of *Animals*. White left Lizzy in 1982 and scored his own solo hit with *Bird of Paradise* in 1984.

ROXY MUSIC - Over You (#6)

It's lucky for the Kid that he's already secured a job with CNN, because he's about to stretch your credulity to the limit with his next two sentences. "Thin Lizzy, on the way to... I would have thought the top five there with *Chinatown*." Really, Kid? Given that *Whiskey in the Jar*, *The Boys Are Back in Town* and *Waiting for an Alibi* all fell short of the top five? But his next statement takes even more believing. "One of the most requested records on the radio is definitely this one these days, the latest from Roxy Music." Well, I know people

are easily pleased, but who's requesting it? Certainly not anyone who remembers Roxy from their heyday in the first half of the '70s. Over You is a limp, fake leather trousered, entirely chorus-free plodder which, incredibly, was considered good enough to be the first single – the *first single*, no less – from the band's latest album *Flesh + Blood*. Mind you, the album became their first chart topper since 1973 and spent 60 weeks on the chart, so their move from art rock to bland pop obviously had some benefits.

ORCHESTRAL MANOEUVRES IN THE DARK – Messages (#26)

While the Human League took a year or so to get over their TOTP début and reconfigure themselves into the electronic ABBA, OMD – who débuted on the same show, lest we forget – hit the ground running and managed to stay true to their artistic leanings while carrying on a pop career in a way that the original all-male Human League never did. This is OMD's second appearance on the show and they're already growing in confidence, propping up their equipment with die-cut panels echoing the design of their album sleeve while Andy McCluskey plays a colour co-ordinated bass guitar. He still manages to look like Beaker from the Muppet Show, but there's not much they can do about that. *Messages* climbed as high as number 13, paving the way for their first top ten hit *Enola Gay* after The Event.

JERMAINE JACKSON – Let's Get Serious (#21)

"The runaway Jackson," as Kid Jensen charmingly refers to him, Jermaine was one of the Jackson Five until they got a bit arsey with Motown in the mid-'70s and decided to change labels. Being married to the daughter of Motown boss Berry Gordy, Jermaine wisely stayed behind and was replaced by little brother Randy in the new, non-numerically specific Jacksons. Although he had scored a solo hit in the US with *Daddy's Home*, better known in the UK as a Cliff Richard hit, *Let's Get Serious* was Jermaine's first solo chart entry in the UK. He certainly looks serious enough, in his non-matching three piece suit, flanked by two dancers in rainbow dresses on a set which seems to almost spell out *"Top of the Pops"* in an abstract fashion (in fact the clip comes from the Dutch equivalent show *Top Pop*). While *Let's Get Serious* would eventually reach number 8, Jermaine's only other hit of any note over here was *Do What You Do* five years later, giving him a level of minor stardom which made him a perfect fit for a role in *Celebrity Big Brother* in 2007.

STIFF LITTLE FINGERS – Nobody's Hero (#36)

It's not easy being a TOTP presenter, of course, and there are times when you just have to laugh. Unfortunately for The Kid, one of these times occurs midway

May 29 119

through his introduction to Stiff Little Fingers with no obvious indication of what's set him off. It could be the generic Smashie-and-Niceyness of the link ("Jermaine Jackson and *Let's Get Serious*, and now getting serious are Stiff Little Fingers..."), it could be the fact that in the background bassist Ali McMordie is desperately running to get on stage before the song starts, or it could just be that Kid knows that when Jake Burns starts singing it's going to be in a comical rasp that sounds uncannily like (Sir) Lenny Henry's *Tiswas* character Algernon Razzmatazz. Stiff Little Fingers had already peaked chartwise with previous single *At the Edge*; *Nobody's Hero* failed to climb any higher than number 36 and, surprisingly, has yet to be picked up by any enterprising advertising agency for use in an ad for throat lozenges.

MYSTIC MERLIN - *Just Can't Give You Up* (#23)

There's still a barely suppressed giggle in Kid's voice as he introduces Mystic Merlin, a band so unsure of their musical talents that they have to do a magic act at the same time. The result is the worst kind of disco cabaret, involving a smoking saxophone and a singer who somehow seduces a lady onto a conveniently placed bed, only to spend the next few minutes making her levitate, in a way which is not a euphemism for anything vaguely sexual. What a romantic. *Just Can't Give You Up* eventually reached number 20 but was Mystic Merlin's only UK hit, although the band released three albums and a later line-up included vocalist Freddie Jackson who went on to have numerous solo successes including the 1986 top twenty hit *Rock Me Tonight (For Old Times' Sake)*. As far as is known, however, Jackson never sawed a woman in half.

LENA ZAVARONI - *Jump Down Jimmy*

And so we reach the end of an era, the last desperate gasps of the TOTP Orchestra backing former child star and *Opportunity Knocks* winner Lena Zavaroni on a song which everyone involved must have known had absolutely no chance of going anywhere near the chart. It seems churlish to be rude about Lena, who became hugely famous at a very young age and then lost it all soon afterwards, suffered from anorexia and depression for much of her life and died in 1999 at the age of just 35. However, in the interests of fairness and context, it cannot be denied that *Jump Down Jimmy* is utter horseshit. This is quite possibly the worst song that ever appeared on TOTP in the whole of the 1980s, and given that Ken Dodd is on the show in December 1981, that's saying something. It's an horrific song, full of references to *"the bayou"* and Lena's *"momma and poppa"*, phrases no other 16 year old from Renfrewshire has ever uttered. The audience is suitably unmoved, some of them even turning their backs on the stage in disgust, while one young man glares at Lena with his arms folded as if attending the show at gunpoint. With acts like this being given airtime, it's worrying to

think what TOTP might have become if The Event hadn't intervened.

THE MASH - Theme from M*A*S*H (#1)

And so, what better way to end the last edition of this era of TOTP than with the total anti-climax of a repeat of Legs & Co swaying aimlessly to a decade-old song about suicide? Yes, The Mash, a band that never existed outside of the minds of some record company executives, have made it to number 1. You won't be surprised to learn that this was their only hit, unless you're in charge of the Official Charts Database, in which case you'll have confused them with dubious mid-90s dance act Mash! who reached number 37 with a track loosely based on Dusty Springfield's *You Don't Have To Say You Love Me*. This '70s/'80s Mash spent three weeks at number 1, so you can thank The Event for sparing you two of those, although on the original broadcast the Limbs & Co routine was intercut with clips from the film, which BBC Four has deemed too expensive to show again. So it's farewell to '70s style TOTP and farewell to Kid Jensen, who signs off with just the briefest of mentions for his final Radio 1 show the next day, but don't worry because - spoiler alert - the CNN job doesn't work out and he'll be back on Radio 1 and TOTP in just over a year's time. TOTP will also be back on BBC Four in a couple of weeks, as The Event doesn't quite coincide with the annual break for the Proms, so before you know where you are it'll be August and everything will be different. Until then, remain indoors.

July 9

"A place where nobody dared to go"

And so, as The Event raged on into its second month, the powers-that-be grew restless and began to long for a time when hostilities would cease and a dozen or so of the week's hit singles could once again be welded together in an ungainly manner to fill 40 minutes of peak time Thursday evening viewing. It didn't have to be like it was before, though. What if we got rid of the troublesome TOTP Orchestra? What if we got a new executive producer in? What if the top thirty countup was split into chunks throughout the show instead of giving away all the surprises in the first minute? What if we had special guest celebrity hosts working alongside the Radio 1 DJs? Ah, what if. You might as well ask "What if Elvis hadn't died and was still around, recording disco tunes penned by the bloke out of Mungo Jerry?" And yet... what if, in the downtime while the show was still off air, someone was to put together an example of how things might change? A programme never to be broadcast, but a pilot edition for a new look TOTP yet to come? But, alas, that could never happen; the Musicians' Union would never allow it. And yet... and yet, one evening in July, TOTP stalwart Peter Powell and Twitter irritant B.A. Robertson found themselves in a barely decorated, dimly lit, scarcely attended studio pretending to host a non-existent episode of *Top of the Pops*. "Forget about me though," insists B.A., who seems to have lost height since he was last on the show, "forget about Peter Powell and the chart, forget about the script, 'cause we have, and just sit on your father's neck and then you'll be on top of the pops."

SAXON - 747 (Strangers in the Night) (#14)

The first obvious difference in this edition is that instead of the top thirty countup, the show opens with a brief montage of some of the acts who will (or, in this case, won't) be appearing later on, while *Computer Game (Theme from The Invaders)* by the Yellow Magic Orchestra plays in the background, completely unannounced. The opening feels very slow, with around ten seconds given to each act, leading not so much to a sense of breathless anticipation as a check of the watch and perhaps a muttered "Get on with it!" Once that's out of the way, Powell introduces the first act, "heavy metal at its finest" from Saxon, only there's something a bit odd looking about Saxon tonight. Yes, because the Musicians Union is still on strike there are no musicians available to perform on tonight's show (yes, ha ha, that's why B.A. Robertson is on, very good). In their stead, various crew members and people who just happened not to be doing anything much have been brought in to pretend to be Saxon while their second top twenty hit plays in the background. Unfortunately nobody seems to have told them what they should do once they're up there. The bespectacled "singer"

looks like he was expecting to have to perform the similarly titled Frank Sinatra number and so makes a few vague attempts to open and close his mouth in time to the music, which looks even stupider than if he had kept it shut. Luckily the bloke to his right is clearly a frustrated axe god, so most of the attention goes on him. Best of all is the fella tentatively prodding at a keyboard in the background, an interesting addition to the display as Saxon didn't have a keyboard player.

ODYSSEY - Use it Up and Wear it Out (#2)

Once "Saxon" have been put out of their misery, we are introduced to another innovation that would stick around for the rest of the decade - the name of the act displayed on screen as their performance ends. They seem to be experimenting with various ways of doing this, not that there would ever be a definitive method, so the band is slowly obliterated as "No 14 SAXON No 14 SAXON No 14 SAXON No 14 SAXON" is overlaid on screen in a seemingly infinite loop. B.A. seems unimpressed, bursting into Sinatra's *Strangers in the Night* for a moment before going all unnecessary. Yes, for various reasons Odyssey aren't here tonight, so... enter Legs & Co! "It's not much of a body but they can use it up and wear it out any time they like," offers Robertson, reusing the gag Mike Read did about the Bodysnatchers last time B.A. was in the studio. *Use it Up and Wear it Out* was the second of five top ten hits for Odyssey and was hanging around at number 2 for a fortnight before giving the New Yorkers their only UK number 1. As the show isn't going out on TV, clearly nobody has bothered to choreograph or learn a routine and the girls just wiggle around a bit, shaking their bodies down as per the lyrics... or maybe that *was* the routine. It's hard to tell.

PAUL McCARTNEY - Waterfalls (#11)

After seeing off Limbs & Co, Powell foolishly asks Robertson his opinion of the new McCartney single. "Well, it's slower than his last one," he begins, and then dozes off during the second half of his own sentence. B.A. is certainly not wrong though, *Waterfalls* is significantly slower than *Coming Up* and is something of an overlooked entry in the McCartney canon, unless you're TLC who definitely remembered it fifteen years later. (It's slower than TLC's song too.) Nobody wants to stand up and pretend to be fab wacky thumbs-aloft Macca, who almost certainly wouldn't have done the show anyway, so we get the video which starts with him composing the song in his home studio, just as it happened in real life, although whether he wrote the song in such a hideous tank top is not on record. But suddenly Macca gets up from his piano, the walls disappear and there's a fountain behind him! Not an actual waterfall, but beggars can't be choosers. The fountain dies down and, without warning, he's in the Arctic Circle! Or, more plausibly, somebody has left some white bedsheets lying around which looks

great but must be confusing the hell out of the polar bear. But then, before we know what's happened Macca's walking through the enormous back garden of McCartney Towers, complete with merry-go-round which he has a quick spin on before the sprinklers come on again, leaving him back in his studio. Paul McCartney is not on drugs, *this really happened*.

THIN LIZZY – Chinatown (#21)

Back to reality now... well, back to the studio anyway, and Peter Powell in front of a large, very dim video screen which promptly goes blank and flickers a bit. No time to fix it though, as TOTP demands a chart countup and we haven't had one yet. Now here it is, cut into three bite-size chunks of ten positions each and peppered throughout the show in a way that would become the norm for the rest of the decade and beyond. The captions are still the same as before, except for a new and terribly exciting graphic which illustrates whether a song is going up, down or nowhere fast, while the countup music sees the return of an old friend, *Whole Lotta Love* sounding reassuringly familiar in this frightening new TOTP world. Also familiar is this Thin Lizzy number which has been in the chart so long it was on the last pre-Event edition of TOTP six weeks ago and it's still only climbed to number 21. Still, as the band were on the show we can just edit that performance in, right? Of course not, we've got another bunch of extras who don't really know whether they're supposed to mime or just fill the space where the band members would stand. Extra marks for the time-honoured yet always surprising drums-at-the-front stage layout and a Phil Lynott stand-in whose neatly trimmed hair and moustache suggest what Lynott might look like if he were still with us today.

LEO SAYER – More Than I Can Say (#22)

Worrying scenes as B.A. Robertson engages threatening Glaswegian mode: "Phil Lynott and the Lizzies down in Chinatown, but would you let *your* sister go with them?" he asks Powell. "No way!" squeaks Pete, anxious to play along and too scared to tell him that he doesn't have a sister. We move on with Leo Sayer, who of course isn't really Leo Sayer but one Mike Martin. As the only stand-in soloist on the show, he realises pretty quickly how stupid he's going to look just standing there for three minutes and decides to start lip-synching to the song. Fair play to him, he does a decent job for someone who doesn't really know the song, as well as having the air of a young Rick Astley; he even gives the camera a knowing look at the end of his performance. *More Than I Can Say* became the last of four number 2 hits for Leo Sayer; his first seven hits all reached the top ten while the eighth, *Thunder In My Heart* became a belated number 1 in 2006. Sayer now lives in Australia and released his latest album *Restless Years* in 2015; Mike Martin doesn't seem to have released any records but was good

enough to take part in the BBC's documentary *Top of the Pops: The Story of 1980*.

KATE BUSH - Babooshka (#16)

After the second instalment of the top thirty, which includes B.A. Robertson's *To Be Or Not To Be* falling to number 12, we move on to the highest new entry via the new and now working again video screen. "The face you see behind me, the voice you're just about to see" - that needs a bit of work, Pete, but we know what you mean. Clearly nobody was prepared to pretend to be Kate Bush either (although Mike Martin might have had a decent shot at it), so here's a video clip we made earlier: not the familiar promo video though, but a clip from - can this be right? - *Makin' Love and Music*, the Dr Hook TV special from back in April which Kid Jensen warned us about at the time. Kate's doing one of those routines that involve two costumes split in half and joined down the middle - sensible Kate in profile from the right, dangerous shiny adulterous Kate on the left. *Babooshka* would become Kate's biggest hit since *Wuthering Heights* and until *Running Up That Hill* five years later; with the help of a proper TOTP appearance it might have made it all the way to the top.

DARTS - Let's Hang On (#24)

After a brief introduction in which B.A. auditions for *Give Us a Clue* by miming the next band and song title, we're onto the last chart gasp of one of the great TOTP Twitter talking points of the past few years. Darts have been polarising opinions on social media since their first TOTP appearance back in 1977/2012, with the lunatic antics of Den Hegarty and the suggestion that various members of the band look a bit like Peter Capaldi and/or Armando Iannucci sparking all sorts of baffled tweets. Despite scoring three consecutive number 2 hits in 1978, Darts' appeal waned after Hegarty's departure and this Four Seasons cover would be their last top forty hit. The video sees them fannying about in Alton Towers, standing in front of - and later riding on - the infamous Corkscrew which at the time was the most extreme rollercoaster in the UK, so of course they would have had to hang on. D'you see? Darts' video director had clearly borrowed the *Flick Colby Big Book of Literal Interpretation* while the show was off air. It's a shame The Event deprived us of a final studio appearance for the group, although Hegarty would return to our screens in autumn 1981 as a host of the final series of *Tiswas* at much the same time as Barry Manilow's cover of *Let's Hang On* became another top twenty hit.

OLIVIA NEWTON-JOHN & ELECTRIC LIGHT ORCHESTRA - Xanadu (#1)

Before the number 1 we've got to get through the top ten countup, and by jingo if they haven't messed with that as well, giving us a brief clip of each song in the top ten, even the ones that are just accompanied by a still picture of the artist. Such a shame they didn't get someone to pretend to be Splodgenessabounds. So we come to the number 1 and perhaps the greatest (Dave Lee) travesty of The Event: the fact that ELO are robbed of their only chance to appear on TOTP as chart toppers. Despite having scores of hits through the '70s and well into the '80s, *Xanadu* was the only one to reach number 1 in the UK, and how does practise TOTP illustrate it? With a still photo of Olivia Newton-John who had already spent most of 1978 at number 1 with John Travolta. A *still photo*, mind, even though it moves around the screen very slowly like a half-arsed screensaver. Behind those shades, Jeff Lynne must be fuming. B.A. Robertson isn't too happy either – "You didn't even get a chance to sing," taunts Powell; "And my record went down!" B.A. sobs. "See you next week," Powell offers with misplaced optimism, before giving Robertson a friendly pat on the shoulder which sends him tumbling head-first off stage as the credits roll over *A Lover's Holiday* by Change. Never mind, B.A., you've still got another hit to come and you might even get to present a proper edition soon if things get really desperate.

August 7

"Moving with the rhythm, sweating with the heat"

"Hello, we're back!" Isn't linear time a strange and intangible thing? In terms of BBC Four reruns of TOTP, it's only been two weeks since the end of May and we're used to losing a week every now and then because of *The Sky at Night* or some other unrelated nonsense. In the TOTP timeline though, we've lost two months to The Event and now everything has changed. Well, not quite everything; the Radio 1 DJs are still in charge, but now with the help / hindrance / pointless vacuum of a celebrity guest host. Filling those shoes tonight is Elton John, who at least has a bit of previous in this field having hosted an edition of TOTP in his own right just prior to Christmas 1977. For reasons known only to himself, Elton seems to be affecting some kind of vague West Country accent as Peter Powell shocks the nation by not going into the top thirty countup, but instead running through a list of acts coming up on the show. Thankfully the production crew has taken our retrospective advice since the pilot episode and tightened up this section, with a still picture and video clip crammed into a couple of seconds for each act, while that old favourite *Whole Lotta Love* chimes out in the background.

THE PIRANHAS - Tom Hark (#26)

Without pausing to consider how odd it is that this revamp reinstates the old theme tune to the top of the show for the first time since the summer of '77, we're straight into the music. Proving that new executive producer Michael Hurll means business and that there'll be no more light entertainment nonsense that was so prevalent under Robin Nash's reign, we kick off with a novelty ska-punk cover of a South African kwela tune that was first a hit in 1958. With new lyrics added by lead singer "Boring" Bob Grover, *Tom Hark* was the Piranhas' chart début and their only top ten hit, thanks in no small part to the efforts of drummer Dick Slexia who is, unless you know otherwise, the only drummer to have appeared on TOTP stripped to the waist, greased up and playing the drums in a standing position using fish instead of drumsticks. Even the drummer from Liquid Gold wasn't this extreme. The idea of explaining what just happened via electronic captions hasn't moved on much from the pilot episode a month ago, so a simple 10 PRINT "No. 26 THE PIRANHAS" : GO TO 10 loop ends the performance.

DIANA ROSS - Upside Down (#2)

"I tried to kill off disco, but it's reared its ugly head again," admits Elton in reference to his 1979 album *Victim of Love* which we ripped to shreds two

shows ago. Indeed, far from being dead, disco had thrived during The Event and two of its main practitioners had begun their quest to polish up all pop music with their particular disco sheen. Chic's Nile Rodgers and Bernard Edwards wrote and produced Miss Ross's 1980 album *Diana* but Motown baulked at the result and had it remixed to make it a bit less disco. This didn't go unnoticed by Elton John who scandalously goes on to suggest that the original mixes were probably better. Nevertheless, it became Diana's biggest selling album and this lead single gave her her biggest UK hit for nine years. Shame then that they didn't bother to make a proper video, instead promoting it with this cack-handed montage of stills and brief video clips which zoom in and out and occasionally turn round and round, yet at no point does anything actually turn upside down. Poor show.

ROXY MUSIC - Oh Yeah (On the Radio) (#9)

At last we've found a valid reason to have two presenters; one, Sir Elton in this case, can do a rant about Diana Ross not appreciating the talents of Bernard Edwards and Nile Rodgers and then go on to introduce Roxy Music's *Oh Yeah*, after which Pete can undermine him by completing the song title *(On the Radio)* as if Elton's failure to read out the bit in brackets that nobody ever uses anyway was some kind of heinous error. Anyway, Roxy's latest album *Flesh + Blood* had been released just prior to The Event and had spent the entire duration in the top five, so it was inevitable that this second single from the set would give them another top ten hit. Roxy are very much in smart casual mode tonight, although extra points must be awarded for Andy Mackay's mullet which looks like it's been flown in specially from 1985. "Good to see Bryan Ferry looking better," observes Powell which suggests that he's either been ill recently or Pete just didn't like Bryan's leather trousers last time he was on.

TOM BROWNE - Funkin' for Jamaica (NY) (#16)

Another club hit that had crossed over to the mainstream while The Event starved other musical genres of publicity, *Funkin' for Jamaica (NY)* is the second song in succession with a parenthetical addition that nobody ever uses. The song is an homage to Jamaica, a town in the Queens district of New York where trumpeter Browne grew up - so a sort of *Tom Browne's Schooldays* then. Unfortunately Tom isn't available, or couldn't be arsed turning up to pretend to play the trumpet for three minutes, so - you've guessed it - enter Legs & Co! Yes, while the new order of TOTP has dispensed with the services of the orchestra and the Maggie Stredder Singers, the services of Flick Colby and her girls were still very much required. Distressingly, it seems that the extra money spent on the electronic caption generator has been taken straight from the dancers' costume budget, meaning that the girls are required to appear on TV in

bra, knickers, girdle, stockings and suspenders. The end result is not particularly titillating – "Cold Gossip," as one Tweeter put it – but at least the caption machine is put to good use, superimposing each dancer's name over their brief solo routine. Whether this is reward or punishment for each dancer is not clear. To add to the confusion, the end caption reads "No. 16 TOM BROWNE'S FUNKING FOR JAMAICA" – is he really? That's very interesting, but what's the song called? Never mind, at least his next single *Thighs High (Grip Your Hips and Move)* didn't make the top forty, Lord knows what kind of routine Limbs & Co would have done to that.

HOT CHOCOLATE – Are You Getting Enough Of What Makes You Happy (#21)

Before the next song, part one of the top thirty countup is crowbarred in, with captions as before but now including helpful icons to indicate in which direction each song is moving. Awkwardly the captions still change at the same pace as before, meaning Pete has all sorts of trouble reading out each record's details in its allotted three seconds. We break off at number 21 for some Hot Chocolate with a song which demonstrates why their chart positions over the years were so erratic. For every *No Doubt About It* or *You Sexy Thing* there was always a *Mindless Boogie*, a *Going Through the Motions* or this. "Are you getting enough happiness?" enquires Errol, following up his query with the explanatory "Are you getting enough of what makes you happy?" Well I was until you started singing this rubbish. All the usual ingredients are there – the funky keyboard line, the impossibly tight trousers – but on this occasion they don't come together to form anything particularly nourishing. The pulsating "No. 21 HOT CHOCOLATE" at the end of the performance feels vaguely suggestive though, so that's something.

KELLY MARIE – Feels Like I'm in Love (#29)

So, on with the "middle ten" countup and then back to number 29 for the former Jacqueline McKinnon who, like Lena Zavaroni from the last pre-Event show, had won *Opportunity Knocks* at a young age in the early '70s. Although she had scored hits in Europe, Australia and South Africa, Kelly hadn't repeated this success at home, which turned out to be beneficial as it meant she could launch an assault on the UK chart with this single without any of the baggage of being a "former child star". Although it went on to become an enormous synthdrum-driven monster hit, *Feels Like I'm in Love* was written by folk-rocker Ray Dorset, hirsute singer with '70s chart toppers Mungo Jerry. While they did record the song, it was actually written in the hope that Elvis Presley would record it, although Elvis inconsiderately died before he could do so. Shame really, because if he had recorded it it would have sounded infinitely better than this.

THE GAP BAND - Oops Upside Your Head (#7)

Another outbreak of disco here as Elton - now wearing a green leather overcoat for some reason - introduces "the biggest dance record at the moment." Indeed *Oops Upside Your Head* had become something of a phenomenon in the clubs, with its accompanying dance requiring revellers to sit on the floor and pretend to be rowing a boat. This distracted from some of the song's more suggestive lyrics such as *"Jack and Jill went up the hill to have a little fun / Stoopid Jill forgot her pill and now they have a son"* - and to think they wouldn't play the last verse of *Too Much Too Young* a few months back. The video is standard performance fare but of remarkably low technical quality, having seemingly been played out from a domestic video cassette. Despite this, *Oops Upside Your Head* was a hit again in remixed form in 1987 and also formed the basis of hits for Snap (*Ooops Up*), Snoop Dogg (*Snoop's Upside Ya Head*) and most recently Mark Ronson, whose oblique tribute to the song in his chart dominating *Uptown Funk* was recently deemed to be enough to entitle the Gap Band to a share of the writing credits.

THE GIBSON BROTHERS - Mariana (#14)

More disco? Yep, more disco as the Gibson Brothers are back from Cuba and they've brought some marijuana with them. Ah... no, hang on, they've brought a girl called Mariana with them. Sorry about that. This is the first real glimpse of TOTP gaining its true '80s party atmosphere, with the band performing in the middle of a crowd that actually seems to be having a good time; some of them are even dancing - which seems incredible given the complete indifference of the last audience before the strike, some of whom had to be propped up - and Michael Hurll has hit upon his secret weapon: balloons. Thousands of them. In all colours. On the stage, in the air, in the hands of dancers, balloons. They liven up the performance immeasurably, getting in the way of the drummer and distracting us from the fact that singer Mel Chris has a voice like a goose farting in the fog. This was the Brothers' last TOTP appearance so it's a final outing for the entertaining fact that this and their other hits were produced by Daniel Vangarde, father of Thomas Bangalter from Daft Punk. There you go.

SHEENA EASTON - 9 to 5 (#5)

"This is *Top of the Pops*, and what was happening while we were away?" You tell us, Pete. We recap the last two months' number ones in a quick montage - including a clip of Limbs & Co "dancing" to *Use it Up and Wear it Out*, the only officially broadcast clip from July's pilot edition until the *Story of 1980* documentary at the beginning of 2015 - and then the party balloon is well and truly popped with a behind the scenes clip, apparently from the "*Top of the Pops*

Office", of two unnamed characters poring over the chart and lamenting that Sheena Easton's *Modern Girl* has gone down from 60 to 62. That clip comes from *The Big Time*, an Esther Rantzen-endorsed series which took ordinary people, gave them the chance to become famous, and then pointed and laughed as the whole thing fell to bits. Despite her relative failure in the programme, the actual airing of the show in July gave Sheena the publicity she needed and now her second single was in the top ten, with the first one on its way back up the chart to join it. Within a few years she would be an international superstar, romantically linked with Prince and roundly mocked for returning to Glasgow with a weird transatlantic accent, but for now it's just some antiquated light entertainment moves and a jade onesie borrowed from Peter Powell.

BAD MANNERS - Lip Up Fatty (#15)

With Madness out of the charts over the summer as they realise they have to knuckle down and produce a second album, it's left to Bad Manners to carry the torch for gloriously silly ska-pop, which is fair enough as no doubt your mum got the two confused anyway. Having stumbled into the top thirty with the nonsensical *Ne-Ne Na-Na Na-Na Nu-Nu* in April, their second hit was barely more intelligible but took them into the top twenty. The band's shtick is much the same as last time: the huge, bald, sweaty man jogs on the spot while the rest of the band do whatever they like, safe in the knowledge that everyone's looking at Buster Bloodvessel and not them. They would come up with numerous variations on the theme in order to keep the hits flowing for another two years, but for now it's enough for Buster just to pull silly faces and do semi-vigorous exercise in a white boiler suit.

ABBA - The Winner Takes It All (#1)

"So, good manners would be to let you know what's happening with the brand new top ten." I see what you did there, Pete. The format for the top ten countup is not yet finalised; this week it involves the usual slide followed by a video clip for each song, which takes far too long, and who is this "Katie Bush" of whom Peter Powell speaks? We eventually get to number 1 and it's ABBA - complete with trademark reversed "B" on the caption - tugging at your heartstrings with lots of still photos of the group in their pomp cutting suddenly to a lachrymose and heavily eyeshadowed Agnetha, the unlucky winner of the in-group "Who can get their ex-wife to sing the bleakest lyrics?" contest. *"I don't wanna talk about things we've gone through,"* she insists, before listing everything she and Björn have gone through in eye-watering detail. After a quick gratuitous plug for Elton's new single *Sartorial Eloquence*, which limped to number 44 at the end of the month, we play out with George Benson's *Give Me the Night* which Elton professes not to like. Accordingly he shuffles off to leave us with the audience

dancing under the end credits – yes, even the psychedelic kaleidoscope shots of the lighting rig have been done away with in this exciting new world. Join us again next week as we realise that this whole guest presenter thing is actually a complete disaster.

August 14

"Music for the show of life that never ends"

In the classic Comic Strip film *More Bad News*, a spoof documentary depicting a no-hope heavy metal band plucked from obscurity to perform at the Monsters of Rock festival, there's a scene where the band, overcome with their new found success, "pretend to be The Who." While it's obvious that drummer Spider Webb will be Keith Moon (a role he takes on with relish, proceeding to smash up the band's hotel room), there's a huge fight (leading to a possible broken nose, several arrests and potential criminal proceedings) over who gets to be Pete Townshend and who has to take on the lesser role of Roger Daltrey. The following day, while out on bail, Bad News are introduced on stage at Castle Donington by guitar based rock legend Tommy Vance who, by a staggering coincidence, is presenting tonight's edition of TOTP with "help" from the aforementioned Daltrey. Vance is, of course, his usual gravel-voiced authoritative self, while Daltrey is a complete tit, sulking because The Clash aren't on the show and generally behaving like he'd rather be down the pub. Luckily the show is only half an hour long this week so we shan't detain him for too long.

ULTRAVOX - Sleepwalk (#29)

As Tommy Vance long-windedly but authoritatively points out, we're coming out of the very short period during which former Ultravox! lead singer John Foxx was more successful than his former band; since going solo at the start of the year he'd scored two top forty hits and appeared twice on the show with ~~Underpants~~ *Underpass* and *No-one Driving*. What Foxxy hadn't bargained for was an Ultravox revival, heralded by the disposal of the exclamation mark and the arrival of Midge Ure on a free transfer from Thin Lizzy. We first saw Ure on the TOTP reruns back in 2011 when he was lead singer of Slik - who, in boy band terms, were a Let Loose to the Bay City Rollers' Take That - but since then he had progressed through various acts including Rich Kids and Visage. With Ure at the helm Ultravox would become one of the most successful bands of the first half of the 1980s, but at the moment they're still fairly anonymous, dressed sensibly and hidden behind banks of synths while Ure and his blossoming moustache take centre stage. As soon as he learns how to tie that bow tie they'll be huge.

DAVID BOWIE - Ashes to Ashes (#4)

"Not a guitar in sight!" exclaims Vance, choking back a tear. What better way to counteract this travesty than by attempting to interview co-host Daltrey, who clearly doesn't want to be interviewed. We establish that The Who have been on

tour, it's been a good tour and Roger likes so many singers he can't even name one. "It's easier to name people I don't like," he claims, and indeed we're left in no doubt during the show about what he doesn't like. He does like David Bowie though, "one of the guv'nors," which is a relief as *Ashes to Ashes* has crashed into the chart at number 4 this week. Bowie's not in the studio, of course, but luckily he's sent along a "piece of film" which "cost something like £40,000 to make," according to Tommy. Other sources reckon it cost closer to quarter of a million, but it was still money well spent because everyone in the entire world has seen the *Ashes to Ashes* video. Clearly not much of it was spent on the "Bowie in Pierrot costume waist-deep in water" effect though, which looked as unconvincing then as it does now. Still, interesting that this video, starring New Romantic pioneer Steve Strange, is placed directly after Ultravox whose Midge Ure and Billy Currie were also members of Strange's synthpop collective Visage. We won't be seeing them on TOTP for a few months yet though.

ELECTRIC LIGHT ORCHESTRA - *All Over the World* (#18)

Whoever made the decision to employ Roger Daltrey as a television personality is now committing seppuku in the control room, as he falters to the conclusion that "there's an awful lot I'd like to say about Legs & Co, but I'm afraid they'd probably bleep me out." Presumably this is intended as playful, non-specifically sexist "banter" but it could equally be that Roger just thinks they're f<BLEEP>ing awful. For all their success - and they had 27 top forty hits between 1972 and 1986 - ELO's only number 1 single came during The Event and is therefore lost to TOTP history; even the cobbled together pilot edition in July covered *Xanadu* with just a still photo of Olivia Newton-John. This would, however, have been preferable to Limbs & Co arsing around in front of a giant globe in skimpy yet stereotypical costumes representing various nations: a Stars & Stripes bikini; an improperly short kimono that would get you arrested in Japan; a kilt for Scotland, where of course everyone wears kilts all the time, although if you went out wearing a shirt with no back like that you'd catch your death of cold. Let's face it, it's the worst BBC 1 ident ever.

MIKE BERRY - *The Sunshine of Your Smile* (#22)

"Now here's a song that first came out in 1913!" Cue jokes about Tommy Vance being old enough to remember it the first time around, etc. It's absolutely true, however; one of the earliest documented commercial recordings of the song was released by Fred Douglas on a 78 RPM disc over a hundred years ago. Blimey. By contrast Mike Berry's first hit, the self-explanatory *Tribute to Buddy Holly* was only 54 years old at the time of this BBC Four rerun, although his brief '60s chart career was over before TOTP started in 1964 so the Chas Hodges-produced *The Sunshine of Your Smile* was his début on the show. By 1980 Berry

was more famous as an actor, having appeared in kids' favourite *Worzel Gummidge*, which made his belated return to the chart all the more bizarre. It may not be quite in keeping with the brave new world of balloons and streamers, but Berry makes a brave front of it and the crowd at least attempts to sway along instead of just staring contemptuously as the Robin Nash-era audience would have done. Berry went on to become even more famous the following year when he replaced Trevor Bannister in the long-running BBC sitcom *Are You Being Served?*; whatever you may think of *The Sunshine of Your Smile*, you have to admit it's better than John Inman's 1975 hit single.

GRACE JONES - Private Life (#24)

"If the arrows are going up, it means it's going up, doesn't it?" "I would think so." Tommy explaining the hugely complicated new icons on the top thirty countup to a nonplussed Glaswegian lady there, no wonder he got the Radio 1 Top 40 gig a few months later. The new format is still being tinkered with so we get numbers 30 to 11 in one go this week, still slightly too fast for the host to read comfortably. "Oh, he does go on!" moans Daltrey, before hesitantly introducing Grace Jones, another artist making her TOTP début tonight. Initially a model, Jones branched out into acting in a couple of low budget movies while also releasing a trio of disco albums in the late '70s. For the new decade Island Records wisely teamed her up with Sly & Robbie for this Pretenders cover which became Jones' first hit single. As expected Grace considers herself far too cool to be doing this sort of thing but is contractually obliged to turn up, doing the whole thing with a sour face, arms folded and a fag on the go.

VILLAGE PEOPLE - Can't Stop the Music (#27)

"Can't get me words out!" Vance exclaims as he repeatedly trips himself up on his link out of Grace Jones, "let's see if Roger Daltrey can speak better than I."Nnnnnnno. You'll be amazed to discover that Daltrey is not a fan of disco – "Urgh! Can't stand it! It's terrible!" And so we reach the point in the show that everyone remembers, thanks to its appearance in *The Story of 1980* at the start of the year: Vance announces the Village People as Daltrey sneers, "Watch yer backs!" But, wait a second, it's not there! That's right, having drawn everyone's attention to Daltrey's homophobic comment in the documentary, the BBC Four scissor-wielders have only gone and cut it out of the actual show. We would never have known he'd even said it if the documentary hadn't made such a big deal of it. Anyway, here's a clip from the Village People movie. Yes, the *Village People* movie. With a cast of thousands – and that's just the band, ha ha – and starring roles for Steve Guttenberg and Bruce Jenner, the movie is famous for being the first ever recipient of the Golden Raspberry Award for Worst Picture. The clip here is nothing more than the group performing the title song on stage,

but that's still enough to turn Daltrey's stomach.

SUE WILKINSON - *You Gotta Be A Hustler If You Wanna Get On* (#30)

Don't worry about Roger though, he's found some consolation. "They haven't got the Clash, but they've got some lovely birds on the show." Oh, that's alright then. Time for one of those bizarre novelty hits that these TOTP reruns throw up from time to time, this one from Sue Wilkinson who is accompanied by a keyboardist and - rather unnecessarily - Don Powell from Slade behind a drum kit that clearly doesn't feature on the record. Despite its long winded title, *You Gotta Be A Hustler If You Wanna Get On* is pleasingly minimalist plinky-plonk with only a few bars of electronic snare here and there and the occasional sound of someone twanging a ruler off a desk. While this is going on, Sue tells us about her childhood neighbour Sally who, it transpires, has become rich and famous by... well, "putting out". Sue's not like that though, she's a good girl, and tells us in her best good girl voice about how awful Sally is for copulating her way to fame and fortune and how terrible it is that this is considered not only acceptable, but necessary behaviour, all while Roger Daltrey stands leering just off camera. This is, as Daltrey says, a cleaned-up version of the song for single release; if you're not shocked by the word "hooker" they you may be eligible for the ruder version, if you can find it anywhere.

ABBA - *The Winner Takes It All* (#1)

Meanwhile Vance is still chatting up the girl from Glasgow, telling her to listen to the lyrics next time because they're very clever, and did she recognise the drummer? No, of course she didn't, and even after being told who he is she seems no further forward. The top ten countup is tightened up from last week, with captions over the video clips instead of before them, although with Tom Browne at number 10 and Odyssey at 9 it does look for a moment as if Limbs & Co are going to dance to the entire top ten. ABBA's magnum opus is still at the top and we get the bottom-lip-quavering video (or is it a "piece of film"?) again, after which we find the increasingly recalcitrant Daltrey reclined on the stage beside Vance. No wonder he's pretending to be asleep though, Tommy wants to interview him some more. Leave it out, Tom! Daltrey doesn't even bother to say goodnight before a horde of dancers descend on the scene to stand around aimlessly to Diana Ross's *Upside Down*. Never mind, next week's celebrity host will be far more enthusiastic.

August 21

"Neon bright to light our boring nights"

After last week's toe-curlingly anti-establishment edition of TOTP in which Roger Daltrey was paid to sit around looking sullen, we have a far more showbiz-friendly pair of hosts tonight. Everyone's favourite God-botherer Cliff Richard is here, straight from the hairdresser but - like Midge Ure last week - completely unable to tie a tie properly. Cliff had some experience in TV presentation, having done several series of *It's Cliff Richard* for the BBC in the early '70s amongst other similar light entertainment shows. In contrast, the "proper" host is Steve Wright, at the helm of TOTP for only the fourth time, and also fresh from the barber's having had his "poor man's Kenny Everett" chinstrap beard surgically removed. Unlike last week, there's a genuine rapport between the two hosts: "Cliff, how come you always look so brown?" "It's rust, mate." We're still persisting with the "what's coming up later" introductory passage which serves no real purpose when we could just be getting on with it, but it does give Cliff the chance to squeal "Meee!" like an excited child when he sees himself on screen. Alright, Cliff, calm down!

NICK STRAKER BAND - A Walk in the Park (#28)

Annoyingly, the new format means it's now much easier for the BBC Four editor - a Mr E. Scissorhands, I understand - to begin the continuingly ludicrous half-hour 7.30 edit by chopping out the first song, something which has rarely happened before now, and it would have to be one of the best songs on the show. *A Walk in the Park* was a huge hit in Europe, as Wrighty is keen to point out several times, but a disastrous flop in the UK when it was first released in 1979. After the single's initial release most of the band, apart from Straker himself, went off to become New Musik, so while we lost their final top forty hit *Sanctuary* to The Event, they've managed to sneak in the back door without anyone noticing. Unfortunately there's no sign of Tony Mansfield here tonight, alarmingly-permed Mike Batt impersonator Straker being backed by some anonymous musicians who may or may not be his current "band", if indeed he still had one at this point. Annoyingly the only version of *A Walk in the Park* on Spotify is a dubious late-'80s PWL remix, so adjust your playlist expectations accordingly.

SHEENA EASTON - Modern Girl (#25)

After an initially disappointing chart career, the power of television means that things are now moving faster for Sheena Easton that anyone can keep up with. Her second single *9 to 5* is already on its way down the chart, but not to worry

because her first single is on its way back up to meet it. Two weeks ago we saw a clip from documentary show *The Big Time* in which two TOTP bigwigs were disappointed to discover *Modern Girl* had gone down back in April, but now all is well and the song has finally made it onto the show. Of course we don't get to see the revealing clip from the show where Sheena attempts a high note in the song and breaks down with an anguished cry of "Mah voice sounds *terrible!*", but never mind. She's given the green jumpsuit back to Peter Powell and donned a natty black and white number for this... *interesting* take on early '80s feminism. *"She's been dreamin' 'bout him all day long... He asks her to dinner, she says 'I'm not free, tonight I'm gonna stay at home and watch my TV.'"* I mean, there's playing hard to get and then there's just being rude. And who eats a tangerine on the tube anyway?

THE JAM - Start! (#3)

"You've really hit the big time when you've got two records in the charts," observes Wrighty, whose optician has certainly hit the big time judging by the amazing magnitude of his glasses. On to the week's highest new entry now, ~~Taxman~~ *Start!* by The Jam which, even at the time, was such a blatant rip off of George Harrison's finest moment that nobody could quite believe Weller & Co had the gall to release it. There's no puoS otamoT znieH apron in sight in this video but a lot of arty shots taken through Venetian blinds, while Weller models the kind of tinted specs that Liam Gallagher would covet for the next fifteen years. ~~Taxman~~ *Start!* was the only UK single release from The Jam's 1980 album *Sound Affects* at the time, although a European release of *That's Entertainment* later made the UK chart on import sales. We're still experimenting with the captions at the end of each song, this one involving the word "JAM" made out of Os in a way which is perhaps the closest so far to the famous excesses of the mid-'80s graphics.

SHAKIN' STEVENS - Marie Marie (#32)

A meeting of the generations here, as the "British Elvis" of the late '50s and early '60s introduces the "British Elvis if he wasn't dead" of the '80s. Although he'd already been plying his trade for over a decade, young Mr Stevens had come to national attention in the stage musical *Elvis!* in 1977 and the subsequent revival of ITV's rock 'n' roll show *Oh Boy!* and was now finally starting to achieve chart success. As with his previous hit *Hot Dog* Stevens is up for a bit of horseplay, going cock-eyed for his introductory close-up and generally shakin', gyrating and even leaping into the air and staying there at one point in a move which definitely isn't a clever video effect, oh no. This would become Shaky's first top twenty hit; after a few false starts he would go on to have an unbroken run of 21 top fifteen hits starting in March 1981 and running right

through until 1987.

THE CLASH - Bankrobber (#24)

"It's at times like that I wish I'd've learned to jive," says Wrighty, inexplicably sat behind a drum kit. Onwards, though, to the part of the show which has finally caught Roger Daltrey's attention: The Clash with already their ninth top forty hit *Bankrobber*. Alas, despite the Rezillos' optimistic boast that *"Everybody's on Top of the Pops,"* Jones, Strummer and cronies decided early on that it just wasn't their thing and stuck rigidly to that decision throughout their career. So, with three videos in the running order already... enter Legs & Co! Really they could have interpreted any of the songs represented by videos in tonight's show, but *Bankrobber* was the most obvious entry in the *Flick Colby Big Book of Literal Interpretation*, so we get the girls in stripy leotards (as issued as standard to all female thieves) each dancing behind her own set of bars, with nothing to prevent them just taking a couple of steps to the side and walking free. This performance really does stretch literal interpretation to its breaking point, the girls throwing money into the air on the word "money" and bending over backwards for the line *"I don't believe in lying back."* And because they're in a minimum security jail, they've managed to acquire guns! Oh, it's alright for them to stick the guns in their mouths though, because they're made of chocolate. Someone should have been locked up for this routine.

BILLY JOEL - It's Still Rock 'n' Roll To Me (#30)

"That could have won the Eurovision Song Contest!" smirks Cliff. Somewhere in London Joe Strummer picks up a revolver, spins the barrel and aims it at the television. Let's move on before anyone gets hurt. Another video now, this one for Billy Joel, still in his pre-*Uptown Girl* phase when he was routinely referred to as "Billy Jo-elle." Surprisingly Wright gets the pronunciation right this time, although he gets the title completely wrong, introducing "It's Only Rock 'n' Roll" after he and Cliff have indulged in an Elvis-style lip-curling contest. *It's Still Rock 'n' Roll To Me* is a strange beast, seemingly written as a call-and-response duet but sung by Joel alone, giving him the appearance of a madman who keeps talking to himself. Interestingly though, the video seems to have a live vocal from Joel – certainly a different vocal take to the one on the record – and his willingness to shoot the video on an undressed set in the middle of a scene-shifters strike does him immense credit. Hedging his bets, Wrighty pronounces it "Jo-elle" on the way out of the video but then pronounces it properly in the next sentence. Make your bleeding mind up!

HAZEL O'CONNOR - Eighth Day (#27)

He pronounces it properly in the top thirty count-up too, but then spoils it all by affecting an appalling West Indian accent for Bob Marley at number 23. If we're ticking boxes that covers "casual racism" and we can also tick off "casual sexism" as Wright introduces "the lovely Hazel O'Connor", who proceeds to perform the deeply sinister *Eighth Day* with an intensity which suggests she could snap Wright's scrawny neck if she wanted to. The song, which describes an apocalyptic scenario in which man creates machines in to do his menial work, only for them to become sentient and really pissed off, comes from the equally unsettling film *Breaking Glass* which starred Hazel alongside Phil "Parklife" Daniels, Mark "Zaphod Beebelbrox" Wing-Davey and Gary "well, at the moment I'm in Roxy Music but there's a good chance I might get a transfer to Adam & The Ants next year" Tibbs.

THE PIRANHAS - Tom Hark (#9)

Another case of old meets new now as Cliif tries to come to terms with the Piranhas. "I do believe it's their first single, but I could be wrong, in which case it's their second single. Either way... it's their single." Well done, Sir Cliff. In actual fact *Tom Hark* was the Piranhas' fourth single, but the first one to come anywhere near the chart. This time around they opt for a more conventional stage presence with drummer Dick Slexia relegated to the rear of the stage and required to play his drums with sticks rather than fish as in his first appearance. He's still topless though, for no obvious reason. Meanwhile saxophonist Zoot Alors is dressed as Joe 90 dressed like Captain Scarlet. Sadly this is the last time we'll see the Piranhas for two years until they return with their other hit *Zambezi*, a cover of a '50s instrumental with newly penned lyrics – anyone see a pattern forming here?

KELLY MARIE - Feels Like I'm in Love (#8)

"Now we've got another lady coming up, in fact our third lady..." Cliff is appalled, as you might imagine. "Is nothing sacred?" he blusters in what we're expected to assume is mock outrage. The real problem here is nothing to do with the fact that they allow women in the charts now, but more that Kelly Marie is this week flanked by what appears to be two of the Black & White Minstrels. This is going to be on loads of times over the next few weeks (although BBC Four will skip a couple of those, so, you know, every cloud) and it hasn't even got anywhere near number 1 yet. Kelly's career after this hit was amazingly consistent – not in terms of chart positions, but over the next two years she released eight more singles, all of which had the word "love" in the title. We're getting ahead of ourselves though, so with a tip of the hat to the audience

members gamely attempting to pogo to the track, we move on. "Who's next?" Wrighty calls out. "I dunno, some old... somebody next."

CLIFF RICHARD - Dreamin' (#20)

What you did there: I see it. A swift cut to Cliff's backing band missing their singer, then to Cliff minus his backing band, and then the two together. This was the only time in this short period of celebrity guest hosts that one of them had to nip out halfway through to go and sing, and clearly Cliff isn't quite sure of the protocol. The weather is too nice for him to be wearing his jacket, but because he's had to move between stages he's got nowhere to hang it up so he's had to bring it with him, tossing it casually over his shoulder but also holding on to it lest it should slip off and become lost forever in the dry ice, or even worse, one of the thieving pogoing types in the crowd should half-inch it. *Dreamin'* is another of those songs from the difficult period when, regardless of your opinion of Sir Cliff as a person, he was releasing some great pop songs which are very hard to dislike. I mean, it's no *Devil Woman*, obviously, but it's pretty good. You probably shouldn't be calling women up at five in the morning though, Cliff, that's not going to get her on your side.

DAVID BOWIE - Ashes to Ashes (#1)

The top ten countup is still being tinkered with; it's now becoming horribly complicated with the video clip inset into the slide where the still picture would go, before fading into the same clip in full screen, for each song. Just tell us what the songs are, we'll understand! There's still absolutely no bass on the Gap Band clip either. "What a top ten," enthuses Cliff, now returned to his hosting position, "I'll never get into it." Last week's highest new entry has deposed ABBA at the top of the chart; it's that old familiar *Ashes to Ashes* ~~video~~ piece of film again, but what you may not know is that the padded cell set was first used for a performance of *Space Oddity* on Kenny Everett's ITV show the previous December. Reduce, reuse, recycle. Meanwhile, Cliff's off to South Africa for a month, a revelation which we don't dwell on, and we play out with the crowd milling around to ELO's *All Over the World*. It's the return of an old favourite hosting duo next week, so no doubt Twitter will be appalled.

August 28

"I don't care about the rest of the year"

Given that BBC Four has spent four years rerunning episodes of *Top of the Pops* as historical documents from 35 years in the past, it's an unavoidable fact that there are certain people whose presence on the show is less welcome than others. Obviously Jimmy Savile and Dave Lee Travis are strictly out of bounds (although the justification for the latter's absence is significantly flimsier than for the former). Then we have the likes of Jonathan King - who served his time and is now apparently allowed to be seen again - and Gary Glitter, whose eligibility for the show seems to be in a constant state of flux. Yet none of these people have drawn as much flak from social media over the past year or so as one man, a man whose every appearance on TOTP provokes an outpouring of foul-mouthed hatred so vitriolic that even Peter Powell doesn't want to co-host with him. "I pleaded with them, I begged with them, please don't let me do *Top of the Pops* with B.A. Robertson... and look what I got." For some reason Robertson is opening with the same "Look, I'm really short" gag he opened with on the unbroadcast pilot episode last month, although his claim to be following "other great guest presenters like Atilla the Hun, Dame Edna Everage and Elton John" is at least one-third accurate.

THE BARRACUDAS - Summer Fun (#37)

Let's be frank, the main selling point of the Barracudas' only hit single was the introduction, based on a genuine 1966 US car commercial which attempted to sell the Plymouth Barracuda to hip young things via a hapless square salesman who *"can't pronounce Baccaruda"*. Of course we can't have advertising on BBC Television (even for a product that wasn't available in the UK, although it was perfectly acceptable on Radio 1) so here's B.A. to deliver the same idea in a much less entertaining style. "For the first time on TOTP this week, it's the Pacaroonies!" The what now? With its novelty intro replaced by a weedy *"1-2-3 rock!"* that could easily be The Ramones - especially now that they're all dead - the band still turn in an energetic performance of their classic punk / surf / power-pop hit. Singer Jeremy Gluck is particularly vigorous, jumping around and shaking his head in a desperate attempt to disguise how much he looks like Rowan Atkinson, while the rest of the band are required to wear dark glasses to combat the glare from their white denim outfits. Alas, despite their enthusiasm, *Summer Fun* failed to climb any higher than number 37 and was their only hit, so the washing powder commercial never came to fruition.

GARY NUMAN - I Die: You Die (#8)

We leave the Baccarudas and find B.A. physically assaulting Peter Powell for reasons unknown. Robertson does his "Pacaroonies" joke again and proceeds to introduce Nary Guman, receiving an audible bonk on the head from Powell's microphone for his troubles. There'll be tears before bedtime at this rate. ~~Nary~~ Gary isn't in the studio; he hasn't been since last Christmas and won't be again until just before this Christmas when he shares the bill with Chas & Dave, the Barron Knights and the St Winifred's School Choir. You can pick your moments, can't you Gary? Instead we get the video for *I Die: You Die* which consists largely of shots of Gary in his car and shots of Gary in the studio. It sounds horrible too, as if played off a worn out 78. After his two number ones in 1979, Numan was now a major cult artist but having trouble crossing back into the mainstream; he had a big enough fanbase to send *I Die: You Die* straight into the chart at number 8, but not sufficient crossover appeal to propel it any higher than number 6, after which it sank like a stone.

THE SELECTER - The Whisper (#44)

Like Numan, the Selecter had quickly become aware of the law of diminishing returns. Attempting to broaden their horizons, the band had moved away from the 2 Tone label and signed directly to its parent label Chrysalis, while Pauline Black dared to dress in red and white rather than the compulsory monochrome of previous releases. Sadly, the song just wasn't up there with the quality of their previous hits and stumbled to number 36, becoming the band's last hit single. Black went solo the following year with little success, while the rest of the band split soon afterwards. Having spent the rest of the decade inserting a digit into various pies, from portraying Billie Holiday in a stage play to hosting kids' game show *Hold Tight*, Black reformed the Selecter in 1991 with original guitarist and songwriter Neol Davies. Pauline still leads a version of the Selecter today; their 2015 album *Subculture* saw them back in the top sixty for the first time since 1981.

MIKE BERRY - The Sunshine of Your Smile (#10)

After a rambling and barely coherent introduction from B.A. Robertson it's the return of TV's Mike Berry, who we saw patiently waiting in the background while the Selecter were on and who now gets to sing his song. Although popular legend has it that the all-powerful hand of Michael Hurll swept away all the easy listening and light entertainment nonsense the day he took over TOTP, it's clearly not true, just as punk failed to infiltrate the show in any meaningful way despite what the 2012 TOTP documentary *The Story of 1977* may tell you. In reality Hurll's hands were tied as this was a massive hit; despite being as completely out of step with the musical zeitgeist then as it is now, it's still a

lovely song and it was produced by Chas Hodges out of Chas & Dave, so everyone who tweeted to say that they'd fallen asleep during it can do one. Although it was his last major hit, Berry did lots of other things in the '80s: he replaced Trevor Bannister in *Are You Being Served?*, made a memorable TV ad for Blue Riband biscuits and inadvertently became a groundbreaker in multimedia technology when his song *Everyone's a Wally* was released as part of the computer game of the same title: program on side 1 of the cassette, song on side 2, like an early Enhanced CD. Remember those? Blimey, I feel old.

THE SKIDS - Circus Games (#33)

Things are getting physical between Powell and Robertson as Pete sticks his hand over B.A.'s mouth to stop him singing, only for the lanky Scot to bite it. "You're the first donkey we've had on this show," Powell tells him, which is clearly untrue as anyone who saw the Roger Daltrey edition will testify. Coming to Powell's rescue are the Skids, fronted by TV's Richard Jobson. Normally Jobson was wont to leap about, arms flailing, in an elaborate game of "The Floor is Made of Lava"; fortunately tonight someone (probably B.A. Robertson) has taken the pre-emptive measure of gluing Jobson's shoes to the floor, meaning that his performance more resembles a Wacky Waving Inflatable Arm Flailing Tube Man. This was the Skids' last top forty hit and the last time we'll see them on the BBC Four reruns, although they will be back in a couple of weeks on an edition hosted by Public Enemy No.1.

ELTON JOHN - Sartorial Eloquence (#48)

Being Scottish, of course B.A. knows the Skids: "They're tremendously well educated young men... before I met them I thought Jean Paul Sartre played right back for Barcelona." Powell's resulting "What do you know about football?" line is a setup for a link into Elton John via Watford that's so obvious the keeper saw it coming from the halfway line, but it would be remiss of me not to remind you that B.A. wrote and produced the 1982 Scottish World Cup Squad song *We Have a Dream*. Anyway, Elton's latest assault on the chart is from the period when he was estranged from long term lyrical collaborator Bernie Taupin, leading him to have a go at writing with Tom Robinson, formerly of *2-4-6-8 Motorway* fame and now a DJ on BBC 6 Music. Sadly Elton wasn't ready to come out with something as brash as Robinson's *Glad to be Gay* so instead we get a nondescript ballad which Dame Elton performs in a jockey's cap and schoolboy blazer, rather making a mockery of the song's title. *Sartorial Eloquence* peaked at number 44 and Elton was still a year and a half away from returning to the top ten.

SUE WILKINSON - You Gotta Be A Hustler If You Wanna Get On (#25)

The 30-11 countup is next, Powell finally coming to terms with the sheer speed of the thing, before we're tossed back down to number 25 for another performance of this... oddity. Slade's Don Powell (no relation) is back pretending to be playing drums, a favour to bandmate Jim Lea, co-owner of Cheapskate Records who released the single. Slade themselves would soon sign to the same label having revitalised their career with a legendary performance at the 1980 Reading Festival. Annoyingly this fascinating piece of social comment set to minimalist electronica still isn't on iTunes or Spotify or anything, which seems a terrible oversight as it could have sold well as one of those bizarre records you'd forgotten about or never heard before until the TOTP repeats brought it to your attention. This was, inevitably, Sue's only hit; this and the rest of her output are lost to the mists of time (or the vagaries of whoever owns the rights to the Cheapskate back catalogue) although she did attempt a comeback in 1987 with a single *Toy Boys* on the Hustler label. Don Powell went back to Slade for their renaissance in the early '80s; sadly Sue died of cancer in 2005.

IAN DURY & THE BLOCKHEADS - I Want to be Straight (#39)

Criminally cut from the 7.30 edit by someone who clearly knows nothing about musical history but has to get the show down to a tight 28 minutes at any cost, this was Dury's first single since *Reasons to be Cheerful Pt 3* a year earlier, during which time there had been some upheaval in the Blockheads' line-up, so it's only fair that they should get to introduce themselves individually at the start of the track, with varying degrees of menace. In fact it's all quite amiable until we get to the band's new guitarist, the indefatigable Wilko Johnson, formerly of BBC Four favourites Dr Feelgood, and indeed this must be the first time BBC Four has cut him out of anything. Wilko, of course, has become a national treasure in the past few years as he fought a long and very public battle with cancer and - remarkably - seems to have won, albeit after having numerous parts of his body removed. Dury, on the other hand, succumbed to the disease back in 2000, yet here they both are in their pomp. A shaven-haired and strangely made-up Dury leads us through what isn't perhaps his catchiest single but one which is more representative of his uncompromising style than his bigger, better known hits. Wilko, of course, is just Wilko.

VILLAGE PEOPLE - Can't Stop the Music (#17)

Now I know what you're thinking, "Everyone has managed to make it in to the studio this week, except that wastrel Gary Numan who you're dying to tell us again is older than Gary Oldman, but if all the acts are here, where is our

favourite literal interpretive dance troupe?" Well, do try and restrain yourselves but I'm afraid Legs & Co are not on the show this week. They're "on holiday" according to Peter Powell, which conjures up all sorts of images of the girls sharing a chalet at Butlins, going to the bingo and dancing in a circle around the lucky winner who's just deprived them of a full house, reproachfully wagging their fingers at him or her. Still, don't despair because Pete tells us we have "the next best thing" - that clip from the Village People movie again. Not sure whether that's a bigger slight on Limbs & Co or the Village People. This is almost the last we'll see of the People on TOTP; their brief reinvention as a poor man's Frankie Goes To Hollywood in 1985 fell flat when *Sex Over the Phone* only just made the top sixty, so their only appearance on the show after this was a brief video clip when a remix of *YMCA* became a hit in 1993. No doubt Roger Daltrey was furious.

JUDAS PRIEST - United (#49)

But if you're a fan of the Derek Smalls look, don't fret, because here comes the man who invented it. No, not B.A. Robertson - *"Can't Stop the Music* from the Village People, and I'm glad I don't live in their village... don't laugh, you're not here to enjoy yourself y'know" - we're talking about Rob Halford, leader of Judas Priest and high-camp leather-clad NWOBHM icon. Like Ian Dury he's had his hair cut surprisingly short, dispensing with the pudding bowl cut which made him resemble Graham Chapman a few months back. *United* is a no-nonsense "everybody come together, it'll be great" anthem which, if anything, is a bit *too* no-nonsense - it sounds like a demo recording, crying out for some exciting production tricks to lift it off the ground and rubbing our noses in the fact that The Event deprived us of their greatest single *Breaking the Law* back in June. Like Samson, Halford seems to be have been robbed of his power by having his hair chopped off, turning in a lacklustre performance in which he seems to be more concerned with chewing gum than actually lip-synching to the song. A disappointing performance all round, which is a shame as the song deserves better.

DAVID BOWIE - Ashes to Ashes (#1)

So on with the top ten countup, which still isn't quite working somehow and seemed to be better that one time they just overlaid the captions straight onto the video clips. Never mind, because *Ashes to Ashes* is still number 1 and David Bowie is here in the studio! No, sorry, of course he's not, it's the video again. Still, we're only about six months away from the point where you can discuss just how much of an influence the *"My mother said to get things done you'd better not mess with Major Tom"* line was on the outro of Landscape's hit *Einstein A Go-Go*. Powell and Robertson close the show amongst a throng of

excited audience members, or perhaps they're about to get lynched, it's hard to tell. We play out with a static camera shot of the crowd dancing uninterestedly to The Beat's new single *Best Friend* as we come to an interesting point in the BBC Four reruns. With only a week to go before the Proms take the repeats off air over the summer, we're going to have to jump into mid-September for a week before disappearing. That episode won't be here for a while though, as we have two forbidden episodes to get through first.

September 4

"Don't waste your money on a new set of speakers"

A full month into the new look *Top of the Pops* and a pattern is starting to emerge: all the guest presenters have singles out. Admittedly Elton was between singles on his hosting stint and while B.A. Robertson had *To Be Or Not To Be* in the chart when he hosted the pilot episode it had long gone before his only broadcast appearance, but other than that the theory is completely watertight. Hold on though, because the Hairy Cornflake's glamorous assistant tonight is that legendary musical heavyweight... Kevin Keegan? Surely the permanently-permed goal machine doesn't have a record out? But yes! Having signed for Southampton after three seasons in Hamburg, Keegan was so keen to get back to his home country that he recorded the homesick ballad *England* and watched it fail to set the chart alight the way the previous year's *Head Over Heels In Love* had (it got to number 31). To be fair, Keegan's 1979 hit had the hitmaking stamp of Smokie's Chris Norman and Pete Spencer all over it which England didn't, although the epic 6 minute plus *Somebody Needs* on the B-side deserved more success. All this is covering up the fact that BBC Four wouldn't show this episode because of DLT and the only version I could get hold of has the introduction cut off, but I'm sure it wasn't any more edifying than the rest of the show.

SECRET AFFAIR - Sound of Confusion (#45)

As we push on through 1980 it's becoming clear that the ska and mod revivals that took hold last year are beginning to lose momentum. We saw last week that The Selecter had begun to take a more mainstream approach, with The Beat and Madness following suit in due course. Similarly Secret Affair, one of the leading lights of the mod revival, are also moving towards a more pop-based sound. *Sound of Confusion* is a great little song but it feels like it has more in common with the jangly guitar indie-pop bands of the early '80s than the '60s mod movement, despite bassist Dennis Smith's stubborn refusal to ditch his stripy blazer. With the exception of Madness, most acts from this era found it hard to move on from their roots and take their audience with them; Secret Affair faired particularly badly in this area, *Sound of Confusion* failing to climb any higher than number 45 making this their last appearance on TOTP. The band split in 1982 but reformed twenty years later, with singer Ian Page and guitarist David Cairns fronting a new line-up of the band which still tours and finally released a third album in 2012.

KELLY MARIE - Feels Like I'm in Love (#3)

Someone showing absolutely no inclination to move with the times is Dave Lee Travis, who takes co-host Keegan aside and asks him conspiratorially, "Do you like redheads?" "Well... I like Alan Ball," squirms Kev. Also in need of change is the redhead DLT was referring to, Kelly Marie who's back again doing the same routine with the same dancers to the same song that feels like it's been on the show a million times and it's not even got to number 1 yet. Whoops, spoiler alert. One fact of possible interest to those who care about these sorts of things is that *Feels Like I'm in Love* was the last ever UK number 1 single on Pye Records, home over the previous two and a half decades to such luminaries as Petula Clark, The Kinks and, er, Brotherhood of Man, but about to come to a shuddering halt as the label's lease on the Pye trademark ran out. Hopefully Kelly's lease on that terrible black jumpsuit will also run out in the near future.

NICK STRAKER BAND - A Walk in the Park (#22)

"Not only a beautiful redhead but also a great dancer and singer," stumbles Kev, unable to make eye contact with the camera for more than a second and apparently distracted by the presence of the Nick Straker Band in his eyeline. "They're gonna take you for a walk in the park," he warns, but are they really? We established two weeks ago that this wasn't the real Nick Straker Band because they had all quit to become New Musik, so how do we know this is even the real Nick Straker? He looks an awful lot like Simon Farnaby from *Horrible Histories*. And isn't that Stig O'Hara from The Rutles on drums? Actually it could be, because although Stig was the Rutles' guitarist, his real life persona Ricky Fataar is a drummer, so unless anyone can conclusively prove otherwise I'm going to go ahead and start the rumour that Stig isn't dead, he went off to play drums in the Nick Straker Band, which is possibly worse.

HAZEL O'CONNOR - Eighth Day (#5)

You'll have noticed that this week's show is distressingly similar to the one two weeks ago, as the charts stagnate over the summer while everyone goes on holiday and stops buying new records. Only three songs on this show haven't been on before, and one of those was last week's playout track. The new *enfant terrible* of Rock Cinema (a particularly niche genre which I've just invented) hasn't even turned up for a second appearance, so we get a repeat of Hazel's vaguely unsettling performance from a fortnight previous. This was the highest position for *Eighth Day* and Hazel never really managed to forge a career from her role in *Breaking Glass*; although she did score three top ten hits, the biggest one after this was *Will You*, another *Breaking Glass* track belatedly released as a single nine months later. In fact A&M Records were still releasing O'Connor singles from the soundtrack as late as 1982, which scuppered her own post-

movie single releases and, in turn, her career. That's the music business for you.

BILLY JOEL - It's Still Rock 'n' Roll To Me (#20)

An unnecessarily long, rambling intro from DLT, most of which is drowned out by audience noise, leads us into the first part of the chart countup which, curiously, features the eleven records between numbers 30 and 20. We pause here for Billy Joel (not Jo-elle, because if nothing else, at least Travis has learned to pronounce Billy's surname before most of his peers) who isn't here because he's far too important to bother with a poxy little British TV show. In fact Joel never appeared in the TOTP studio, not even when he was enjoying five weeks at number 1 with *Uptown Girl* which you'd think would be enough reason for him to get on a plane, and even the 2001 TOTP2 Billy Joel Special was all videos. We saw the video for this two weeks ago though, so... enter Legs & Co! Yes, fresh from their summer holidays where they all had their hair braided, the girls are back to fanny about in non-matching red / yellow / green dresses which they bought on holiday in the hope that they would get to dance to Bob Marley when they came back instead of this. Better luck next time, ladies.

CLIFF RICHARD - Dreamin' (#10)

"Legs & Co, looking like an explosion in a paint factory... Aren't they beautiful? Gay colours, that's what *Top of the Pops* is all about." Stop there, Travis, you're just digging a hole for yourself. On with the countup, from 19 to 11, after which DLT is accosted without warning by Hank Marvin, appearing from nowhere and for no other reason than to introduce his erstwhile colleague Sir Clifford of Richard. As we move closer to autumn the weather has clearly taken a turn for the worse and Cliff is forced to keep his jacket on this week, rather than have it dangling over his shoulder as in his last appearance. Despite his grumbling two weeks ago that the top ten was so good he'd never get into it, here he is at number 10 still riding the wave of his career resurgence which began with *We Don't Talk Anymore* a year ago and would carry on for at least another year with gems like *Wired for Sound* and *Daddy's Home* still to come. Sad then to think that he would eventually lower himself to dreck like *The Millennium Prayer*. Never mind, this is a fine single although it's probably best if we draw a discreet veil over Cliff's keyboard player who, in tribute to Kevin Keegan, has turned up in an unpleasantly short pair of nylon football shorts. Ewww.

SHEENA EASTON - Modern Girl (#13)

Speak of the devil, just when you had convinced yourself that the presence of Kevin Keegan as co-host was so improbable you must have imagined it, here he is again, but now sporting a lavish fake beard because, yes, he *is* Dave Lee

Travis. But so is Dave Lee Travis. Confused? I know I am, and the situation isn't helped by Keegan bashfully mumbling his way through the sketch, reminding viewers that he's doing the Radio 1 breakfast show tomorrow so "don't forget to watch." Travis glosses over this glaring error by reverting to interviewing football's Kevin Keegan: "Have you got a record out at the moment, by any chance?" "I have," sighs Kev, "it's shooting up the charts... from number 81 it went down to 200 this week." Travis then proceeds to prove that if Keegan can do his show, he can play football just as well, heading a conveniently thrown football clear out of shot by about six inches. "None of that body contact," he gloats, before losing the moral high ground by turning it into a link to Sheena Easton - "I wouldn't mind a bit of physical contact with our next lady though." Yes, it's Sheena "two records in the charts" Easton, who has two records in the charts. Although *9 to 5* was only on the show once, it's still outselling this which is now on its second TOTP appearance. This is a repeat of her previous performance of *Modern Girl*, which is pretty disappointing for someone with two records in the charts. Did you know she had two records in the charts? Well, she does.

THE BEAT - *Best Friend (#27)*

After a mercifully brief edit of Sheena Easton (did you know she has two records in the charts? Amazing, isn't it?), it's an inelegant cut into the video for this latest effort by The Beat. As previously discussed there's a general feeling that the 2 Tone movement has run its course and *Best Friend* seems to be a conscientious move towards jangly brassy guitar pop, with everyone dressed in different brightly coloured shirts like a ska Showaddywaddy, although the inclusion of Ranking Roger and Saxa in the band's line-up limits just how far they can move away from their 2 Tone roots. With that in mind, the single was released as a double A-side with a dub mix of the band's anti-Thatcher rant *Stand Down Margaret*, although the dub effects only distract from the message of the song when a straight release of the song itself would have been a much more effective protest. After three top ten hits from their first three single releases, *Best Friend* could only reach number 22.

RANDY CRAWFORD - *One Day I'll Fly Away (#26)*

Anxious to get as much TV exposure as possible at all times, Sir Cliff has - apparently without invitation - joined Dave and Kev for a quick interview between songs. "What about the charts generally?" Travis asks. "How do you think the charts are going as far as different types of music are concerned?" If that's not a leading question I don't know what is. "I think at the moment there's something in the charts for everyone," obliges Kev, lamely. More fittingly, Dave asks Cliff what he thinks about Elvis being back in the charts - oh yeah, Elvis is

September 4 151

back in the charts, but we'll come to that next week. "It doesn't matter what I think," Cliff shrugs, "B.A. Robertson's hairdresser thinks he's terrific." This baffles Travis who clearly hasn't been watching the show for the past couple of weeks and missed the running gag about Cliff's hairdresser. Moving on, DLT urges decorum for "the best record you've ever heard in your life," to no great interest from his charges. "If you fly away eventually, I'll wait," deadpans Cliff. We'll be seeing more of this over the next few weeks so, other than to say it's absolutely not the best record you've ever heard in your life, let's leave it there for now.

THE JAM - Start! (#1)

And so, as has become the norm, we countup the top ten (including Sheena Easton, who has two records in the charts) to discover that David Bowie has been squeezed out of the number 1 slot by a band DLT can't mention because he's on a diet. "Big cream cake?" Keegan suggests. "Greasy bacon sarnie?" No, ha ha, it's the Jam. A quick run through the ~~Taxman~~ *Start!* video again and we're at the end of the show. We play out with *Bankrobber* by The Clash – who, despite the often-repeated fact that they never appeared on *Top of the Pops*, seem to still get their music on the show with alarming regularity – but Kev has enjoyed himself so much that, like a game show contestant, he's decided he'll come back next week. Once you've seen who's hosting next week, you'll wish he had.

September 11

"Please keep in touch, I'll be running along"

Now then, now then, what 'ave we 'ere? An episode of *Top of the Pops* nominally hosted by Jimmy Savile who, lest we forget, is still number one – Public Enemy No.1, that is, so this is another show that's gone missing from the BBC Four reruns. Shame really, as it's a particularly odd one, with the guest presenter idea already falling apart and Sir Jim'll just bringing in people he knows to do bits of the show seemingly at random. The closest we have to a co-host this week is Richard Skinner, at the time one of the main newsreaders on Radio 1's *Newsbeat* but with some experience holding the fort after Kid Jensen decamped to the States and soon to graduate to a show of his own on the station. Within half a decade he would be making the opening announcement at Live Aid, but today on his TOTP début he just stands around being the sensible one in a grey cardigan. Savile vaguely promises us "music with a difference" (he's certainly right there; if you squint you can just make out that he's wearing a Splodgenessabounds lapel badge) as well as "music you expect" which, as usual, means Kelly bloody Marie.

THE SKIDS - Circus Games (#32)

But first, fire up the subtitles one last time for The Skids – "right alongside so as I could touch 'em," Savile threatens – who are back in the studio for the final time. The pre-recorded children's choir adds a slightly sinister touch to an already Yewtree-troubled show and while still desperately trying to unstick his shoes from the floor, Richard Jobson has come as a cricketer tonight and – ha, yes – they've had a good innings but this was their last top forty hit and final TOTP performance. Guitarist Stuart Adamson went on to enjoy greater success as the frontman of Big Country while Jobson formed The Armoury Show to little acclaim and went on to pursue a career in television and, later, as a film director. The Skids, meanwhile, enjoyed a minor renaissance in 2006 when their 1978 single *The Saints Are Coming* was unexpectedly covered by U2 and Green Day as a charity record for the victims of Hurricane Katrina. Fortunately the Red Hot Chili Peppers' version of *Working for the Yankee Dollar* remains non-existent.

BLACK SABBATH - Paranoid (#17)

It's all go on the show tonight, as no sooner has Savile brought on Skinner with a clutch of mysterious framed items under his arm, Skinner introduces another guest – Diana Ross! Yes, even though she never ever turns up to plug any of her records, Miss Ross is actually here tonight, if only to accept a clutch of silver and platinum discs for her most recent releases. Savile asks her if she wouldn't

mind, instead of disappearing back to her dressing room, hanging around and mingling for a bit; "I'd like that very much," she says through gritted teeth as if to imply that she'd rather be asked to kick a football into a goal for the World Cup opening ceremony. As Richard chaperones Diana out of Jimmy's clutches, we return to the chart and... UNEXPECTED ITEM IN BAGGING AREA. Ten years after giving the Sabs their first hit single, *Paranoid* was back in the chart. By this time Ozzy Osbourne had been ousted from the band and replaced by Ronnie James Dio, this new line-up recording the album *Heaven and Hell* and embarking on a world tour. The Ozzy camp was displeased, however, and their loyalty saw this reissue outsell the band's "proper" new single *Neon Knights*, while a live album *Live at Last* recorded in 1973 and released without the band's permission outperformed *Heaven and Hell* on the album chart. Although the band had performed *Paranoid* on TOTP back in 1970, here it was represented by a grim live clip from several years later, with Ozzy in full frilly sleeved Elvis jumpsuit mode, which would have made a nice segue into the real filly sleeved jumpsuited Elvis if the running order had been arranged slightly differently.

IAN DURY & THE BLOCKHEADS - I Want to be Straight (#25)

Moving on, Savile inexplicably talks to a couple of girls with A Flock Of Seagulls hair which impresses him so much he decides to give them the top six singles - three each - but any impropriety is nipped in the bud as we bring on Ian Dury & the Blockheads, all - and you couldn't make this up - dressed in full police uniform. As if Wilko wasn't threatening enough in civvies. It's the end of another era here as, only two singles after the monster hit *Hit Me With Your Rhythm Stick* this was Dury's last top forty hit and final TOTP appearance, although he tickled the underbelly of the chart in 1985 with the Adrian Mole TV theme *Profoundly In Love With Pandora*. Shortly before his death from cancer in 2000 Dury released the critically acclaimed comeback album *Mr Love Pants* and collaborated with long term fans Madness on their single *Drip Fed Fred*; Dury's life was later chronicled in the 2010 biopic *Sex & Drugs & Rock & Roll*. The Blockheads continue to perform and record despite their erstwhile leader's persistent absence while Wilko, having seemingly recovered from terminal cancer, continues to be a law unto himself.

ELVIS PRESLEY - It's Only Love (#7)

What better way to celebrate the life and career of Ian Dury than by bringing on Leo Sayer for no apparent reason to do a completely fact-free interview? "What about the new record?" "Yeah, I'm just doing a recording for it here actually." "How's the folks?" "They're very good, me mum sends her regards." After his allotted thirty seconds Leo is hooked around the neck and yanked off stage again, while Savile introduces an act he's actually heard of, the one and only

King of Rock 'n' Roll, Mr Elvis Presley! Er, except, hang on, Elvis has already been dead for three years at this point. This would at least explain his relative lack of hits since 1977, a situation which was curtailed by this release of a 1971 minor US hit which hadn't been a single in the UK until now. Quite why it was deemed worthy of release at this stage isn't really clear, but it quickly became Elvis's biggest hit since his demise and required a TOTP appearance. Elvis's manager "Colonel" Tom Parker was an illegal immigrant to the US who feared he would not be allowed to return if he accompanied Elvis out of the country, hence the reason Elvis only ever performed in the States, so really the chances of Elvis appearing on TOTP in 1980 were about as good as they were while he was alive. Nevertheless Presley failed to show up from beyond the grave, so... enter Legs & Co! Dressed in cowboy hats and the remnants of Elvis's old white jumpsuits which had apparently been shredded following his death (other than the one acquired by Ozzy Osbourne earlier), the girls gyrate aimlessly to what would be The King's last hurrah until the JXL remix of *A Little Less Conversation* returned him to number one 21 years later.

SHAKIN' STEVENS - Marie Marie (#21)

Another change in TOTP format now as Savile, ever the gentleman, finds a young lady who is "considering fainting" and decides he "must take her away to a place of safety." As a nation who now knows lots of things it didn't know in 1980 rolls its collective eyes, Richard Skinner gamely reads out some music news, concerning the release of the new Police album, the arrival of Kiss for a UK tour and a glaringly obvious edit, although whether this was in the original broadcast or the '90s UK Gold repeat isn't clear. The 30-21 chart countup follows, pausing at 21 for the Welsh Elvis himself, following his idol on the show for surely the only time. Although he's been on several times already this year, this is a watershed for Shaky as this performance sees the introduction of his classic double denim look. It also provides final and conclusive proof that the video screen, a major feature of the post-strike brave new world of '80s TOTP, is blatantly black and white. For shame. After a fortnight at number 21 this would climb to a peak position of 19 the following week, making it the first of twenty-two consecutive top twenty hits for the Shakester.

JUDAS PRIEST - United (#26)

Back to Skinner for more news, including Blondie who are "changing their sound because they're fed up with rock 'n' roll" (an apoplectic Shakin' Stevens is now almost certainly being forcibly restrained by two burly security guards and bundled back to his dressing room). Another quick chart countup takes us back down to number 26 for a repeat performance from Judas Priest, and it's the end of yet another era as this was also the Priest's last TOTP appearance. Although

September 11 155

they continued to score minor hit singles for another thirteen years – and are still regular visitors to the album chart to this day – *United* was the band's last top forty hit. Since then the Priest is best remembered for the ludicrous 1990 court case which suggested that a subliminal message in one of their songs prompted two of the band's fans to commit suicide; and for vocalist Rob Halford's coming out in 1998, as if anyone familiar with his leather-and-chains stage getup was still in any doubt. The band undertook an alleged "farewell tour" in 2011, but refused to lie down, releasing a further album *Redeemer of Souls* in 2014 which they then proceeded to tour.

SPLODGENESSABOUNDS - Two Little Boys (#40)

You have to feel for Splodgenessabounds. They scored their first and biggest hit back in June when The Event was keeping TOTP off air: the A-side *Simon Templar*, based around the lead character from TV action series *The Saint*, was overshadowed by one of the B-side tracks, the fantastically insistent *Two Pints of Lager and a Packet of Crisps Please*, the success of which took the single to number 7 (for completeness' sake, mention should be made of the EP's third track, *Michael Booth's Talking Bum*, the inclusion of which quite probably kept the record from getting any higher). Now their one and only TOTP appearance has been stricken from the public record thanks to Operation Yewtree feeling the collars of not only the show's host, but also the artist most associated with the song they chose for their novelty cover version follow-up. Released with the catalogue number ROLF 1, Splodge's version of *Two Little Boys* is an anarchic yet affectionate rampage through the last number one of the 1960s, each member of the band determined to bag themselves as much screen time as possible, including hefty keyboardist Winston Forbe who at one point picks up his equally hefty keyboard and parades around the stage with it. This TOTP performance helped the single shoot to number 26 the following week but then it started to fall and Splodgenessabounds never troubled the top forty or TOTP again.

SPLIT ENZ - I Got You (#27)

"I tell you what," chortles Savile, "it's all happening tonight... let's hear it for the Bee Gees!" Yes, it's yet another random celebrity guest moment as Maurice and Robin Gibb are shoved onstage for a completely pointless, rambling interview. With nothing new for the Gibbs to promote, even Savile isn't sure where this is going. "Er, listen, I tell you what I'll do with you... see the group over there, do you recognise 'em?" "......No." Hardly surprising unless the Gibbs had spent a while in New Zealand lately as even though one or two of them went on to become pretty famous in the next decade, you'd be hard pressed to pick them out of the line-up. Dressed in different coloured suits like a new wave

Showaddywaddy, Split Enz make their TOTP début with what would be their one and only UK top forty hit. We'll see them properly on BBC Four after the annual lengthy summer break for the Proms, but it's not giving away too much to say that the famous ones are Neil and Tim Finn who went on to find greater UK success with Crowded House in the early '90s, by which time even the Bee Gees had a vague inkling of who they were.

KELLY MARIE - Feels Like I'm in Love (#1)

Before Savile can bring on any more random pop stars with nothing in particular to contribute, we get on with the top ten, now completely without numbers, just the act's name superimposed over a performance clip – can we please just pick a way of doing the top ten and stick to it? Anyway, the Bee Gees don't know what's number one either, and why would they? As Kelly Marie and her black & white minstrels get wheeled out again for the 27th time, still using that strange mix of the track that's not quite the same as the 7", Ray Dorset must be fuming that Elvis is in the top ten with a completely different song and not this one. Anyway, with the number one taken care of there's nothing more to do except for Richard Skinner to stand around looking uncomfortable between Savile and two Bee Gees and for him to get hit in the face with a balloon as we play out with Queen's *Another One Bites the Dust*. Another baffling and completely different episode of TOTP next week, oh yes.

September 18

"It's hotter than July"

Hey ho, another week, another TOTP, but something isn't quite right here. For once the problem isn't housewives' favourite Simon Bates grinning into camera for slightly too long before remembering to start speaking. "Hello and welcome to a slightly new look *Top of the Pops*," he grins, hesitantly, "because of our... small problems at the BBC." Yes, you guessed it, they're on bloody strike again. This time it's an actual BBC dispute rather than the Musicians Union strike which took the show off air for two months a short while back, and they've managed to work around the problem better than they did in November 1979 when the show was just pre-recorded clips and videos linked by an out-of-vision voiceover for two weeks. Alright, so this week's show is also just pre-recorded clips and videos, but at least they're linked in vision. Mind you, it's Simon Bates doing the linking so maybe that's not progress after all. The whole premise is very strange because although Simes is standing in an empty studio with only some lights in the background for decoration, we're still pretending that nothing is wrong, to the extent that the usual audience noise has been dubbed on even though there's quite clearly nobody there except a camera person, a sound person and whoever Bates can coax into the studio to pad out the show. Luckily Bates knows *a lot* of people.

XTC - Generals and Majors (#32)

Yep, something's definitely not right with the show this week: we're starting with a video. A video! Have they no respect for tradition? Never mind that it was directed by Russell Mulcahy, you don't start with a video! Especially one like this that's full of obvious symbolism such as the band dressed as waiters serving guns and medals on silver platters to some Generals and/or Majors. Still, it's interesting to see Richard Branson sending himself up as one of the Generals and/or Majors, and Colin Moulding's impression of Mañuel from *Fawlty Towers* is exquisite. This was XTC's second top forty hit, almost a full year after *Making Plans for Nigel*, and like its predecessor featured vocals by guitarist Moulding rather than the band's more regular singer Andy Partridge, which must have confused a lot of newcomers who bought up the band's already considerable back catalogue on the strength of the two hits. Bates informs us that "BBC television has just made a stunning film about XTC" - presumably he means *XTC at the Manor* which was indeed broadcast a few weeks after this show first aired. Not that Simes is really bothered, it just provides him with a nice link from TV screens to cinema screens...

RANDY CRAWFORD - One Day I'll Fly Away (#2)

...because here's Olivia Newton-John, who comes on to enormous fake applause from the non-existent audience. "I should be at the première of my movie," she suddenly remembers, which in all fairness is probably preferable than being interviewed by Simon Bates. There's an obvious edit in the BBC Four repeat to excise a clip from said movie *Xanadu*, presumably for financial reasons, which means we don't get to hear Olivia gushing about how wonderful it was to dance with Gene Kelly, nor do we have to squirm through Simes asking her what it's like having to dance in a tight skirt, to which her answer is surprisingly not "Mind your own business you creep." Also not dancing in a skirt – other than gently swaying a little – is Randy Crawford, who's still on her way up the chart with DLT's favourite record. There's no doubting the quality of Crawford's voice, but her static performance does nothing to enliven this soporific ballad; even having three Randys on-screen at the same time doesn't help matters. "Ooh, that lady can really sing," gushes Olivia, who's stuck around for a while at the behest of Simes, making her the first female to present TOTP since this repeat run began four years ago, and probably for a long time before that.

STEVIE WONDER - Master Blaster (Jammin') (#4)

Another video, or at least some concert footage of the former Steveland Judkins performing his latest (raising the question, why hasn't Stevie Wonder opened his own theme park? He could call it Steveland). This doesn't look particularly out of place or mark the show out as being odd, as Stevie hadn't graced the TOTP studio since 1974. Since then he's had half a car seat cover woven into his hair in a style no-one ever really managed to pull off, except perhaps Nick Beggs out of Kajagoogoo. *Master Blaster* is a tribute to Stevie's friend Bob Marley, albeit eight months before Marley's death, and despite giving away the punchline to Peter Kay's favourite joke "How does Bob Marley like his donuts?" it would go on to reach number 2, making it his joint biggest UK hit to date (alongside other number 2 hits *Yester-Me, Yester-You, Yesterday, Sir Duke* and later *Happy Birthday*), before *I Just Called To Say I Love You* came along and ruined everything.

SHEENA EASTON - Modern Girl (#8)

Talking of coming along and ruining everything, here's Simes again, trying to chat up an unimpressed Olivia by mentioning that Stevie Wonder had recently done a tour of the UK. Realising he has no way of linking this fact to the next song, Simes – ever the professional – decides to brazen it out. "Talking of that, and talking of ladies who've really made it..." Stevie may have long hair, Simes, but as far as I know he's all man. Simes goes on to fail to impress Olivia by comparing her to Sheena Easton on the basis that they're both female,

September 18 159

explaining the story of Sheena's career to date with increasing fervour until one might expect him to start wildly gesticulating, Magnus Pyke style. He doesn't though, because that would be interesting. Instead we're treated to a yawnsome third outing for *Modern Girl*, making it seem terribly unfair that *9 to 5* only got one. Did you know she had two records in the top ten? If DLT were here he'd tell you that, although *9 to 5* had dropped to number 11 this week so it wouldn't have worked.

NICK STRAKER BAND - A Walk in the Park (#20)

So, with music restricted to videos and previously shown clips, how else to fill up the time? Well, with some pop news, of course. Having exclusively revealed that Sheena's next single "should be *One Man, One Woman*" (maybe it should, Simes, but it wasn't) he goes on to show us the cover of the new Police album *Zenyatta Mondatta* but wisely stops short of attempting pronounce its name. "Talking of tours," which we weren't, The Dooleys are on tour, as is Cliff Richard. But never mind that, Simes, what about the chart? Obligingly, Bates takes us from 30 to 20, where we pause for another outing for the ~~Mike Batt~~ ~~Simon Farnaby~~ Nick Straker Band. We've established that the musicians on the record - essentially the members of New Musik - aren't the people miming to the track here, but we never did work out whether that was Stig from the Rutles pretending to play drums. Anyone?

MADNESS - Baggy Trousers (#21)

Funny how things turn out, isn't it? It's a good (or bad, depending on your point of view) thing that BBC Four managed to squeeze this episode in before the summer break because, well, I'm afraid Jonathan King has turned up. Not only that, he's brought with him some baffling thing which is only ever referred to as "an irritating game from New York". It's a Rubik Cube. Yes, Jonathan King was the first person to bring the Rubik Cube to British television; within a year it would be so ubiquitous that the Barron Knights would be doing songs about it. Anyway, after the next bit of the chart we get the video for Madness's *Baggy Trousers* which saves getting the band into the studio so they can get banned again. We're also treated to some genuine baffling 1980 censorship as the line *"Gone to fight with next door's school"* is mysteriously edited, the word "fight" being replaced by a corresponding syllable from another line of the song so Suggs now appears to sing *"Gone to not to next door's school"* which is utterly meaningless but at least doesn't encourage fighting in the playground. Playing the saxophone in mid-air, on the other hand, is perfectly acceptable.

BILLY JOEL - It's Still Rock 'n' Roll To Me (#15)

As I mentioned earlier, Simes knows lots of people, and who better to pad out this performance-light show than... Lynda Carter? Yes, just as comic book superheroes are all over the cinema screens these days, they were all over TV in the late '70s and early '80s, and Lynda here was famous for portraying Wonder Woman. What's that got to do with TOTP? Oh, of course, she's got a record out. On Motown, no less, and maybe 14 years from now if the TOTP repeats are still going and we get to see *I Want You* by Inspiral Carpets & Mark E. Smith, I'll tell you the story of the time The Fall almost signed to Motown. Anyhow, one of the benefits / misfortunes (delete as appropriate) of this strange TOTP format is that we don't get to see Legs & Co, as the powers that be have decided to show the video for *It's Still Rock 'n' Roll To Me* again rather than dig the L&C interpretation out of the archive. This seems to have been in the chart for months but still hasn't gone any higher than number 15; in fact it would climb one place higher next week before falling. We won't see Billy in the chart again for another three years, but by jingo what a comeback that will be.

KELLY MARIE - Feels Like I'm in Love (#1)

With only eight performances on this week's show, we still have plenty of time for Simes to ask Olivia all sorts of pertinent questions about her pets and her new single with Cliff Richard ("Whose idea was that, yours or his?" "Mind your business, four eyes.") before the top ten count-up and, yes! A fifth outing for *Feels Like I'm in Love*, whose presence is now about as welcome as that of David Cameron in a pork butcher's. The fake audience gives Olivia a standing ovation as she disappears off to her film première, Simes wishes us "lots of luck until next week's *Top of the Pops*" and we play out with Queen's *Another One Bites the Dust* for the second week in a row. What do they have to do to get on the show proper? Maybe we'll find out after the summer break...

September 25

"Strong words in the staff room"

The world of 1980 TOTP on BBC Four is a strange place indeed. Earlier in the year two entire months disappeared without comment as we skipped over The Event – which wiped out the whole of June and July – without a murmur. Now we come back from a break of ten weeks for the Proms, *The Sky at Night* and whatever else they can crowbar into the gap – and we've only progressed a week. Even stranger, when we do return we come crashing straight into the "coming up later" section with no introductory preamble. Another tweak as Michael Hurll attempts to fine tune the formula? No, it's the BBC Four editor again – Mr E. Scissorhands, as we established a few weeks ago – deciding that the modern audience couldn't stomach this week's celebrity guest host Russ Abbot dressed as a Boy Scout exchanging banter with Mike "this record is obscene and I'm not going to play it" Read. "Unfortunately the Beatles will not be appearing tonight," Russ warns us, "and you will not be grabbed by the Dooleys..." See, it's not just me using that joke, everyone was doing it back then. There's even a genuinely funny moment as the turn introduces himself to Read as "Russ Abbot, BSc." Read appears genuinely impressed. "You're a Bachelor of Science?" "No, Boy Scout." Why this section was excised remains a mystery, but having averted the potential of another unsavoury Daily Mail filler article, we move on with the show.

BLACK SLATE - Amigo (#35)

Off we go then, with "a bunch of guys from Hackney, North London, but come from Jamaica," however that works. This was the first and only top forty hit for Black Slate, but its bog-standard Rastafarian message – that Jah is your best mate and if you believe in him he won't mess you about or nuffink – is somewhat undermined by singer Keith Drummond's sombrero, a titfer of such gargantuan proportions it makes Speedy Gonzales look like a subtly underplayed depiction of everyday Mexican life. A catchy piece of pop-reggae like it used to be before UB40 devalued the genre with their radio-friendly karaoke, *Amigo* would rocket into the top ten next week, peaking at number 9. Black Slate carried on into the mid-'90s before splitting, but reformed in 2013 with new singer Jesse Brade – presumably chosen for his lack of colossal headwear – and are still performing and recording, having released their latest album *World Citizen* in 2014.

SPLIT ENZ - I Got You (#22)

"And talking of amigos, here is my amigo Leo Sayer!" Yes, not content with one

guest host, Read requires a second backup presenter in the shape of curly-haired songster Sayer, making his second non-singing appearance on the show in three weeks. Yes, he has a new single out, *Once in a While* which, despite being written and produced by pop legend Alan Tarney, made no impact on the top 75 whatsoever. Yes, Leo secretly wrote the lyrics to Cliff Richard's current hit *Dreamin'*, which is as good a reason as any for Read to wheel out his Cliff impression. Yes, the only way Leo can get on the show these days is as a guest presenter, so he makes himself useful by introducing Split Enz. This is a repeat of their performance from two weeks ago but it's the clip's first airing on BBC Four, so the Antipodean New Wave Showaddywaddy suits are still a surprise to most. Yes, it's baby Neil Finn on vocals, years before finding any kind of success with Crowded House. Yes, the fact that large sections of the audience are wearing police helmets goes unremarked upon; presumably they were something to do with Ian Dury's performance on the original show. Yes, it's a cracking one hit wonder. No, it's not as good as *Six Months in a Leaky Boat*.

DIANA ROSS - My Old Piano (#13)

Hang on though, Sayer's building his part up and coming back to introduce the next song too! Bear in mind that BBC Four viewers haven't seen Russ Abbot yet, so it looks for all the world as if Leo is the guest host this week. Oh boy, are they in for a treat in a couple of links' time. "Here's Miss Diana Ross, the wonderful Diana Ross," enthuses Sayer, all unnecessarily. She was in the studio with Leo and Split Enz and Public Enemy No.1 two weeks back, but having received her sales awards from Richard Skinner she clearly didn't hang around to record a performance for the show, as we're subjected to the video for *My Old Piano*. And what a video it is, with Miss Ross apparently in the lounge of a boarding house in Brighton where she strokes, dances around, rubs herself against and generally fetishises a relatively new-looking grand piano. Note that at no point does she actually attempt to play it. Like previous single *Upside Down* this came from the Nile Rodgers / Bernard Edwards produced album *Diana*, which Diana hated and insisted be remixed by someone else before release, proving that she knows as much about disco as she does about penalty taking.

QUEEN - Another One Bites the Dust (#7)

Queen, Read informs us, have been in the States for two months and have a Greatest Hits album coming out at Christmas. Indeed they did, but not *this* Christmas as it was pushed back until 1981 to make room for the band's *Flash Gordon* soundtrack. Maybe Queen weren't really in the US either, maybe they were at home watching TOTP and wondering why they'd bothered making a video for a single they didn't really like in the first place; after being used as the play-out track two weeks running, *Another One Bites the Dust* finally gets on the

show proper and... enter Legs & Co! Unfortunately the *Flick Colby Big Book of Literal Choreography* has gone missing, otherwise it might have fallen open at "dust" and we'd have had the girls doing the housework in PVC skirts and stilettos four years ahead of the *I Want to Break Free* video, which would have confused future pop music historians like me no end. Instead the literal interpretation extends no further than Pauline walking *"warily down the street"* and the others pointing at the camera every time the word "you" appears in the lyrics. Another opportunity missed.

OTTAWAN - D.I.S.C.O. (#8)

On with the relentless pace of the nation's fastest moving, most breathlessly exciting pop show as we stop everything for the Tedious News Section™. Read gets very excited about Toots & the Maytals and boxer Alan Minter, whose walk-on music for his next fight will be released as a single, surely the most tenuous piece of so-called pop news ever broadcast. It's almost a relief when Abbot's Teddy Boy character Vince Prince interrupts him – "'ey, just a minute, Eamonn" – to plug his own single, *The Space Invaders Meet the Purple People Eater*. You'll be devastated to learn that he doesn't get to perform the song on the show and it wasn't a hit, although 1982's *A Day in the Life of Vince Prince* reached number 62 and Abbot returned to TOTP in 1985 for a toe-curlingly uncomfortable performance of his inexplicable hit *All Night Holiday*. After the first section of the chart countup we're treated to the video for *D.I.S.C.O.* performed by one of the Gibson Brothers and a dancing parrot. BBC Four being what it is, this is the only time we'll see the video in full, so make the most of it, plumage fans.

SHALAMAR - I Owe You One (#16)

After the middle section of the countup (still awkwardly divided into 30-20 and 19-11, even when they're not pausing for the number 20 record) we get our first view of Shalamar on TOTP, three years after their first hit but still eighteen months away from their run of top ten hits in 1982-83. After a suspiciously high rate of staff turnover in the group's early years, *I Owe You One* was the first hit for the classic Shalamar line-up of Howard Hewett, Jody Watley and Jeffrey Daniel; Hewett in particular seems ill-prepared for his new role, having apparently forgotten to put his shirt on before going on stage. Don't worry, they're not in the studio, this is a clip of the group performing live in front of a throng of enthusiastic backing musicians who are apparently having a lot more fun than the audience, two of whom can be seen walking out during the first verse. Don't worry about what you owe us, Howard, we'll pick it up later.

164 September 25

LINX - *You're Lying (#43)*

Even Vince Prince has nothing to say about Shalamar, so he links us straight into, er, Linx. Let's get the roll call out of the way: the singer in the massive comedy specs is TV's David Grant, as seen on *Fame Academy* and even preschool kids show *Carrie & David's Pop Shop*; bassist Peter "Sketch" Martin is Richard Blackwood's uncle; keyboardist Bob Carter and drummer Andy Duncan were last seen as part of Hazel O'Connor's *Breaking Glass* band; and backing vocals came from an unseen Junior Giscombe. Undoubtedly the highlight of the band's performance comes when Carter, having apparently detached the keyboard from an old analogue synthesizer and slung it around his neck, attempts to play it one-handed while using the other hand to fiddle with the synth's controls, none of which seems to make any difference to the sound coming out of the machine. Like Shalamar, Linx would go on to have bigger and better remembered hits, although by the time of *Intuition* and *So This is Romance* they were down to a duo of David and Sketch. Still, the influence of *You're Lying* on Jimmy Nail's music career should not be underestimated.

THE POLICE - *Don't Stand So Close to Me (#1)*

Right, enough frivolity, on with the top ten countup, this week done without onscreen numbers but with a snippet of fascinating news about each artist in the top ten... until we get to Kelly Marie at number 4, at which point Read runs out of news. He does have a fascinating fact about the Police though, which is that they're only the seventh act ever to enter the singles chart at number 1. Despite the subject matter, *Don't Stand So Close to Me* is not drowned out by the Yewtree klaxon and we even get far enough into the video for Mr Sting to remove his jacket, shirt and tie in one well-practised movement. Just time, then, for a baffling final sequence involving Mike Read with a balloon up his jacket and Russ Abbot as Cooperman flinging himself face-first onto the studio floor. Don't worry kids, he's not hurt, although it might have been better for him if he was, as he's forced to get up and dance an awkward can can with Read, Sayer and some random audience members as *Searching* by Change plays us out. Somewhere in an office in Television Centre, Michael Hurll crumples up a piece of paper with "celebrity guest hosts" written on it and throws it in the bin.

October 2

"My middle name is Misery"

And yea, no sooner are we back from the seemingly endless summer break in the BBC Four reruns of 1980 TOTP than the spectre of Dave Lee Travis looms up again and we're skipping another week. Shame really, as this week it appears Travis is auditioning for a job on *Top Gear*. "I don't know if you're aware of this, but the Paris Motor Show opened recently..." I wasn't aware of that, Dave, no. "...and soon we've got the Birmingham Motor Show." Turn left at the Arc de Triomphe and carry on until you reach Spaghetti Junction, great. What's this leading up to, Travis? "Well, there is one car that they've both been trying desperately to get their hands on and it's here, under wraps, and nobody's gonna get it!" Dave, son, it's *Top of the Pops* you're doing, remember? Records and that? Oh dear, he's gone off on one. Still, let's press on, with our silk shirts open to just above the belly button to reveal our hairy chests and medallions in a way nobody has done since 1977... ah, no, that's just DLT.

GILLAN - Trouble (#22)

We kick off with a bit of Guitar Based Rock from Gillan, a band which former Deep Purple singer Ian Gillan formed in 1978 from the ashes of his previous band The Ian Gillan Band. No ego issues there, then. This was the first of six top forty hits for Gillan the band, with Gillan the singer epitomising brutality by standing stock still for the full duration of the performance, occasionally glancing menacingly towards the camera or – horrors – lifting one finger from its position curled tightly around the microphone. At no point does he look anywhere near as menacing as bassist John McCoy who, with his bald head, dark glasses and copious goatee beard, looks like he's just stepped out of the board game *Guess Who?* Written by legendary songwriters Lieber and Stoller, *Trouble* was first performed by a comparatively unthreatening-looking Elvis Presley in his 1958 movie King Creole, although it's hard to imagine a better version of the song than the one occasionally performed by the desperately missed Rik Mayall, which climaxes with the line *"I once showed my willy to Princess Anne."*

STEVIE WONDER - Master Blaster (Jammin') (#2)

In modern tabloid parlance, Travis is now sharing the stage with a curvy model clad only in a flimsy satin sheet, which he can't wait to remove, exposing her to the world. Yes, it's the car again. Two non-glamorous assistants peel back the sheet to reveal the "London Proof Car", the revelation only around 75% spoiled by Chas Smash from Madness walking in front of the camera at precisely the

right moment. Said vehicle includes a "Traffic Warden dispersal unit" (machine gun), "Polaris anti-taxi missiles", and double yellow lines painted along one side to aid parking. Just what you want from TV's top pop music show. Perhaps DLT could sell the car to Stevie Wonder, who is known to be keen on driving, to such an extent that the internet is awash with pages claiming that Wonder is not actually blind and has just been having us on all these decades. Certainly his video for *Master Blaster* is not particularly interesting to the sighted, a fact which TOTP addresses by repeatedly cutting back from the clip to the TOTP studio to watch various clods in boiler suits dancing on roller skates. There's a clod in silver boiler suit who thinks he's a robot, a clod in an orange boiler suit who looks uncomfortably like a young Frank Zappa, and some female clodettes in boiler suits (plus one in a white swimsuit, for some reason) who struggle not to fall over. If Stevie had seen it, I'm sure he'd have laughed too.

MATCHBOX - When You Ask About Love (#38)

Despite Vince Prince's best efforts to torpedo the rockabilly revival, it still refuses to die. The Middlesex branch of the Confederate States of America – still fighting the Civil War over a century after it finished – are back with another single, only this time it's not an uptempo rockabilly floorfiller but a sensitive Buddy Holly-esque ballad. The comedy quiffs and sideburns are still very much in evidence though, and singer Graham Fenton has spotted a conveniently placed blonde lovely at the side of the stage to whom he can sing the middle eight. His advice to her to *"rely on someone who's older"* seems a bit unnecessary though, not least because he's already old enough to be her father or a Radio 1 DJ, but also because his assertion that *"what you feel for me is infatuation"* suggests a *Don't Stand So Close to Me*-style Yewtree klaxon isn't far away. Despite the cloying sentimentality and the vague rumblings of inappropriateness, *When You Ask About Love* was on its way to becoming the band's only top ten hit.

THIN LIZZY - Killer on the Loose (#18)

Perhaps equally surprisingly, this was on its way to becoming Thin Lizzy's last top ten hit, even though nobody really remembers it very well. DLT promises us "an amazing film" at the start of the show, but in reality it's neither amazing nor, strictly speaking, a film. It's the band performing on an unconvincing, badly-lit, litter-strewn street – clearly indoors, because apparently they couldn't find a real badly-lit, litter-strewn street to perform in. Phil Lynott, sporting an unusual bit of chin-fluff to go with his trademark moustache, insists that *"there's a killer on the loose again."* If only the police who couldn't work out where the jailbreak was going to be had thought to try the jail first, they would have got the killer before he escaped and he wouldn't be on the loose. Who's running this police

department, Chief Wiggum? Still, as a rock legend and future TOTP theme composer, I suppose we can forgive Lynott most things.

CHANGE - Searching (#11)

Lounging against his London Proof Car and flanked by a couple of young ladies, including one of the roller skaters from earlier who wisely turns down an offer to buy the vehicle, Travis introduces us to Change whose previous hit *A Lover's Holiday* achieved notoriety as the playout track on the unbroadcast pilot episode of the show during The Event. Inspired by the similarly-named Chic, Change was a complicated studio-based project involving music recorded in Italy which was then flown to the USA to have vocals added to it. Far too complicated to appear in the TOTP studio, of course, so... enter Legs & Co! The fact that the ladies have, again, forgotten to put their trousers on cannot detract from the unavoidable observations that (a) that's Luther Vandross on vocals, and (b) it doesn't half sound like *Warning Sign* by Nick Heyward. This was as high as Change ever got in the UK chart and it would be another four years before they had another hit, their third and final top twenty entry *Change of Heart*.

ODYSSEY - If You're Looking for a Way Out (#20)

Cooling everyone down - especially himself - after Limbs & Co, DLT takes this opportunity to invoke the Tedious News Section™, and for a second week TOTP is amazed by the new Toots & the Maytals live album which was apparently recorded, pressed and made available for sale in the space of 24 hours - still a fairly impressive achievement today, given that we're talking about an actual vinyl album and not just an mp3 wristband that you can buy in the foyer 20 minutes after the gig. There's also a mention for the new Rod Stewart album which no doubt took considerably longer to make. Time for the chart countup, using the now established 30-20 format, meaning we pause at number 20 for Odyssey. Their dancefloor anthem *Use it Up and Wear it Out* had been another casualty of The Event over the summer, reaching number 1 regardless of the lack of TOTP exposure, but now they're back with one of the saddest songs ever written. Sung from the point of view of someone desperate to keep their partner from leaving, but resigned to the fact that they will and wanting not to hurt them when they do, *If You're Looking for a Way Out* is crying out for a chart-conquering cover. Sadly the version by indie miserablists Tindersticks wasn't it.

MADNESS - Baggy Trousers (#4)

"Now then, I can't promise you what's happening next musically on the programme is gonna be really unbelievable..." Not sure exactly what Travis means by this. A convoluted dig at Madness? This would seem churlish,

especially given some of the dross he's swooned over as "one of the best records ever made" in the past few months. Mind you, Chas Smash did spoil DLT's car joke earlier on and he does turn up again to gurn to the camera during his next link so maybe Travis has taken the hump. Anyway, after the next bit of the chart countup it's the Nutty Boys themselves, in the studio again so that they can be banned from the studio again. Any issues Auntie Beeb may have had with the line *"Gone to fight with next door's school"* two weeks ago seem to have been resolved now as Suggs gets to mime to the proper lyrics in what has become time-honoured Suggs style, i.e. from behind the very darkest of dark glasses while jerking his head rhythmically in all directions except towards the camera. *Baggy Trousers* was the band's third top ten hit of the year and – hard working lads that they were (and still are) – they would manage to squeeze another one in before Christmas. Indeed, such is their eagerness to please that they end up falling off the front of the stage by the end of the performance, being ordered back to their positions by Travis who warns them off starting any trouble – "I'm a black belt in Ludo, me." Who would have thought that Chas Smash, waving "Hello Mum" into the camera, would go on to create such mature and heartbreaking music as his solo album *A Comfortable Man* 35 years later?

THE POLICE - Don't Stand So Close to Me (#1)

So, onwards with the top ten, again with no numbers on screen because then you wouldn't have to listen to what DLT was saying. Before we get to the number 1 though, we have another pointless bit of fluff to get through as Travis has to give prizes – records, of course, including a copy of the hilariously titled K-Tel compilation *Mounting Excitement* – to the "best dancers" in the audience this evening. The two female winners get an LP and a kiss from the Hairy Monster, while the male winner gets a single and no kiss because, for reasons unknown, he's shaving with a battery operated razor. Well, wouldn't want to be mistaken for DLT now, would we? The Police still can't be bothered to come to the studio so we get the video again, with troublemaker Copeland smoking in class and climbing the stepladder that seems to be there for no reason at all, and yet again the central heating is stuck on full and Sting has to take his clothes off. Travis signs off with Bob Marley's *Three Little Birds* and the promise of "Next week... someone else doing *Top of the Pops*." Cheers Dave, we'll work it out for ourselves.

October 9

"We got your message on the radio"

Good times afoot in the TOTP studio as we join the show already in progress with a group of generic audience members grooving unenthusiastically to Ottawan's *D.I.S.C.O.* - the English language version, not the more exotic French version on the B-side, but our genial host Peter Powell is looking decidedly French himself, with stripy top and red jumper casually hung around his shoulders like a prototype *Long Hot Summer*-era Paul Weller. "As you can see we've already started," Powell grins chummily, "but you're very welcome to tonight's edition of *Top of the Pops*." Oh good, because it would really awkward if you were just staging the show for your own amusement. Is this the latest in a long line of tweaks to the format as Michael Hurll fumbles towards the show's classic era? Yes, probably. Coming up on the show tonight we have Linx "for you jazz-funkers," the Nolans looking like an advertisement for lemons, and that bleeding Police video again. But Pete, you're giving away the plot!

STATUS QUO - What You're Proposing (#27)

Opening the show tonight, The Status Quo on the 216th of their 492 appearances on TOTP during their 90-year career. Okay, they've been on a lot of times but nowhere near the figure of 106 appearances their press office blithely trots out at any given opportunity - that would work out at almost two separate performances of each of their fifty-five top forty hits during the show's run. Presumably that figure includes videos, repeat performances, being danced to by Limbs & Co and brief clips of this song in the top ten countup over the next few weeks, as it's on its way to being their biggest hit since *Down Down* reached number 1 in 1974. Accordingly, the band is still very much in classic '70s Quo mode: the ponytail for men isn't yet a thing so Francis Rossi's hair is still dangling over the shoulders of his denim waistcoat, Rick Parfitt is sporting the full David St Hubbins shaggy perm and drummer John Coghlan still has the type of moustache everyone else grew around 1968. Having said that, the vaguest hints of '80s excess are beginning to show - almost hidden at the edge of the stage, the Quo have acquired a keyboard player. And he's wearing a tie. It's a slippery slope from this to sampled vocals and comedy videos.

DIANA ROSS - My Old Piano (#5)

"What we've been proposing to do for ages is to get you some T-shirts," links Powell without a hint of embarrassment. Yes, BBC Enterprises have come up with the breathtaking idea of printing the TOTP logo on some T-shirts and

hawking them to gullible members of the public. Apparently only available in red with yellow print (although there are a couple of girls in the audience wearing sky blue versions over their normal clothes) and modelled by two random blonde females, this is not some cheap excuse to fill the screen with a shot of a lady's chest, but a genuine once in a lifetime opportunity to own a piece of pop history. Er, or something. But don't go mad, because for reasons which are not divulged, the T-shirts aren't available for another two weeks yet! No doubt the details of how to order said garments will be culled from the BBC Four reruns lest some dolt should attempt to send a postal order to 1980. That infomercial out of the way, we move on with another showing of the *My Old Piano* video as it reaches its chart peak. Makes you wonder what she's doing with that piano, as she's clearly never played it. Just waving your hands over the keys doesn't work!

ORCHESTRAL MANOEUVRES IN THE DARK - Enola Gay (#35)

Although the idea of having a celebrity guest host seems to have fallen by the wayside, we're now just getting random celebrities in to plug whatever they're doing at the moment, and if anything that's even more annoying. For example, before we get on to OMD Pete has to drag in Dennis Waterman - formerly of *The Sweeney*, now of *Minder* - to plug his "rock 'n' roll tour" (with such well known rock 'n' rollers as Gerard Kenny and Sheena Easton) and his single, a vocal version of the *Minder* theme *I Could Be So Good For You*, which we won't see on BBC Four because of reasons. Anyway, OMD are back with a second hit, rocking the groovy geography teacher look, Andy McCluskey swinging his bass from side to side as if fighting off imaginary baddies with it. Two hit singles, real instruments, cardigans? The Human League must be fuming. *Enola Gay* would eclipse OMD's first hit *Messages* to become their first top ten single, despite the band looking just a little too jaunty to be singing a song about the plane that dropped the atomic bomb on Hiroshima and killed 80,000 people. Still, prime time TV, people!

COFFEE - Casanova (#19)

Uh oh, look out, it's the Tedious News Section™ already! What's happening this week that we don't care about? Well, the Crusaders are playing the Albert Hall tonight (which isn't actually tedious, but quite startling - were the Crusaders really big enough to fill the Royal Albert Hall? Or was it the Albert Hall in Stirling?), the Shadows are on tour, and there's "good news for Queen fans... and indeed for Queen as well," as they're number 1 in both the singles and albums charts in the US. "Talking about our charts, which we weren't, but we will now..." Oh dear, Pete, this is why rehearsals are so important. Counting up from 30 we break at number 19 for coffee. Ah, no, sorry, we break for Coffee, a female vocal trio enjoying their only hit with a discofied cover of a 1967 US hit

for Ruby Andrews. They're not here, of course, so... enter Legs & Co! Now then, Flick has employed some lateral thinking this week: Casanova, the great adventurer, author and - let's be honest - tart lived during the Georgian era, so the obvious thing to do is to dress the girls up in Georgian costumes. Unfortunately there's been some terrible accident in the wardrobe department so all the dresses are cut off just below the waist and barely cover the girls' frilly knickers. Obviously they can't go on television like that, so we'll just cut this section and have the song playing over a blank screen for three minutes. What's that? Oh, sorry, apparently that's not allowed so you'll just have to get out there and make the best of it. Blimey, the things you have to do for television.

BLACK SLATE - Amigo (#9)

Back to the chart for a brief 18-11 countup after which we're back in front of the (still resolutely monochrome) video screen as Powell introduces Black Slate - "For a new name to go straight into the charts and do so well, it's gotta be right!" Hang on, Mike Read told us last time they were on that they'd had six singles out! Get your story straight before you go on telly. And now there's someone in the audience in a black TOTP T-shirt as well. Lies and deception everywhere. Still, the Slate are back for their second and final appearance but, horror of horrors, Keith Drummond's colossal sombrero has shrunk in the wash! By way of compensation he's come in full costume this week, but whether his outlandish outfit is supposed to be mariachi or matador is unclear. Either way, he's blown the entire costume budget on it so the rest of the band have to stand around in jeans and casual shirts. Number 9 was peak position for *Amigo* so alas we never got to see what Drummond would have dressed up as if it had gone higher. The mind boggles.

THE NOLANS - Gotta Pull Myself Together (#25)

Pulling back from this bizarre scene, the camera picks up Powell and Waterman looking on in disbelief. There's a lovely bit of behind the scenes nonsense as Powell starts applauding too early so has to stop and start again five seconds later. After a quick plug for Dennis Waterman's Showbiz XI charity football team, Pete makes the mistake of mentioning the Nolans and asking Den "What does that conjure up in your mind?" Obviously Waterman can't express it in words, not at 7.30 in the evening anyway, but the face he pulls says it all. Dirty bleeder. Luckily the sisters aren't in the studio this week but they've sent along a video which involves a suitably wholesome dance routine, although for some reason someone's put some black plastic sheeting on the floor. Maybe they're getting ready to paint the set yellow to match the girls' outfits, apparently part of a sponsorship deal with the Banana Marketing Board. Having moved on from the forced disco pomp of *I'm In the Mood for Dancing*, the Nolans are doing pretty

well for themselves; *Gotta Pull Myself Together* is a fine pop song, slowly making its way into the top ten, and nobody says "Doctor, I feel like a pair of curtains," so that's a bonus.

LINX - You're Lying (#23)

What this fast moving show needs now is another celebrity guest so it can grind to a halt again. And we're in luck! Here comes Paul Jones, the former Manfred Mann singer who, in a strange reverse Yewtree moment, can be seen fending off the advances of the audience in one of the few surviving '60s TOTP clips. That was fifteen years earlier though, since when he's had a few solo hits, done a bit of acting and now formed a blues band called, with staggering originality, The Blues Band. He's here to plug their new record but also, more excitingly, their appearance on BBC 2's *Boom Boom... Out go the Lights*, a show most alternative comedy aficionados have heard of but few have actually seen. Jones promises us "the sort of comedians you get at the Comedy Shop. I don't want to say 'alternative' comedians, but they're not... 'conventional' comedians." It's okay Paul, you can say "alternative comedians" as the show included early TV appearances by Rik Mayall, Alexei Sayle and Nigel Planer and was an important step towards the Beeb commissioning *The Young Ones* and The Comic Strip getting a series on Channel 4. Oh, and it's the Comedy *Store*, Paul. More TV-related shenanigans next with another chance to see TV's David Grant - novelty Trevor McDoughnut glasses and all - in a repeat of Linx's performance from a fortnight ago. After two weeks at 23 *You're Lying* would jump to number 15 next week but that was as high as it went.

GILBERT O'SULLIVAN - What's in a Kiss? (#36)

It's been a long, hard show for Pete who has to do the next link sitting in an old fashioned looking armchair, the kind you see in ads targeted at the elderly during *Countdown*. Mind you, he's not getting any younger, nor is the next guest, "someone who hasn't been with us for a long, long time." Not as long as Paul Jones, to be fair, but it's been four and a half years since Gilbert O'Sullivan was on TOTP, way back in the very first month of the BBC Four repeats. Back then he was performing his single *Doing What I Know*, but after five years of hits people were getting bored of him doing what he knew, so he stopped doing it for a while. Now he's back, doing exactly the same thing, and despite being at odds with just about everything else in the chart *What's in a Kiss?* has given Gilbert his first top forty hit since 1975. You could argue that it's not up with his best work - lines like *"Any time you need a light refreshment, baby you can count on me, I am your very own delicatessen"* don't compare favourably with the devastating *Alone Again (Naturally)* for example - but bear in mind that O'Sullivan also had hits called *Ooh Baby* and *Ooh-Wakka-Doo-Wakka-Day* as well

as the more erudite ones you remember. You could at least put a shirt on to play the grand piano though, Gilbert. Even Diana Ross put on a nice frock and she never touched the damn thing.

THE POLICE – Don't Stand So Close to Me (#1)

It's a curious top ten countup as Pete does everything he can – short of actually shouting "Look! Over there! A puppy!" – to divert attention away from the controversial new Specials single *Stereotype* at number 6. Okay, there wasn't much of it you could play on daytime radio but Powell doesn't even mention the song's title. It's another outing for the *Don't Stand So Close to Me* video to finish, but by now everyone is wise to Sting's behaviour and as soon as he stands up with that look in his eye, we're whisked back to the studio before the shirt can come off again. The ending of the show seems very abrupt, as if BBC Four's editor E. Scissorhands has had enough of Jones and Waterman's banter and just wants to get off home for the night. And *D.I.S.C.O.* is still playing in the background. If anyone knows where to find this 35-minute-long hyper extended mix, please, for heaven's sake, keep it to yourself.

October 16

"Only idiots ignore the truth"

Good times afoot in the TOTP studio as we join the show already in progress with a group of generic audience members grooving unenthusiastically to Ottawan's *D.I.S.C.O.*... hang on, isn't this how we started last week? Yes, there's a humanitarian crisis ongoing in Television Centre where dozens of people have been held in captivity for over a week. Forced to listen to *D.I.S.C.O.* on an infinite loop and with only balloons and streamers to eat, their movements have become erratic and uncoordinated, many of them throwing balloons skyward in the hope that one of them will manage to penetrate the roof of their makeshift prison and attract the attention of the outside world. On guard duty tonight is Tommy Vance, in a none-more-early-'80s nylon football shirt of no fixed affiliation for fear of reprisals from his captives. "Let me tell you, have we got a party or have we got a party?" he asks, in a voice which suggests that some form of medieval torture implement awaits anyone who gives the wrong answer. "Aaaaaaall... *whatever* is gonna break out tonight," he adds, which clearly translates as "No-one is going to break out of here tonight," and gives us the usual spoilers for the rest of the show, including "a gentleman called Adam & The Ants, who's getting a big following." Tommy, a word in your shell-like...

MADNESS - Baggy Trousers (#3)

We start off with "a group called Madness and they're in *Baggy Trousers*. Are you?" Vance demands of the unfortunate TOTP T-shirt wearer next to him. "No," she says, firmly. They laugh, both realising that she's just earned herself three days' solitary confinement. Once again Madness have not been invited back to the studio for a further performance of their latest hit, so we get another showing for the clip recorded two weeks back, ensuring that Chas Smash doesn't wander in front of the camera for another cheeky "Hello mum!" With Madness still a going concern some 35 years on, it's strange to see them looking so young, fresh-faced and not bald, a bit like Queen's *The Miracle* video where they got children in to dress up and perform as the band members. Except Suggs, who still looks exactly the same. He must have a portrait of Lee "Kix" Thompson in his attic.

SHOWADDYWADDY - Why Do Lovers Break Each Other's Hearts (#36)

"Now, they always say that good things come in small packages," announces Vance, who has clearly never accidentally poured a tiny individual sachet of artificial sweetener into his coffee by mistake. "So I think I'll introduce you to

one of the nicest small packages I know, a lady by the name of Suzi Quatro!" Yes, it's another instalment of Michael Hurll's latest wheeze, bringing on stars to promote their latest records without actually letting us hear them. Suzi has a new single out called *Rock Hard*, which reached number 68 and never made it onto the show. Then there's another of those suspicious-looking edits as the interview ends abruptly and we're deposited straight into Showaddywaddy's latest effort. Yes, although you remember them as a '70s anomaly, they were still a "thing" for the first few years of the '80s. The primary coloured suits have gone though, as they sold them to Split Enz a few weeks back, but never mind, singer Dave Bartram has managed to salvage a bright pink satin suit from somewhere. He's also sporting a natty new '80s hairdo which looks like two guinea pigs mating on top of his head, until one of the other band members whips the monstrosity off Bartram's bonce - ha ha, it was a wig all along. Terrific.

BARBRA STREISAND - Woman in Love (#9)

Incidentally, Showaddywaddy are still going today with two original members including the splendidly named drummer Romeo Challenger, although in their heyday they were well known for having two drummers in their line-up. Thankfully punk put a stop to such extravagance and such a thing would never happen in the '80s. We move on from such backward-looking sentimentality to a new name on the scene... hang on, what? Yes, some twenty years into her career, the inaccurately spelt Barbra has roped in the Bee Gees to write and produce what would become her biggest ever UK hit single. "You know," begins Vance, "when you say the name Barbra Streisand you introduce into your conversation a name that means a lot of talent." You're making this too easy for us, Tommy, because obviously she's far too talented to be here tonight, so in the absence of Streisand's talent... enter Legs & Co! Faced with a mid-tempo Gibb Brothers ballad and with no obvious literal interpretation available - the set doesn't even have a wall for them to turn away from - the girls are reduced to twirling about in matching frocks. Mind you, Barbra doesn't even like the song so maybe that's all it deserves.

ADAM & THE ANTS - Dog Eat Dog (#37)

More bringing on stars to promote their latest records now, but in an unexpected twist Vance brings on Michael Palin to talk about *Monty Python's Contractual Obligation Album*. Tommy points out that the risqué nature of much of the album has led to the IBA banning it from being advertised on TV or radio, a fact which clearly concerns Palin no end - "we're just going to have to rely on our earnings from films, TV, books, socks, Python underwear..." As the interview progresses we gradually become aware that *I Like Chinese* is playing in the

background, and if that's the most inoffensive track the BBC could find on the album it's no wonder the IBA banned it. Anyway, this leads us to the bizarre situation where one of the 1980s' biggest pop stars is introduced on TOTP for the very first time by Michael Palin in a fake German accent. Having had all his Ants stolen away by Malcolm McLaren to form Bow Wow Wow, Adam confounded expectations by forming a new band (including two drummers which, despite what anyone else may tell you, is a fantastic forward looking brand new '80s idea) and became the first enormous pop sensation of the decade. Gone is the bondage wear and the songs about bizarre fetishes and Nazis (for now, anyway) in favour of facepaint and self-mythology as Adam invents his own musical genre "Antmusic" and gets beaten up by a gang of skinheads after the show for his trouble.

GEORGE BENSON - Love x Love (#21)

"Every once in a while you see a band who are gonna make it, and I think they will," prophecises Vance, making this the only time in history that a prediction of success from a TOTP host hasn't proven to be an instant kiss of death. No time to bask in that glory though as we're on to the Tedious News Section™ and after a quick plug for Stevie Wonder's new album *Hotter Than July*, Tommy wheels on Dollar who, it would seem, have just got engaged. To each other. The body language between the alleged happy couple is amazing, Thereza Bazar happy to show off the ring ("How much did it cost him?" asks Vance, dispensing with any semblance of tact) while David Van Day is more concerned with showing off the copy of the duo's new single which he just happens to have with him. Of course it was all a publicity stunt, the duo never actually married and they remain happily not married to each other 35 years later. After the first part of the top 30 countup (The Specials' *Stereotype* still doesn't have a title, incidentally), we pause at 21 for film of George Benson with his special high-waisted guitar performing *Love x Love* which of course is pronounced "Love times love" and not, as a certain cigar-smoking tracksuit-wearing DJ once insisted, "Love ex love."

MATCHBOX - When You Ask About Love (#10)

As Tommy introduces the next part of the chart countup, one of the jackasses in shamrock T-shirts who've been making nuisances of themselves throughout the show (and one or two previous outings, although they've been easy to ignore until now) has positioned himself directly behind Vance and appears to be doing some kind of Nazi salute. If you're going to do that, son, have the courage of your convictions and don't pretend you're just stretching out your arm to scratch your head. Talking of white supremacists, the Confederate flag is still very much in evidence on Matchbox's double bass, although what it has to do with this limp

love song isn't obvious. This is another showing of the band's performance from two weeks ago and thanks are due to everyone who pointed out that the reason this sounds so Buddy Holly-esque (as noted on its first showing) is that it was actually a hit for The Crickets back in 1960. Perhaps Graham Fenton's bequiffed, bespectacled look is an artist's impression of what Holly himself would have looked like in 1980. Or perhaps not.

BAD MANNERS - Special Brew (#25)

"Now," begins Tommy, "I'm going to introduce you to a band who've had countless hit records and the length of this guy's tongue continually still foxes me." Countless hit records? I know certain Radio 1 DJs of this era have a reputation for not being the most intelligent beings on the planet, but I always had a great deal of respect for Vance and it saddens me to discover that he couldn't even count to three. With a forced chuckle he introduces Buster Bloodvessel and chums, who start out in fairly normal clothes, Buster himself in a white boiler suit relaxing in a rocking chair as if he'd just finished painting a particularly high and difficult ceiling. Then, by the magic of early '80s television, the screen flashes twice (without so much as a FLASHING IMAGES warning, dear me, how did that get past compliance?) and suddenly there are palm trees everywhere and everyone is wearing grass skirts. Nobody knows why. *Special Brew*, despite the alcoholic connotations of its title, was the nearest Bad Manners had come to a proper pop song rather than a breathless, baffling ska knees-up, and even Buster's channelling of Val Doonican doesn't seem out of place (apart from the bit where he tries to eat the microphone) until a couple of minutes in when everything speeds up and he's out of the rocking chair and dancing like a lunatic. How anyone who exerts that much energy on stage could still carry so much body mass is a mystery which plagues us to this day.

THE POLICE - Don't Stand So Close to Me (#1)

"What's between 9 and 1? This is!" For some reason the top ten countup is ignoring Matchbox at number 10 and starting at 9, and they seem to have misplaced Status Quo's performance from last week as they're represented by a still photo instead of a clip. Best of all though is the baffling appearance of Sweet People at number 4 with their hit *Et Les Oiseaux Chantaient* which is nothing more than some ambient synth noodling with birdsong on top of it, making it surely the least hummable top five hit of the entire decade. Meanwhile *Don't Stand So Close to Me* is enjoying its fourth and final week at number 1 and I think we've done very well to get this far without mentioning the sole release from The Police's final recording sessions, *Don't Stand So Close To Me '86*, the video for which may require another flashing images warning and may be a startling example of style over content, but at least Sting doesn't get his kit off

in it. As we play out with - guess what? - *D.I.S.C.O.* again, Tommy foolishly mentions that DLT will be hosting next week, meaning that his final link gets cut from the BBC Four rerun because we can't have that, can we? Fortunately we have the internet so nothing is ever truly lost if somebody wants to share it, as you'll find out next week.

October 23

"Should have been a rock star"

Desperate, soul crushing times afoot in the TOTP studio as – for the third week in succession – we join the show already in progress with a group of generic audience members grooving unenthusiastically to Ottawan's *D.I.S.C.O.* Indeed, it's like déjà vu all over again because not only is it Dave Lee Travis's turn to host the show again, the studio is full of cars, Travis is babbling something about a motor show and the morons in shamrock T-shirts who were pretending not to be doing Nazi salutes and laid into Adam & The Ants after the show last week are back again. Turns out, according to Ants bassist Kevin Mooney, they were members of also-ran punk band 4" Be 2". Once again they've managed to squeeze into shot and pretend to be doing some kind of arm-related stretching exercises. What larks. It's not clear why they keep turning up, because most of this week's show is videos and repeat clips and the two acts who are in the studio are probably not to 4" Be 2"'s taste.

STATUS QUO - What You're Proposing (#4)

Having said that, 4" Be 2" might enjoy a bit of straightforward, uncomplicated, no-nonsense white male rock 'n' roll, in which case this should be right up their cul de sac. Opening the show for the second time in three weeks, the Quo are on ~~so much cocaine~~ such a roll at the moment that they've recorded two new albums: *What You're Proposing* comes from the first of these, *Just Supposin'* which entered the album chart at number 4 this week, while the same recording sessions also spawned their next album, released with almost indecent haste five months later and ironically titled *Never Too Late*. Clearly there's some kind of barely concealed drugs reference in the song – why else would Francis Rossi, who did so much cocaine in the '80s that part of his nose fell off, be *"runny, runny, runny, runny nosin'"*? – but back in 1980 we were all too innocent to understand why Rick Parfitt finds it so hilarious when Rossi taps his nose during the first verse. At least they – and 4" Be 2" – are enjoying themselves.

THE NOLANS - Gotta Pull Myself Together (#9)

Meanwhile Travis, having brought a car into the studio three weeks ago for a pointless gag, has gone full Partridge and filled the studio with cars from the British International Motor Show being held in Birmingham that week. "Lots of other cars we can look at too, but how about artists to look at?" Yes, Travis has also filled in the Bring On A Star To Promote Their New Record Without Playing It form because here to not perform their latest single are Gladys Knight and the

Pips. That's right, all of them in the studio for a pointless 30 second interview to plug their new single *Bourgie' Bourgie'* before we're whisked away for another showing of the Nolans video. And, inevitably, DLT undoes all of Peter Powell's good work from two weeks ago by introducing *Gotta Pull Myself Together* as "The Curtain Song". Very poor, Travis, very poor. The video is mainly the sisters dancing in very yellow outfits, but full marks to the director for dropping in some moody staring-sadly-into-the-middle-distance shots – after all, it worked for ABBA.

GILBERT O'SULLIVAN – What's in a Kiss? (#27)

With the studio still full of cars and Gladys Knight and her Pips out of the way, what else is left for Travis to do but try and chat up some beautiful ladies? His first victims are a couple of French girls – you can tell they're French because (a) they're wearing Renault T-shirts and (b) they remain thoroughly unimpressed by Travis's attempts to talk to them, not least because he's decided that if you can't speak French, the French will still understand you if you speak English to them in an Inspector Clouseau accent. Travis uses this method to ask one of the French ladies how to say "What's in a kiss?" in French; realising that she's on television she obliges with a translation rather than simply shrugging and mumbling "Je ne comprends pas." In the end it's all fairly irrelevant as O'Sullivan isn't in the studio anyway. This repeat of his performance from two weeks ago would be his last appearance on the show; the single got as high as number 19 next week but failed to spark off a revival and Gilbert's only subsequent hit came ten years later when the dance influenced *So What* reached number 70.

KELLY MARIE – Loving Just for Fun (#37)

The answer to "what's in a kiss?" is, as it turns out, about 80 million bacteria, which doesn't sound terribly romantic but it's still disappointing that O'Sullivan didn't work that into the lyrics somehow. This unpleasant fact doesn't seem to deter DLT who has had another of his favourite ladies sent out to promote her new record without performing it. This time it's Elkie Brooks who has to suffer Travis's attention as he butters her up by saying her new single *Dance Away* is the best she's ever made, and then immediately ruins everything by telling her she looks tired. Charmer. This attempt at single promotion fell completely flat, not least because nobody remembered to mention the title of the single at any point. Never mind, time for another young lady who's enjoying greater success – for now, anyway – as Kelly Marie is back. Her new single is very eco-friendly, recycling as much of the backing track from *Feels Like I'm in Love* as is humanly possible, and even Kelly's sidekick dancers are back to provide moral support. Unfortunately the lack of any memorable tune is something of a problem, and

you won't be surprised to learn that it didn't get anywhere near the success of her previous single.

AIR SUPPLY - All Out of Love (#20)

"I've peeled myself off the Lancia Delta and the beautiful ladies down there..." DLT is having the time of his life in the studio tonight, even if nobody else is. Leaning on the shoulder of another unimpressed female audience member, he takes us through "the bottom half of the top thirty" - the top thirty being split into three halves this week. Intriguingly the Specials' *Stereotype* still doesn't get a mention - apparently the BBC thought that the merest utterance of the song's title would invoke some kind of evil spirit - but the nominal "other" A-side *International Jet Set* does. We pause at number 20 for the one and only TOTP appearance by Air Supply, an Australian band who have been together now for forty years but still only troubled the UK top forty on this sole occasion. If they'd known this would be their only hit they might have put more effort in and turned up to the studio, but instead we get three minutes of the band performing in almost total darkness - at one laughable point in the video only the drummer can be seen, the others all appearing in silhouette. Unfortunately we can still hear them.

KATE BUSH - Army Dreamers (#26)

Oh dear, Travis has found some more young women to squeeze himself between. "Air Supply, which is something I am finding is cut off at the moment because I'm very closely confined with a lot of ladies - I'm not complaining, mind you!" I'm sure you're not, Dave. After the next section of the charts we head back to number 26 for another video - can't help thinking that if there were less cars in the studio they'd be able to get more bands in, but what do I know? Having missed out on Kate Bush's previous single *Babooshka* in the summer thanks to The Event, we at least get to see the video for the follow-up. *Army Dreamers* is a chilling tale about the death of a young soldier, the effect of which is somewhat lessened by the sight of Kate and some dancers, all in full military camouflage, doing choreographed combat manoeuvres in strict waltz tempo. It's all a bit Limbs & Co and hard to watch without expecting Graham Chapman's Colonel to appear in shot, crying "Stop that! It's silly!"

ORCHESTRAL MANOEUVRES IN THE DARK - Enola Gay (#12)

Out of the video, back to the studio and once again DLT has his arm around someone - except this time it's a bloke! In fact it's Matthew Waterhouse, just about to start his role in the latest series of *Doctor Who* as the Doctor's newest companion Adric. Surely he can't just be on TOTP to promote another, unrelated

BBC programme? No, of course not. He has a BBC Records 7" of the *Doctor Who* theme to promote as well. "You can go over and shake hands with the girls," Travis tells him, "because you're too small to kiss them. Leave that to me." We can safely assume that this edition of TOTP was not shown as part of the case for the defence at any of Travis's court appearances. Time for another pre-recorded musical clip, with OMD's appearance from a fortnight ago getting another showing in the week that it becomes their biggest hit to date. Their image still needs some work though, as their performance looks like history teachers Mr McCluskey and Mr Humphreys have asked for two pupils to help them with their educational song about the bombing of Hiroshima at school assembly. Despite this *Enola Gay* would go on to become their first top ten hit, ricocheting between numbers 8 and 9 for the next month, while the drummer was later expelled for putting stink bombs under the headmaster's chair.

OTTAWAN - D.I.S.C.O. (#2)

FOR THE LOVE OF GOD MAKE IT STOP! Like the scene in *Father Ted* where the priest running the mobile disco has only brought one record, *D.I.S.C.O.* is still playing and, as if that wasn't bad enough, Legs & Co have been shoved on to dance to it. Not that there's much room to dance with all the cars taking up space on the studio floor. Despite its almost constant exposure on TOTP, this poor man's *YMCA* couldn't make the leap to number 1; in fact this was its last of three weeks at number 2, meaning that they're going to have to find another record to play next week. Fans of limp Caribbean disco shouldn't worry too much though, as Ottawan had another massive hit a year later, although sadly it wasn't the remarkable *Qui Va Garder Mon Crocodile Cet Eté?*, or "Who will look after my crocodile this summer?" Maybe one of the lads from 4" Be 2" will do it, after they've finished trying to P.O.G.O. to *D.I.S.C.O.* and looking like T.W.A.T.S. in the process.

BARBRA STREISAND - Woman in Love (#1)

Did DLT mention the motor show that's on at the moment? Better mention it again, flanked by two bored looking women, just to make sure. On with the top ten countup, this week tweaked again by removing all captions and just having the clips, or in the case of Sweet People a still photo. Wouldn't it be great if Sweet People turned out to be Throbbing Gristle under an assumed name? Leaping up from last week's number 9 it's Barbra Streisand with her first and only UK number 1 hit, illustrated here by a hastily cobbled together montage of still photos and clips from her films, with bits of Limbs & Co's routine from last week thrown in for good measure. We play out with *Casanova* by Coffee and look forward to next week's show, hosted by Peter Powell, "who himself has just got himself a new car." Oh, do shut up, Dave.

October 30

"It's big and it's bland, full of tension and fear"

After last week's automobile-related tomfoolery it's time to bring some sense back to the proceedings with the ever-reliable Peter Powell. But hang on, who's this with him? Powell introduces him as "one Colin Berry" (sadly this doesn't spark a football chant response of "there's only one Colin Berry") and before you can say "Hang on son, only Radio 1 DJs allowed in this area" Berry's gone on to tell us about how he's been sitting in for Terry Wogan on the Radio 2 breakfast show all week. Although a Radio 2 regular for many years, Berry's TV work was mainly confined to announcing the votes of the UK jury at the Eurovision Song Contest, which he did most years between 1977 and 2002, although curiously not in 1980 when Ray Moore took the job. As is now usual we get a quick glimpse of a few of the acts coming up on the show; this week we're promised two repeated clips and a video that was on a DLT episode a month ago. Oh Pete, You're spoiling us! But the vital question remains unanswered: is that really a young Dermot Murnaghan in the audience behind Pete's head?

ADAM & THE ANTS – Dog Eat Dog (#13)

"Right now no show seems to be complete without a band called Adam & the Ants," Powell advises us. "The reason is because they're going on tour currently and you'll see for yourself." Not sure that fully explains the situation, but never mind because here are the erstwhile Stuart Goddard and his band, back in the studio having survived their altercation with the members of 4" Be 2" last time. No sign of the shamrock T-shirted goons this week, although it's unclear whether the person in the peaked cap glaring at the crowd from in front of the stage is an actual security guard or a member of the Ants' entourage who didn't get the memo about the band's new image. Halfway through the performance Adam produces a cane from somewhere, which he wields like Fred Astaire having some kind of seizure. While Adam's first appearance pushed the single into the top twenty, it could be argued that this was the performance that sparked Antmania, propelling *Dog Eat Dog* to number 4 and sending sales of Tipp-Ex through the roof.

ODYSSEY – If You're Looking for a Way Out (#6)

Bit of a reverse Yewtree moment before the next song as Pete is apparently goosed by one of the young ladies behind him. "What are you up to?" he demands, before remembering he's on telly and has to keep smiling. Never mind, because it's time to bring on one of the rapidly-becoming-infamous *Top of*

the *Pops* T-shirt models, so Powell can put his arm around her and everything's back to normal. You'll be fascinated to know that the T-shirts come in three colours and two sizes, adults and children – so hopefully she's wearing a kids' one otherwise they've grossly underestimated the size of most adults. Details of how to get them will be in the *Radio Times* in the next couple of weeks, apparently, although I'm sure they promised that a couple of weeks ago. Moving on, it's a second outing for the *If You're Looking for a Way Out* video, a song that's been hanging around the bottom reaches of the top ten for a month now without any further TOTP action since DLT introduced it four weeks back. A showing last week or even the week before might have given it the top five placing it deserved, but number 6 was as far as it went.

BAD MANNERS - *Special Brew* (#5)

Where's Colin Berry gone then? Haven't seen hide nor hair of him in three links now. Poor Pete could be doing with his help as he seems to be having trouble getting his words out this week and runs out of them altogether during this link, eventually having to chat up the young lady next to him in order to fill time. More repetition next: they can't risk having Bad Manners back in the studio again after the scenes they caused two weeks ago, the sight of Buster Bloodvessel's legs under that grass skirt caused several members of the audience to pass out, and not in a good way. However, with the single ploughing relentlessly up the chart, there seems no option but to show the same performance again, with Buster's brief but energetic burst of dancing bringing new meaning to the phrase "Legs & Co". *Special Brew* got as high as number 3 but for some reason it was never shown again, even though this performance seems fairly tame once you've seen their other number 3 hit from the summer of '81.

DAVID BOWIE - *Fashion* (#20)

Ah, it's okay, nobody panic, we've found Colin! He's been off picking up a script and the sleeve of ABBA's new single for the Tedious News Section™ which he reads with his usual gravitas, warning us to "watch out for Geraldine Hunt" as if reading a news item about an escaped murderer, "her single *Can't Take the Feeling* (sic) has been a hit in the discos." Berry proceeds to warn us of other new releases including the horror of Liquid Gold, while Dermot Murnaghan looks on open mouthed, clearly thinking he could do this better and considering his future career plans. Colin gets a shot at the top thirty countup as well, expertly enunciating his way from 30 to 20 where we pause for the new Bowie single. Sadly it would still be another eleven years until Bowie was desperate enough to appear on TOTP again – and even then it was as part of Tin Machine – so... enter Legs & Co to "interpret" *Fashion* in the least fashionable way

possible, dressed in brightly coloured corsets and hot pants like a nightmarish Showaddywaddy, overlaid with shots of the girls in other unfashionable outfits. Hurry up and finish your video, Dave!

SHEENA EASTON - One Man Woman (#17)

"Good single, yeah?" Powell asks Berry as we pan away from Limbs & Co. Awkward pause. "Good one," Colin finally nods, clearly having no opinion on it whatsoever. Berry's talents are put to better use as he counts up from 19 to 11, and eagle-eyed viewers will note that the caption person has already acknowledged Antmania by using a reversed "D" in "ADAM AND THE ANTS" as per the band's logo. Back down to 17 for Sheena Easton's new one which, despite Simon Bates' confident claims a few weeks back, isn't called *One Man, One Woman*. Although it's clearly miles better than either of her first two singles and accompanied by a glossy promo video full of perfect makeup and multiple costume changes, *One Man Woman* stalled at number 14 and Sheena "two records in the top ten" Easton's UK chart career had already peaked. Isn't showbiz fickle? Good job she discovered Prince.

OLIVIA NEWTON-JOHN & CLIFF RICHARD - Suddenly (#25)

If you've managed to blag tickets for tonight's edition of TOTP, bunked off school and nicked a tenner out of your mum's purse to get to Television Centre just to be in the audience, you're probably feeling pretty short changed by now. Were it not for Adam & the Ants, you'd have come all that way just to see Limbs & Co, a Radio 2 DJ and loads of pre-recorded footage. Here's another video, the fourth hit single from the soundtrack of *Xanadu* which makes the soundtrack infinitely more successful than the movie itself. Cliff and Olivia simper their way through this limp ballad in a video which Cliff himself seems to have storyboarded, as he finally gets the chance to kiss, fondle and generally get unnecessarily intimate with Olivia, even looking as if he's about to strangle her at one point. Thankfully we cut back to a gently swaying audience before they get down to it in front of the roaring fire. Let's face it, he's no John Travolta.

SHOWADDYWADDY - Why Do Lovers Break Each Other's Hearts (#22)

After that romantic interlude there's an awkward moment for Powell as the freakishly tall boyfriend of the girl he was chatting up earlier has arrived. Leave it, Pete, he's not worth it! And talking of not worth it... no, that's unfair. It's another repeat though, Showaddywaddy's "humorous" performance with the reveal of Dave Bartram's fake spiky hairdo managing to seem even less funny now you know what's going on. Co-written by Phil Spector, *Why Do Lovers*

Break Each Other's Hearts was originally recorded in 1963 by the improbably named Bob B. Soxx and the Blue Jeans before becoming the 'Waddy's last top thirty hit. Don't worry though, you haven't seen the last of them – in fact they'll be back with another single in just a couple of weeks' time. Do they never sleep?

BARBRA STREISAND – Woman in Love (#1)

So, really, you got Colin Berry in just to read the news and part of the chart? He doesn't even get to do the top ten, which this week has been tweaked yet again so that the words "TOP TEN TOP TEN TOP" flash constantly across the top and bottom of the screen so as to alleviate any doubt about what you're watching. At least Pete doesn't do the curtain joke. Babs is still at number 1 so we get the montage of photos and film clips of Streisand snogging people masquerading as a video once more, but without Limbs & Co interrupting it this week so we can see just how saucy it really is. Colin's back to say goodbye and take part in the ID parade of people wearing TOTP T-shirts, while Powell and his Radio 1 colleagues are apparently off to Birmingham for the week, which is why next week's edition is hosted by a certain infamous jewellery enthusiast. Not that Powell is free from accusations of impropriety as he pretends to toss a coin to decide which of the female T-shirt models he gets to go off with. Smooth. Fortunately a gang of revellers descends on the studio floor to cavort to Stephanie Mills' *Never Knew Love Like This Before* and in the confusion she makes good her escape, leaving Powell to go home with Dermot Murnaghan.

November 6

"The dead man's hand again"

The last few episodes of TOTP have been a bit "meh", in all honesty. There's been a lot of repetition, not just of songs but of performances, especially evident in last week's show when only Adam & The Ants and Legs & Co turned up; everything else was videos or clips from previous editions. This week, however, it's all change – all but two of the songs featured tonight are brand new to the show, including some absolute solid gold musical legends. Of course, nothing in the world of TOTP repeats is ever straightforward, and the presence of one Jimmy Savile meant that BBC Four predictably chose not to bother showing this one again. What's even more irksome is that presenter "issues" mean that every second episode is being skipped at the moment, with the result that most of these songs won't make it to air at all. Thank heavens somebody had the foresight to record them all at the time, otherwise this would just be a blank page. Anyway, Savile does one of his "idiosyncratic" introductions which involves him and various audience members swaying enthusiastically to Bad Manners' *Special Brew* (careful where those elbows are going, Jimmy) and we're off and running.

KOOL & THE GANG - Celebration (#33)

"How's about... we should have... Kool & The Gang... right this second. Thank you." Yes, Savile is still talking like someone who is learning English as a second (or possibly third) language and can only process... a few words... at a time. This is the first trip to the TOTP studio for one of the most prolific bands of the decade, performing the third of their eighteen top forty hits been 1979 and 1986. It's a proper classic too, the band's only US number 1 and a top twenty hit for Kylie Minogue twelve years later. As with so many bands from this era Kool & The Gang seem to be chronically overstaffed, but they also seem to be doing the whole performance live, lead singer James "J.T." Taylor - winner of the Least Original Nickname In Funk award for three years running in the early '80s - doing his best to get the audience in the mood. Michael Hurll really should send out for more balloons, though.

STATUS QUO - What You're Proposing (#2)

Obviously it's unfair to expect a man of Savile's advanced years - even in 1980 - to host an entire TOTP on his own; likewise it wouldn't be proper to ask Radio 1's "new boy" Richard Skinner to start doing the show single handed (even though he's been with the station since 1973 and gained plenty of TV experience

as a Thames continuity announcer, and pretty much every other presenter to date did his first show solo, *and* Skinner's already been broken in on another Savile episode back in September). And so the two are reunited for a second and final show together, Skinner forcing his way through the audience into shot, still in his regulation newsreader sweater and slacks. Things are changing though, as Richard is about to take over Mike Read's weekday evening Radio 1 show, in preparation for Read inheriting the breakfast show from DLT in January. Of course Skinner went on to great heights at the BBC; over the next five years he hosted TOTP, *Whistle Test*, the Radio 1 Top 40 show and of course *Live Aid*, famously introducing Status Quo as the concert kicked off. Tonight, though, Savile beats him to it and links into another showing of the first performance of *What You're Proposing* from a month ago, horrible denim waistcoat and all.

STEPHANIE MILLS - Never Knew Love Like This Before (#18)

"I have got... next week's... number one record there!" No you haven't, Jimmy, you're holding a copy of *Looking for Clues* by Robert Palmer, who is wheeled on to take part in a thoroughly pointless interview involving searching questions like "When are you going to come back and live in Yorkshire?" Spoiler alert: the single didn't get to number 1 next week, or ever. Despite this Palmer, ever the gentleman, helps out an OAP by introducing Stephanie Mills. A Broadway star since the age of 9 and recording artiste since she was 16, Mills finally scores her first UK hit at the ripe old age of 23 and celebrates with a walk in the park (Nick Straker Band not pictured). To the accompaniment of a wax cylinder recording of her hit (why did so many promo films sound so bad, even into the '80s?) Stephanie extols her new found love while crouched down on a path, balanced on a giant rock and even walking past some spiky railings which threaten to take her hand clean off if she's not careful. The things we do for love, eh?

NEIL DIAMOND - Love on the Rocks

"Wonderful," enthuses Skinner, who has planted himself in the middle of a gaggle of audience members with balloons and silly hats and proceeds to ruin the party atmosphere by launching straight into the Tedious Music News™. Barry Manilow is coming to tour the UK, but all his shows are sold out, so the point of disseminating this news is unclear. Meanwhile Dexys Midnight Runners haven't split up, as we'll find out in due course, and Neil Diamond has made a film. Not just any old film, but a remake of *The Jazz Singer*, originally a 1927 vehicle for Al Jolson and acclaimed as the first feature-length "talkie", although in fact the film only includes a couple of minutes' worth of actual dialogue amongst the songs so really it was more of a "singie". Either way, it still sounded better than that Stephanie Mills promo. The new remake isn't due out until January but Skinner offers us an "exclusive preview of the film" which amounts

to little more than a clip of Diamond sitting in a recording booth singing *Love on the Rocks* and if that doesn't make you want to go and see the movie, I wouldn't be at all surprised.

DENNIS WATERMAN with the DENNIS WATERMAN BAND - I Could Be So Good For You (#19)

"That'll be in the charts soon," predicts Richard, "let's have a look and see what's in the charts right now!" The top 30 countup begins poignantly with a new entry at 30 for *(Just Like) Starting Over*, the big comeback single for John Lennon (and Yoko Ono, as Skinner helpfully points out) and carries on up to number 19 where we find Dennis Waterman whose single has made it into the top twenty a full four weeks after he was first persuaded on to the show to talk about it. Lest we forget, the single credits "Dennis Waterman with the Dennis Waterman Band", and what a fortunate occurrence it is that the Dennis Waterman Band met up with Dennis Waterman and persuaded him to become their lead singer, otherwise they'd have had a really stupid name. Waterman does at least put in a decent shift, singing the *Minder* theme totally live and hoping nobody noticed that he forgot the lyrics to the different chorus combinations and just bluffed his way through by singing the second chorus over and over again. No, we didn't notice.

ROXY MUSIC - The Same Old Scene (#29)

Back to Skinner and the chart countup, this time in an almost invisible dark blue on black, before we dive back down to number 29 and the third single from Roxy Music's all-conquering *Flesh + Blood* album. Unfortunately the band can't make it to the studio due to a recent onstage accident when everyone slipped in the grease from Bryan's hair and ended up in traction, so instead... enter Legs & Co! Heaven knows what they've come as this week, it looks like some kind of highly impractical gold swimsuit collection but it's hard to tell through the mess of dry ice and unnecessary video feedback which lends a lovely drug-induced nightmare effect to the performance. Although *The Same Old Scene* only reached number 12, ending Roxy's run of four consecutive top five hits, it remains a fan favourite and has been pressed into service for remix purposes on more than one occasion.

UB40 - The Earth Dies Screaming (#25)

Oh, look out, Savile's back, still swaying from side to side long after it ceased to be a thing. "As it 'appens... ladies and gentlemen... number 25 in the charts... UB40!" Solving the "add some words to form a sentence" puzzle we do indeed find UB40, now on their third hit single, all of them double A-sides and most of

them thoroughly depressing, none more so than this one. Named after a 1965 film about an alien invasion, the video for *The Earth Dies Screaming* finds a terrifyingly young looking Ali Campbell and band throwing up lyrics like *"Bodies hanging limp, no longer bleeding,"* in front of some solarised stock footage of mushroom clouds. It's just the kind of thing you want to hear in the run up to Christmas, although we do cut back to the studio fairly sharpish, just as it looks like Brian Travers is blowing a mushroom cloud out of his saxophone. Of course they could have shown the video for the single's other A-side *Dream a Lie* which would have carried on the show's Al Jolson theme nicely.

MOTÖRHEAD - Ace of Spades (#21)

As he recovers the power of speech, we find Savile between two young ladies, "debating". Yes, you heard correctly, he's debating whether to give the two girls prizes for being dressed colourfully, which is a perfectly rational thing for a man in his fifties to do. Such extra-curricular activities mean we're deprived of peak Motörhead; in the week the *Ace of Spades* album entered the chart at number 4, their highest chart position to date, Lemmy & co are here to blaze through their best known song. All the classic Motörhead traits are in place: Lemmy's microphone is, as usual, too high and angled down towards his mouth as he glares directly into camera to deliver the *"I don't want to live forever"* line, while Philthy Animal bashes all hell out of the drumkit while wearing a silly hat. Although it wasn't their biggest hit *Ace of Spades* is still the band's best remembered song, thanks mainly to their appearance in *The Young Ones* in 1984. Just don't mention the dance remix to Lemmy or you're liable to end up with a broken face.

BARBRA STREISAND - Woman In Love (#1)

Finally Savile has finished debating and decides to give prizes to both women, beckoning on his associate "Barry The Bag" with a pile of promotional guff which Sir Jim'll proceeds to distribute between the lucky winners: the top ten singles, some articles of clothing which are probably T-shirts, and best of all a copy each of the new Liquid Gold album. Stop, please stop. Time for the Top Ten countup, which is a bit of a shambles this week: the name "Orchestral Manoeuvres In The Dark" is clearly beyond Savile's linguistic expertise, so he doesn't even try; the TOP TEN TOP TEN TOP caption gets mysteriously switched off and on seemingly at random; Adam & The Ants and Bad Manners are represented by still photos instead of clips, while *Special Brew* gets its own title caption but *Dog Eat Dog* doesn't. That's about as far as we can go this week, as whoever was thoughtfully taping the show on its first broadcast has discovered that Barbra Streisand is still at number 1 and switched off in disgust, but we can assume that the bizarre montage of photos and film clips was shown again. What

would be a good song to play out on? Why, John Lennon's *(Just Like) Starting Over*, of course. That's TOTP logic for you.

November 13

"I'm gonna be your number one"

This is a story about a young fella - well, a fella - who found himself... in a position he wasn't entirely comfortable with. Let's call him "Simon", because that's his name. Now, Simon was blessed with a pleasing, mellifluous voice which made him a hit with ladies of a certain age, so naturally it wasn't long before he found himself hosting the mid-morning show on Radio 1. Simon didn't mind his job, but it did come with a few drawbacks: for one, he couldn't just talk for three hours but had to play lots of pop music he didn't particularly like. This he could live with, but Simon's main concern was that he was contractually obliged to host *Top of the Pops* every few weeks. On these occasions, not only did he have to introduce and even mingle with the pop groups he didn't really like, but he had to reveal the fact that he had... well, let's be charitable and call it "a good face for radio". Eventually, after many years, Simon stopped being asked back to do TOTP and finally found his true calling: warning viewers of 18-certificate videos about the potential for "sexual swearwords". However, one song in particular reminds Simon of his time as a TOTP host...

IRON MAIDEN - Women in Uniform (#35)

Yes, Simon Bates is back in charge this week and being forced to sound enthusiastic about Iron Maiden. Not even proper Iron Maiden, but unrecognisable 1980 Iron Maiden without Bruce Dickinson. Even the song is unrecognisable, except in Australia where it was originally a hit for the band Skyhooks two years earlier. Recorded by Maiden at the insistence of their publishing company who wanted a proper hit single from them, it became the band's third top forty hit but it's not on any of their albums (other than the Australian version of 1981's *Killers*) and consequently the only version on Spotify comes from one of numerous albums of Maiden songs re-recorded by the band's vocalist in this era, Paul Di'Anno. It's almost as if the rest of the band are somehow embarrassed by the song for some reason. The whole shebang could easily be a performance by the Comic Strip's spoof metal band Bad News, but even Vim Fuego would baulk at lyrics like *"Women in uniform, sometimes they look so cold / Women in uniform, but oh! They feel so warm."* Just be thankful DLT wasn't hosting this week.

DAVID BOWIE - Fashion (#6)

Bates can hardly keep a straight face, what with the ludicrousness of the previous song and the fact that Iron Maiden's upcoming UK tour takes in such musical metropolises as Uxbridge and Redcar. On with "a beautiful thing from

the top ten", Bowie still isn't in the studio of course but he has sent along a film (Simes still hasn't come to terms with the word "video") which doesn't feature Steve Strange almost getting flattened by a bulldozer, although Bowie does mimic Strange's peculiar bowing manoeuvre from the *Ashes to Ashes* "film". *Fashion* also includes a cameo appearance from May Pang, wife of producer Tony Visconti and "companion" of John Lennon during his 18-month "Lost Weekend" period in 1973-74. The song seems to be openly mocking the New Romantics to whom Bowie was such an icon, but nobody seemed to mind and it became his second top five hit in a row, the first time he'd achieved such a feat since 1974.

GLADYS KNIGHT & THE PIPS - Bourgie' Bourgie' (#33)

"Old four eyes is back," grins Simes cryptically, leaving us unsure whether this is a self-deprecating comment, a spectacularly unpleasant dig at the bespectacled girl in the audience beside him, or an ironic introduction to his next guests, who have only three eyes between them. Yes, despite public demand, Dr Hook are back! Don't panic though, it's just Ray Sawyer and Dennis Locorriere here for one of those increasingly pointless quick chats between songs. Nobody seems to know why they're there, not even Bates or the band themselves, although there seems to be some kind of private joke going on between the three of them to which we are not party. Never mind, maybe if their next single is a hit (it won't be) they'll be asked back to do a song (they won't) just like Gladys Knight and the Pips have. Even if they did, it surely wouldn't be a song suggesting that everybody wants to own the means of production in order to control the working class, which is what Gladys seems to be suggesting. Death to the bourgeoisie in their purple velour jackets and spangly waistcoats! But not to the mid-'80s jangly Scottish group who named themselves after this song.

JOHN LENNON - (Just Like) Starting Over (#20)

Now that Dr and Mrs Hook have been dispatched off back to the green room Simes cracks on with the Tedious Music News™ section, including a mention of U2's début album *Boy* a full nine months before it charted in the UK. Then, just when you think things might have taken a positive musical turn, along comes Stu Francis, host of Friday afternoon kids' TV show *Crackerjack* and purveyor of various catchphrases including "Ooh, I could crush a grape" and the lesser spotted "Ooh, I could jump off a doll's house." Of course Francis has a record to plug, but thankfully it's not his; it's *BBC TV's Best of Top of the Pops* with a list of artists on the front in order to distinguish it from the low budget anonymous cover version albums also called *Top of the Pops*. The confusing world of trademarks, there. It's a particularly busy link as Simes also has to fit in the first part of the top 30 countup which seems like a lot of faffing about before we get

to John Lennon. It had been five years since Lennon's last single, and even that was a belated release of *Imagine* to promote his 1975 best-of *Shaved Fish*, so naturally expectations were high when he finally got bored of being a househusband and went back to the studio. It seems churlish now to suggest that his comeback single was a bit underwhelming, but it certainly didn't break any new ground and was struggling its way up the chart. Perhaps if John had come to the UK to do some promotion it might have helped (not being in New York in early December would certainly have been a bonus) but it wasn't to be, so... enter Legs & Co, obscured behind semi-opaque screens in various baffling costumes which have little to do with the song apart from looking as dated as the track sounds. Never mind, Lennon's back and surely he'll make lots more records in the years to come, won't he?

LIQUID GOLD - The Night, the Wine and the Roses (#32)

Having derailed the show with the overlong link before Lennon, Simes decides to cut his losses with the next one, scooting through the next part of the chart and straight into Liquid Gold. Yes, this lot again. It may be six months since we've seen them but it seems like only yesterday, mainly because they're doing exactly the same shtick over exactly the same backing track. Other than Ellie Hope attempting to subvert proceedings by singing into a rose instead of a microphone (But how does that work? Is the rose electronic? Does it convert sound into electrical impulses through the power of pollen?) everything is just as you remember it: the drummer still looks like he's been thrown out of a fancy dress party, this time wearing some kind of Stars & Stripes Lycra bodysuit and knee high stockings; Ellie is still wearing a cocktail dress that she looks like she might pop out of at any second; and if the song sounded any more like *Dance Yourself Dizzy* they'd have to sue themselves. The law of diminishing returns was never more evident than in Liquid Gold's chart career (except maybe in Kelly Marie's) – this would be their last top 40 hit, although we haven't quite seen the last of them. Sorry about that.

SPANDAU BALLET - To Cut a Long Story Short (#43)

Cracking on with the shorter links, Simes barely acknowledges Liquid Gold and moves straight on to "five young guys from Islington who are causing a real buzz in the music industry." Indeed, long before they adopted the sensible suit and tie look you remember from the *True* video, Spandau Ballet were among the original New Romantics, regularly playing at London's Blitz nightclub where they were contemporaries of Boy George, Steve Strange, Rusty Egan and everyone David Bowie was taking the piss out of earlier. It's not hard to see why the New Romantics were figures of ridicule for the older generation; Spandau look like they've just come from a wedding in Inverness, tartan and sporrans

everywhere, although Steve Norman is the only one brave enough to actually wear the kilt. This TOTP performance would propel the band's début single into the top twenty next week and sow the seeds of a career that has lasted thirty-five years so far, albeit with a twenty year break in the middle when they hated each other's guts.

ABBA - Super Trouper (#13)

Talking of hating each other's guts... Sweden's finest are up next and Simes is all excited because *Super Trouper* has entered the chart at number 13, "something that's amazed even the record company." It's not immediately clear why this is so amazing, given that three of their last eight singles débuted inside the top ten, but Bates does at least get the honour of introducing the song's ~~video~~ film for the first time on British television. Of course, everyone knows it off by heart by now: the huge stage light being shone directly at the camera, the group in white costumes grinning wildly whilst surrounded by circus performers, Frida's amazing jumper, "*I was sick and tired of everything when I called you last night from Glasgow*" (yup, that's Glasgow for you). Musically it's miles away from *The Winner Takes It All* but lyrically the undercurrent of barely contained despair is still very much in evidence. Still, it's business as usual and *Super Trouper* is on an immutable path to number 1.

BLONDIE - The Tide is High (#1)

Put that light out! On with the top ten then, again with the TEN TOP TEN TOP TEN caption that comes and goes seemingly at random, and now with a caption for "ADAM AND ANTS" at number 7. "And for those people who thought that Barbra Streisand would be at the top 'til Christmas, you're wrong!" You certainly are. Blondie have done it again with their third number one of the year, although the video isn't finished yet so we get the opening shots of the Blondiemen looking up at Debbie's apartment from the familiar video and a brief clip of Ms Harry lip-synching to the chorus, but the rest is pans over still photos and footage from other videos, including a section accompanying the "*I'm gonna be your number one*" line where a giant blue 1 floats across the screen like a scene from *Sesame Street*. Simes bids us goodnight over the unexpected sight of Stu Francis and Dr Hook batting balloons at each other and we play out with *I Like (What You're Doing To Me)* by Young & Company, who were a funk group from New York and not a firm of estate agents from Aberdeen.

November 20

"Glad to see the place again, it's a pity nothing's changed"

Another week, another episode deemed unsuitable for broadcast by BBC Four thanks to the host's behaviour elsewhere. I mean, really, it's not like we're going to zoom in on DLT through the unenthusiastic crowd and find him locked in an embrace with a mystery blonde in a dimly-lit corner of the studio while Stephanie Mills' *Never Knew Love Like This Before* plays in the background, is it? *Is* it? Ah... it is. Well, this is awkward. But Dave's been too clever for us this time. "You thought you'd caught me, listen, before you start gossiping, it's the wife, so pack it in." Bah, you win this time, Travis. Anyway, this is the last Yewtreed edition of the show until we get to Christmas, when both end-of-year specials are scuppered by their hosts, which is a bit inconvenient and means BBC Four will have to show the 1978 and 1979 specials again like they did last year. At least UK Gold had the foresight to repeat this edition back in the 1990s, so here's what you missed.

MOTÖRHEAD - Ace of Spades (#15)

So here we are in the second half of November, but unlike today when there are already at least five TV channels devoted exclusively to showing Christmas films before December has even started, back in 1980 we were a bit more restrained about the festive season. That's excepting Motörhead of course, who were rarely restrained about anything. Travis holds in his sweaty mitts one of 50,000 12" copies of the *Ace of Spades* single with the band dressed in Santa outfits on the cover, although the TV picture isn't quite clear enough to show that Santa Lemmy is holding a can of Special Brew and giving a one-fingered salute. No time for such fripperies in the band's performance though, as they blast through their anthem as before except this time, as well as having to deal with Lemmy's microphone placement issues, they are bombarded with balloons and Philthy Animal has a knife through his head. Tough crowd. It's particularly unfortunate that we didn't get to see either performance of *Ace of Spades* on BBC Four, as Phil Taylor died shortly before the first one would have been shown and Lemmy finally proved himself not to be immortal just after Christmas 2015.

BOOMTOWN RATS - Banana Republic (#23)

There's an awkward silence after Motörhead finish, like the audience aren't really sure what just hit them, before the usual crowd noise is played out and DLT returns, cleaning wax out of his ear. On to the Boomtown Rats next, a new entry at number 23 although Travis expresses surprise "that it took that long to get in, it seemed they were never gonna make it." Give them a chance, Dave, the

chart only comes out once a week. *Banana Republic* is an attack on the Rats' homeland; after a controversial appearance on RTE's *Late Late Show* back in 1977 when Geldof accused the church and state of keeping the Irish Republic in the dark ages, the Irish authorities responded in much the same way as the establishment in Britain responded to the Sex Pistols and banned them. Although the Pistols had imploded by 1980, the Rats had gone from strength to strength but still found it impossible to get gigs in their own country. Naturally, Geldof's response to this was to (a) write a song repeating the accusations and (b) make an arty video in which the Rats all take their shirts off, the sight of the bare Geldof torso surely enough to make any politician or clergyman rethink his position.

DIANA ROSS - I'm Coming Out (#18)

Well, it's no wonder BBC Four wouldn't show this edition. We've had Lemmy flipping us the bird, Geldof using the word "whore" and getting his nipples out, and now Diana Ross is admitting she's a lesbian! Ah, hang on... no, apparently that's not right, although *I'm Coming Out* has been so widely adopted as a gay anthem that it's now difficult to envisage any other meaning. Diana isn't coming out to play tonight anyway, so... enter Legs & Co! Now pay attention to the choreography, because it's quite complicated. One of them is dancing around in a posh ballgown and comes to a halt behind the others, who are all wearing similar dresses... except once we get past the interminable intro they all walk away, revealing that the skirts of their dresses were just lecterns for them to stand behind and they're actually just wearing their underwear. How unusual.

EDDY GRANT - Do You Feel My Love? (#30)

Where's Simon Bates when you need him? Obscene gestures, partial nudity, sexual swearwords, homosexualism and now Travis has taken to cross-dressing. Yes, he's tried one of Limbs & Co's fake skirts on for size and discovered that it's a bit small. So small, in fact, that he can't get out of it. Hilarity ensues, as do cries for help and another "Pack it in!" directed at an audience member. While someone goes to fetch an oxyacetylene torch, we carry on with Eddy Grant whose solo career has been entirely bypassed by BBC Four so far; he appeared on three episodes of TOTP in 1979 with his first solo hit *Living on the Frontline*, all of them hosted by Savile or Travis, and now his second hit has fallen foul of the same issue. Grant, of course, had been on TOTP back in the late '60s as a member of The Equals and will finally get a BBC Four slot in a couple of weeks' time, when you'll be able to see that he's brought his mum and her friend along to do backing vocals.

ROD STEWART - Passion (#22)

Freed from the rogue skirt, Travis recovers from his ordeal by propping himself up with some young women as he expounds his theory about Eddy Grant's latest hit: "Another big success after *Living on the Frontline* was the last one... quite similar-ish sound, actually, so perhaps it's not so surprising it has got in the charts." Paul Gambaccini can rest easy knowing his services are not required tonight. Having established that Eddy Grant is at number 30, Travis takes us through an unusually short countup from 29 to 23, pausing here at 22 to address a shifty looking fella in a Captain's hat – "D'you like Rod Stewart?" "Naah!" "Well, get off then!" The unfortunate Captain is forcibly removed from the stage before the video for Sir Rodney's latest. It's a pallid and almost tune-free funk-rock workout – the only tangible melody comes in the middle eight, and even then it's only noticeable because of how much it sounds like *Do Ya Think I'm Sexy?* – but it gives Rod a chance to strut around in tight, stripy trousers and wiggle his arse at the camera, which seemed to be his entire raison d'être at this stage of his career.

KOOL & THE GANG - Celebration (#12)

Still weak from his earlier exertions, Travis has found a shoulder to cry on, or at least a short lady with a shoulder to lean on. "I feel sad for you," he tells her, "you can't take my place ever because you're not big enough, are you?" Steady on, Dave, no need to rub it in. He does at least give her the opportunity to link to the next part of the chart countup, after which Travis ups the offence ante by affecting what he seems to believe is a black American accent. "Alright, my children, everybody say yeah! We got a bit of *Celebration* from Kool & the Gang at number 12, boogie on down and all that stuff!" He ends his link with a self-satisfied smirk-pout as if he's just done something very clever, such as using the toilet like a big boy for the first time. Luckily there's no danger of gang violence this evening as neither Kool nor his Gang are in the studio; instead we get a repeat of their performance from two weeks ago. Although they still had almost a dozen top twenty hits to come, this was one of only five studio appearances for Kool & the Gang so it's a shame that the combination of presenters has kept it off BBC Four both times.

DENNIS WATERMAN with the DENNIS WATERMAN BAND - I Could Be So Good For You (#4)

Also falling foul of the presenter rota is Dennis "write the feem toon, sing the feem toon" Waterman, with another repeat performance that hasn't been seen on the BBC Four reruns. Indeed our loss is perhaps greater in this instance, because we got to see him talk about the single weeks ago but never got to see

him fumble his way through it. This was the first of three *Minder*-related hit singles during the show's heyday; Waterman and co-star George Cole, in character as Terry McCann and his boss Arthur Daley, reached number 21 in 1983 with the festive cash-in *What Are We Gonna Get 'Er Indoors?* but not until after The Firm had reached the top twenty with their entirely unofficial and non-festive cash-in *Arthur Daley ('e's Alright)* the previous year. Outside of the show, Waterman made numerous stabs at proper pop stardom, all of which failed miserably, even 1982's alarmingly titled *We Don't Make Love On Sundays*. At least he's been able to rely on his acting career for an income. Where are The Firm now?

BLONDIE - The Tide is High (#1)

Time to plug that TOTP album again, an end best achieved by giving it as a prize to two young ladies who, Travis informs us, "have been outstanding... I don't know why, why've you been out standing? You had tickets, you could've come in!" Apparently they've been chosen as outstanding dancers and not just two random audience members drafted in as an excuse to show the album sleeve on TV again, oh no. Top ten countup time – this time they manage to keep the TOP TEN TOP TEN TOP captions on until number 6 before they disappear, only to reappear during the number 3 clip – before another showing of the cobbled together Blondie video, proving that it wasn't a BBC Four creation, it really did look this rubbish at the time. This is Blondie's last week at number 1 for almost two decades; they took most of 1981 off, which proved to be a poor decision as their career quickly divebombed and didn't recover until their big reunion single *Maria* débuted at number 1 in 1999. Before we we play out with the highly appropriate *The Earth Dies Screaming* by UB40, DLT suddenly remembers he hasn't done a Tedious News Section™ this week, but he does have a bombshell to drop: he's "asked to be relieved from" the Radio 1 breakfast show because he's sick of getting up so early. Unfortunately this gives him more time to do TOTP, so more missing shows next year no doubt.

November 27

"What will the neighbours think?"

How do you set up an edition of *Top of the Pops* in late 1980? Follow these steps and you'll be there in no time. Fire up Stephanie Mills' *Never Knew Love Like This Before* yet again! Flood the studio with unenthusiastic punters! Sit one of them in the wrong place so he has to run across the front of the seating area to get into position before the show starts properly! Drag Tommy Vance away from preparing for the *Friday Rock Show*, stick him in a terrible jumper and prop him up in the studio! Surround him with girls! Give him something daft to say, like "Tonight it's my absolute promise that it's going to be a good one!" Tempt us in with clips of Spandau Ballet, Robert Palmer and Madness! Have we started yet? Yes we have!

SHOWADDYWADDY - Blue Moon (#50)

"First we're gonna have a band for you." Well, that's a good way to start. Or is it? Well, judge for yourself because the band in question is Showaddywaddy and they've got another single out less than a month after they were on doing their previous one. We've established that the 'Waddy have a penchant for covering old songs but they've outdone themselves here, reviving one that was written by Rodgers and Hart back in 1934. Originally conceived as a ballad, as per Elvis Presley's 1956 hit version, the most successful version of *Blue Moon* was the Marcels' 1961 doo-wop interpretation and it's this version that Showaddywaddy have gone for. Interestingly, Showaddywaddy's American equivalents Sha Na Na had been performing a similar version of the song since the early '70s, but when called upon to record it for the *Grease* soundtrack in 1978 they opted for the ballad version instead. Showaddywaddy put in an energetic performance and at least it's not Beady Eye's version, so we can be thankful for that.

UB40 - Dream a Lie (#10)

"Now, every once in a while record companies put out a thing called a double A-side." Indeed they do, Tom, and UB40's record label Graduate had done it with all three of their singles to date; indeed, we joked a few weeks back that the video for *Dream a Lie* might have been better prime time viewing than *The Earth Dies Screaming*, never thinking that they would actually show it. With the BBC going out of its way to avoid drawing criticism from the press, dropping shows due to their presenters and editing out potentially offensive content from the Barron Knights (not to mention Roger Daltrey's infamous "Mind yer backs" comment about the Village People) there was no way they were going to show a video which featured the lead singer in blackface make-up. As we've found out,

however, nothing is straightforward in TOTP land and the video did indeed make it to the BBC Four reruns, even the edited 7:30 showing. There's a lot more to the video than meets the eye, of course, as once you're over the shock / offence / hysterical laughter you'll notice that only the white band members are in blackface, while the black musicians are in whiteface; the video was the band's response to death threats from racists who compared them to the Black and White Minstrels. As it turned out the 2015 showings went unnoticed by the press, although some eyebrows were raised on Twitter, mostly by people making Papa Lazarou jokes.

ROBERT PALMER - Looking for Clues (#42)

"They, of course, come from Birmingham, here are a couple of gentlemen who come from the United States of America." Nicely done, Tom, linking UB40 to Daryl Hall and John Oates by virtue of the fact that they both come from somewhere. After several false starts Hall & Oates were finally enjoying a UK top 40 hit with *Kiss on my List*, which they've come to talk about but not sing, hence the reason it didn't get any higher than this week's position of number 33. This method of promotion very rarely achieved results, but one act bucking the trend is Robert Palmer whose *Looking for Clues* is on its way up the charts, although nowhere near the number 1 position Jimmy Savile confidently predicted for it a few weeks back. It's certainly working better for him than his former Vinegar Joe bandmate Elkie Brooks. Although it feels like Palmer had lots of hits over the next decade or so, he only performed on TOTP a handful of times; this was the first, but he won't be back until 1982. Shame really, as a xylophone solo is something you don't often hear in pop music these days.

ELECTRIC LIGHT ORCHESTRA - Don't Walk Away (#26)

Following a 20-second summary of Robert Palmer's entire life so far, Vance brings on improbably-named ELO drummer Bev Bevan. Bevan's written a book about ELO which Vance is having trouble asking him about. "In just one word, how, really, is *it*?" he asks. "How is *it*?" repeats a baffled Bevan, before answering "great" in a long-winded sentence which Vance has to interrupt in order to stop it taking over the entire show. ELO were noticeably reticent when it came to TOTP appearances, their last was in 1976 and just having the drummer in the studio wasn't enough to constitute a full performance, so... enter Legs & Co! The *Flick Colby Big Book of Literal Choreography* has let everyone down tonight; dressed in different coloured but equally revealing tiny outfits like an exhibitionist Showaddywaddy, the girls do exactly what they were asked not to and spend the whole song just walking around. Remarkably this was the sixth hit single out of the ten tracks on the *Xanadu* soundtrack album; even Michael Jackson hadn't managed six hits from an album yet so this was

quite some achievement, especially when the movie itself stiffed so badly.

STRAY CATS - Runaway Boys (#49)

A bolt through the bottom third of the top 30 (including AC/DC represented by a photo of their first appearance on TOTP, complete with now deceased singer Bon Scott) and we're on to the second half of a coded message: "Legs & Co: Don't walk away - run away, boys!" Vance reckons the Stray Cats are "one of the hottest properties in the record business at the moment," although the market for '50s rock 'n' roll revivalists seems quite crowded already with Matchbox, Showaddywaddy and Shakin' Stevens all fighting for chart space. The Stray Cats have a few points in their favour though, as they're authentically American and sing songs about rebellion and teenage angst in preference to the limp love songs favoured by the British acts, even if Brian Setzer's hair makes him look like an authentic '50s rocker who's been put in a teleport machine with members of A Flock Of Seagulls. This would become the first of five top 40 hits for the Cats although their last, 1983's *(She's) Sexy and 17* probably wouldn't make it past the Yewtree police today.

SPANDAU BALLET - To Cut a Long Story Short (#11)

"What do you think, twins, good?" The two completely dissimilar looking young women either side of Vance grin and nod. "They had to agree, 'cause they're twins, right?" They grin and look a bit sheepish, knowing that they told Tommy they were twins in an attempt to get noticed and he fell for it, so now they have to continue with their deceit and go on TV pretending to be twins when all their friends know they're not. On with the next bit of the chart countup then, pausing at 11 for a repeat of Spandau Ballet's début performance from two weeks back, everyone still in tartan for no clear reason and Tony Hadley looking so fresh faced you wouldn't imagine he'd last five minutes in the jungle, even as he faced the prospect of having to eat kangaroos' unmentionables as a contestant on *I'm A Celebrity, Get Me Out Of Here* in the same week this repeat went out on BBC Four. It's a funny old game, showbiz.

MADNESS - Embarrassment (#12)

And so we reach the low water mark of the "bring someone on to talk about their single without actually singing it" era as Tommy welcomes Martha Davis and Marty Jourard of The Motels. Who? Exactly. They had reached number 42 in October with the single *Whose Problem?* and would go one place better in January 1981 with *Days Are OK* but never actually performed on the show and this rambling excuse for an interview tells us absolutely nothing about them. Moving along as swiftly as he can, Vance introduces Madness with their fourth

hit of the year, but we only get to see the video as it's much easier than having the band back in the studio to cause even more chaos. To be fair though, Madness have grown up pretty quickly over the past fifteen months; *Embarrassment* is an acerbic comment on the attitudes of flying saxophonist Lee Thompson's family towards his sister having a mixed race child – *"How can you show your face when you're a disgrace to the human race?"* – and nobody has to black up to make the point. Except Mike Barson, who blacks up anyway.

ABBA - Super Trouper (#1)

Time for the top ten, including the return of ~~Papa Lazarou~~ UB40 at number 10 and "more exposure" for John Lennon at number 8 – he's about to get far more exposure than anyone ever expected. ABBA are at number 1 for the ninth and final time, replacing *The Tide is High* with its lyric *"I'm gonna be your number 1"* with a song that includes the line *"feeling like a number 1"* just like *Mamma Mia* replaced *Bohemian Rhapsody* with its *"Mamma mia, mamma mia let me go"* opera section in 1976. Pop genius or what? *Super Trouper* is a strange beast, ostensibly an upbeat love song but with an unmistakable subtext of "It's shite being in ABBA." Still, at least you're not Tommy Vance, forced to hobnob with Hall & Oates, Bev Bevan and two of the Motels while making incorrect predictions about the Christmas number 1 as Young & Company's *I Like (What You're Doing To Me)* plays us out again. Peter Powell hosts next week, meaning that for the first time in ages BBC Four will be able to transmit two consecutive shows.

December 4

"Won't you believe in my song?"

Who remembers the great vinyl shortage of 1980? Generally remembered as a mid-'70s problem, it seems to have reared its head again this year as once more the record that played us out of last week's TOTP - Young & Company's *I Like (What You're Doing To Me)* - is still playing at the start of this week's edition. As we join chummy Peter Powell sitting legs akimbo on the steps at the back of the set, casually pretending to chat to one of the girls in the audience, all becomes clear: there's a shortage of plastic because it's all been used to make his trousers. "You're very welcome as always on a Thursday," he tells us, so if you're watching the Saturday repeat you can naff off. Powell promises us a great show, "not only musically but also one or two personalities popping in." After some of the awful, joyless guests that have been on the show recently, personalities would be a welcome change, but don't hold your breath.

EDDY GRANT - Do You Feel My Love? (#9)

"For starters, one for our audience here to dance to and enjoy, I hope." Isn't that the entire point of the show, Pete? It's all somewhat academic anyway as Eddy Grant isn't even in the studio, it's a repeat of his previous performance although it does mean BBC Four finally acknowledges his solo career instead of just repeating clips of The Equals as part of *Sounds of the Sixties* whenever there's a gap in the schedule. It also means we get to see his remarkable backing group which includes his mum on backing vocals, a drummer who's just come from running a half marathon and one person whose entire job is to rattle some kind of African percussion instrument for dear life. This was the first of four top ten solo hits for Grant, five if you count the remix of *Electric Avenue* that turned up completely out of the blue in 2001, twelve years after his last hit.

NEIL DIAMOND - Love on the Rocks (#27)

There's one of those signature clunking great edits in the middle of Powell's next link, which looks like it was on the original broadcast as even Eddie Scissorhands in the BBC Four editing suite would be ashamed of this one. We can only speculate about what was removed - a dig at Eddy Grant bringing his mother and auntie along to do backing vocals, perhaps - before we're thrown back into the middle of a sentence and Powell is introducing Neil Diamond. It's another outing for that clip from Diamond's movie *The Jazz Singer* whose soundtrack album has already made the top twenty even though the film's still not out for ages. Unlike the original Al Jolson movie - and last week's TOTP - nobody's blacking up in this one, although it might have livened up an otherwise

dull clip if Diamond had slipped into a Black & White Minstrel routine halfway through. After an excruciatingly slow climb *Love on the Rocks* eventually peaked at number 17 in January 1981, making it Diamond's last excursion into the top twenty singles chart.

JONA LEWIE - Stop the Cavalry (#15)

"Guests keep on popping into the show nowadays, which is good news," lies Powell as he brings on two of Earth, Wind & Fire: Maurice White (Earth) and younger brother Verdine (Wind - sadly Fire couldn't make it this evening). "Two of the... nine, I think, isn't it?" Pete asks Maurice, who replies with a gormless "How are you?" and fails to answer the question. Earth and Wind are here to plug their latest album *Faces* (which has "just gone silver" - big deal, that's about 20 sales for each member of the band), their latest non-top 40 hit single *Back on the Road* ("It's taking off?" Powell asks Maurice, which isn't really a question so he just grins and replies "Yes, very good, right.") and their next UK tour which isn't until next August. Having gleaned absolutely nothing from the conversation, Powell asks Earth and Wind to hang around and listen to *Stop the Cavalry* by "a band called Jona Lewie," promising that they "might recognise one or two faces in the band". We never find out if they do recognise anyone, but unless anyone in EWF was a fan of Terry Dactyl & the Dinosaurs, the Kursaal Flyers or John Otway, it seems unlikely. *Stop the Cavalry* wasn't even meant to be a Christmas song, but give Stiff Records a song with the word "Christmas" in it and they'll do whatever they can to make it so, even releasing a version with a Welsh male voice choir the following year.

KENNY ROGERS - Lady (#22)

After a brief chart countup from 30, including Queen's *Flash* at 30 illustrated by a thoroughly unrepresentative photo of the band in their glam pomp six years earlier, we pause at number 22 for Kenny Rogers who has finally followed up his gang rape anthem *Coward of the County* with this limp ballad. Of course he's not here though, Kenny only ever graced the TOTP studio once and that was back in 1970 with his band the First Edition, so... enter Legs & Co, right? Well, sort of, except they're not in the studio either. As the song's called *Lady* and the first line includes the words *"knight in shining armour"* Flick has whisked the girls off on a pre-Christmas day out to Camelot *("Camelot!" "Camelot!" "It's only a model." "Shhh!")* where they've all dressed up as damsels in distress prancing around waiting for their knight to arrive, although presumably not in the same way as they do in Castle Anthrax. The knight never quite makes it to the cardboard castle, although one of the damsels does get to pick a golden pear off the otherwise bare tree in the courtyard, so that's some compensation I suppose.

AC/DC - Rock 'n' Roll Ain't Noise Pollution (#17)

The countup is very strange this week as Powell returns to the chart but only takes us from 21 to 17, where we find AC/DC represented by a photo of the band on the show in 1978 with by now deceased vocalist Bon Scott. After Scott's death in February 1980 (shortly after the band's last TOTP appearance) he was replaced with almost indecent haste, the band considering Noddy Holder for the role (an appointment which would have changed Christmas forever) but finally employing Brian Johnson, the former Geordie singer (although of course he remains a Geordie singer, but is no longer the singer in Geordie). Less than six months after Scott's death, the new-look AC/DC released *Back in Black* which went on to sell fifty million copies, making it the second biggest selling album in history after *Thriller.* Here we get the video for the album's second single, a performance clip which - apart from the obvious change of frontman - features all the usual AC/DC traits including guitarist Angus Young in full schoolboy uniform and a song about how great rock 'n' roll is, proving that despite Scott's demise it was business as usual for the band, as it has been ever since.

ST WINIFRED'S SCHOOL CHOIR - There's No-one Quite Like Grandma (#16)

Two consecutive acts on TOTP performing in full school uniform? That must be a first, right? After the third half of the countup we return to number 16. "At Christmas all sorts of things happen in the British charts," observes Powell, and he's certainly not wrong there. Some members of St Winifred's School Choir had already performed on Brian & Michael's 1978 number 1 *Matchstalk Men and Matchstalk Cats and Dogs* but now they were back for a crack at the big time in their own right. Ten years earlier Clive Dunn had topped the charts with *Grandad* and now the music industry thought we were finally ready for a similar record for granny too, albeit a saccharine drenched one with all the nostalgic melancholy of *Grandad* sucked out of it. Tempting as it is to mock a lisping eight year old in a hideous pink frock and the gang of grinning loons with awful haircuts behind her, there's little point because all their schoolmates will surely have done it more effectively than I ever could. *There's No-one Quite Like Grandma* would go on to commit one of the worst chart crimes in history, denying a dead man the Christmas number 1 spot, as a result of which St Winifred herself was decanonised early in 1981.

THE BOOMTOWN RATS - Banana Republic (#3)

Remember how Powell promised us "personalities" at the start of the show? He's now backpedalling furiously and pretending he only promised us "guests", because here's Mike Oldfield in a terrible green velour tracksuit to mumble

December 4 207

about his latest single, a double A-side release of *Sheba* and *Wonderful Land* which utterly failed to chart. He does get to introduce the Boomtown Rats though, not that they really need Oldfield's patronage. The reggaefied introduction to *Banana Republic* sees the Rats framed by some cartoon palm trees, because nobody has worked out that the lyrics are about Ireland and not some insignificant Caribbean state. Bob Geldof is his usual grandstanding self, wearing a daft hat and eschewing conventional microphone techniques, but the rest of the band do occasionally get a look in by throwing themselves to the front of the stage and jostling for position. This was the Rats' last top ten hit but they still have a couple of smaller hits to come.

ABBA - Super Trouper (#1)

Despite being top of the singles and albums charts at the same time with identically titled records, everything's still relentlessly grim in ABBA land, although they're still *"feeling like a number one."* You should have gone before you left the house. Of course *Super Trouper* was used as the basis for the famous *Not the Nine O'Clock News* "tribute" *Supa Dupa*, written by Richard Curtis and Howard Goodall before they became part of the establishment. In fact there's an obvious parallel between ABBA and NT9OCN; both their legacies have been reduced to a handful of over-familiar pieces with *ABBA Gold* becoming the biggest selling compilation album in history and the re-edited mid-'90s compilations of *Not the Nine O'Clock News* still running on various digital channels, while dozens of other works lie forgotten on ABBA's neglected albums and *Not*'s original (apparently unrepeatable) series. Still, that's progress. Earth and Wind have long since left the building but Mike Oldfield is still here to prop up Powell as he bids us farewell to the strains of Diana Ross's *I'm Coming Out*. It's a solo hosting début for Richard Skinner next week, by which time the music world will have changed forever.

December 11

"That music's lost its taste so try another flavour"

December 1980 was all set to be a cracking month for Richard Skinner. After years reading the news on Radio 1 he'd landed a proper DJ gig on the station, taking over Mike Read's evening show in the post-Christmas week, and after a couple of supporting roles on TOTP (on editions nominally hosted by Jimmy Savile, which is why we haven't seen him on BBC Four until now) he's graduated to the main hosting rota. Of course every silver lining has a cloud and Skinner's first solo flight on TOTP came just three days after John Lennon was murdered; still working on *Newsbeat* when the news broke, Richard had the unenviable job of calling Paul McCartney to tell him what had happened. No wonder Skinner's entirely devoid of colour tonight, rocking the grey shirt / grey jumper / grey slacks / grey hair look like only a newsreader can. The Pops don't stop though, and as *that* Robert Palmer track plays in the background again (no matter how many plays it gets on the show, it's still not going to make the top thirty) Skinner draws us in with the line "If you're *Looking for Clues* as to what we've got on today's TOTP, how's about this for a start?" Smooth.

ADAM & THE ANTS - "Antmusic" (#16)

While the cool kids already had "hussar jacket" and "year's supply of correction fluid" on their letters to Santa after seeing *Dog Eat Dog* a few weeks back, it was the blatant self-mythologising of this song that really established Adam as a force to be reckoned with in the coming year. *"Antmusic"* - the quotation marks are an indispensable part of the title, like Bowie's *"Heroes"* - differed little from *Dog Eat Dog* except for having a catchier chorus, but established the clickety-clack twin-drummer Ants sound as a recognised musical genre and helped distinguish it from the similar sound peddled by Adam's former Ants, now working for Malcolm McLaren as Bow Wow Wow. For some reason the video screen has been pressed into service as a prototype karaoke machine, displaying the lyrics for you to sing along with so everyone can see how alternative you are. Don't forget to look out for cameras though - one of the hulking early '80s beasts almost flattens a couple of unfortunate audience members as it gets wheeled back into position for the next link.

SHOWADDYWADDY - Blue Moon (#32)

"That's number 16 in the charts this week and if you double 16 you come to 32, and at number 32 it's Showaddywaddy and *Blue Moon!*" With irrefutable logic like that it's no wonder Skinner spent so long in the news department. This is another outing for the clip from two weeks ago with only lead singer Dave

Bartram persevering with the coloured suit (and if anyone's lost a Pepperami, Dave has found it and is keeping it safe for you. In his pants.) while the rest of the band have variously opted for leather jackets, white satin shirts or just plain black T-shirts which isn't really entering into the spirit of things. The enthusiastic tag-team backing singers do make up for the lack of wardrobe effort, although it seems unfair that the BBC couldn't give them a microphone each. *Blue Moon* dropped down the chart over Christmas and climbed back up to number 32 in January but got no higher.

MADNESS - Embarrassment (#4)

Time to bring the show to a crashing halt again by bringing on Jermaine Jackson who's here "promoting my album and meeting people." He hints at a possible Jackson Five reunion in the new year (it didn't happen) and is presented with a birthday cake (complete with eye-wateringly suggestive candle) as Skinner haltingly and erroneously suggests that he doesn't look a day over 15. Jackson has also never heard of Madness, "but I hear that they're very exciting," he lies. Appropriately enough after such a cringeworthy interview, *Embarrassment* is up to number 4 and the Nutty Boys have outdone Showaddywaddy in a range of gaudy tartan jackets which suggest that they've skipped Christmas altogether and have already moved on to celebrating Hogmanay. For once there are no shenanigans, apart from Chas Smash smirking into a trumpet for the entire song, and nobody gets banned from ever appearing on the show again like they usually do.

STATUS QUO - Lies (#17)

"If you think we're a bit legless tonight," begins Richard, apropos of nothing, "it's because Legs & Co are actually rehearsing today for our two Christmas shows, both on Christmas Day and New Year's Day, so stay tuned for that one." Which one? Doesn't really matter, because thanks to the vagaries of the presenter rota BBC Four won't be showing either of them. It's also a pretty flimsy excuse for their absence because there's only one new Limbs & Co routine and two repeats across both specials. More BBC deception and propaganda, there. Speaking of falsehoods, *Lies* and its double A-side *Don't Drive My Car* were the second single from Quo's ~~coke-fuelled~~ enthusiastic recording sessions this year which spawned two whole albums. After numerous visits to the TOTP studio for *What You're Proposing* we only get the video for *Lies*, not that it's really any different from a standard Quo TV appearance except for the smoke and wind machines which are playing merry hell with some of the shaggy perms on display. The single spent six weeks slowly climbing the top twenty, with a post-Xmas switch to promoting *Don't Drive My Car* as the main A-side propelling it as high as number 11.

MATCHBOX - Over the Rainbow / You Belong to Me (#31)

How to follow the good-time boogie of the Quo within the confines of an upbeat pop music show? Mention the fact that John Lennon died three days ago, obviously, "but as well as that, it's Christmas coming up soon!" Apparently Dire Straits are playing all the way up to Christmas, as if things weren't bleak enough. Then, to lighten the mood even further, we get a quick interview with smiling Gary Numan, who it seems is retiring from playing live. "Why are you withdrawing from live appearances?" Skinner asks. "Er... I don't know!" Skinner also asks Numan about his new hobby, flying - not by flapping his arms really fast, but piloting aeroplanes. "Bit of a dangerous hobby?" "Nah, it's alright," scoffs Numan, offering some excuse about being able to switch to the second engine if one fails, but overlooking the possibility that the plane might run out of fuel, as his did in 1982 necessitating a crash landing on the B3354 near Southampton. Still, once you've heard Matchbox simpering through *Somewhere Over the Rainbow*, even crowbarring in an unnecessary verse from *You Belong to Me*, death loses its sting a bit.

THE POLICE - De Do Do Do, De Da Da Da (#9)

And talking of Sting - ha ha, this thing isn't just thrown together you know - the Police are still refusing to come to the studio but have sent in another video, this one set in the mountains of Canada; the band arse about in the snow while Stewart Copeland films them on a Super-8 camera, footage Copeland used in his 2006 documentary *Everyone Stares - The Police Inside Out*. Sting maintains that the banality of the chorus is a statement about the power of simplicity in lyrics, although what *"When their eloquence escapes you, their logic ties you up and rapes you"* means is, frankly, anyone's guess. At least he doesn't get his kit off in this one. Like their previous hit *Don't Stand So Close To Me*, the Police re-recorded *De Do Do Do, De Da Da Da* in 1986 for inclusion on their album *Every Breath You Take - The Singles*, but it was decided to use the original version instead and the new recording remains unreleased, except for the time it slipped out on an obscure SACD version of the album in 1995.

QUEEN - Flash (#20)

Back to normal in the chart countup this week as we go from 30 to 20, including obligatory subdued voice as John Lennon's *(Just Like) Starting Over* sinks to 21, to reach Queen, still illustrated by a photo from at least five years earlier even though they look completely different in the *Flash* video. Except Brian May, obviously. In fact this is the first time we've seen Freddie's face furniture ('Tache! Aa-aaaah!) in full since he grew it sometime between making the videos for *Save Me* and *Play the Game* earlier in the year. The theme from the much heralded remake of the *Flash Gordon* film serials of the 1930s and '40s, *Flash*

makes extensive use of sampled snippets of dialogue from the film, making it the prototype for subsequent movie themes such as Prince's *Batdance*. Although now a favourite, the track polarised opinions of Queen fans at the time, in much the same way that Freddie's moustache had done back in the spring but to nowhere near the same extent that *Hot Space* would in 1982. Oh, and if you haven't seen *Flash Gordon*, turn on ITV2 now and wait, they seem to show it every two or three hours.

STRAY CATS - Runaway Boys (#10)

Back to the chart for a countup from 19 to 11, followed by the number 10 hit which begins with a close-up of the giant video screen so you can see just how low quality it really is. Produced by Dave Edmunds, who for once hasn't brought Nick Lowe with him, this was the first of three huge UK hits for the Cats over the next six months or so. Although American, the band moved to the UK to be part of the ongoing rockabilly revival and didn't really take off in the States until 1982, by which time their British success had faded somewhat. We're getting ahead of ourselves though; this is a second showing for the band's performance of *Runaway Boys* which peaked at number 9 next week. Presumably they're not in the studio because, with their authentic rock 'n' roll haircuts, instruments and tattoos, Matchbox are terrified of them. Richard Skinner had the pleasure of working with them in Norwich recently, which is nice in an Alan Partridge kind of way.

ABBA - Super Trouper (#1)

On with the top nine then, and the end of an era as ABBA spend their last ever week at number 1 in the UK singles chart. It's the video again of course, but unusually the credits run over the end of the video and we fade back to Skinner, looking disembodied in front of a stark black background. It's the inevitable Lennon tribute as a sombre Skinner suggests that we should "remember him as he was at his best." We don't get to do that though, because apart from an insert in an episode of *Doctor Who*, all the Beatles' TOTP performances were disposed of years ago. Instead we get footage of Lennon's last public performance back in 1975, singing *Imagine* at an all-star tribute to Sir Lew Grade, head of ATV (makers of *Tiswas*, *The Muppet Show* and *Crossroads*) and, following many protracted and baffling legal battles, then owner of Lennon's music publishing rights. Lennon was clearly in no mood to salute Sir Lew, unless it was a one-fingered salute, but was contractually obliged to appear at the event. Fractiously he brought with him his new backing band BOMF - "Brothers of Mother F***ers", which makes Frank Zappa's Mothers seem pretty tame - and ran through a couple of songs, dressed in an appalling red leather onesie while other members of the Lennon entourage wore masks on the back of their heads as a

sardonic reference to Grade's "two-faced" business dealings. It's all pretty shabby and makes the fact that this was Lennon's last live performance all the more depressing. Still, it's nearly Christmas.

December 18

"Christmas turkey, you can stuff it"

So this is Christmas, and what have you done? Employed sensible Simon Bates to host the last regular TOTP of the year, that's what. This could all go terribly, terribly wrong but thankfully he's flanked by three young ladies in the now ubiquitous TOTP T-shirts (we never did find out how we could buy these, did we?) to wave balloons around and generally lighten the mood as the Stray Cats' *Runaway Boys* plays in the background. This still fails to draw attention away from Bates and his total lack of hosting ability as he tells us "It's the last Christmas *Top of the Pops* before the Christmas *Top of the Pops*... if you see what I mean." Not really, Simes, no. There's no "coming up" spot in the intro this week, but whether that's because Michael Hurll has finally realised it doesn't work or because Simes has forgotten to do it is unclear. By the time he reaches the end of the link, with one of the women doing rabbit ears behind another's head as the third puts a party hat resembling a giant liquorice allsort on Simon's bonce, all sensibility has gone out of the window. Behave yourself, Bates, this is Christmas, not a time for frivolity!

THE BEAT - *Too Nice To Talk To* (#31)

It's been quite a year for The Beat, now on their fifth hit single, and Dave Wakeling has dressed up to celebrate, because nothing says Christmas like a ska revivalist wearing some kind of Russian military uniform. Rather than exchanging gifts this year, The Beat and The Specials have exchanged band members: look closely and you'll notice Sir Horace Gentleman taking over bass duties here, while David Steele turns out for his former 2 Tone labelmates later on. Perhaps other bands should have swapped members too in the interests of keeping the show fresh, but they didn't, so we'll just have to make some up. *Too Nice To Talk To* was on its way to becoming The Beat's fourth top ten hit, a level of success they would be unable to maintain with only a couple of top forty hits next year and none at all the year after that, before bowing out in 1983 with their biggest hit which, as it turned out, had been hiding on their 1980 début album *I Just Can't Stop It* all along.

ST WINIFRED'S SCHOOL CHOIR - *There's No-one Quite Like Grandma* (#2)

Meanwhile, Simes still hasn't quite got to grips with the concept of Christmas or how long it lasts. "There's one more BBC Top 40 coming out before the end of Christmas... or the *start* of Christmas!" Well, which is it? What Bates means is

that this isn't the Christmas chart, but because December 25th fell on a Thursday in 1980 there was no proper TOTP for that week, just the traditional Christmas Day special which reviewed the entire year as per usual. Simes does get one thing right, however, when he predicts that the Christmas number 1 slot might just go to the St ~~Winalot~~ Winifred's School Choir – indeed, they would have been number 1 this week were it not for the actions of Mark Chapman. Due to the age of the participants the choir has not returned to the studio, that sole performance from two weeks ago remains the abiding image of TV's Sally Lindsay and her childhood contemporaries and there's no alternative clip in which one of the boys in the choir swaps places with Angus Young from AC/DC.

THE BARRON KNIGHTS - Never Mind the Presents (#27)

"Now then, there's a band that produces a single every Christmas – every Christmas, sure as fate, they have a hit with it." This rather over-simplifies the career of the Barron Knights; this was their fourth consecutive hit at this time of year but their first was back in the summer of 1964 and they had enjoyed numerous successes in various seasons since then. *Never Mind the Presents* sticks rigidly to their winning formula: three recent hit songs performed with humorous alternative lyrics on a similar theme. Previous hits had been based around bands being conscripted in to the armed forces (*Call Up the Groups*), casual violence (*A Taste of Aggro*) and last year's infamous grubfest *Food for Thought* which was cut from the BBC Four reruns due to its dubious rewrite of M's *Pop Muzik* as an ode to the Chinese takeaway. This year's theme, not unreasonably, is Christmas, so we're treated to parodies of *Another Brick in the Wall*, *Day Trip to Bangor* and *The Sparrow*, suggesting that the whole thing was written this time last year. Also not swapping places with a member of St Winifred's School Choir is singer Duke D'Mond, in full school uniform for no obvious reason. Sadly D'Mond died in 2009 but comedy pop fans everywhere felt a little flicker of excitement, followed by crushing disappointment, when the unrelated Duke Dumont scored a number 1 hit in 2013.

THE SPECIALS - Do Nothing (#34)

So *Never Mind the Presents* might not have been the Barron Knights' finest hour, all things considered, but thoughtfully the Beeb have made them look infinitely more entertaining by bringing on Little & Large directly after them. Thankfully the BBC's third-best comedy double act (since Morecambe & Wise went to ITV) don't have a record to promote but they do have a TV show, a live show and a new series in the pipeline, none of which Syd Little seems to be able to talk about. Eddie Large does an Eddie Waring impression and tells us why Syd likes The Specials – "'e likes Special Brew and 'e went to a special school." Okay... maybe the BBC's fourth-best comedy double act. Having given their

previous single *Stereotype* the cold shoulder to the extent that the title wasn't even mentioned, this is a strange way for TOTP to welcome the Specials back to the studio. Never mind though, it's Christmas and the band have found the trousers to match Madness's tartan jackets from last week, teaming them with some very fetching Christmas jumpers which are humorously at odds with yet another grim single release from Jerry Dammers & Co. Still, it's good to see that two members of the band have taken their own headgear advice from *Too Much Too Young* and tried wearing a cap.

GARY NUMAN - This Wreckage (#35)

Thanks to the unique way the BBC is funded, it's perfectly acceptable for Simes to plug a couple of "gramophone records" as perfect last minute Christmas gifts, because they're both on the BBC Records label: that *Best of Top of the Pops* album again, or the *Not The Nine O'Clock News* album which has just gone platinum, because home video still wouldn't take off properly for another few years and this was still the only way to relive the sketches from the TV series. That done, Bates introduces us to "a guy you might have thought you'd never see on *Top of the Pops* again." Presumably this is a reference to Gary Numan's interview last week in which he confirmed that he'd retired from live performance, but TOTP hardly counts. In fact Numan's performance was almost certainly recorded last week while he was hanging around, as on the day this show was recorded he was busy getting his pilot's licence. As well as being an entirely inappropriate title with which to celebrate such an occasion and sounding like a prototype for Soft Cell's *Say Hello Wave Goodbye*, *This Wreckage* brought Numan's run of top ten hits to an end, peaking at number 20.

ROBERT PALMER - Looking for Clues (#33)

While a search party is dispatched to hunt for the chorus of Gary Numan's single, Simes has his arm around a woman in some kind of makeshift Santa outfit. "This is Mummy Claus," he tells us, "it's a good family life we have on *Top of the Pops*." No further explanation is forthcoming and it's probably best not to ask. Bates has already moved on to introducing Robert Palmer, "who had a beautiful single out a while back called *John and Mary*, which wasn't a massive hit." Despite an inordinate amount of promotion on TOTP - as well as this performance, now on its second showing, the track was used as intro music last week and no less a personage than Jimmy Savile was raving about it back at the start of November - *Looking for Clues* wasn't a massive hit either and holds the unusual distinction of having spent five consecutive weeks at number 33. Palmer would go on to bigger things, of course, but not with this drummer who looks like the kind of hipster who would put Christmas baubles in his beard.

CHAS & DAVE - Rabbit (#18)

Another plug for the Christmas and New Year specials takes us into the chart countup, all the way from 30 to 18, although Simes doesn't seem to know any of the songs' titles until we pause at 18 for the mighty Chas & Dave. Having been involved in music since the '60s, mainly as session musicians in a career which eventually saw their work sampled by Eminem, Chas Hodges and Dave Peacock had settled into a life of novelty pop success, fusing rock with a Cockney accent to invent "Rockney". That explains the unorthodox title for a song about someone who won't stop talking - "rabbit and pork" being Cockney rhyming slang for "talk" - but sadly nobody seems to have understood this, so the audience is suddenly full of people in terrifying rabbit heads like you've fallen asleep and had a terrible nightmare during *Watership Down*. It doesn't help that the Barron Knights' Duke D'mond is now in the back row of the audience among the rabbits, still in his school uniform. No more cheese for me.

THE NOLANS - Who's Gonna Rock You (#39)

After a pointlessly short countup from 17 to 11 (halfway through which Simes finally finds his sheet of paper with the song titles written on it) Bates makes a baffling rabbits / Nolans comparison: "Wherever you look in the TOTP studio tonight there are Nolans everywhere!" Funny, because I can only see four. It's been a good year for the Nolans; this is their seventh time in the TOTP studio this year (and they're not finished yet) and their fourth top forty hit. Although *I'm In the Mood for Dancing* remains a millstone around the collective Nolan neck to this day, here we find the sisters continuing to distance themselves from the cheesy disco of their first hit. *Who's Gonna Rock You* is an unexpectedly funky synth workout which replaces the TOTP Orchestra of old with a proper band including Santa himself on drums, and like *Gotta Pull Myself Together* it's much better than you remember it. If this carries on into 1981 we may all have to rethink our attitudes.

JONA LEWIE - Stop the Cavalry (#3)

Don't worry, I won't be asking you to rethink your attitude towards Simon Bates, who introduces the top ten countup via a terribly convoluted sentence about success stories which he himself doesn't even seem to understand. Hang on though, the top ten already? Yes, everything has gone weird since the death of John Lennon just ten days ago, so while the countup has gained a spinning caption spelling out the position of each song, it only gets as far as number 3 before we pause to hear *Stop the Cavalry* in full. Given the success of this single and *You'll Always Find Me In The Kitchen At Parties* a few months back you'd expect to be hearing a lot more from Jona in the coming year, but for some baffling reason this was his last hit and last appearance on the show. Still, he

was good enough to give *The Sound of the Crowd* a quick interview for our *Tweet Little History* feature, so he's a top bloke in our book. Just remember it's not a Christmas song.

JOHN LENNON – (Just Like) Starting Over (#1)

With most of the top ten already counted up, there's just time for a cursory mention of St Winifred's at number 2 and yet another reminder about the Christmas specials we won't see on BBC Four before we're into the number 1. Rather jarring with Simes's hope that we "have a marvellous time" over Christmas, a recent black and white photo of John Lennon fades into the star on top of a Christmas tree. Yes, being the most widely available single in the shops at the time of his unexpected demise, *(Just Like) Starting Over* has rocketed back up the chart from last week's number 21 to the very top. All hopes of a dignified tribute are soon dashed, however, as Legs & Co appear one by one from behind the tree in red dresses which seem to be adorned with ferrets. Their joyless shimmying is interspersed with various poignant portraits of Lennon: loveable moptop John in the Beatles, beardy four-eyed John in bed, cleaned-up respectable John in the '70s and so on. The credits roll over the song's outro and another shot of the top of the tree, bringing us to the end of the 1980 re-runs on BBC Four. Still those Christmas specials to come though, if you know where to look...

December 25

"Feeling like a number one"

Even though *Top of the Pops* ceased to be a weekly event in 2006, the Christmas Day special looking back on the year gone by remains an unavoidable Christmas tradition, like turkey, the Queen's speech and having to be nice to relatives you can't stand. Like poor unfortunate Peter Powell, forced to spend his Christmas lunch visiting his old uncle Jimmy, who's relaxing in his tracksuit and toting a cigar while sat behind a table full of turkey and crackers… so just like every day in the Savile household. "Apologies if we stop you mid-mouthful of your Christmas lunch," offers Jim, "my colleague Mr Powell will tell you the first item whilst I have a look at the goodies, thank you." Sadly Jimmy hasn't gone to watch Bill Oddie and friends on a portable in the bedroom, he's just inspecting the food on the table, picking up a satsuma and trying not to get cigar ash all over the turkey. Chin up, Pete, it's only for an hour and then we can go home and watch the Bond film on ITV.

THE NOLANS - I'm in the Mood for Dancing

Again? Yes! They seem to have spent more time in the TOTP studio than their own homes this year, and they were on just last week doing their latest single, but the Nolans just can't help themselves. They're back for another performance of *I'm in the Mood for Dancing*, which was released at the tail end of last year but became the sisters' biggest hit when it reached number 3 in February. This is now their eighth appearance in the studio this year, a figure which puts them way ahead of their nearest rivals, and when you consider that the video for ~~The Curtain Song~~ *Gotta Pull Myself Together* was shown twice, they could easily have been in double figures. As a reward for their efforts, Creepy Uncle Jimmy and Young Peter join them on stage at the end of the song. "Would anybody like a Nolan for Christmas?" asks Savile. "Please!" replies Powell, raising his hand, but alas Uncle Jimmy has got there first, taking each Nolan by the arm as if trying her for size before grabbing Coleen around the waist and taking her away for his own purposes. This is why we BBC Four viewers can't have nice things.

DEXYS MIDNIGHT RUNNERS - Geno

One of the aforementioned nice things we're missing out on now, as the recently hastily reconstituted Dexys Midnight Runners Mk II turn up for a run through of the Mk I version's biggest hit. A tribute to Geno Washington, but you knew that, *Geno* spent a fortnight at number 1 in May, bringing the band huge success which Kevin Rowland immediately set about trying to dismantle. Follow-up *There, There My Dear* hit number 7 during The Event but Rowland fell out with

the entire music press, next single *Keep It Part Two (Inferiority Part One)* was a disaster and the band split. Kevin was having none of it though and employed an army of new musicians to become Dexys Midnight Runners, adopting a new sweatpants and boxer boots image to replace the docker chic of the original band. Re-recorded with the new line-up, *Geno* sounds noticeably different, but Rowland's trademark whooping, hiccupping vocals are still in place so that's really all that matters.

BLONDIE - Atomic

So the Nolans might have had a great year with four hits and a squillion appearances on TOTP, but Blondie have had an even better year: three number one hits from three attempts, without ever so much as setting foot in Television Centre. Even their videos were a bit weird: *The Tide is High* was represented by a hodgepodge of bits from the real video and a lot of clips from elsewhere, *Call Me* didn't have a video at all so we got clips from *American Gigolo*, and while *Atomic* did have a video, it used the strange version of the track with only one verse and a seventeen minute bass solo, while visually it employed all sorts of peculiar solarised effects and starred Debbie Harry wearing a torn bin liner. It's the only proper video available though, so it's the one we get here. "Post apocalyptic nightmare scenario with your sprouts, dear?" "Ooh, don't mind if I do, dear."

PAUL McCARTNEY - Coming Up

Look out, Uncle Jimmy's been at the sherry again. Like a man concentrating on his words extra hard in an effort to make you believe he's not drunk, Savile hesitantly hopes we're all having a very fine Christmas and introduces another video. It's not been the greatest of years for fab wacky thumbs-aloft Macca - what with spending nine days in a Japanese prison at the start of 1980 and his friend and colleague being senselessly murdered at the end - but his first post-Wings album *McCartney II* made number 1 and this single got to number 2, although weirdly it was a live Wings version of the song that did the business in the US. The video, as you'll remember, features an entire orchestra of McCartneys in all sorts of guises ranging from fab '60s moptop Paul to Buddy Holly to Ron Mael to Animal from The Muppets, plus Linda as Linda. Incidentally there's no tribute to - or even mention of - John Lennon during the show, suggesting that it was recorded weeks ago. More lies and deception from the BBC, there.

BARBRA STREISAND - Woman in Love

Back in their seats now, Uncle Jimmy leers over the turkey in a most disturbing

manner as Young Peter picks up a leg. "Don't eat with your mouth full!" Savile admonishes him, before picking up the plate with the turkey on it and giving it a look which quite definitely says "Hey baby," the senile old goat. Trying his best to ignore him, Powell introduces Barbra Streisand with her unexpected Bee Gee-penned number 1 hit from a few months back. She's not here, of course, so... enter a recording of Legs & Co! Yes, even though they missed a regular weekly edition recently because they were "rehearsing" for the Christmas special, they still can't manage to do two routines in the same day so the one they did for the song's first airing on the show will have to suffice. We don't even get the hybrid version that's intercut with clips of Streisand snogging a variety of men who look a bit like Barry Gibb, it's the full routine for us. This number 1 was, of course, the peak of Barbra's UK singles success; it would be another seventeen years before she returned to the top ten by way of duets with Bryan Adams and Céline Dion, and another thirteen years after that before Duck Sauce managed to smuggle her to number 3.

LIQUID GOLD - Dance Yourself Dizzy

Meanwhile our hosts are working their way through the mountain of food on the table; Uncle Jimmy has a turkey leg (not a medical condition) while Young Peter is peeling a satsuma (not a euphemism). "My colleague's appetite seems to have taken a considerable nosedive, ladies and gentlemen," announces Savile, and with Liquid Gold up next it's easy to see why. This week Ellie is wearing a gold lamé onesie while appropriately-named drummer Wally is wearing... well, it's hard to tell. Zebra skin pants and boots? Whatever it is, there's so little of it that it's probably put a significant number of people off their Christmas lunch, not just Peter Powell. Of course they do the "xylophone on the chest" routine again and Wally gets a custard pie in the face for his trouble. Sheer comedy bronze. Thankfully we'll see significantly less of Liquid Gold next year, as their bid to represent the UK at the 1981 Eurovision Song Contest was roundly defeated by the British ABBA.

DAVID BOWIE - Ashes to Ashes

Leaving Uncle Jimmy to try and seduce the turkey, Young Peter wanders over to the (still resolutely monochrome) video screen to introduce... another video, or "piece of film" if you're Tommy Vance. Yes, it's the *Ashes to Ashes* video again, complete with the "David Bowie invented the iPad" rumour, the £3.39 "standing in the middle of some water without getting wet" effect and the late, great Steve Strange attempting not to trip over his outfit and get flattened by a bulldozer. Bowie ties with Blondie for the number of times he's been on the show in 1980 without ever turning up to the studio, his tally bumped up by the unexpected reissue of *John I'm Only Dancing* in the very first week of the year and the use of

Alabama Song as the show's least appropriate playout track of the year at the end of February. 35 years on, Bowie is one of the few acts from 1980 who can still generate excitement by promising a brand new album in January 2016, unless there's a sudden Liquid Gold reunion over Christmas.

MARTI WEBB - Take That Look Off Your Face

It's that awkward lull in Christmas Day where the festive spirit is starting to run short but it's too early to start drinking. Young Peter attempts to amuse himself by juggling satsumas, throwing them on the ground in mock disgust when his attempt ends in inevitable failure. Equally disappointing was Marti Webb's year, after it got off to such a promising start when *Take That Look Off Your Face* got to number 3 back in March. Her two follow-up singles both stalled outside the top sixty, so having only bothered to record one TOTP performance for the song when it was in the chart, Marti appears to have been press-ganged into coming back to do another one on the grounds that it may be her last chance. She shouldn't have bothered. With all the enthusiasm of a beleaguered housewife who's just received an iron for Christmas, Webb performs the song standing stock still with barely as much as a hand gesture. As it turned out she did get on the show again, but not until 1985, and with that attitude it's no wonder.

THE POLICE - Don't Stand So Close to Me

Having merely wielded his cigar like an extra finger until now, Uncle Jimmy has thrown caution to the wind and is now actually smoking the damn thing. In a TV studio. With food still on the table. And as if that wasn't bad enough form, he decides to pull a cracker. With himself. "He wins everything," says Young Peter with a resigned half-grin, "and so do the Police." Notebooks out, conspiracy theorists. "And there are one or two people back at home who are just waiting to see the Police." I bet there are. Sting, Andy and Stewart have taken time out from trying not to kill each other to make a new video for *Don't Stand So Close to Me*, apparently filmed at the same time and location as the *De Do Do Do, De Da Da Da* clip shown a couple of weeks back and involving some skiing Santas as well as the band arseing about on a snowmobile as before. Sting can't break with tradition though and, despite the extreme cold, starts taking his clothes off halfway up a mountain. Won't somebody think of the children?

FERN KINNEY - Together We Are Beautiful

"Yes indeedy, ladies and gentlemen..." Uncle Jimmy's put his cigar down somewhere. It's probably setting fire to the tablecloth as he goes to have some fun with the camera crew. "Crew 7, who are responsible for your pictorial elegance and such like, wish you a very merry Christmas and disassociate

themselves with the next title, *We Are Beautiful*." This provokes a hearty laugh from the crew, although Kenny Everett is probably not concerned about Savile taking over his *Video Show* on ITV. Fern Kinney is another turn who only recorded one performance of her big hit and then failed to have any more, so she's back to do it again, but unlike Marti Webb this really was her last appearance on the show as Fern turned out to be a genuine honest-to-goodness one hit wonder and she went back to her day job as a backing singer soon afterwards. At least this time she doesn't have to battle against the TOTP Orchestra. Are we still allowed to mention the TOTP Orchestra? Probably not.

JOHNNY LOGAN - What's Another Year?

Back to Young Peter now and, excitingly, he has a cake! It's a reminder of the time DLT and a random audience member presented Johnny Logan with a birthday cake back in May. "We can't give him a Christmas cake," admits Peter, rather spoiling the effect and giving away the fact that J-Lo's performance is pre-recorded, "but we can certainly give you out there Christmas wishes, and Johnny Logan too." Logan's also had trouble following up his big hit, even after getting his hair cut to make him look less like Rodney Trotter, but he's back on his Westlife stool for another run through *What's Another Year?*, this time in a suit so bright all available light is reflected straight back off it. Still, at this festive time let's remember that Shane MacGowan also did a version of the song, which makes this one seem much, much better. It would take Johnny even longer than Marti Webb to get back on the show, right up until he did the unthinkable and won Eurovision for a second time in 1987 with *Hold Me Now*.

ABBA - Super Trouper

Time to settle the traditional Christmas Day argument – what's the badge Young Peter is wearing on his jumper? Even Pete himself isn't sure whose picture has been adorning his chest all afternoon (although he wasn't wearing it in the opening link, continuity fans). "It's Bogart... isn't it? I think?" "Humpty Go-cart," confirms Uncle Jimmy, now totally bladdered. Better stick on another video, this time the most recent hit – and final UK number 1 – for ABBA. One gets the feeling that the Swedish pop legends are now all heartily sick of being in the band and they'd all quite like to take a break from it, but people just won't stop buying their records, no matter how miserable they make the lyrics. At least Frida has a nice Christmas jumper. This showing brings ABBA to a total of eight times on the show this year without being in the studio, the same number as the Police, Bowie and Blondie. Can any of them sneak in a ninth appearance and win the award for Most Appearances For Least Effort? Time's marching on...

LIPPS INC. - Funkytown

Indeed, as time marches on and Uncle Jimmy continues to lay into the sherry, his behaviour is becoming increasingly erratic. We return from watching ABBA to find him pointing and grinning at something off screen - who knows what? - before becoming uncontrollably excited at Young Peter's merest mention of Limbs & Co. Yes, this is the routine they've been rehearsing all month, and being Christmas it naturally involves toys. Lots of toys: dolls houses, teddy bears, clockwork robots, a train set (maybe that's what Jimmy was getting so excited about), alphabet blocks arranged on the floor to spell out "XMAS TOP OF THE POPS" and even an inflatable paddling pool, just what you want on a midwinter's day in Grimsby. The girls are dressed as... well, it's hard to tell. "Sexy fairies", possibly, or perhaps their dresses were torn to shreds by an angry dog before the performance started. This was the only full airing for Lipps Inc. on the show as *Funkytown* reached its peak position of number 2 during The Event and they never ever looked like having another hit single. Funnily enough, Peter Powell was also co-hosting TOTP the week in 1987 when Pseudo Echo made their only appearance on the show performing their only UK hit - a cover of *Funkytown*.

LEO SAYER - More Than I Can Say

It's not all fun being in Legs & Co though - sometimes you have to stop dancing and stand beside Jimmy Savile. As it turns out, all the toys that were littered around the floor during the dance routine - at least the ones Limbs & Co didn't trip over or stand on - are "going out to deprived children all over the country" because Uncle Jimmy is, as we all know, an eccentric philanthropist who's very fond of children. Be that as it may, time for another number 2 hit that was kept off screen by The Event over the summer, although Mike Martin made a decent fist of it as part of the legendary unbroadcast pilot episode in July. Leo Sayer made a couple of appearances on TOTP during the year, but only as pointless interviewee or emergency guest host, so as a special Christmas gift he finally gets to sing his biggest hit of 1980. Unfortunately, on his big moment, he cuts a faintly ludicrous figure in jacket and tie teamed with leather trousers, with his hair at peak afro, swinging the microphone about by its lead with gay abandon. Careful, Sayer, you'll break that! Honestly, that Mike Martin was never this much trouble.

SHEENA EASTON - 9 to 5

It's all too much for Uncle Jimmy, who's had to go and sit down at the table again so he can "close my eyes and visualise myself as the boyfriend of this young lady," before sinking back in his chair and uttering a faint "Uh-eh-uh-eh-uh" noise, as was his wont. It's left to Young Peter to introduce TV's Sheena

Easton, with only the second performance on the show of her second single but first hit, as the belated success of her first single but second hit rather engulfed it TOTP wise. Does that make sense? More than anything Savile's said all afternoon, I'm sure. Two singles in the chart at the same time, both of them about the drudgery of the daily commute - what a time to be alive. Sheena's appeal would become more selective after this, at least in the UK, although she did get the nod to sing next year's Bond theme *For Your Eyes Only*, beating off a challenge from Blondie who'd already written a song and everything. In the States, of course, Sheena went from strength to strength after Prince took her under his grubby wing, but that sort of association didn't cut the mustard over here.

PINK FLOYD - Another Brick in the Wall (Part 2)

Look out, Uncle Jimmy's woken up again and his quick power nap seems to have done him the world of good. "We should actually pay the BBC for having a super time like this," he offers, before Young Peter needlessly asks us if we remember Pink Floyd. Indeed we do, Pete; we remember the fact that *Another Brick in the Wall* was number 1 last Christmas and for the first couple of weeks of 1980, we remember the "double negative" joke and we particularly remember the terrifying video with cartoon teachers turning into hammers and feeding children through mincing machines. Never the most prolific of acts, the Floyd never scored another top twenty hit single but did manage four number 1 albums over the next 35 years. The choir of Islington Green School never had another hit either; by the end of 1980 there was a new, much more polite gang of singing kids in town.

ST WINIFRED'S SCHOOL CHOIR - There's No-one Quite Like Grandma

It's all over for another year, the turkey has been cleared away before Uncle Jimmy can interfere with it and Limbs & Co are back, still in their dog-ravaged costumes. "Who would not like to spend Christmas like this, dear friends?" asks Savile, as a million hands go up across the country. "Now then, Mr Powell will tell you of the musical content whilst I attend to Legs & Co." Thankfully Jimmy's attentions are limited to offering them a chocolate each from a large box on the table, while Young Peter reminds us that Pink Floyd were number 1 last Christmas but fails to tell us what's number 1 this Christmas because the whole thing was recorded weeks ago before anybody knew. Of course it's the choir again, because even recently deceased rock legends can't compete with the power of the grey pound in Christmas week. So we come to the end of *Top of the Pops for 1980*, a transitional year, but the transition is far from complete: Michael Hurll is still tinkering with the format and even bigger changes are

afoot next year. Not immediately, though, because in those far off days there was no chart published in the week between Christmas and New Year, so TOTP 1981 kicks off on New Year's Day with another look back at 1980 that BBC Four won't be showing.

January 1 1981

"It wasn't an illusion"

The holiday period has been unusually helpful to the BBC One schedulers this year. Some years are awkward and the Christmas Day TOTP special has to be slotted in a day or two before or after a regular edition, but with 25th December 1980 and 1st January 1981 both falling on Thursdays, the Beeb has been able to stick rigidly to the usual quota of one edition of TOTP per week, no more, no less. Last week's special may have been shunted up the schedule to 2pm in order to drum up extra viewers for the Queen's Speech at 3, as per usual, but on New Year's Day everything starts to get back to normal and here we are back in our usual slot just after 7pm. This strict rationing does raise a minor issue though, in that the Christmas week chart didn't have a proper TOTP of its own. Never mind, because in those days no chart was published in the Twilight Zone between Xmas and New Year, so the previous week's chart still stands, ergo we can do it this week, right? Hmmm... actually, no, best not, we tried that last year and ended up with a load of Christmas records in January. Best stick with what you know and go for another compilation of hits from 1980, hosted by "Thomas the Vance" and "D.L. the T." who bash their mics together as a toast to another year gone by.

STATUS QUO - What You're Proposing

And what better way to kick off than with a pre-recorded clip from a previous show? *What You're Proposing* was Quo's biggest hit for a good five years either side, since *Down Down* had reached number 1 in January 1975 and until *In The Army Now* matched *Proposing*'s number 2 position in 1986. Despite this we only saw it once on BBC Four, having featured on both a DLT edition and a Savile edition, and now this clip from the Travis-hosted show on 23 October gets Yewtreed again. Not for us the jeans, white shirt, waistcoat and runny nose look which Francis Rossi made his own; nor the Neanderthal thumping of John Coghlan, Quo drummer of almost twenty years' standing, who just got up and left during the making of the band's 1982 album *1+9+8+2* and didn't come back for three decades. On the bright side, we're spared the pogoing antics of the insufferable 4" Be 2" in their shamrock T-shirts, so it's not all doom and gloom.

OTTAWAN - D.I.S.C.O.

"Tommy, you're really into heavy rock... heavy *metal*, aren't you?" Travis asks Vance, almost blowing the punchline in the process. "Oh, I love heavy metal, David!" Tommy enthuses. "Cop for that then," sniggers Travis, handing Vance a large weight, which is heavy, and made of metal. Doesn't sound funny on paper,

but the way Vance falls out of shot and lands on the floor with a clatter is a performance of great beauty and provokes a moment of genuine shock from DLT, followed of course by hysterical laughter. Still, the show must go on... "Right, well, we've got one dead presenter and we've got Ottawan and *Disco!*" While Tommy Vance is rebuilt we get another outing for this video, complete with female singer Annette dressed up like a parrot beside Jean Patrick Baptiste in a Norwegian blue jumpsuit. This is the fifth and final time *D.I.S.C.O.* graced the TOTP airwaves – if we're counting the times it was played in an endless loop in the background for an entire programme as one play per week – but don't worry, Ottawan will be back with a remarkably similar hit later in 1981.

MADNESS - Baggy Trousers

Thankfully, despite his recent accident Tommy is fit and well enough to provide the next link, although he may have suffered a blow to the head as he struggles to remember the title of *D.I.S.C.O.* and then introduces *Baggy Trousers* by showing his arse to the camera – still inside his fetching grey slacks, thankfully, but even so, it's not what you want if you're still nursing a Hogmanay hangover. Having behaved impeccably during their performance of *Embarrassment* a few weeks back, the Nutty Boys have been allowed back into the studio to create mayhem. They're covered in white powder – presumably fake snow, although this is unclear – and Chas Smash seems to have come as an undertaker, while Lee Thompson has brought his toy saxophone again, even taking a phone call on it during the first chorus. By the end of the song they've formed a line across the front of the stage, Bedders spraying more fake snow into the air, and they'll all be banned again for another month or so. By now you wouldn't expect anything less from them.

THE JAM - Going Underground

And now here's Dave Lee Travis surrounded by five women. Some things never change, eh Dave? He mutters something by way of vague explanation but really, with the canned applause even more deafening than usual, it's like trying to decipher a Rowley Birkin QC monologue. "Right, mumble mumble sublime to the ridiculous, mumble mumble rather nice dresses, mumble cameraman on number 5, mumble mumble ha ha ha! These are the Jam." Yes, Weller & Co are back to perform *Going Underground* for only the second time in the studio, and Weller himself could not be less happy to be here. Maybe it's because the BBC made him leave his Heinz Tomato Soup apron at home this time, but even though he gets to show off the splendid Roy Lichtenstein "Whaam!" guitar he got for Christmas, Weller still looks like a man who'd rather be down the pub. Still, only another two years of the Jam and then he can go swanning off to France and take his shirt off with Mick Talbot. We're jumping ahead, though. The Jam had

two more number 1 hits to come and *Going Underground* also gave Buffalo Tom their only UK hit in 1999.

BILLY PRESTON & SYREETA - *With You I'm Born Again*

Seems like Vance and Travis have been sent to opposite ends of the studio since the first link ended in near disaster. It's Tommy's turn to do a link now, so he promises us "something by two really talented people: Syreeta Wright is the lady, Billy Preston, of course, is the fella." It's another run out for this number 2 from the start of 1980 starring Stevie Wonder's ex-wife and the featured keyboardist on the Beatles' *Get Back*. Written for the soundtrack of the movie *Fast Break* (yeah, me neither – it's a comedy about basketball, apparently) the song remains as mawkish and turgid as it was this time last year, but it was the last top forty hit for either of the duo as Syreeta died in 2004 and Billy in 2006. Back in 1977 Syreeta recorded an album with G.C. Cameron, former lead singer of American soul group The Spinners – whatever happened to them?

DETROIT SPINNERS - *Working My Way Back To You / Forgive Me Girl*

Oops, look out, Travis and Vance are back together again. "It's time to send the kiddies off to bed," advises DLT, "and me, possibly." The reason for such drastic advice? Yes, inevitably, it's time for Legs & Co. "Down boy!" scolds Vance, quickly ushering Travis off stage, not that the girls are even in the studio this week as it's another showing for *that* routine from the *Flick Colby Big Book of Literal Choreography*. Remember when it fell open at the word "working" and Flick had the set decorated with workman's tents and big signs reading "DANGER! LADIES AT WORK"? Yes, that one. We missed out on the Spinners' similarly-themed follow-up *Cupid / I've Loved You For a Long Time*, another medley of a '60s hit with a freshly-penned Michael Zager composition which reached number 4 during The Event, so this is the last we'll hear of them on TOTP until 2003, when the group's backing vocals on Elton John's *Are You Ready For Love?* finally made the chart 24 years after they were recorded.

UB40 - *Food for Thought*

As DLT reminds us that this is the first TOTP of 1981 (and tries to confuse the cameraperson by swaying from side to side) we continue with another hit from 1980. With so many bands of this era having huge line-ups – UB40, Dexys, Madness, the Specials, Bad Manners et al – it's surprising that nobody has yet suggested to Michael Hurll that a bigger stage might be in order. UB40 had three hits in 1980, all of them double A-sides, and we know what that means because Tommy Vance explained it last time they were on. This was the more

January 1 1981

popular A-side of their first hit and, technically, a Christmas song, although only in as much as it juxtaposes African famine with Western Christmas gluttony in a far more eloquent way than *Do They Know It's Christmas?* ever managed. Nobody really listened to the lyrics though, but UB40 persevered with this kind of material for a couple of years before slowly descending from political rhetoric into reggae karaoke. At least nobody blacked up for this one.

KELLY MARIE - Feels Like I'm in Love

Maybe UB40 weren't that bothered about having to squeeze onto a tiny stage for their performance though, because as Tommy Vance informs us "that record was recorded in a two room flat in Birmingham just over a year ago, and they had to keep on putting **ten pees** in the **meter** to keep the actual machinery running!" (Emphasis: model's own.) No such problems for Kelly Marie, one presumes. Aware that nobody gives a monkey's about her other songs, Kelly is back in the studio for one final outing for the song Ray Dorset of Mungo Jerry wrote for Elvis Presley and which became Pye Records' last ever number 1 hit. For reasons unknown we're still using the same mix that's slightly different to the one on the record, and the two twirling loons are still in place behind Kelly, this time in Elvis-style jumpsuits just to rub it in. Despite Kelly's constant whinging that the media are only interested in Sheena Easton we'll still get to see her next single *Hot Love* three times in 1981, which is more airings than some number ones get.

HOT CHOCOLATE - No Doubt About It

More baffling behaviour from Travis as we find him sat behind a drum kit. "We're gonna have a quickie quiz!" he announces. "Here's a clue as to the start of the next record, it starts like this." Cue five seconds of DLT knocking seven bells out of the drum kit, quickly fading into the start of *No Doubt About It* which quite blatantly doesn't have a drum solo at the beginning, or indeed at any point. We shan't dwell on that though, just as we shan't dwell on where the applause is coming from when we can quite clearly see the audience standing around not applauding. This is a repeat of the first performance of the song from the beginning of May, complete with video feedback effects giving you a whole army of Errols at key moments. Despite the oft-repeated fact that Hot Chocolate had a hit every year between 1970 and 1984, this is all we'll see of them in 1981 as their only hit of the year *You'll Never Be So Wrong* only reached number 52, maybe because it was written for Kim Wilde.

BOOMTOWN RATS - Banana Republic

While DLT is elsewhere, probably still amusing himself on the drums, Tommy has

January 1 1981

found a young, apprehensive-looking lady called Debbie to put his arm around. He proceeds to tell her all about the story behind *No Doubt About It*, except he's under the impression that it was Hot Chocolate themselves who were visited by little green men, when in fact none of the band had anything to do with writing the song. Vance noticeably fails to impart any information regarding the story behind *Banana Republic*, which is probably just as well. This seems a bit recent to be appearing on a review of the year, being still at number 11 this week, but it was the Rats' biggest hit of the year and, as it turned out, their last ever top twenty hit. Be warned though that this is the video again, so everyone takes their shirt off for no adequately explained reason and Geldof almost has a nasty accident with a set of chest expanders. Do be careful, Bob.

STEVIE WONDER - Master Blaster (Jammin')

"I hope 1981 is going well for you... what do *you* want?" Travis is back to interrupt Vance's sincere good wishes to the viewing public, but he's gained a pair of braces from somewhere and decided that it would be a great idea to come on doing an impression of Bobby Ball. "I'm worried about your trousers at the moment," Tommy admits, causing DLT to snigger again. "I'm not worried about my trousers at all, I'm worried about that fact that we have Stevie Wonder and we're talking when he should be singing!" Don't worry yourself, Dave, he's not actually here, it's that video again and it goes on for a full minute before he even starts singing. After a bit of a lull around the turn of the decade, Wonder was back on form and had another three top ten hits to come in 1981, including another number 2. In contrast it's fair to say that Bob Marley, the subject of this song, didn't have such a good year, but we'll come to that in May.

ABBA - The Winner Takes It All

Oh dear, Travis has finally lost it. Holding a briefcase with "BBC TV 51" printed on it, he adopts some kind of vaguely American accent. "For 1981, *Top of the Pops* goes commercial. Do you have a friend who's awfully dirty? Buy him an official BBC portable sink!" The joke might have worked better if we'd been able to see what was inside the briefcase when Travis flipped it open, but we'll never know. Still, it's not easy to pad these out to 45 minutes. On with DLT's favourite group in the whole world, still at each other's throats and antagonising each other in their song lyrics while pretending in interviews that nothing's wrong and they've got no plans to split up. ABBA would release their final album *The Visitors* at the end of 1981 but with previous LP *Super Trouper* still in the middle of a nine-week run at number 1, here's another chance to see that toe-curlingly awkward video for the album's first single. Agnetha's restraint in this video is remarkable; while everyone else is laughing uproariously at the one about the two nuns in the nudist colony, she stares quietly at her salad rather

January 1 1981

than flipping the table, giving everyone the finger and torching the place. Maybe she realises that, if you count this as the last TOTP of 1980 instead of the first of 1981, this is ABBA's ninth appearance of the year without them ever being in the studio, putting them at the top of that particularly niche leaderboard.

THE PRETENDERS - Brass in Pocket

"If you can think back 365 days, you might even remember that this particular record by the Pretenders was at number 1!" Oh Tommy, it's good but it's not right. Of course *Brass in Pocket* was the first single to reach the top in 1980, but not until Pink Floyd relinquished the position in mid-January. Let's not worry about little things like facts, though, as Chrissie and the boys are back for one last run through of the song before 1980 is finally consigned to history. Vance and Travis say goodnight, but not before a reminder of the impending Radio 1 reshuffle: DLT is handing over the reins of the Breakfast Show to Mike Read, whose evening show has already been taken over by Richard Skinner, while Tommy Vance... gets to carry on doing the *Friday Rock Show* as per usual. No personnel changes on TOTP over the coming year, apart from the return of a certain likeable Canadian later in the autumn, if BBC Four lasts that long.

Index

#
4" Be 2"......................................180, 184, 227
7 Teen..30, 38
747 (Strangers in the Night)............................122
9 to 5...130, 224

A
A Forest...90
A Lover's Holiday......................................126
A Walk in the Park......................137, 149, 160
a-ha..20, 39, 85
ABBA.....16, 131, 136, 196, 204, 208, 212, 223, 231
Abbot, Russ..162
AC/DC..39, 207
Ace of Spades....................................191, 197
Adam & the Ants.....................176, 184, 209
Air Supply..182
Alabama Song..54
Alcazar..30
All Night Long......................................53, 61
All Out of Love..182
All Over the World...........................134, 141
Amigo...162, 172
And The Beat Goes On..........................37, 48
Another Brick in the Wall (Part 2)....15, 19, 215, 225
Another Nail in my Heart........................57, 64
Another One Bites the Dust...........157, 161, 163
"Antmusic"..209
Are You Getting Enough Of What Makes You Happy
..129
Are You Ready..34
Armoury Show, The...................................153
Army Dreamers..182
Arthur Daley ('e's Alright)...........................200
Ashes to Ashes....................133, 141, 146, 215
At the Edge..44, 52
Atomic.............................46, 54, 58, 220
Attractions, The.............................42, 50, 90
Average White Band........................101, 113
Azymuth...26, 32

B
Babe..23
Babooshka..125
Baby I Love You........................33, 44, 48
Back Together Again.................................116
Bad Manners.............92, 131, 178, 185, 188
Bad News..133, 193
Baggy Trousers...................160, 168, 175, 228
Banana Republic..........................197, 207, 230
Bankrobber......................................139, 152
Barracudas, The......................................142
Barron Knights, The................61, 160, 215, 217
Bates, Simon....................20, 79, 193, 214

Batt, Mike..29
Beat, The........13, 47, 56, 86, 97, 108, 147, 151, 214
Bee Gees...............................20, 27, 156, 176
Benson, George...............................131, 177
Berry, Colin..184
Berry, Mike.....................................134, 143
Best Friend.....................................147, 151
Better Love Next Time........................14, 23
Bevan, Bev..202
Big Country..153
Big Time, The................................131, 138
Black Sabbath...153
Black Slate.....................................162, 172
Blockheads, The.............................145, 154
Blondie.............46, 54, 58, 85, 93, 196, 200, 220
Blow, Kurtis...13
Blue Moon......................................201, 209
Bodysnatchers, The........................64, 82
Boney M..12, 102
Booker T & the MGs........................19, 24
Boom Boom... Out go the Lights.............173
Boomtown Rats, The..........27, 37, 197, 207, 230
Bourgie' Bourgie'..............................181, 194
Bowie, David...12, 54, 133, 141, 146, 185, 193, 221
Brass in Pocket.................12, 24, 30, 232
Breathing......................................98, 108
Bremner, Billy...53
British Electric Foundation........................99
Brooks, Elkie...181
Brothers Johnson, The........................60, 70
Browne, Tom..128
Bucket of Water Song, The......................107
Buggles......................................26, 39, 47, 82
Bush, Kate.............................98, 108, 125, 182
Buzz Buzz A Diddle It......................29, 41

C
Cage Against the Machine.........................72
Call Me...85, 93
Can't Stop the Music........................135, 145
Cappella..62
Captain & Tennille, The.....................55, 63
Captain Beaky....................................35, 41
Caravan Song..29
Carrie..36, 48
Carter The Unstoppable Sex Machine........92
Carter, Lynda...161
Casanova.......................................171, 183
Celebration....................................188, 199
Change......................................126, 165, 168
Chas & Dave...................................144, 217
Check Out the Groove.........................88, 91
Chic..........................14, 17, 21, 128, 168
Chinatown......................................118, 124
Chords, The......................................38, 95

Christine..81
Christmas Rappin'13
Circus Games......................................144, 153
Clash, The.............................11, 113, 139, 152
Clean, Clean..82
Cockney Rejects, The......................91, 102, 112
Coffee..171, 183
Cole, George..200
Comic Strip, The.......................133, 173, 193
Coming Up..89, 220
Computer Game (Theme from The Invaders)......122
Costello, Elvis................................42, 50, 90
Council Collective, The...............................106
Coward of the County........................31, 44, 49
Crackerjack..118
Crawford, Randy..................................151, 159
Crown Heights Affair.............................105, 117
Crying...118
Crying at the Discoteque...............................30
Cuba...52, 55, 58
Cure, The..90

D

D-a-a-ance...110
D.I.S.C.O...................164, 170, 175, 180, 183, 227
Daltrey, Roger...133
Damned, The..24
Dance Stance...22
Dance Yourself Dizzy............51, 58, 61, 69, 79, 221
Darts..125
Day Trip to Bangor (Didn't We Have a Lovely Time)
...13, 215
De Do Do Do, De Da Da Da..............................211
Dear Miss Lonely Hearts...............................84
Def Leppard..61, 85
Dennis Waterman Band, The...................190, 199
Detroit Spinners, The.............60, 64, 72, 83, 88, 229
Dexys Midnight Runners.....22, 75, 87, 93, 98, 103, 219
Diamond, Neil.....................................189, 205
Dickson, Barbara......................29, 66, 74, 84
Do Nothing..215
Do That To Me One More Time....................55, 63
Do You Feel My Love?............................198, 205
Dog Eat Dog..176, 184
Dollar...................................18, 28, 80, 177
Don't Make Waves..........................87, 97, 107
Don't Push It, Don't Force It...............73, 75, 94
Don't Stand So Close to Me.165, 169, 174, 178, 222
Don't Walk Away..202
Dooleys, The..59, 71
Dr Hook.......................14, 23, 70, 78, 80, 125, 194
Dream a Lie...201
Dreamin'..141, 150
Dury, Ian..101, 145, 154

E

Earth Dies Screaming, The.....................190, 200
Earth, Wind & Fire......................................206
Easton, Sheena...........130, 137, 150, 159, 186, 224
Echo Beach..56, 67
Edmunds, Dave..........................42, 43, 53, 212
Edwards, Bernard....................17, 21, 128, 163
Eighth Day..140, 149
Electric Light Orchestra..............126, 134, 141, 202
Embarrassment....................................203, 210
Enola Gay...171, 182
Escape (The Pina Colada Song).................24, 33
Essex, David..79, 92
Et Les Oiseaux Chantaient...........................178
Eyes Have It, The.......................................111

F

Fashion...185, 193
Fatima Mansions, The...............................114
Feels Like I'm in Love..129, 140, 149, 157, 161, 230
Fialka, Karel...111
Fiddler's Dram..13
Filthy, Rich & Catflap..................................19
Firm, The..200
Flack, Roberta...116
Flash...211
Flying Lizards, The......................................42
Food for Thought (Barron Knights).............61, 215
Food for Thought (UB40)..................66, 76, 87, 229
Fool For Your Loving..............................95, 107
Four Bucketeers, The..................................107
Foxx, John................................32, 72, 133
Francis, Stu..194
Franklin, Rodney.............................89, 91, 95
Funkin' for Jamaica (NY)............................128
Funkytown......................................110, 117, 224

G

Gabriel, Peter..........................49, 52, 62, 63, 108
Games Without Frontiers.....................49, 52, 62
Gap Band, The...130
Gardiner, Boris..113
Generals and Majors..................................158
Genesis...63, 69
Geno................................75, 87, 98, 103, 219
Gibson Brothers, The.................52, 55, 62, 130
Gillan..166
Girl...85
Give Me the Night.......................................131
Going Underground.....................67, 72, 78, 228
Got to Love Somebody..................................21
Gotta Pull Myself Together.....................172, 180
Grant, Eddy.......................................198, 205
Greatest Cockney Rip-Off, The............91, 102, 112
Green Onions...19, 24
Groove, The.................................89, 91, 95

H

Half Man Half Biscuit.........................16, 24, 82

Hall, Daryl	202	Jon & Vangelis	25, 34, 43
Hands Off... She's Mine	47, 56	Jones, Grace	135
Happy House	62, 71, 81	Jones, Paul	173
Hathaway, Donny	116	Judas Priest	70, 74, 81, 146, 155
Haywood, Leon	73, 75, 84, 94	Jump Down Jimmy	120
Heaven 17	99, 106	Just Can't Give You Up	99, 106, 120
Hello America	61	(Just Like) Starting Over	190, 192, 194, 218
High Fidelity	90		
Hodges, Chas	134	**K**	
Hold On To My Love	96, 106	KC & The Sunshine Band	18
Holdin' On	58	Keegan, Kevin	89, 148
Holiday '80	99	Killer on the Loose	167
Hollywood Tease	85	King, Jonathan	160
Holmes, Rupert	24, 33	Kinney, Fern	48, 57, 63, 222
Hot Chocolate	96, 104, 106, 116, 129, 230	Kiss on my List	202
Hot Dog	46, 57, 66	Knight, Gladys	180, 194
Hot Gossip	18	Kool & the Gang	30, 41, 188, 199
Human League, The	31, 38, 79, 99, 103, 105	Kool in the Kaftan	67, 77, 85
I		**L**	
I Can't Stand Up For Falling Down	42, 50	L.A. Guns	85
I Could Be So Good For You	171, 190, 199	Lady	206
I Die: You Die	143	Lambrettas, The	55, 65, 77, 110
I Got You	156, 162	Leaving Here	97
I Have a Dream	16	Legs & Co	14, 18, 24, 27, 32, 37, 42, 48, 53, 57, 60, 65, 70, 76, 80, 85, 91, 93, 95, 101, 106, 114, 117, 121, 123, 128, 134, 139, 146, 150, 155, 161, 164, 168, 172, 176, 183, 185, 190, 195, 198, 202, 206, 210, 218, 221, 224, 229
I Hear You Now	25, 34		
I Like (What You're Doing To Me)	196, 204, 205		
I Like Chinese	176		
I Owe You One	164		
I Shoulda Loved Ya	94, 109	Lennon, John	190, 192, 194, 212, 218
I Wanna Hold Your Hand	18	Let's Do Rock Steady	64, 82
I Want to be Straight	145, 154	Let's Get Serious	114, 119
I'm Born Again	12	Let's Go Round Again	101, 113
I'm Coming Out	198, 208	Let's Hang On	125
I'm Forever Blowing Bubbles	112	Lewie, Jona	101, 111, 206, 217
I'm in the Mood for Dancing	19, 26, 37, 219	Lies	210
If You're Looking for a Way Out	168, 184	Linx	165, 173
Imagine	195, 212	Lip Up Fatty	131
Iron Maiden	49, 193	Lipps Inc	110, 117, 224
Is It Love You're After	15, 17	Liquid Gold	51, 58, 61, 69, 79, 116, 195, 221
It's Different for Girls	17, 27, 40	Little & Large	49, 215
It's Only Love	154	Little Jeannie	117
It's Still Rock 'n' Roll To Me	139, 150, 161	Living After Midnight	70, 74, 81
		Living by Numbers	20, 34
J		Livingstone, Dandy	64
Jackson, Freddie	120	Logan, Johnny	93, 98, 99, 109, 114, 223
Jackson, Jermaine	114, 119, 210	London Calling	11
Jackson, Joe	17, 27, 40	Looking for Clues	189, 209, 216
Jackson, Michael	42, 51, 63, 100, 110	Love Enough for Two	77
Jam, The	67, 72, 78, 138, 152, 228	Love on the Rocks	189, 205
Jane	36, 50	Love Patrol	59, 71
January February	66, 74, 84	Love x Love	177
Jazz Carnival	26, 32	Loving Just for Fun	181
Jefferson Starship	36, 50	Lowe, Nick	43, 53
Jensen, David "Kid"	16, 31, 50, 74, 116	Lynott, Phil	84
Joel, Billy	139, 150, 161	**M**	
John I'm Only Dancing	12		
John, Elton	117, 127, 144, 229	MacColl, Kirsty	101, 114

Index 235

Madness 11, 16, 22, 32, 74, 86, 154, 160, 166, 168, 175, 203, 210, 228
Mama's Boy..28
Manic Street Preachers...114
Mansfield, Tony..20
Mariana...130
Marie Marie..138, 155
Marie, Kelly.........129, 140, 149, 157, 161, 181, 230
Marley, Bob..159, 169, 231
Martha & the Muffins.......................................56, 67
Martin, Mike..124, 224
Marvin, Hank..150
Mash, The...114, 121
Master Blaster (Jammin')......................159, 166, 231
Matchbox...................29, 41, 100, 114, 167, 177, 211
Maybe Tomorrow...38
McCartney, Paul.........................11, 89, 110, 123, 220
McLean, Don...118
Messages...103, 119
Michell, Keith...35, 41
Midnite Dynamos...100, 114
Mills, Stephanie..............................187, 189, 197, 201
Minogue, Kylie...188
Mirror in the Bathroom..................................97, 108
Missing Words..76, 86
Modern Girl...137, 150, 159
Monty Python's Contractual Obligation Album....176
More Than I Can Say..124, 224
Motorbike Beat..31
Motorhead...97, 191, 197
Murvin, Junior..113
My Feet Keep Dancing..14
My Friend Jack..102
My Girl..11, 16, 22, 32
My Oh My...65, 81, 91
My Old Piano..163, 170
My Perfect Cousin..................................79, 92, 103
My World..60, 71, 83
Mystic Merlin...99, 106, 120

N

Narada...95, 109
Ne-Ne Na-Na Na-Na Nu-Nu................................92
Never Knew Love Like This Before....187, 189, 197, 201
Never Mind the Presents...................................215
New Musik..20, 34, 94, 137
Newton-John, Olivia..........................126, 159, 186
Nick Straker Band................................137, 149, 160
Night Boat to Cairo...74
Night, the Wine and the Roses, The...................195
No Doubt About It................96, 104, 106, 116, 230
No One Driving...72
No Self Control..108
Nobody's Hero...119
Nolans, The...18, 19, 26, 37, 87, 97, 107, 172, 180, 217, 219

Numan, Gary.................................113, 143, 211, 216

O

O'Connor, Hazel............................140, 149, 165
O'Sullivan, Gilbert..................................173, 181
Oates, John...202
Ocean, Billy..34
Odyssey...123, 168, 184
Oh Yeah (On the Radio)....................................128
Oldfield, Mike...207
One Day I'll Fly Away.................................151, 159
One Man Woman...186
Oops Upside Your Head.....................................130
Orchestral Manoeuvres in the Dark...103, 119, 171, 182
Ottawan.......................164, 170, 175, 180, 183, 227
Over the Rainbow / You Belong to Me.................211
Over You...105, 118

P

Palin, Michael..176
Palmer, Robert..........................189, 202, 209, 216
Pang, May...194
Paradise Bird...23
Paranoid...153
Passion...199
Peel, John...79
Pink Floyd...............................15, 19, 118, 225
Pips, The..180, 194
Piranhas, The...127, 140
Plastic Age, The..............................26, 39, 47
Platinum Blonde...100
Please Don't Go..18
Poison Ivy..55, 65, 77
Police and Thieves...113
Police, The.......53, 59, 165, 169, 174, 178, 211, 222
Positive Force..22
Powell, Peter......11, 46, 69, 99, 122, 127, 142, 170, 184, 205, 219
Prelude...100
Presley, Elvis..154
Preston, Billy...................................14, 20, 229
Pretenders...................12, 24, 30, 75, 86, 135, 232
Prima Donna...77, 93
Prince..131
Private Life...135
Pulling Mussels (From the Shell)......................105

Q

Quadrophenia..24
Quatro, Suzi...28, 176
Queen..............................35, 38, 157, 161, 163, 211

R

Rabbit..217
Rainbow..46, 61
Rallo, Tony & the Midnite Band..........................58
Ramones, The...33, 44, 48

Rantzen, Esther..63, 131
Rat Race...112
Read, Mike..26, 64, 110, 162
Reasons To Be Cheerful, Pt 3.................................101
Reeves, Vic...96
Regents, The...30, 38
Revillos, The...31
Rezillos, The..31
Richard, Cliff.......33, 36, 48, 54, 119, 137, 141, 150, 163, 186
Riders in the Sky..33, 43, 53
Robbins, Kate...77
Robertson, B.A......36, 63, 67, 77, 85, 122, 142, 152
Robinson, Tom..144
Rock 'n' Roll...99
Rock With You...42, 51
Rodgers, Nile..17, 21, 128, 163
Rogers, Kenny......................................31, 44, 49, 206
Ronson, Mark...130
Rose Royce..15, 17
Ross, Diana........127, 136, 153, 163, 170, 198, 208
Roxy Music..105, 118, 128, 190
Ruffin, Jimmy..96, 106
Runaway Boys......................................203, 212, 214
Running Free..49
Rush..59, 65
Rutles, The...149
Ruts, The..86, 102

S

S-Express...15, 17
Sad Café...21, 63, 65, 81, 91
Saint Etienne..85
Same Old Scene, The..190
Sartorial Eloquence...144
Save Me..35, 38
Savile, Jimmy........................28, 84, 153, 188, 219
Saxon...80, 96, 122
Sayer, Leo.............................124, 154, 162, 224
Searching..165, 168
Secret Affair....................................60, 71, 83, 148
Selecter, The..31, 39, 76, 86, 143
Sex Pistols...38
Sexy Eyes..70, 78, 80
Shadows, The..33, 43, 53
Shalamar..164
Sham 69..38, 88, 91, 102
She's Out Of My Life....................................100, 110
Sheila & B. Devotion................................17, 29, 80
Showaddywaddy...........................175, 186, 201, 209
Silver Dream Machine....................................79, 92
Silver Dream Racer..79, 92
Singing the Blues..43, 53, 54
Siouxsie & the Banshees.........................62, 71, 81
Sister Sledge..21
Skids, The...18, 144, 153
Skinner, Richard.......................................153, 188, 209

Sky...80, 90
Skyhooks..193
Slade..136, 145
Sleepwalk..133
Sly & Robbie..135
Smoke, The..102
Smokie...89, 148
Snap..130
Snoop Dogg...130
So Good To Be Back Home Again....................36, 47
So Lonely..53, 59
Someone's Looking At You...............................27, 37
Something's Missing..95
Soul, David...66
Sound of Confusion..148
Spacer..17, 29
Spandau Ballet..195, 203
Sparrow, The..215
Special Brew..178, 185, 188
Specials, The....................28, 35, 40, 86, 112, 215
Spector, Phil..33, 48, 186
Spinal Tap..26, 80, 85
Spirit of Radio...59, 65
Spirits Having Flown......................................20, 27
Split Enz...156, 162
Splodgenessabounds...156
Squeeze...57, 64, 105
St Winifred's School Choir...............207, 214, 225
Stand Down Margaret..151
Staring at the Rude Boys...............................86, 102
Start!..138, 152
Status Quo......................................170, 180, 188, 210, 227
Stevens, Shakin'.........................46, 57, 66, 138, 155
Stewart, Amii...23
Stewart, Rod..199
Stiff Little Fingers...44, 52, 119
Stomp..60, 70
Stop the Cavalry..206, 217
Strange Little Girl...21
Strange, Steve..134, 221
Stray Cats....................................53, 203, 212, 214
Streisand, Barbra......................176, 183, 187, 220
Styx..23
Substitute...116
Suddenly...186
Summer Fun..142
Sunshine of Your Smile, The......................134, 143
Super Trouper......................196, 204, 208, 212, 223
Sweet People...178, 183
Syreeta...14, 20, 229

T

Take Good Care of My Baby................................89
Take That Look Off Your Face...........44, 50, 63, 222
Talk of the Town..75, 86
Tarney, Alan..20, 66, 84, 163
Tears of a Clown..13

Index 237

Teenage..111
Tell the Children..88
Theme from M*A*S*H (Suicide is Painless) 109, 114, 121
There's No-one Quite Like Grandma...207, 214, 225
Thin Lizzy......................77, 84, 118, 124, 133, 167
This World of Water....................................94
This Wreckage..216
Three Little Birds.....................................169
Three Minute Hero................................31, 39
Thurston, Bobby...................................88, 91
Tide is High, The..............................196, 200
Tiswas.............................107, 120, 125, 212
To Be Or Not To Be....................................77
To Cut a Long Story Short....................195, 203
Toccata..80, 90
Together We Are Beautiful.............48, 57, 63, 222
Tom Hark..127, 140
Too Hot..30, 41
Too Much Too Young........................28, 35, 40
Too Nice To Talk To..................................214
Touch Too Much..39
Tourists, The......................................36, 47
Travis, Dave Lee....55, 105, 148, 166, 180, 197, 227
Triplett, Sally Ann....................................77
Trouble..166
Turn It On Again..................................63, 69
Turning Japanese...........................51, 61, 68
TV...42
Two Little Boys......................................156

U

U Got 2 Know...62
U2...52, 194
UB40.................30, 66, 76, 87, 190, 200, 201, 229
UFO..16
UK Subs...56, 111
Ultravox...32, 133
Underpass...32
Undertones, The............................79, 92, 103
United..146, 155
Upside Down..................................127, 136
Use it Up and Wear it Out..........................123
Utah Saints..105

V

Vance, Tommy...............94, 133, 175, 201, 227
Vandross, Luther....................................168
Vapors, The...............................51, 61, 68, 69
Vicious, Sid...38
Village People, The.............................135, 145
Visage..134

W

Wailers, The...169
Walden, Narada Michael........................94, 109
Warhead..56
Waterfalls..123

Waterhouse, Matthew..............................182
Waterman, Dennis......................171, 190, 199
We Are Glass...113
We Got the Funk......................................22
Webb, Marti...........................44, 50, 63, 222
What You're Proposing........170, 180, 188, 227
What's Another Year?........93, 98, 99, 109, 114, 223
What's in a Kiss?...............................173, 181
Wheels of Steel.................................80, 96
When You Ask About Love...................167, 177
Whisper, The...143
Whispers, The....................................37, 48
White, Snowy...118
Whitesnake......................................95, 107
Who's Gonna Rock You............................217
Why Do Lovers Break Each Other's Hearts. 175, 186
Wilde, Kim...230
Wilkinson, Sue.................................136, 145
Wings..11
Winner Takes It All, The................131, 136, 231
With You I'm Born Again..................14, 20, 229
Woman in Love..................176, 183, 187, 220
Women in Uniform..................................193
Wonder, Stevie..............................159, 166, 231
Wonderful Christmastime............................11
Work, Rest & Play....................................74
Working for the Yankee Dollar......................18
Working My Way Back To You / Forgive Me Girl...60, 64, 72, 83, 88, 229
Wright, Steve....................35, 36, 59, 89, 137

X

Xanadu (film).............................159, 186, 202
Xanadu (song).......................................126
XTC..158

Y

Yellow Magic Orchestra, The......................122
Yes..34, 47
You Gave Me Love..............................105, 117
You Gotta Be A Hustler If You Wanna Get On.....136, 145
You'll Always Find Me in the Kitchen at Parties. 101, 111
You're Lying....................................165, 173
Young & Company......................196, 204, 205
Young & Moody Band, The..........................97
Young Blood..16
Young Ones, The...............................173, 191

Z

Zager, Michael..88
Zavaroni, Lena.....................................120